Wondering about Wildflowers?

A Wildflower Guide for the Northern Rocky Mountains

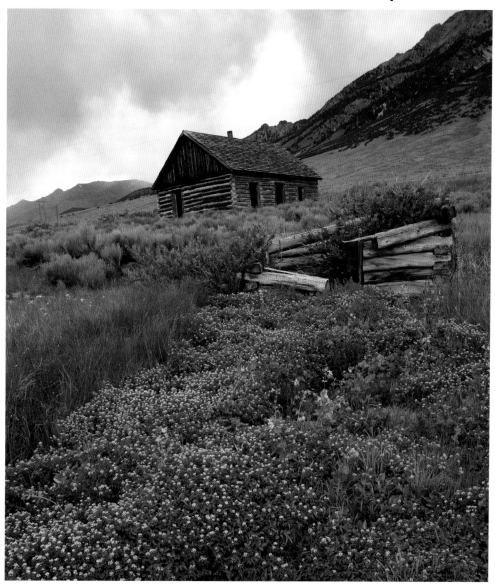

Sharon Huff, Dr. Stephen L. Love, Sharron Akers

ISBN: 978-1-59152-219-5

Photography © 2018 by Sharon Phillips Huff, Dr. Stephen L. Love
and Sharron Larter Akers
© 2018 by Sharon Phillips Huff

For more information or to order extra copies of this book call
Farcountry Press toll free at (800) 821-3874.

sweetgrassbooks
an imprint of Farcountry Press

Produced by Sweetgrass Books
PO Box 5630, Helena, MT 59604; (800) 821-3874;
www.sweetgrassbooks.com

 Produced and Printed in the United States of America.

22 21 20 19 18 1 2 3 4 5

Contents

Acknowledgments

We did not do this alone. A VERY SPECIAL THANKS to the many who have helped us along the way: identifying one flower or many, correcting a mistake/mistakes, confirming an identification, showing or telling us where to find a particular wildflower, suggesting ways to improve the photographs we took or which ones should be replaced with better ones, explaining more about the plants we saw, letting us use a photograph or many photographs, taking us to out of reach places with four-wheel drive, teaching us to use Microsoft Word more effectively, providing music for our slide shows, supervising the cutting of a Water Hemlock root on a ranch, teaching us some of the technical language for wildflowers, encouraging us to keep learning and looking.

We are forever indebted to those who helped us in one or several ways: Steve Love, Research Professor of the Aberdeen Experimental Research Center; Callie Russell, the late Dr. Scott Earle, Wallace Keck, Supt. at the City of Rocks; Paul Santori, Gwen and Don Russell, T. Les Huff, Lenard Ramacher and Jim Bromberg at NPS, Craters of the Moon; Larry Lass at the Erickson Diagnostic Lab at University of Idaho; Mark Turner, Turner Photographies; Eric Russell, Dr. Rick Williams, Dept. of Biological Sciences, Idaho State University; JF Smith, Boise State; Al Schneider, www.swcoloradowildflowers.com; Dr. Karl Holte, emeritus botanist from Idaho State University; Elizabeth Corbin, Owyhee Botanist; Ann DeBolt, Botanist at the Idaho Botanical Gardens; Noelle Orloff, Shutter Diagnostics Lab, Montana State University; LaMar Orton of Plantasia Cactus Gardens; Dr. Tuthill, University of Wyoming; Susan Fritts, District Botanist, BLM; Sonja Hartmann, Native plant Nursery, Glacier Park; Nathan Jerke, Idaho Transportation Department; Jane Lundin, Raeni and Jared Ocean, Jim Linderbom, Howard Rosenkrance, Lauri Bombard, Wendy McGrady, William Russell Jr., Skylee Russell, Marjorie Richard, John Powers.

Stop and smell the Syringa!

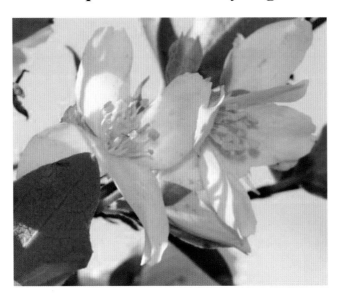

Introduction

Sharron Larter Akers and Sharon Phillips Huff have been friends since the sixth grade in Mackay Elementary School. In 2009, we became interested in photographing wildflowers, as we thought a CD of wildflowers might help raise money for the Veterans Memorial near Challis, Idaho, that Sharron was spearheading at the time.

We do not have any background in botany other than a class in biology our sophomore year of high school in Mackay. In fact, we did not even know that leaves were an important part in the identification of flowers. Not only could we not pronounce the scientific names, we wondered why they were even used. After passing from clueless to curious, we found many pretty flowers that really turned out to be weeds. Larry Lass of the Erickson Diagnostic Lab at the University of Idaho helped us the first year. We still marvel at his patience and help in identifying the many early flowers.

Novices for sure but nevertheless the two of us continued to ask and learn. A spark developed into a passion. We enjoyed our back-road trips stopping at lazy creeks, taking in the breathtaking scenery like the Sawtooths Mountains in the Stanley Lake and Redfish areas, often going places we should not be going to at our age-but oh—there was the adventure, flat tires and dead batteries too. We took dirt roads we had never traveled on, and discovered those beautiful short lived-wildflowers here and there in the out of way places. There is nothing quite like discovering a Fairy Slipper Orchid or a Steer's Head for the first time. Certainly, the shortness of life slapped us in the face and woke us up to enjoying the here and now and appreciating the wonder of it all.

Since then, we have bought and studied books about wildflowers as the pictures helped us learn the various flower names. This led us to studying the descriptions and the pictures of wildflowers in other books. After purchasing what seems now to be a zillion wildflower books and using the Internet for information, we learned that having a good picture of the flower's leaves was vital in its identification for us. Mainly, we could not have learned what we have without the help of Dr. Stephen L. Love, Research Professor of the Aberdeen Experimental Research Center who came to our aid. He corrected our many mistakes and dragged us up the learning curve. Without his help, we would have given up long, long, long ago. Slowly, we learned more, found a new little Eden with unusual wildflowers. Each year we made a new DVD of the flowers we found and made a handful of sales but never enough to buy even one flag for the Veteran's Memorial that had been completed in 2011. Not many were interested in looking at pictures of wildflowers.

Sharron Akers, a widow, returned to Mackay to take care of her ninety something mother. After her mother passed, she stayed in Mackay to live. Sharon Huff comes to Mackay, her old hometown, in the summers with her husband to get out of the Phoenix heat. He often traipsed the back roads with us in the early years.

As the years have passed, our photographs have also improved or maybe we just take more pictures to compensate for our lack of ability! Sharron has the better artistic eye for

panoramic pictures; Sharon is better at the close up shots simply because she has a good close up lens. Since we shake a little more now than we used to, we have to take more pictures simply to get a few good ones. Getting down on our knees and bellies is more and more of a problem and getting back up is more so. We help each other up and use walking sticks.

This year we decided to put all our pictures together in a book, for reference. We are both eighty-two years old, and our brains not too sharp. The book was to help us remember the name of the flower that may be on the tip of our tongue.... Most books have detailed descriptions of the flowers but not enough close up pictures. A beginner usually cannot understand some of the descriptions, and it is the pictures that help identify the flowers. This book is for the beginners, who merely want a clue as to what flower might be in front of them.

Custer County, Idaho is a great place to look for wildflowers as it has so many back dirt roads and not many people. We have not discriminated against native and non-native or even pretty weeds that we see. Occasionally, there is an unusual blossom or berry from a tree or bush that attracted us, so we tossed it into the mix. This book is for the novice, not the learned, for those curious to know more and need a simple guide. We are still out and about, searching for a new wildflower or a scenic wonder, one of those pinch me moments.

When we were twenty years younger!

Sharron Larter Akers, far left

Sharon Phillips Huff, on the right

Photographers

When we were partly through this book, Dr. Stephen Love proofread the identifications we had thus far. There were too many wrong! We cleaned up our mistakes and asked Dr. Love if had some photographs he would like to include. He sent some great pictures and descriptions of wildflowers. His photographs are a welcome addition! We could not have done this book without Dr. Love's wonderful help over the years and are most grateful for his time, patience, and knowledge.

Dr. Stephen L. Love

Wildflower spots that are exceptionally rewarding:

Twin Creeks is about eight or nine miles from the border between the Idaho/Montana in Lemhi County. Watch for the sign, get off Highway 93 and drive about a ½ mile. Find the campground, then walk down to the creeks; look around the creeks and the campground.

There is a wonderful large variety from April through August: Glacier Lily, Dwarf Hesperochiron, Lemhi Midnight, Trillium, Clasping Leaf Twisted Stalk, Cat's Paw Mariposa, Large-flowered Triplet-lily, Big Pod Mariposa, Fairy Slipper Orchid, Birchleaf Spirea, Fivestamen Miterwort, Leopard Lily, Thimbleberry, Little Buttercup, Twinflowers, Wilcox's Penstemon, Kinnikinnick, Beargrass, Pipsissewa, along with the more commonly found flowers.

Stanley, hiking trails around Stanley Lake, woods across from the parking lot at Stanley Lake and also the Stanley Creek area

Watch for flowers along the road from Stanley to Stanley Lake; also see the rock outcrops coming into town. Explore Stanley Creek, just opposite the turn off for Stanley Lake. Early in the spring the Marsh Marigold and several kinds of Buttercups are blooming, a bit later the beautiful Camas, just watch and stop often along the way as you will see so many different ones in various spots from several kinds of Gentians including the White Gentian. Get out and walk in the many areas as you might see the Nevada Bitterroot, Dwarf Hesperochiron, Spring Beauty, Trapper's Tea, Kinnikinnick, Creeping Oregon Grape, Cascara, White Marsh Marigold, several kinds of violets, buttercups and paintbrush. If you are really looking in the spring you can find Cusick's Primrose up Stanley Creek. In July start watching for Rose Spirea, Monkshood, Swertia, Autumn Willowherb, Pond Lily, Prince's Pine, Sticky Polemonium, and many, many others.

Bayhorse, Little Bayhorse Lake and Big Bayhorse Lake

Take Hwy 75 south of Challis for seven miles, then take turn off to Big Bayhorse Lake crossing over the bridge. There is a huge variety because of the increasing elevation (up to 8585') and the different terrain. Look for flowers on the hillsides, around the lakes and in the forested

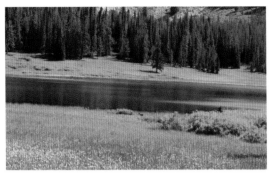

areas, from May through August. Flowers are in the scree as you start up Bayhorse and all along the way: watch for the Naked-Stemmed Daisy, Tufted Evening Primroses, Sun Drops, Idaho Hymenopappus, Ball-head Gilia, Line-leaf Daisy, Popcorn flower, Bitterroot Milkvetch, Mariposas and Bitterroot, Smooth Stem Blazing Star, several kinds of Penstemon from Waxleaf to Mountain to Shrubby. If you have an eagle eye, you might also find the Challis Milkvetch or the Alpine Mountain-Trumpet. Near and slightly after the old town of Bayhorse look for Western Clematis, Western Black Elder, Common Tansy, Mallow-leaf Ninebark, Mountain Ash, Ocean Spray, Lewis' Monkey Flower and Sticky Currant, along with the commonly found wildflowers and weeds.

Both Big Bayhorse and Little Bayhorse Lake and a mile or two before them watch closely as they have a lot to offer: Spring Beauty, Globe Flower, Penstemon, Coulter's Daisy, Explorer's Gentian, Shooting Stars, Big Pod Mariposas, Yellow Bells, Alpine and Nevada Bitterroot, several kinds of Buttercups, Ballhead Waterleaf, Swamp Gooseberry, Pygmy flower, Grouseberry, Nuttall's Leptosiphon, Swamp Saxifrage, Elephant Head, Violets and American Alpine Speedwell, several kinds of Valerian and Paintbrushes along with the more commonly found flowers from Chickweed on. Yes, it is a narrow, steep dirt road!

Craters of the Moon, Tom Cat Hill and Goodale's Cutoff

https://www.nps.gov/crmo/leam/nature/wildflowers.htm. See this web site for what is in

season and when. They also have a wildflower guide, a seasonal list and a wildflower app. Watch for the White Bitterroot, several kinds of Monkeyflower and Buckwheat; there is much to see especially in May.

Tom Cat Hill has a great deal to offer, it is about 5.5 miles from the Craters of the Moon Visitor's Center.

Flowers bloom here long before the Craters and there are several rare ones that you see only on Tom Cat Hill: Pale Indian Paintbrush, Steer's Head, Anderson's Buttercup, Daggerpod, Naked Broomrape, Sagebrush Pansy, Cusick's Primrose, several Rockcress. (Note; these are not even listed on their web site.) There is also the Sagebrush Mariposa.

At Goodale's you will find Snapdragon Skullcap, Tansyleaf Suncup, Arrowhead or Wapato, Slender Buckwheat, Smartweed, Chokecherry and others. There is so much variety in the three separate places.

Burma Road into the Copper Basin and Wildhorse

Over the Burma Road into the Copper Basin in late May or early June and then to Wildhorse is a great day trip with lots of wildflowers along the way including: Parry's Townsendia, Snow Cinquefoil, Rydberg's

Arnica, Snowline Spring-parsley, lavender and white Franklin's Phacelia, in July at Wildhorse look for Wood Nymph, Little Shinleaf, Alpine Sunflower, Rocky Mountain Aster, American and Alpine Bistort.

Doublesprings Pass and the Pahsimeroi

Doublesprings Pass is about seven miles off Highway 93, about 21 miles north of Mackay. Look for the signs for the Earthquake Fault and take the Doublesprings Road. About the second week in June, start looking for Mountain Townsendia and Parry's Townsendia which are near the pass. The Mountain Townsendia is along the left bank; since it is small, walk along the road to find it. The Parry's Townsendia is on the right, down in the lower fields. Ross' Avens, Woollypod-milkvetch, Common Twinpod, Wayside Gromwell, Alpine Bitterroot, Diamond-leaf Saxifrage, Woodland Stars are to be found

also. Look for flowers about a mile or less down the road on the left and right: Leopard Lily,

Cut-leaf Anemone, Cut-leaf Daisy, Monument plant, Paintbrushes and other common ones like Arrowleaf Balsamroot, Low Hawksbeard, Idaho Blue-eyed Grass. The Mountain Penstemon is along the road, just before and just after the Double Springs pass sign in August. Keep going until you see the turn off for the Pahsimeroi where one will find American Thorow Wax, Explorer's Gentian and many others.

Near the Earthquake fault in the spring are Mountain Cactus, Paintbrushes, Lava Aster and other common plants. The first week in August about a half mile up the Mt. Borah Trailhead, one can see the Elegant Asters.

City of Rocks

See their web site and Facebook https://www.facebook.com/CityOfRocksNPS/. They often list which flowers are blooming. This is a great place to find the rare Steer's Head.

Although we have concentrated our wildflower photographic excursions in the areas of central Idaho and Yellowstone, and Grand Teton National Parks, the wildflowers featured in this book can be viewed in numerous locales throughout the northern Rocky Mountain Region. Locations other than those listed above with great viewing: *In Idaho*, Adam's Gulch near Ketchum, Bloomington Lake near Paris, Camas Prairie near Fairfield, Galena Summit north of Sun Valley, Hell's Canyon Rim west of Council, Mores Mountain north of Boise, Mount Borah trailhead north of Mackay, Mount Harrison south of Burley, Big Elk Campground near Palisades Reservoir, Sawtell Peak in Island Park, and Sawtooth Valley south of Stanley. *In Montana*, Glacier National Park, Highland Road south of Butte, Lolo Pass west of Missoula, and Shelter Ridge near Flathead Lake. *In Wyoming*, Beartooth Highway northwest of Cody, ski resorts around Jackson, Swift Creek east of Afton, and Teton Pass west of Jackson.

WHITE AND CREAM FLOWERS

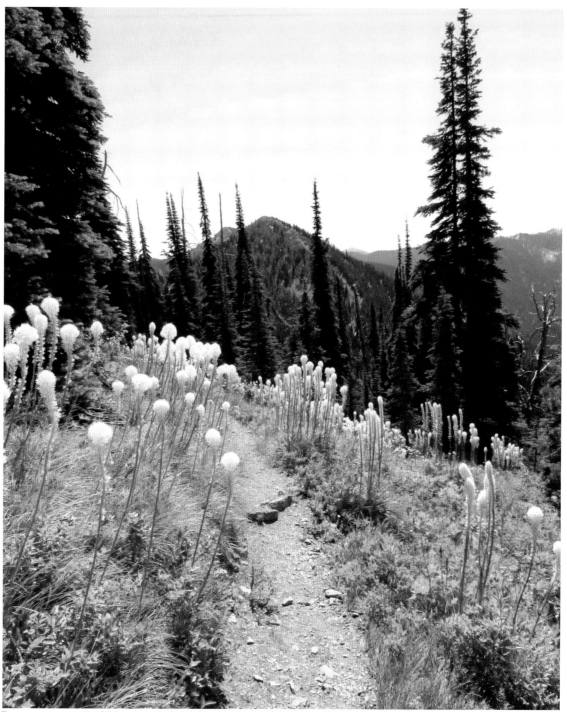

Beargrass near Red Meadow Lake, Montana by *Callie Russell.*

This section is for white, cream and white with a touch of pink.

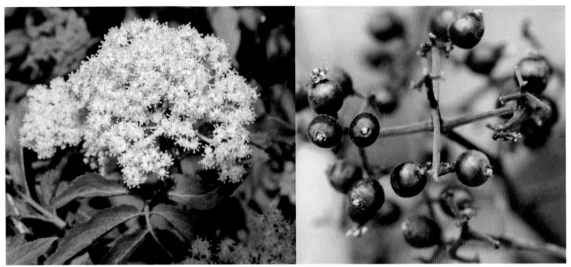

BLACK ELDERBERRY
Sambucus racemosa*
Muskroot or Moschatel* Family (Adoxaceae*)

Flower: Tiny saucer-shaped flowers, white to cream clusters, black berries
Leaves: Opposite, divided into from 5-9 lance-shaped leaflets, toothed
Blooms: June-July Height: 3-12' tall
Found in moist open forest, in shrubby thickets and open valleys.
*sam BYOD kus *ray see MO suh *mos kuh tel *a dox AY see ee

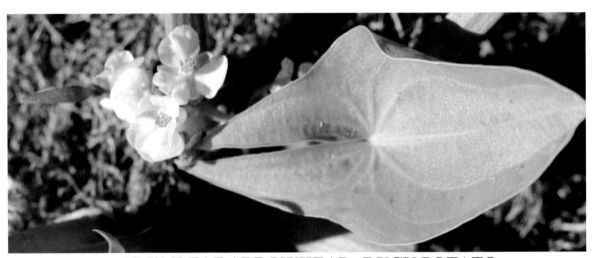

ARUMLEAF ARROWHEAD; DUCK POTATO
Sagittaria cuneata
Water-Plantain Family (Alismataceae*)

Flower: 3 white petals in groups of 3 and a bright yellow center
Leaves: Large leaves shaped like an arrowhead, prominently veined
Blooms: July-September Height: 4-24" tall
Found in swamps and ponds as the water starts to dry up.
*ah liz may TAY see ee

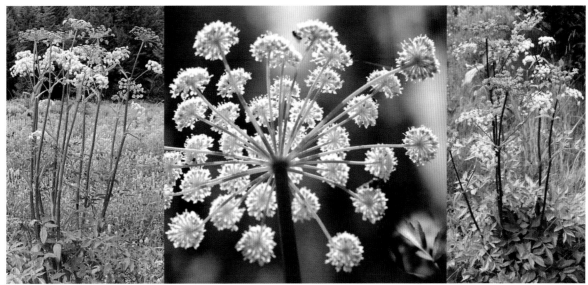

LYALL'S ANGELICA; WHITE ANGELICA
Angelica arguta
Carrot or Parsley Family (Apiaceae)

Flower: White or pinkish, compound flat clusters on a long stem, small flowers
Leaves: 11-23 leaflets with sharp teeth
Blooms: Late June-August Height: 1-6' tall
Found along stream banks and in wet meadows.
Lewis and Clark found this plant on Lost Trail Pass on what is now the Idaho-Montana border.

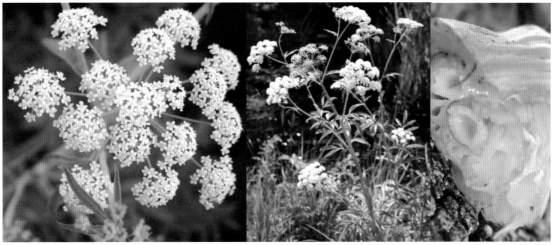

WATER HEMLOCK
Cicuta douglasii*
Carrot or Parsley Family (Apiaceae)

Flower: White to greenish compound clusters, flat-topped
Leaves: Alternate, divided into sharply toothed leaflets, dark green, lance-shaped
Blooms: July-August Height: 2-6' tall
Found along streams, wet meadows, edges of sloughs, and irrigation canals.
The hollow chambers and the cut root (*bottom right picture*) are the most poisonous
part of the plant.
sy KEW tah

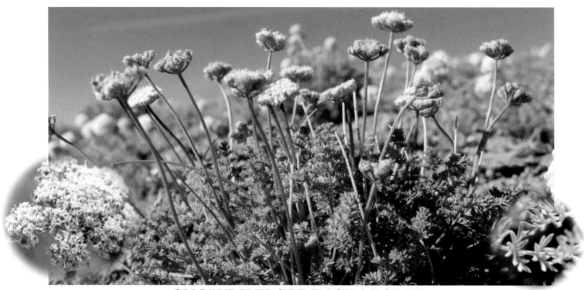

SNOWLINE SPRINGPARSLEY
Cymopterus nivalis*
Carrot or Parsley Family (Apiaceae)

Flower: White-cream colored compact flat clusters, very small ray flowers
Leaves: Basal leaves, divided into many leaflets, stem turns reddish as it matures
Blooms: April-June Height: 2-6" tall
Found on high rocky ridges and in dry alpine meadows.
Top picture by *Gwen Russell.*
*sim OP ter us *niv VAL us

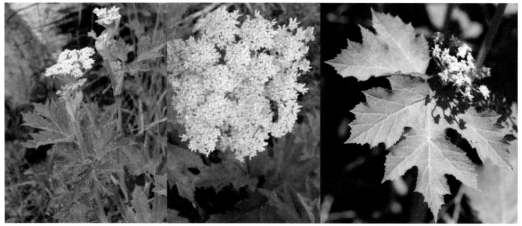

COMMON COWPARSNIP
Heracleum maximum*
Carrot or Parsley Family (Apiaceae)

Flower: White-cream, small flowers in flat umbels,* can be 8" across
Leaves: 3 large lobed leaflets, toothed, broad and almost heart-shaped
at base, hollow stem, hairy
Blooms: June-August Height: 3-7' tall
Found along stream banks and in wet meadows, common.
*hair uh KLEE um *MAKS ih mum
*A cluster where the individual stalks grow from the same point, like the ribs of an umbrella.

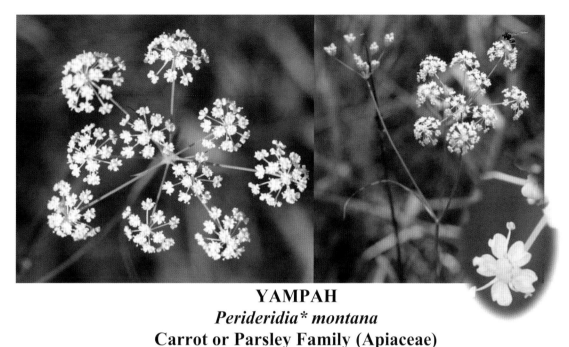

YAMPAH
Perideridia montana*
Carrot or Parsley Family (Apiaceae)

Flower: White compound umbels, 5 tiny white petals, white-cream anthers, flat top
Leaves: Narrow and long that wilt and dry as flowers bloom
Blooms: Late June-August Height: 1-3' tall
Found in open forests and dry meadows.
**per ee der ID ee uh*

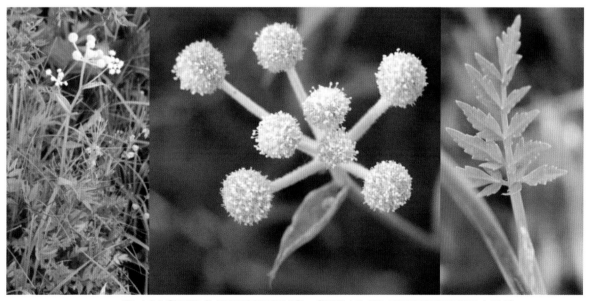

RANGERS BUTTONS; SWAMP WHITEHEADS
Sphenosciadium capitellatum**
Carrot or Parsley Family (Apiaceae)

Flower: Small white balls or heads that resemble buttons (sometimes pinkish), hairy stem
Leaves: Large with 3 or more parts divided with serrated edges, lance-shaped
Blooms: July-August Height: up to 5' tall
Found along small streams and in wet meadows.
**sfen oh skee AY die um *kap ih tel AY tum*

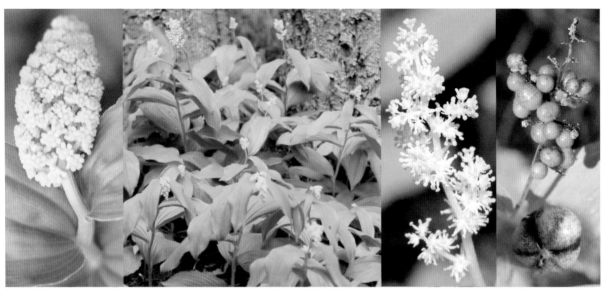

FEATHERY FALSE SOLOMON'S SEAL
Maianthemum racemosum**
Asparagus Family (Asparagaceae)

Flower: 6 petal-like segments, star-like, white to cream, clustered along a stalk,
followed by reddish striped berries
Leaves: Large lance-shaped, alternate, clasping, deep parallel veins
Blooms: May-July Height: 1-3½' tall
Found in moist mountain shrub lands and forests.
**may an the mum *ray see MO sum*

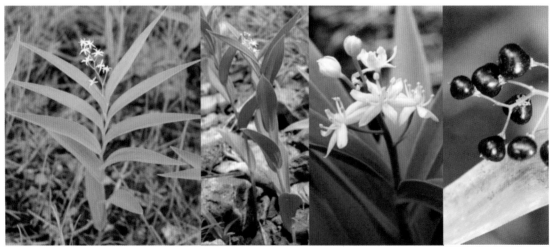

STARRY FALSE SOLOMON'S SEAL; WILD LILY OF THE VALLEY
Maianthemum stellatum (Smilacina stellata)
Asparagus Family (Asparagaceae)

Flower: White, star-shaped in a loose cluster, 6 petal-like segments, berries dark purple-black
Leaves: Lance-shaped, 7-11 leaves about 6" across
Blooms: May-June Berries: July Height: 6-24" tall
Found easily in meadows and shrub lands, almost like a weed in some places.
Middle two pictures by *Stephen L. Love.*

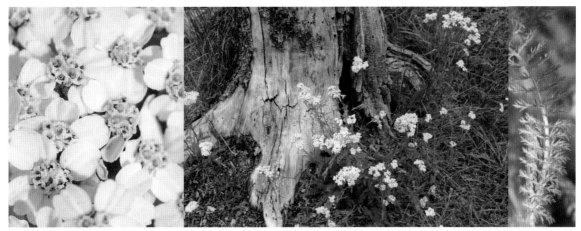

YARROW
Achillea millefolium* var. occidentalis*
Aster or Composite Family (Asteraceae*)

Flower: Many small flower heads, white to cream, in a flat-topped cluster, cream centers, (sometimes pink)
Leaves: Fern-like or feathery, alternate, aromatic
Blooms: June-September Height: up to 3' tall
Found from grasslands to open forests to rocky slopes, very common.
Top left picture by *Skylee Russell.*
**ak ih LEE a *mill ee FOH lee um *ass tur AY see ee*

AMERICAN TRAILPLANT; PATHFINDER
Adenocaulon bicolor
Aster or Composite Family (Asteraceae)

Flower: Tiny white-cream head at top of hairy stem
Leaves: Triangular with wavy edges to coarsely lobed, wooly hair underneath, alternate
Blooms: June-July Height: 1-3' tall
Found in moist woods; these photographed in the DeVoto Cedar Grove on the Lolo Trail.

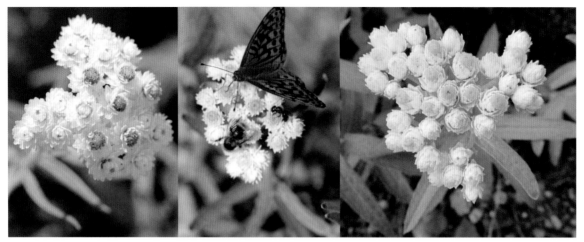

PEARLY EVERLASTING
Anaphalis margaritacea
Aster or Composite Family (Asteraceae)

Flower: Small white clusters of pearl-shaped flowers, yellow-brown center
Leaves: All about the same size on the stem, spear-shaped, alternate, greyish-green
Blooms: July-September Height: up to 36" tall
Found in woodlands and on open hillsides, quite common, great in floral arrangements.

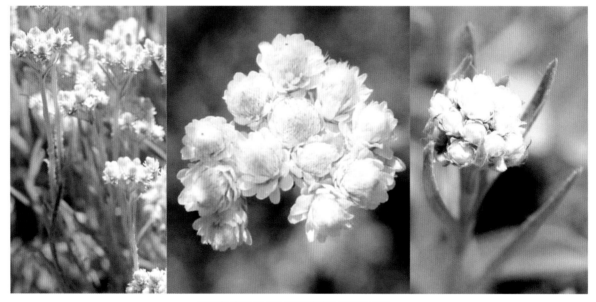

WOOLLY PUSSYTOES
Antennaria lanata*
Aster or Composite Family (Asteraceae)

Flower: Small, white clusters like pads on a cat's paw
Leaves: Narrow, basal rosette, alternate
Blooms: June-August Height: 2-12" tall
Found easily, several different kinds from microphylla to dimorpha.
an ten AR ee ah

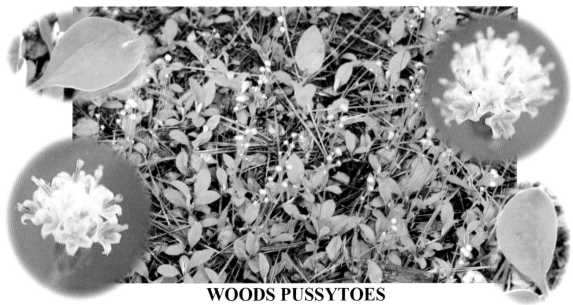

WOODS PUSSYTOES
Antennaria racemosa
Aster or Composite Family (Asteraceae)

Flower: Small, white to cream, close up resembles a pincushion
Leaves: Basal leaves, oval and smooth, underside white and hairy
Blooms: June-July Height: 4-24" tall
Found in woods with shade and in meadows.

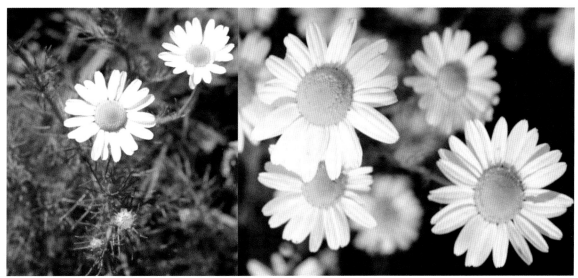

CHAMOMILE MAYWEED; DOG FENNEL
Anthemis cotula (smells) Anthemis arvensis (does not smell)
Aster or Composite Family (Asteraceae)

Flower: White ray flowers, about 10-18 rays, a bright yellow center
Leaves: Fern-like, alternate, oblong, sprawling
Blooms: July-August Height: 4-18" tall
Found easily in disturbed areas, along roadsides, common, **not native.**

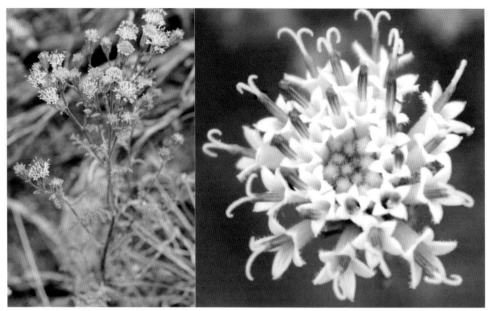

DUSTY MAIDEN; DOUGLAS' PINCUSHION
Chaenactis douglasii* var. douglasii*
Aster or Composite Family (Asteraceae)

Flower: Small white disk flowers dotted with pink, resembles a pincushion, white anthers
Leaves: Fern-like, alternate, hairy, stems hairy
Blooms: May-August Height: 6-26" tall
Found easily in dry and rocky places, along roadsides and in disturbed areas.
*kee NAK tis *dug LUS ee eye

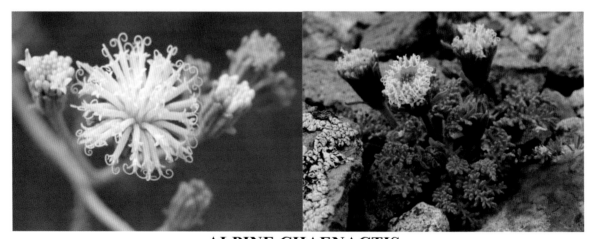

ALPINE CHAENACTIS
Chaenactis douglasii var. alpina
Aster or Composite Family (Asteraceae)

Flower: Small, white and white and pink
Leaves: Fern-like mostly at the bottom of the plant and a gray-green
Blooms: August Height: 6-28" tall
Found at higher elevations in late summer and in rocky, dry areas.
Picture on right by *Stephen L. Love.*

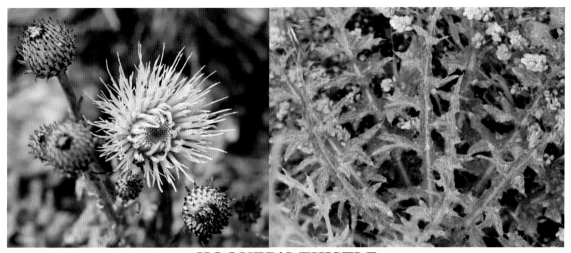

HOOKER'S THISTLE
Cirsium *hookerianum*
Aster or Composite Family (Asteraceae)

Flower: Spiny, usually white but can be cream or a light pink
Leaves: Spiny and toothed, narrow
Blooms: July-August Height: 1-4' tall
Found on open slopes especially in the desert areas.
*SIR see um *hook ere e AN um

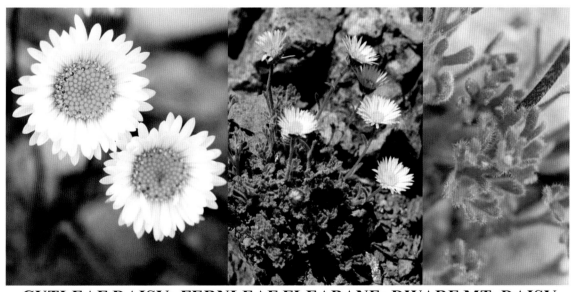

CUTLEAF DAISY; FERNLEAF FLEABANE; DWARF MT. DAISY
Erigeron *compositus*
Aster or Composite Family (Asteraceae)

Flower: Usually white can also be pink and lavender, rayed flower heads, cushion-like,
1 flower to a stem, bright yellow-gold disk
Leaves: Leaflets are deeply divided, basal, usually hairy, reddish stem
Blooms: May-July Height: 3-12" tall
Found easily especially in higher elevations that are rocky.
*er IJ er on *kom POZ ee tus

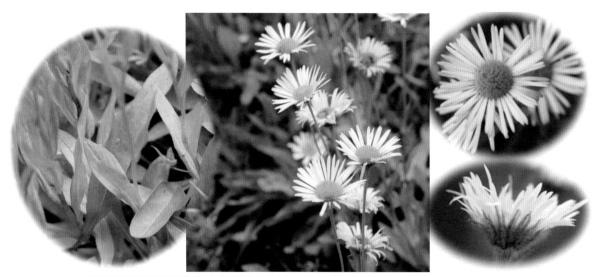

COULTER'S DAISY; LARGE MOUNTAIN FLEABANE
Erigeron coulteri
Aster or Composite Family (Asteraceae)

Flower: Single white rayed flower head, large yellow center disk
Leaves: Lanceolate, alternate, clasping
Blooms: July-September Height: up to 28" tall
Found at higher altitudes along small streams, in moist woodlands.

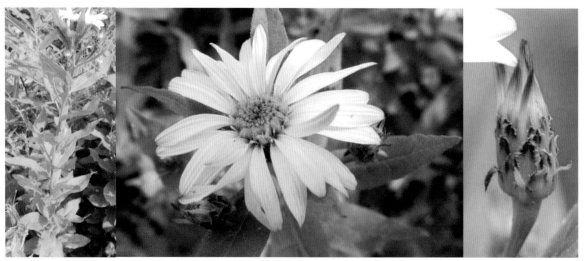

ENGLEMANN'S ASTER
Eucephalus engelmannii**
Aster or Composite Family (Asteraceae)

Flower: Large white rays (15-20), (sometimes pink), a large yellow disk, solitary on stem
Leaves: Large, alternate, spear-like, deeply veined, lower leaves smaller
Blooms: July-September Height: 2-5' tall
Found in mountain meadows and open woods, photographed at Teton Pass.
Note asters have bracts at the base of the flower, like shingles on a roof
*yoo SEF a lus *en gel MAH nee eye

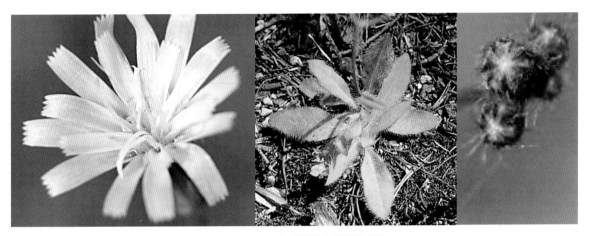

WHITE HAWKWEED
Hieracium albiflorum*
Aster or Composite Family (Asteraceae)

Flower: White and notched, long stem, in clusters, notched petals, yellow anthers
Leaves: Basal, very hairy, oval or spear-like, alternate, cut stem has a milky sap
Blooms: June-August Height: 1-3' tall
Found in dry, open foothills, meadows and shrub lands.
hi er uh KEE um

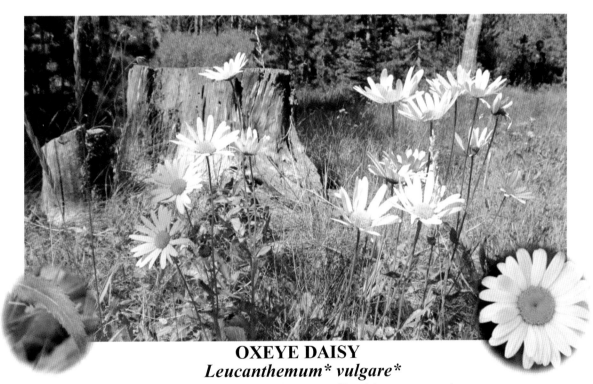

OXEYE DAISY
Leucanthemum vulgare**
Aster or Composite Family (Asteraceae)

Flower: Stems up to 24" with white ray flowers and a yellow center, 3" in diameter
Leaves: Basal, spatula-shaped, coarsely-toothed, creeping roots
Blooms: July-August Height: 1-3' tall
Found in along roadsides, in meadows and in waste places, considered noxious, **not native.**
*lew KANTH ih mum *vul GAIR ee*

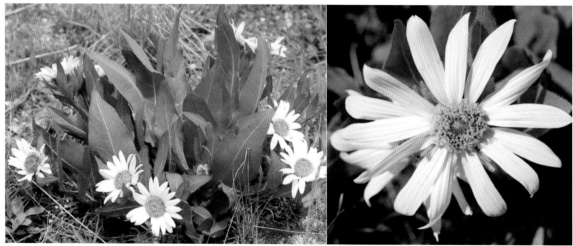

WYETHIA; WHITE MULE'S-EARS; SUNFLOWER MULE-EARS
Wyethia helianthoides**
Aster or Composite Family (Asteraceae)

Flower: Solitary, showy, white or cream, sunflower like blossoms, 1 ½ to 3" across, 13-21 white rays, yellow center disk made up of dozens of tiny yellow flowers
Leaves: Long, elliptic, alternate, mainly basal leaves, shiny and up to a foot long, hairy stems, deeply veined, leaves point upward
Blooms: May-June Height: 12-36" tall
Found in moist meadows soon after snowmelt, common.
**wy eh THEE uh *hee lee an THOY dees*

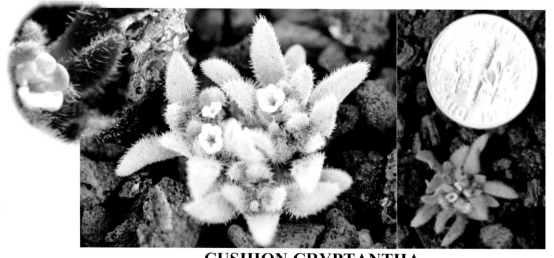

CUSHION CRYPTANTHA
Cryptantha circumscissa*
Borage or Forget-me-not Family (Boraginaceae*)

Flower: Tiny white, 5 lobes, cup-shaped, yellow eyes, cushion forming, ball-shaped
Leaves: Narrow, linear, very hairy
Blooms: April-June Height: ¾-1½" tall
Found in dry, sandy soils, open places. Photographed at Craters of the Moon.
**krip TAN thah *bore aj i NAY see ee*

SALMON CAT'S EYE; MINER'S CANDLE
Cryptantha salmonensis
Borage or Forget-me-not Family (Boraginaceae)

Flower: Tiny white, 5 petals, yellow throats that resemble a star
Leaves: Alternate, narrow, linear, very hairy
Blooms: May-June Height: 6-12" tall
Found on dry hillsides, washes, shale cliffs and slopes. These wildflowers are common along the Salmon River and in the Lost River Valley in Custer County, Idaho.

TORREY'S CAT'S-EYE; TORREY'S CRYPTANTHA
Cryptantha torreyana
Borage or Forget-me-not Family (Boraginaceae)

Flower: Yellow throats, 5 petals, tiny and white also pink, blue, or yellow
Leaves: Alternate, narrow, hairy, simple, stiff, straight hairs
Blooms: May-June Heights: up to 6" tall
Found in dry areas like Craters of the Moon.

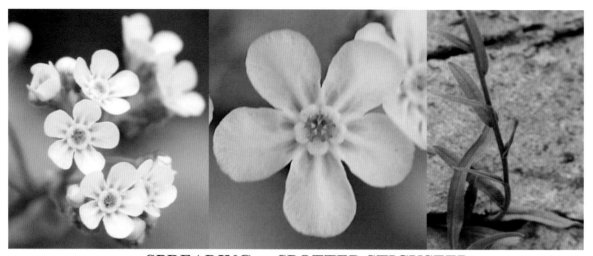

SPREADING or SPOTTED STICKSEED
Hackelia*patens*
Borage or Forget-me-not Family (Boraginaceae)

Flower: 5 white petals, prominent blue or lavender marks near the center, yellow throat
Leaves: Linear, alternate, basal
Blooms: May-June Height: 12-36" tall
Found on hillsides, canyons and open meadows, common.
*ha KEL ee uh *PAT ens

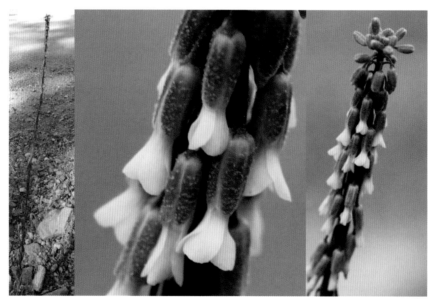

REFLEXED ROCKCRESS; HOLBOELL'S ROCKCRESS
Arabis* holboellii*
Mustard Family (Brassicaceae*)

Flower: 4 white to lavender petals, flowers hang down, stem erect
Leaves: Basal leaves, linear or spoon-shaped with a pointed tip, alternate
Blooms: May-July Height: up to 3' tall
Found in dry rocky areas and in open sites.
*AR uh hiss *hole BOLE ee eye *brass ih KAY see ee

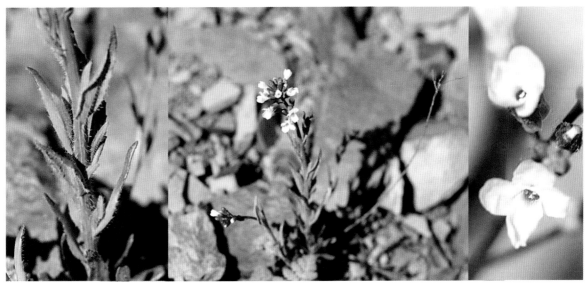

NUTTALL'S ROCKCRESS
Arabis nuttallii
Mustard Family (Brassicaceae)

Flower: 4 white petals, very small plant
Leaves: Hairy, lance-shaped, red-wine stem
Blooms: April-June Height: up to 8" tall
Found in dry rocky areas, meadows, and rock outcrops.
Photographed on Tom Cat Hill within the Craters of the Moon in late April.

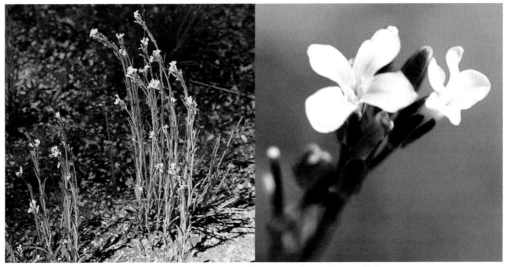

DRUMMOND'S ROCKCRESS
Boechera drummondii
Mustard Family (Brassicaceae)

Flower: Clusters, 4 white to pink or lavender petals on a long stem
Leaves: Partly basal, narrow pointed spoon-shaped leaves on tall stems
Blooms: May-June Height: up to 36" tall
Found in rocky, open or wooded sites.

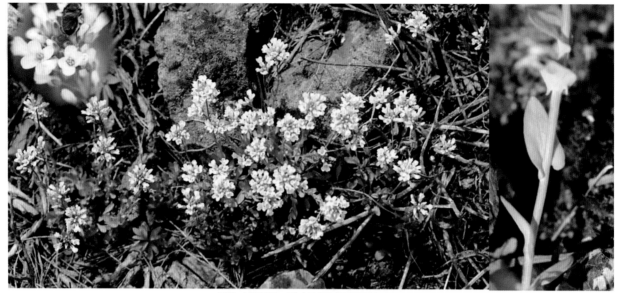

IDAHO CANDYTUFT
Noccaea fendleri var. idahonense
Mustard Family (Brassicaceae)

Flower: Clusters of 4 small white petals, yellow anthers
Leaves: Basal, oval to oblong, clasping, alternate
Blooms: May-July Height: 2-14" tall
Found on rocky slopes in mountains of Central Idaho.

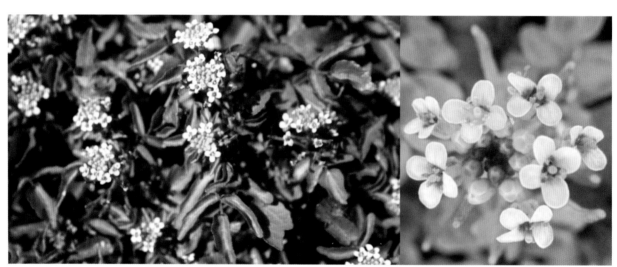

WATERCRESS
Rorippa officinale*
Mustard Family (Brassicaceae)

Flower: 4 rounded, tiny white petals, clusters
Leaves: Small with from 3-9 leaflets, oval to lance-shaped, alternate, leaves to 6"
Blooms: May-August Height: 3-24" tall
Found along slow moving streams, in marshes, common.
Plant often used as a salad green, **not native.**
**ROR ripah*

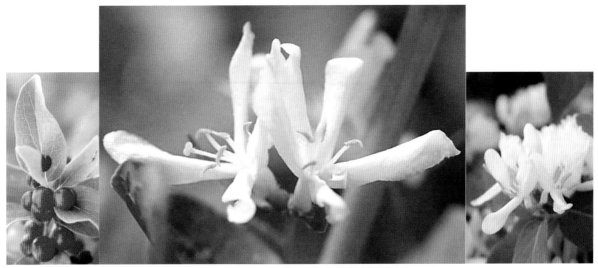

WHITE HONEYSUCKLE
Lonicera albiflora
Honeysuckle Family (Caprifoliaceae)

Flower: White to cream, tube-shaped, grow in pairs between the stem and leaf, yellow anthers
Leaves: Large oval, not toothed, deeply veined
Blooms: June-July Berries: August Height: 4-10' tall
Found in open forests, along stream banks and even in backyards.

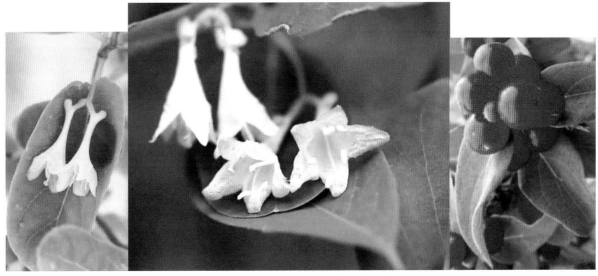

UTAH HONEYSUCKLE
Lonicera utahensis
Honeysuckle Family (Caprifoliaceae)

Flower: White to cream, tube-shaped, nodding, grows in pairs, note small spur on each
side of flower base
Leaves: Large oblong to egg-shaped, deeply veined, opposite, not toothed
Blooms: June-July Berries: August Height: 3-6' tall
Found in wooded or open forests and along stream banks.

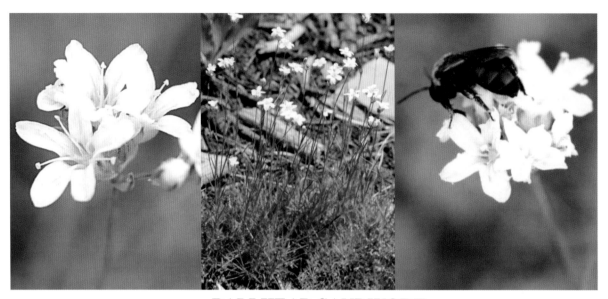

BALLHEAD SANDWORT
Arenaria congesta
Carnation or Pink Family (Caryophyllaceae)

Flower: 5 white petals, white anthers, pungent, many-flowered head
Leaves: Needle-like, opposite, linear
Blooms: July-August Height: 4-16" tall
Found in stony soil, on rocky slopes.

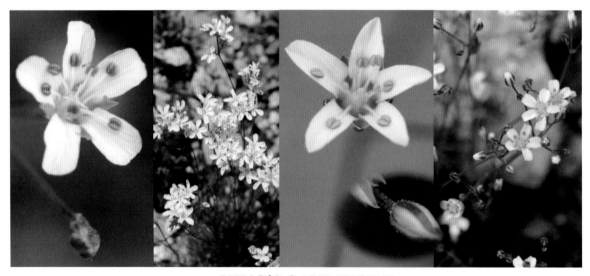

KING'S SANDWORT
Arenaria * *kingii*
Carnation or Pink Family (Caryophyllaceae*)

Flower: 5 white to pink petals, star-shaped, pink anthers
Leaves: Needle-like, opposite
Blooms: June-August Height: 8-12" tall
Found easily in dry, sandy soil, sagebrush flats and on wooded ridges and slopes.
*a re NAY ri ah *carry oh fill AY see ee

28

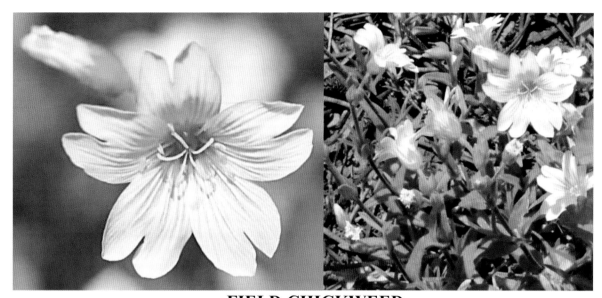

FIELD CHICKWEED
Cerastium arvense
Carnation or Pink Family (Caryophyllaceae)

Flower: 5 small white notched petals, greenish throat
Leaves: Opposite and lance-shaped, may have hairs
Blooms: June-July Height: 4-12" tall
Found open woodlands, along slopes and ridges, moist areas, and in grasslands.

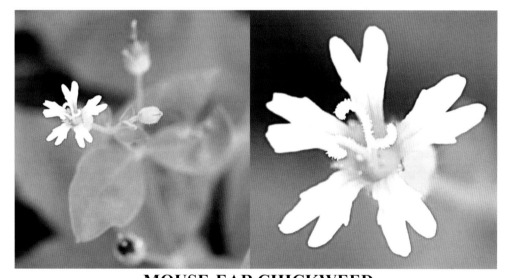

MOUSE-EAR CHICKWEED
Cerastium fontanum
Carnation or Pink Family (Caryophyllaceae)

Flower: Small white with 5 (2-lobed) petals, deep notches, greenish throat
Leaves: Variably shaped from oval to lance to oblong, opposite, toothless
Blooms: June-August Height: 6-18" tall
Found in fields, pastures, lawns, roadsides, vacant lots, and waste areas, **not native.**

29

ALPINE CHICKWEED
Cerastium beeringianum
Carnation or Pink Family (Caryophyllaceae)

Flower: 5 white deeply notched petals, pink anthers
Leaves: Lanceolate to oblong, opposite
Blooms: June-August Height: 2-8" tall
Found at high elevations in rocky areas, woodlands and along riverbanks.
Photographed after a hard rain at Packer's Meadow on the Lolo Trail.

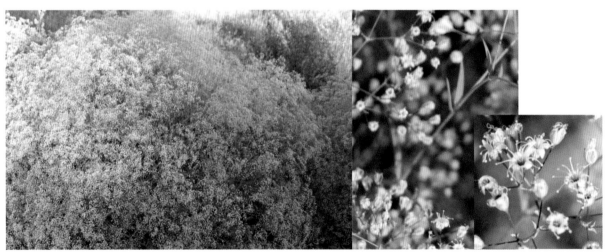

BABY'S BREATH
*Gypsophila*paniculata**
Carnation or Pink Family (Caryophyllaceae)

Flower: Tiny white star-shaped flowers, on upright bushy mound, cloud like
Leaves: Opposite, linear
Blooms: July-September Height: 24-48" tall
Found in dry, stony, sandy places, often in areas that are disturbed, common, **not native.**
Plant is often used as filler in floral arrangements.
*jip SOP il uh *pan ick yoo LAY tuh

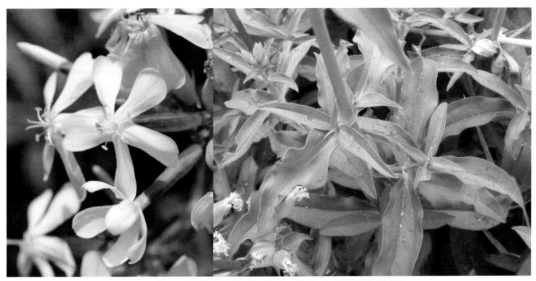

BOUNCING BET; SOAPWORT
Saponaria officinalis
Carnation or Pink Family (Caryophyllaceae)

Flower: 5 white (also pink) tubular petals, about an inch wide, indented at the tip
Leaves: Long and oval-shaped, prominent ribs, opposite, stems smooth
Blooms: July-August Height: 12-30" tall
Found along roadsides and in disturbed areas, **not native.**

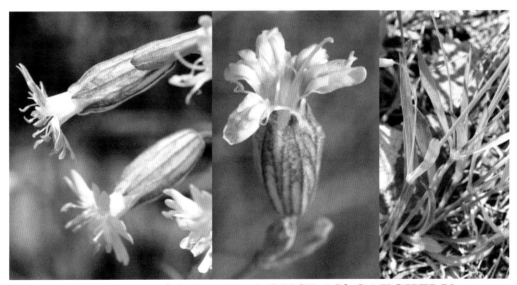

DOUGLAS' SILENE; DOUGLAS' CATCHFLY
Silene douglasii var. douglasii
Carnation or Pink Family (Caryophyllaceae)

Flower: 5 white notched petals in a bottle-shaped tube, outside stripes turn purple-maroon
with age, petal tips sometimes curve upwards
Leaves: Basal, narrow, lance-shaped, opposite, stem leaves linear
Blooms: June-September Height: 4-16" tall
Found along roadsides and on foothills, photographed at Twin Creeks, Lemhi County, Idaho.

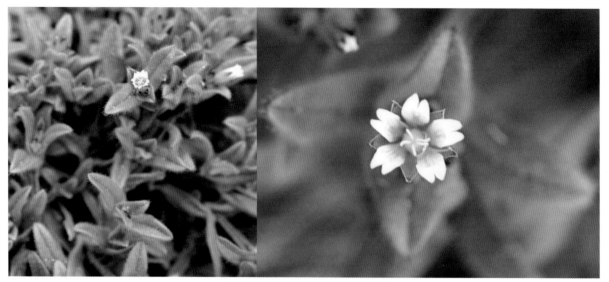

MENZIES' SILENE
Silene menziesii
Carnation or Pink Family (Caryophyllaceae)

Flower: 5 tiny white petals, notched and separated, hairy, greenish throat
Leaves: Opposite, lance-shaped
Blooms: May-July Height: 4-12" tall
Found in open woods.

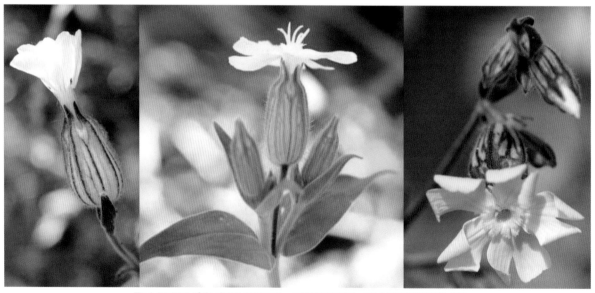

PARRY'S SILENE; WHITE CATCHFLY
Silene parryi
Carnation or Pink Family (Caryophyllaceae)

Flower: White with 5 deeply notched petals in a bottle-shaped tube, outside stripes turn purple or maroon with age
Leaves: Basal, lanceolate
Blooms: June-July Height: 8-24" tall
Found along roadsides, disturbed areas and on foothills, common.

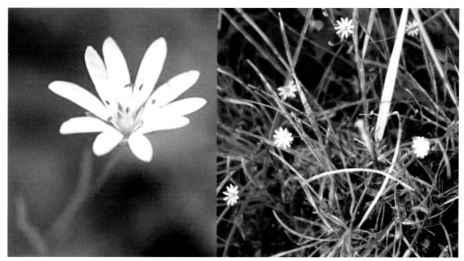

LONG-STALK STARWORT
Stellaria longipes
Carnation or Pink Family (Caryophyllaceae)

Flower: 5 white petals, deeply lobed so it almost looks like 10 narrow petals
Leaves: Narrow, lance-shaped leaves and pointed at the tip, opposite
Blooms: June-August Height: 4-12" tall
Found in higher elevations in meadows, on slopes and near streams.

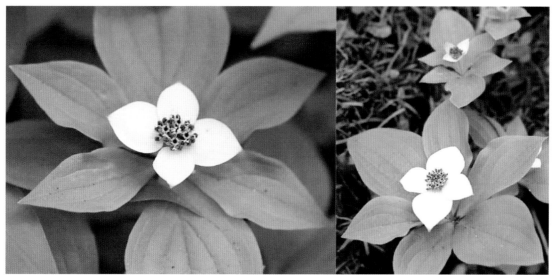

BUNCHBERRY
Cornus canadensis
Dogwood Family (Cornaceae*)

Flower: 4 large white petals (actually modified leaves), later has bright red berries
Leaves: Long oval leaves, prominent veins that are almost parallel to each other, low growing
Blooms: June-July Berries: August Height: 2-8" tall
Found in moist, shady forests. These Bunchberries were photographed along the Lolo Trail.
*kor NAY see ee

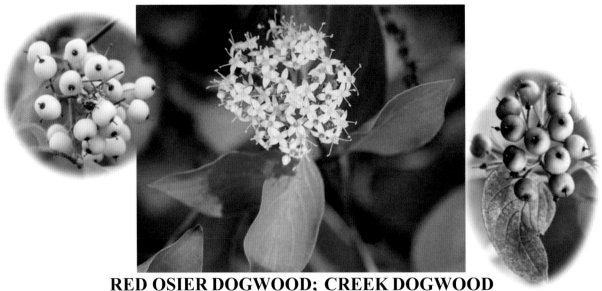

RED OSIER DOGWOOD; CREEK DOGWOOD
Cornus sericea
Dogwood Family (Cornaceae)

Flower: Clusters of 4, tiny creamy white petals, berries usually white but can be a blue-gray
Leaves: Tongue-like with deep lateral veins, red stem
Blooms: May-July Berries: August Height: up to 9' tall
Found along stream banks, near ponds and seeps, very common.

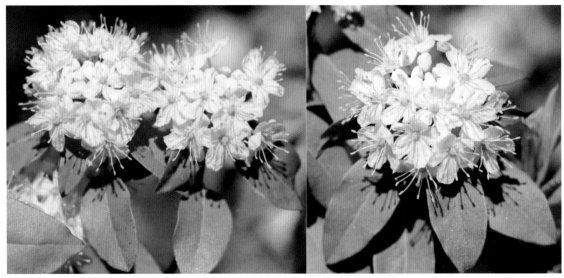

TRAPPER'S TEA; LABRADOR TEA
Ledum glandulosum
Heath Family (Ericaceae*)

Flower: 5 white petals, in clusters, prominent green centers
Leaves: Egg-shaped or oval, shiny, leathery, margin of leaf turns up a little, alternate
Blooms: June-August Height: 24-60" tall
Found along stream banks, shrub thickets, and in bogs. Photographed near Stanley Lake, Idaho.
*eh rih KAY see ee

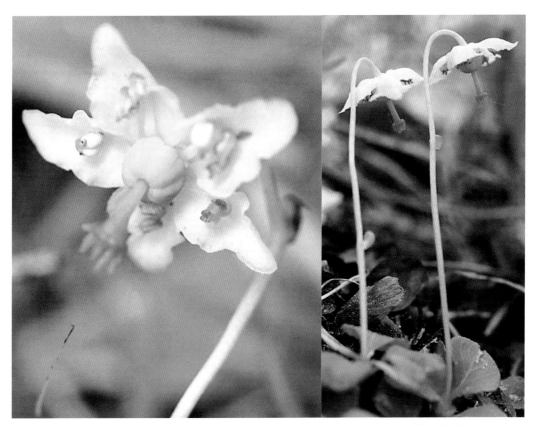

WOOD NYMPH; ONE-FLOWER WINTERGREEN
Moneses *uniflora*
Heath Family (Ericaceae)

Flower: 5 white to pale pink petals, solitary, scalloped edges, star shape, bent stem,
nodding flower, prominent green center
Leaves: Basal, roundish, slightly notched
Blooms: July-August Height: 1½-5" tall
Found in bogs, mossy areas, and in shaded forests.
*mah NEE seez

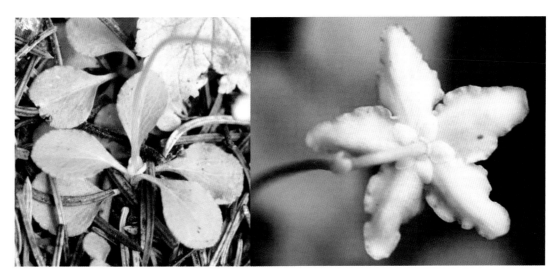

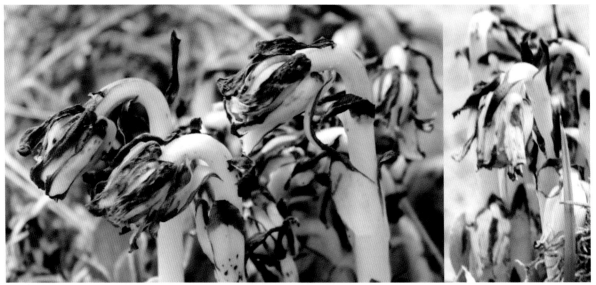

INDIAN PIPE
Monotropa uniflora
Heath Family (Ericaceae)

Flower: Completely white or white with black flecks, also pale pink (turns black if bruised and with age), waxy, stem scaly
Leaves: Fungus, no leaves, no chlorophyll, parasitic
Blooms: July-August Height: 2-10" tall
Found in the forest litter, not common. Top pictures by *Callie Russell.*

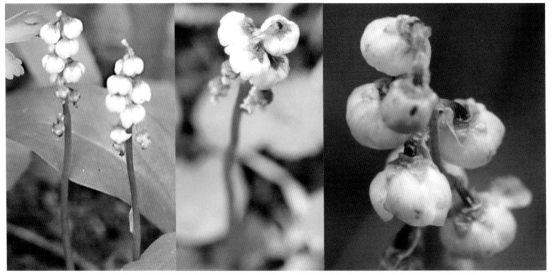

LITTLE SHINLEAF; LESSER WINTERGREEN
Pyrola minor
Heath Family (Ericaceae)

Flower: Tiny, white to pinkish, 5 petals fused into a cup, nodding
Leaves: Round basal leaves
Blooms: Late June-July Height: 3-10" tall
Found in shady spots along small forest creeks.

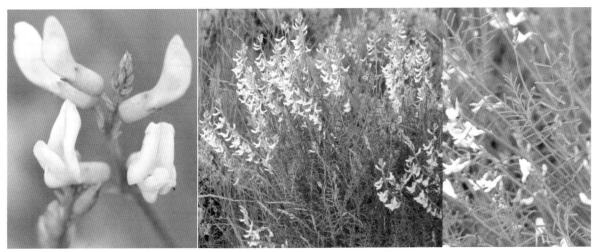

HANGINGPOD MILKVETCH
Astragalus atropubescens
Pea, Bean, or Legume Family (Fabaceae)

Flower: Pea-like, white, cream, or yellowish, nodding, dense clusters, irregular shape
Leaves: Divided into many leaflets, thread-like, (19-29)
Blooms: June-July Height: 1-3' tall
Found in semi-arid areas and sage scrub.

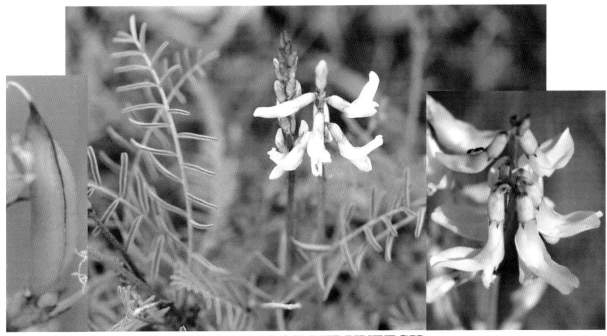

BITTERROOT MILKVETCH
Astragalus scaphoides
Pea, Bean, or Legume Family (Fabaceae)

Flower: Pea-like, white to yellow, has banner, wings and keel, clusters of 15 to 30
Leaves: Divided into many feathery leaflets
Blooms: May-mid-June Height: 10-20" tall
Found in semi-arid and sage scrub.

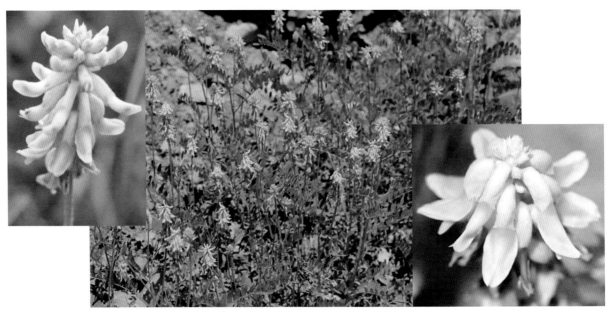

CANADIAN MILKVETCH
Astragalus canadensis var. mortonii
Pea, Bean, or Legume Family (Fabaceae)

Flower: Pea-like on a tall spike, white, cream or yellow clusters, ½-¾" long
Leaves: Divided into many leaflets (15-31)
Blooms: June-July Height: 12-36" tall
Found in open woods and thickets, common.

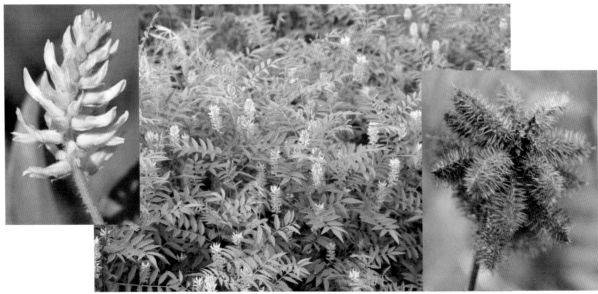

WILD LICORICE; AMERICAN LICORICE
Glycyrrhiza lepidota
Pea, Bean, or Legume Family (Fabaceae)

Flower: Clusters on a single stem, greenish to white, yellowish to white, turns brown and sticky
Leaves: Alternate, 11-19 leaflets, lance-shaped, pinnately divided
Blooms: Late June-July Height: up to 3' tall
Found in moist, sandy soils in disturbed areas, pastures, near ditches and other waste areas.

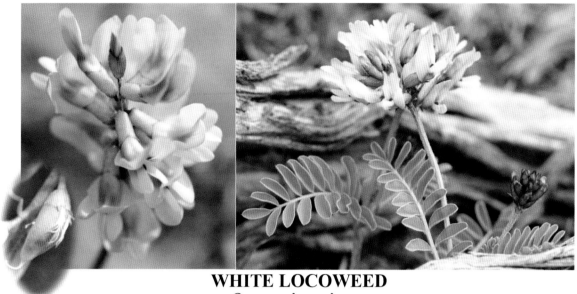

WHITE LOCOWEED
Oxytropis sericea
Pea, Bean, or Legume Family (Fabaceae)

Flower: White, cream, sometimes purple, lavender-purple lines, pea-shaped, base of flower has black hairs, has banner, wings and keel
Leaves: 11-21 leaflets, lance or oval-shaped, hairy
Blooms: May-June Height: up to 2½' tall
Found in sagebrush flatlands, common.

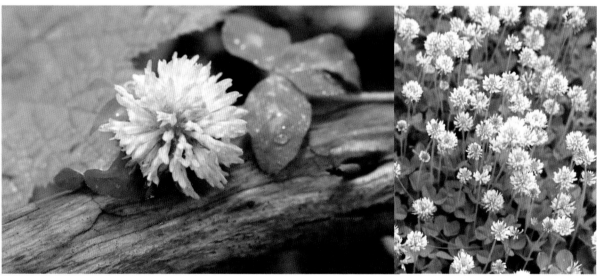

WHITE CLOVER
Trifolium repens
Pea, Bean, or Legume Family (Fabaceae)

Flower: White or tinged with pink or lavender, dense heads
Leaves: Leaves divided into 3 leaflets, egg-shaped
Blooms: June to September Height: 4-10" tall
Found easily in around streams, marshy areas, and woods, **not native.**
Plant introduced as a forage crop. Top left picture by *Eric Russell.*

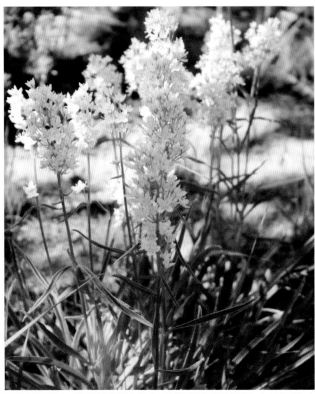

WHITE GENTIAN; WHITE FRASERA
Frasera montana
Gentian Family (Gentianaceae)

Flower: 4 white-cream petals arranged in clusters, depressed green gland with hair on petals
Leaves: Narrow, opposite, basal
Blooms: June-July Height: 1-2½' tall
Found around Stanley and Redfish Lake. It is unique to Central Idaho, but easily found near Stanley Lake and Stanley Creek.

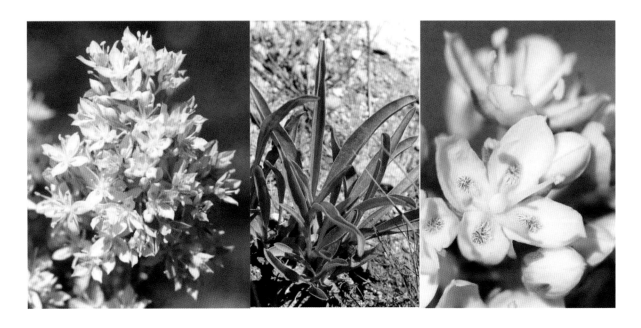

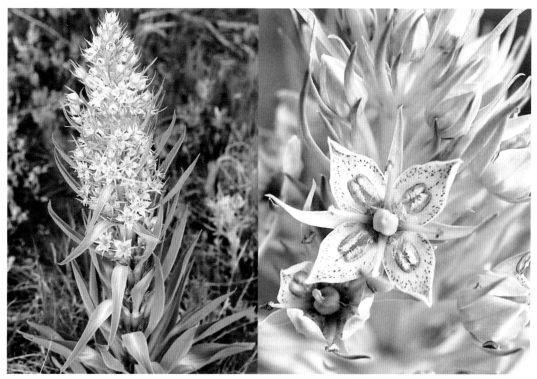

MONUMENT PLANT, ELKWEED
Frasera speciosa
Gentian Family (Gentianaceae)

Flower: White to yellow to greenish flecked with purple, 4 large petals, a large round green center, fringed green glands on petals
Leaves: Large, thick oblong leaves, becoming smaller and narrow at the top of the stem
Blooms: Late June-July Height: 2-6' tall
Found in semi-arid regions and sage scrub, look for it on sunny, open hillsides.

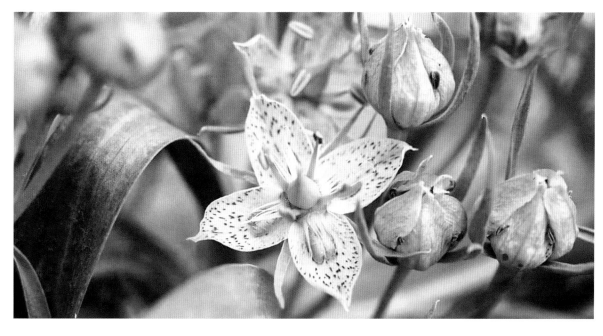

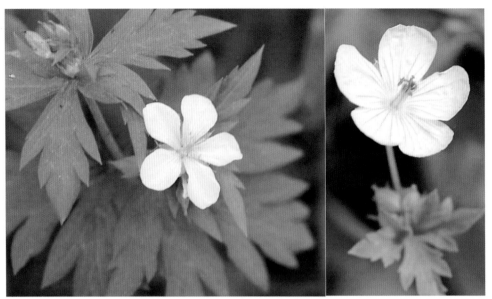

RICHARDSON'S GERANIUM
Geranium richardsonii
Geranium Family (Geraniaceae)

Flower: White to light pink, 5 rounded petals, pink or purple veins, greenish center
Leaves: Palmately divided, mostly basal
Blooms: May-August Height: 10-36" tall
Found in moist meadows and open woodlands.

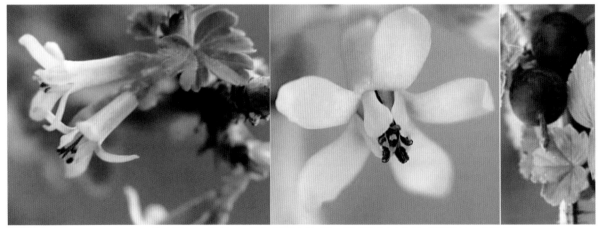

WHITE STEM GOOSEBERRY; STREAM CURRANT
Ribes inerme
Currant Family (Grossulariaceae)

Flower: White, green or pink or a combination, drooping, elongated tube, berries vary from red to green or purple or almost black
Leaves: Deeply lobed into 3 sections, deeply veined
Blooms: April-May Berries: July-August Height: up to 6' tall
Found in moist woodland areas and along streams and ditches in the spring.
RYE beez

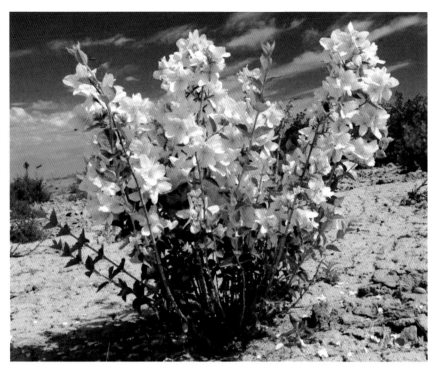

SYRINGA; MOCK ORANGE
Philadelphus lewisii
Hydrangea Family (Hydrangeaceae)

Flower: 4 white petals in clusters, 3-15, many long yellow stamens, sweet aroma
Leaves: Oval or lance-shaped leaves with large veins, opposite
Blooms: June-July Height: 2-8' tall
Found along canyon walls, rocky slopes, and in dry gullies.
Note: The Syringa is the state flower of Idaho.
Top picture by *Stephen L. Love.*

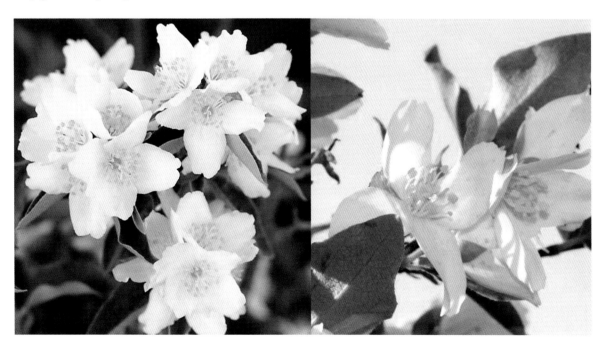

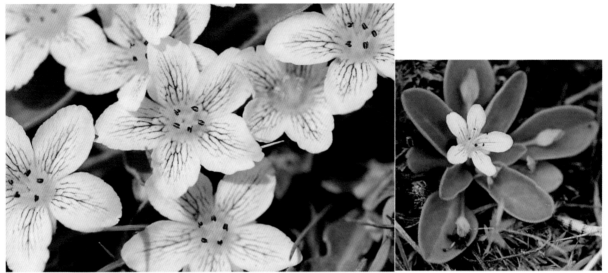

DWARF HESPEROCHIRON
Hesperochiron pumilus*
Waterleaf Family (Hydrophyllaceae*)

Flower: 5 white petals, dark purple veins, a yellow throat, black tipped anthers
Leaves: Large thick basal leaves, egg-shaped
Blooms: April-June Height: 1-4" tall
Found in moist meadows soon after the snow melts.
**hes-per-oh-KYE-ran *hy droh fill LAY see ee*

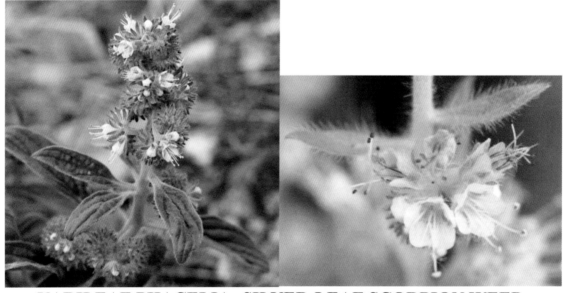

VARILEAF PHACELIA; SILVER-LEAF SCORPION WEED
Phacelia heterophylla
Waterleaf Family (Hydrophyllaceae)

Flower: White-cream clusters, saucer-shaped flower, scorpion-like tail uncoils as it matures
Leaves: Lance-shaped, hairy, deep veins, dark green
Blooms: June-July Height: 8-36" tall
Found in open places, along roadsides, in disturbed places.

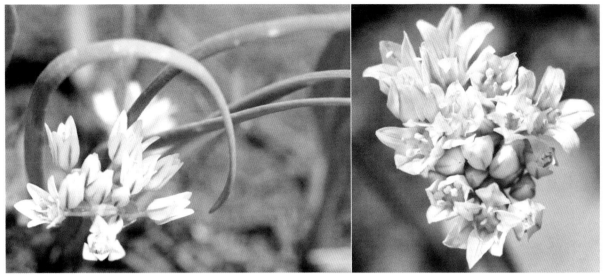

BRANDEGEE'S ONION
Allium brandegeei*
Lily Family (Liliaceae*)

Flower: Usually white but can be pinkish, bell-shaped clusters, prominent lines on outside petals
Leaves: Thin, long and grass-like
Blooms: Soon after the snow melts Height: 1-8" tall
Found on rocky hillsides and open meadows.
*AL ee uhm *bran DEEJ ee eye *lih lah AY see ee

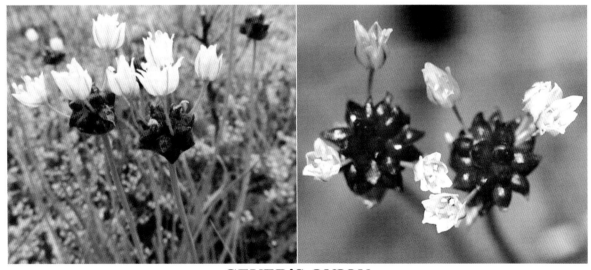

GEYER'S ONION
Allium geyeri var. tenerum
Lily Family (Liliaceae)

Flower: White flowers, deep pink bulbs, thick rib on the back of each petal
Leaves: Grass-like, onion odor
Blooms: May-July Height: up to 12" tall
Found in moist meadows and along small streams.
Top left picture by *Callie Russell.*

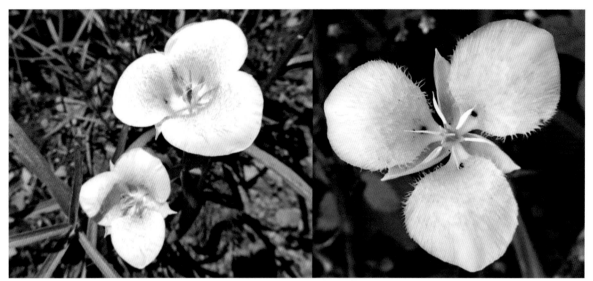

POINTEDTIP MARIPOSA; THREE SPOT MARIPOSA LILY
Calochortus apiculatus*
Lily Family (Liliaceae)

Flower: 3 white oval-shaped petals, each with small black spot, white and yellow hairs
Leaves: Long and linear, basal leaf shorter than stem
Blooms: Late June-July Height: 6-12" tall
Found in open forests, dry rocky slopes, and grasslands. Mariposa means butterfly in Spanish.
Top left picture by *Callie Russell,* top right by *Eric Russell.*
kal oh KOR tuhs

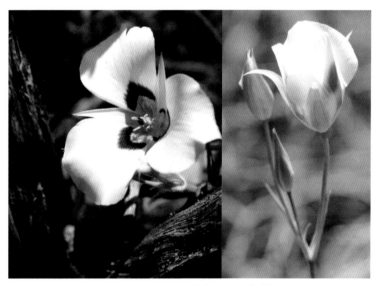

BRUNEAU MARIPOSA
Calochortus bruneaunis
Lily Family (Liliaceae)

Flower: 3 white bell-shaped petals with a distinctive base of purple shaped like an arrow,
petals have a pale greenish stripe on the outside
Leaves: Long and linear
Blooms: Late June-July Height: 6-16" tall
Found in dry soils, sagebrush flats such as this one found near Mackay, Custer County.

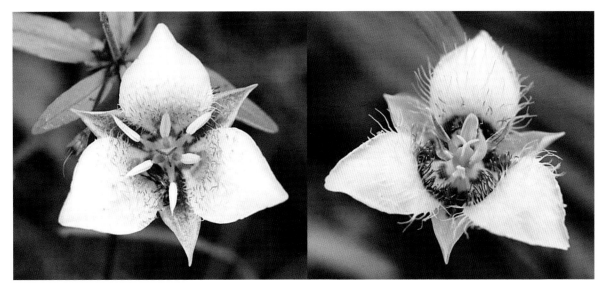

ELEGANT MARIPOSA LILY; CAT'S EAR
Calochortus elegans
Lily Family (Liliaceae)

Flower: Small white petals shaped like a cat's ear, (only about 1" across) very hairy, crescents of purple near the throat
Leaves: Long and linear
Blooms: May-June Height: 3-7" tall
Found in open moist woods, grassy hillsides, one found about 12 miles from the border between Idaho and Montana in Lemhi County, left one from on the Lolo Trail in May.

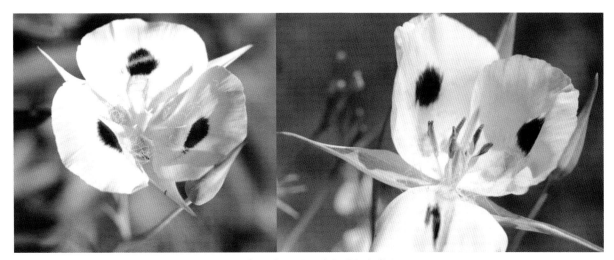

BIGPOD MARIPOSA
Calochortus eurycarpus
Lily Family (Liliaceae)

Flower: 3 white bell-shaped petals, distinctive spots of purple and yellow on the petals, has a pale greenish stripe on the outside
Leaves: Long and linear
Blooms: June-July Height: 4-18" tall
Found in sagebrush woodlands and open sunny meadows.

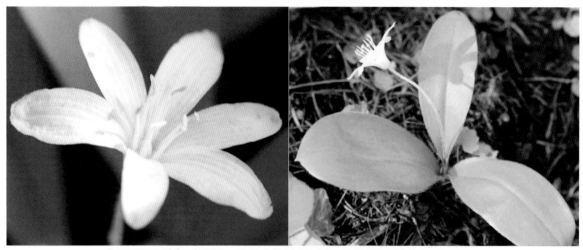

QUEEN'S CUP; BEADLILY; BRIDE'S BONNET
Clintonia uniflora
Lily Family (Liliaceae)

Flower: Single star-shaped white flower, 6 petals, yellow anthers,
develops a solitary blue berry
Leaves: Basal leaves (2-5) may have wooly hairs, oblong or elliptical
Blooms: June-July Height: 2-8" tall
Found in shady moist woods such as those near the Lolo Trail Visitor's Center.

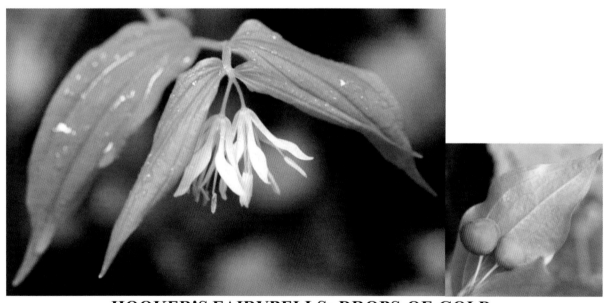

HOOKER'S FAIRYBELLS; DROPS-OF-GOLD
Prosartes hookeri
Lily Family (Liliaceae)

Flower: 2 (sometimes 3) white to cream bell-shaped flowers
Leaves: Large with parallel leaf veins
Blooms: May-July Height: 12-36" tall
Found in shaded forests. Photographed at the DeVoto Memorial Cedar Grove on Lolo Pass.

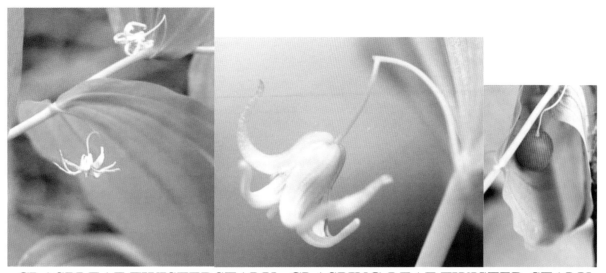

CLASPLEAF TWISTEDSTALK; CLASPING-LEAF TWISTED-STALK
Streptopus amplexfolius
Lily Family (Liliaceae)

Flower: Bell-shaped, 6 white to cream petals, hang from the leafjoint, has a distinct twist, look for the flowers and berries <u>under</u> the leaves
Leaves: Large oval with pointed tips, clasp the stem, alternate
Blooms: May-July Berries: August Height: 12-40" tall
Found along shady stream banks and in moist mountain forests, shady thickets.

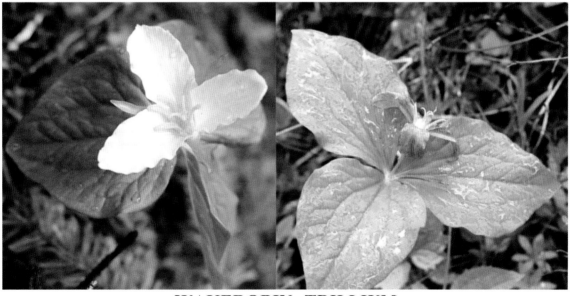

WAKEROBIN; TRILLIUM
Trillium ovatum
Lily Family (Liliaceae)

Flower: 3 white egg-shaped petals that eventually turn pink or purple as it ages, funnel-shaped at base, large, solitary
Leaves: 3 broad, egg-shaped leaves
Blooms: Early spring as the snow is melting Height: 6-20" tall
Found in boggy areas, in shady moist areas such as thickets and woodlands.

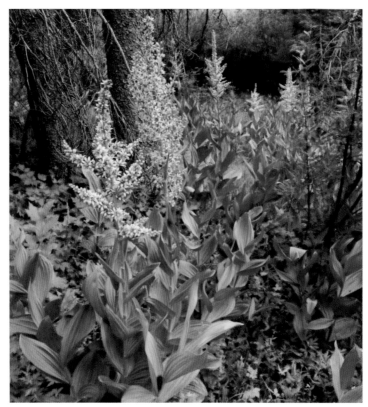

CORN LILIES; CALIFORNIA FALSE HELLEBORE
Veratrum * *californicum*
Lily Family (Liliaceae)

Flower: Dense clusters, white or cream, 6 star-shaped petals, green centers
Leaves: Very large, smooth and pointed, oval, deeply veined
Blooms: July-August Height: 2-7' tall
Found in patches in wet meadows, along stream banks, in clearings in woods.
Since it is very toxic, many counties spray for it; thus is getting harder to find.
Top picture by *Stephen L. Love.*
ver RAH trum

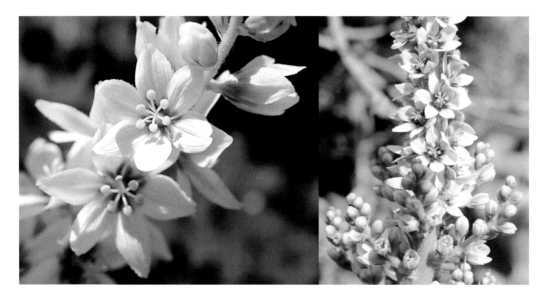

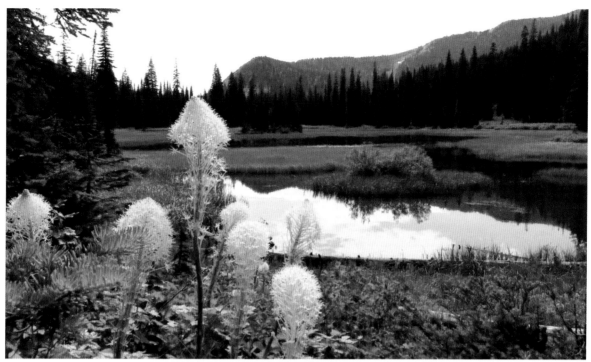

BEARGRASS
Xerophyllum tenax
Lily Family (Liliaceae)

Flower: White or cream clusters, star-shaped petals, on stout stalk
Leaves: Grass-like basal leaves
Blooms: June-August Height: 30-60" tall
Found in open forests, slopes, ridges, and meadows.
Top picture by *Callie Russell.*

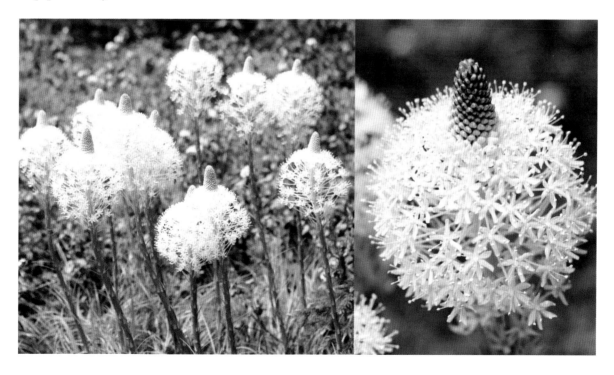

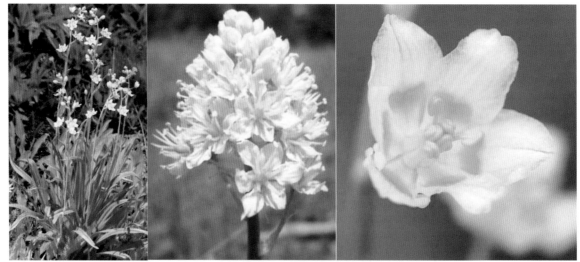

MT. DEATH CAMAS; SHOWY DEATH CAMAS
Zigadenus elegans*
Lily Family (Liliaceae)

Flower: Greenish-white and yellowish-white, several on a stem, green heart-shaped markings at base, in clusters, prominent yellow anthers
Leaves: Grass like, mainly upright basal
Blooms: June-August Height: 6-30" tall
Found in moist meadows. Unpleasant to smell, this plant was often placed around the Native American camps, as they believed it would repel evil spirits.
**zig a DEN us*

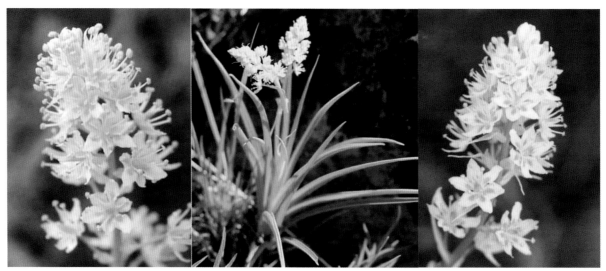

FOOTHILLS DEATH CAMAS
Zigadenus paniculatus
Lily Family (Liliaceae)

Flower: Yellowish-white to greenish-white with several flowers on a stem, prominent yellow-gold anthers
Leaves: Many grass-like leaves
Blooms: April to July Height: 8-20" tall
Found in dry meadows and throughout the sagebrush areas.

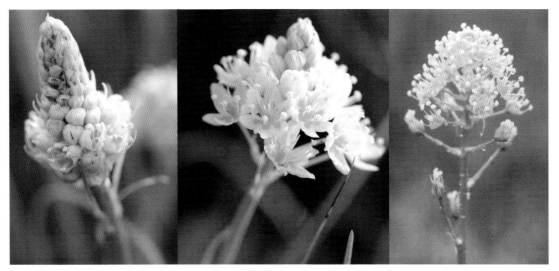

MEADOW DEATHCAMAS
Zigadenus venenosus var. venenosus
Lily Family (Liliaceae)

Flower: Greenish-white petals in a cluster, yellowish round gland at center, white anthers
Leaves: Grass-like
Blooms: April to July Height: 6-20" tall
Found in moist meadows; this seen May 30 in a wet meadow.
Note: Plant can be poisonous to humans and livestock if eaten.

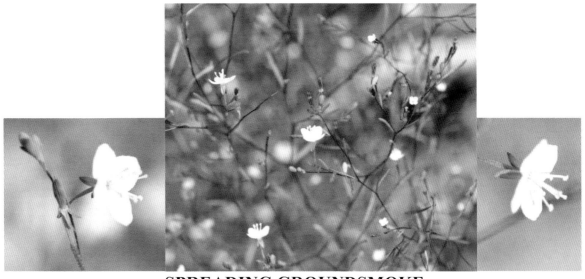

SPREADING GROUNDSMOKE
Gayophytum diffusum
Evening Primrose Family (Onagraceae*)

Flower: 4 tiny white petals, buds pink, white anthers, sprawling stems
Leaves: Linear, small
Blooms: June-August Height: 4-24" tall
Found in sagebrush areas, slopes, and canyons, common.
*oh nah GRAY see ee

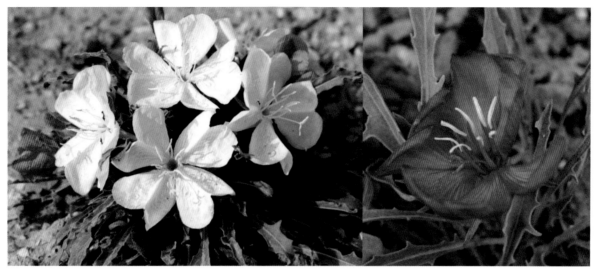

TUFTED EVENING PRIMROSE; DESERT EVENING PRIMROSE
Oenothera caespitosa
Evening Primrose Family (Onagraceae)

Flower: 4 large white notched heart-shaped petals that turn to light pink and then dark pink as it ages, hugs the ground, fragrant, long yellow anthers
Leaves: Basal, long, narrow and notched, may have a reddish stem
Blooms: May-July Height: 10-24" tall
Found in dry areas, slopes, canyons, clay banks, clearings, common. Saw 1/3 mile of them along the roadside on Doublesprings Road, on White Knob and hundreds in one place in Dry Canyon in Custer County.

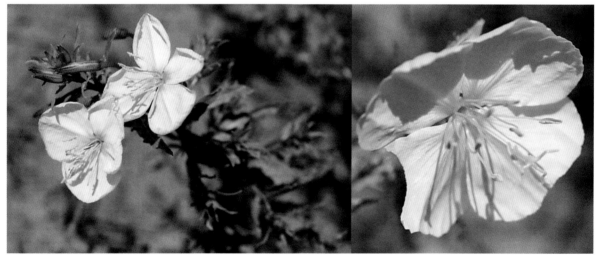

CROWNLEAF EVENING PRIMROSE; CUTLEAF EVENING PRIMROSE
Oenothera coronopifolia
Evening Primrose Family (Onagraceae)

Flower: Large white petals, throat has white hairs, splotch of yellow at the throat
Leaves: Basal leaves finely divided, tips often reddish
Blooms: April-August Height: 12-24" tall
Found in grasslands, dry hillsides, semi-desert, and sandy areas. Although it is found in Franklin County, Idaho, it is more often found in the four corner states and south Wyoming.

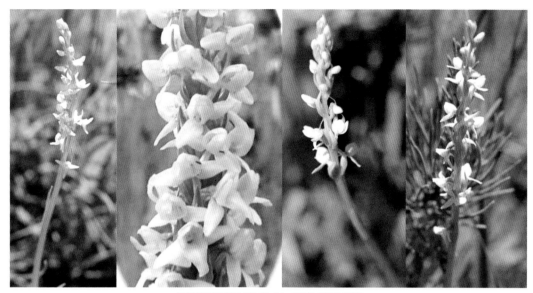

WHITE BOG ORCHID
Platanthera dilatata
Orchid Family (Orchidaceae)

Flower: White and hood-like, lip spur is tubular, on a spike
Leaves: Narrow and lance-shaped
Blooms: June-August Height: 6-20" tall
Found in wet bog like areas and moist meadows.

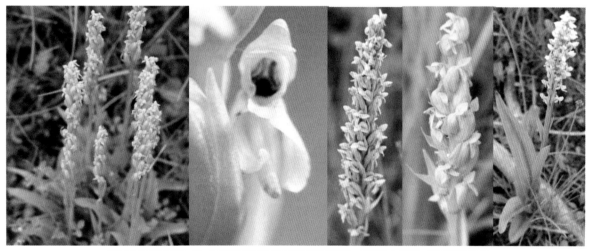

HOODED LADIES' TRESSES; PEARL TWIST
Spiranthes romanzoffiana*
Orchid Family (Orchidaceae)

Flower: Flowers white to cream in 3 parallel rows, 2 upper petals form a hood
Leaves: Narrow, lance-shaped, basal, alternate
Blooms: July-September Height: 6-12" tall
Found in wet areas, along slow moving creeks and on bluffs.
spy RAN theez

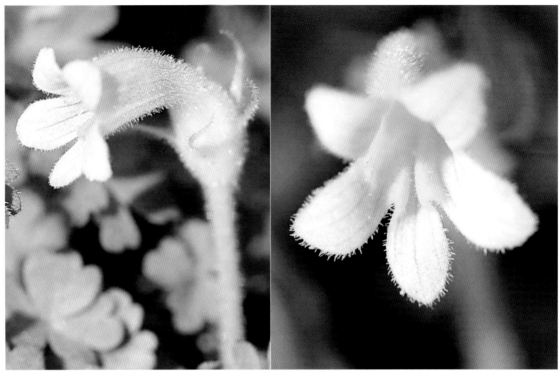

NAKED BROOMRAPE; ONEFLOWERED BROOMRAPE
Orobanche uniflora var. occidentalis
Broomrape Family (Orobanchaceae)

Flower: Tiny, white, funnel-shaped, 5 petals, can be cream-yellow and pink-purple also, hairy
Leaves: Roots wrap around other plants, parasitic and pulls nutrients from other plants,
no real leaves
Blooms: May-July Height: 1-3" tall
Found in meadows and on rocky hills. Pictures enlarged; plant is very small and appears as
the snow melts on rocky hills.

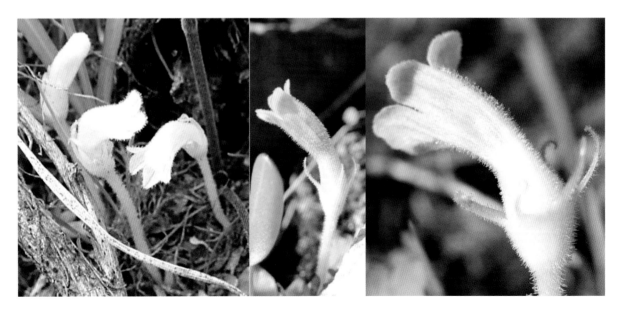

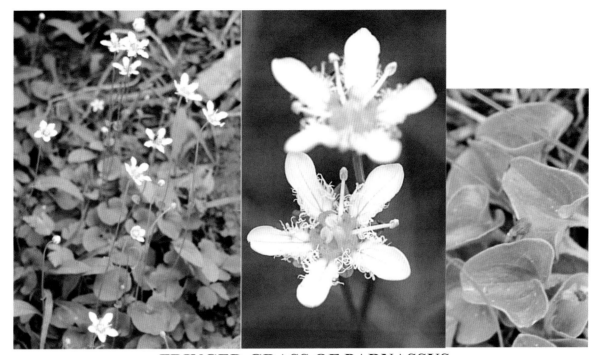

FRINGED GRASS OF PARNASSUS
Parnassia fimbriata
Grass-of-Parnassus Family (Parnassiaceae)

Flower: Solitary white-cream flower with 5 petals, fringed
Leaves: Egg, heart or kidney-shaped, glossy, basal
Blooms: July-August Height: 4-18" tall
Found in wet meadows and along slow moving streams.

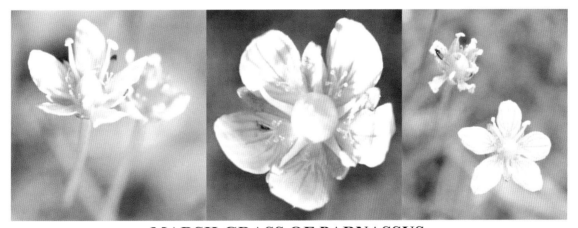

MARSH GRASS OF PARNASSUS
Parnassia palustris
Grass-of-Parnassus Family (Parnassiaceae)

Flower: Tiny, single showy white flower with 5 petals and prominent veins
Leaves: Smooth basal leaves
Blooms: July and August Height: 1-4" tall
Found in wet meadows and along streams.

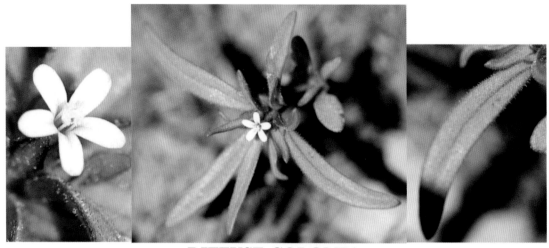

DIFFUSE COLOMIA
Collomia tenella
Phlox Family (Polemoniaceae*)

Flower: Tiny white, 5 petals, delicate
Leaves: Alternate, long and narrow, dark green, long center vein, tiny hairs
Blooms: May-June Height: 2-8" tall
Found on open slopes, rocky areas and in woods.
poh lee mah ni AY see ee

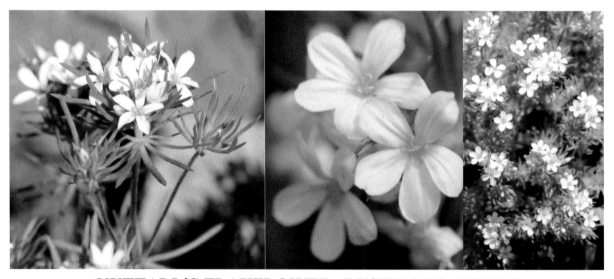

NUTTALL'S FLAXFLOWER; BUSHY LINANTHUS
Leptosiphon nuttallii
Phlox Family (Polemoniaceae)

Flower: 5 white petals with a yellow eye, in clusters, yellow throat, star-shaped, long tubes
Leaves: Divided into many small segments, 5-9, linear, reddish stems, prickly, shiny, opposite
Blooms: July-August Height: 4-10" tall
Found on open slopes and in woods. Photographed near the Titus Bird Watch,
which is about a mile from Galena Summit Overlook, and at Iron Bog Trailhead.

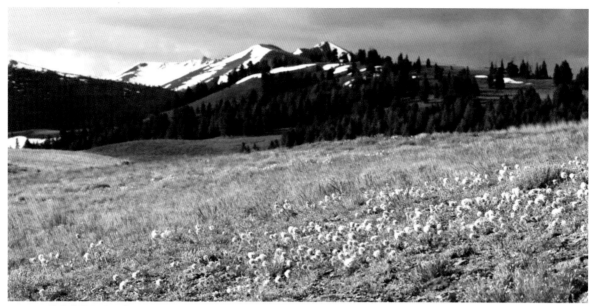

MOUNTAIN BALLHEAD GILIA*; BALLHEAD SKYROCKET; BALLHEAD IPOMOPSIS
Ipomopsis congesta
Phlox Family (Polemoniaceae)

Flower: 5 white petals, ball-shaped cluster
Leaves: Lobed or segmented, alternate, basal leaves, stem turns red
Blooms: May-June Height: 3-8" tall
Found in higher semi desert regions.
Photographed on Corral Summit in the Copper Basin, Custer County, Idaho.
JILLY ah or the Spanish HEEL ee uh

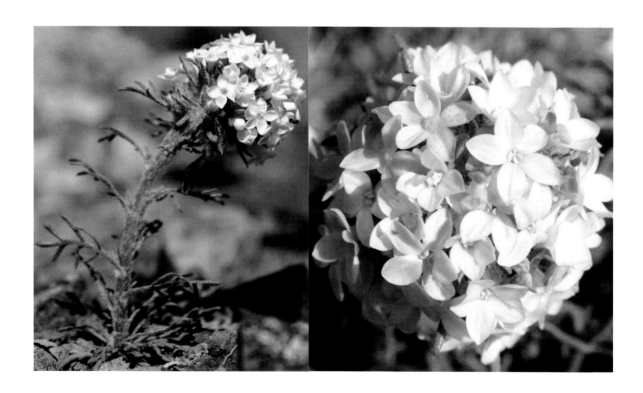

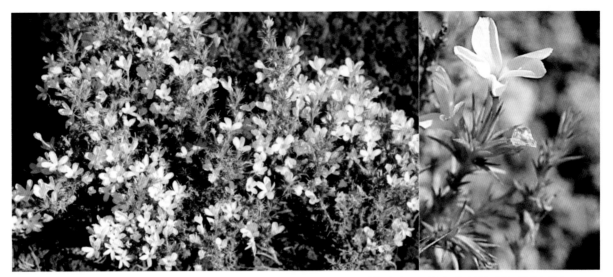

LAVA PHLOX; GRANITE PRICKLY PHLOX; GRANITE GILIA
Leptodactylon pungens
Phlox Family (Polemoniaceae)

Flower: 5 white petals on a funnel-shaped tube
Leaves: Spine tipped, very narrow
Blooms: May-June Height: 4-24" tall
Found in areas in sagebrush flats and on rocky hillsides.

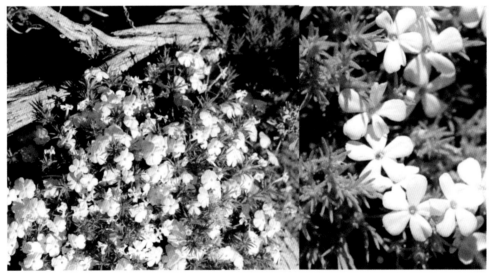

SPREADING PHLOX
Phlox diffusa
Phlox Family (Polemoniaceae)

Flower: 5 petals, white, pink, or lavender, tubular yellow throats and yellow anthers
Leaves: Needle-like with sharp tips, mat forming
Blooms: March-August Height: 2-8" tall
Found in open meadows, sagebrush flats and on hillsides.

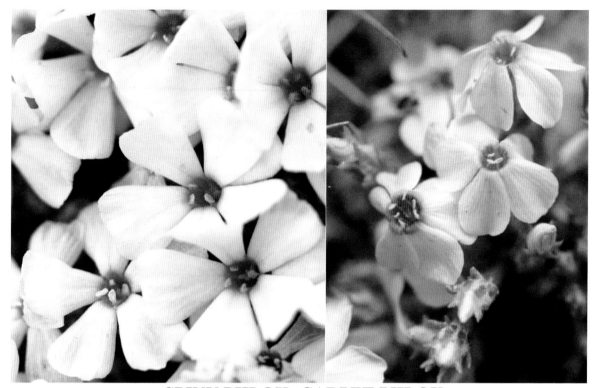

SPINY PHLOX; CARPET PHLOX
Phlox hoodii
Phlox Family (Polemoniaceae)

Flower: 5 petals, white to pink or purple, tubular yellow throats, yellow-gold anthers, throats often turn pink as they mature, low mounds or cushions so thick one cannot see the leaves
Leaves: Tiny, sharp-pointed, hairy leaves that are moss-like
Blooms: April-June Height: 2-4" tall
Found in dry, sandy areas and where there is sagebrush.
Photographed near the Mt. Borah Trailhead.

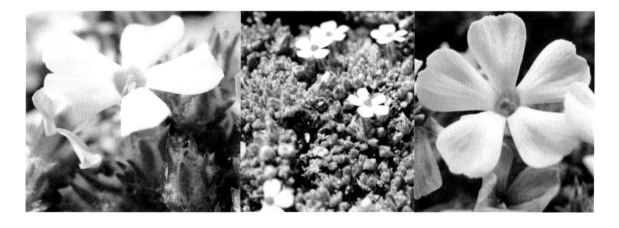

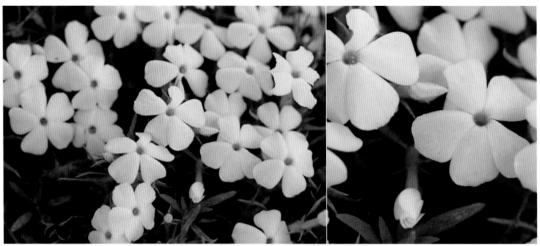

MANY-FLOWERED PHLOX; FLOWERY PHLOX
Phlox multiflora
Phlox Family (Polemoniaceae)

Flower: 5 white broad, rounded petals, narrow throat, yellow-gold anthers in the throat
Leaves: Opposite, linear, flat
Blooms: May-July Height: up to 4" tall
Found in shrub lands, foothills, rocky places, wooded areas. Photographed at Yellowstone Park.

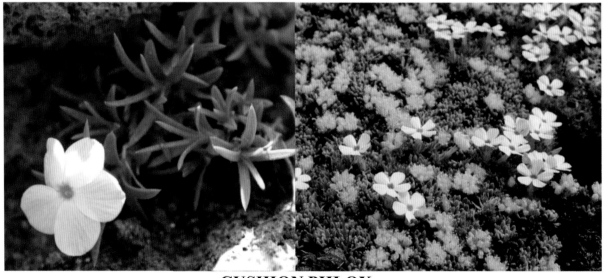

CUSHION PHLOX
Phlox pulvinata
Phlox Family (Polemoniaceae)

Flower: Solitary, on a short stem that holds the flower at the top of the foliage, bright white to occasional light blue
Leaves: Forms a very tight, low mat that hugs the ground, very stiff and needle-like, up to ½" long, somewhat sticky-hairy
Blooms: June and July, shortly after snowmelt Height: 1" tall
Found typically at high elevations on rocky subalpine slopes and plateaus and on alpine tundra. Photographs from Brockie Lake area in the Pioneer Mountains and from the ridges above Targhee Ski Resort. Description and pictures by *Stephen L. Love.*

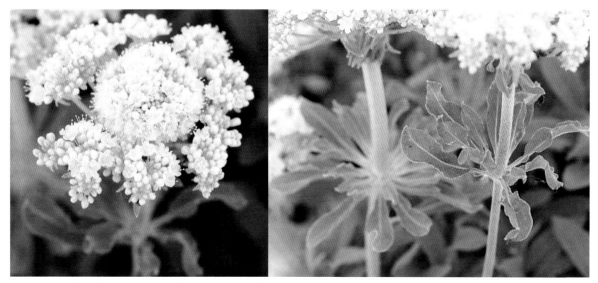

PARSLEY DESERT BUCKWHEAT; WYETH BUCKWHEAT
Eriogonum heracleoides
Buckwheat, Knotweed or Smartweed Family (Polygonaceae)

Flower: Ball-like cluster, white to cream with a touch of pink
Leaves: Stems have a whorl of smaller leaves near the top and larger ones about
mid length, basal leaves linear to rounded leaves with tips, hairy stems and leaves
Blooms: June-July Height: 12-18" tall
Found in sagebrush flats, dry hillsides, gravelly open areas.

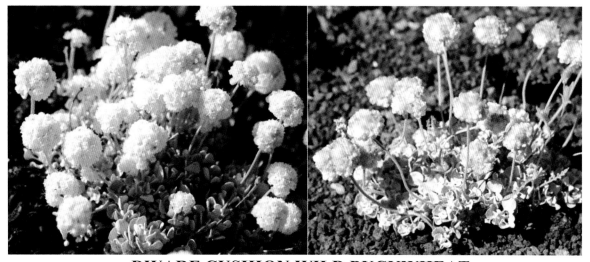

DWARF CUSHION WILD BUCKWHEAT
Eriogonum ovalifolium var. focarium
Buckwheat, Knotweed or Smartweed Family (Polygonaceae)

Flower: White ball-like clusters that turns from white to pink to red
Leaves: Small gray-green oval leaves, mat forming
Blooms: May-June Height: 2-12" tall
Found in sagebrush flats and on dry hillsides, common at Craters of the Moon.

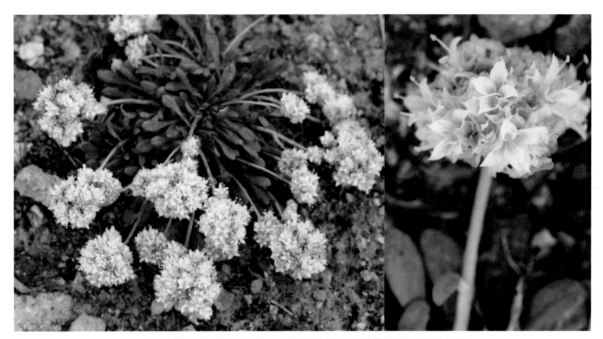

HAIRY SHASTA WILD BUCKWHEAT
Eriogonum pyrolifolium var. coryphaeum
Buckwheat, Knotweed or Smartweed Family (Polygonaceae)

Flower: White clusters with prominent yellow anthers, hugs the ground
Leaves: Bright green, spoon-shaped, basal
Blooms: May-June Height: 4-16" tall
Found on sandy to gravely slopes and ridges; see at high altitudes soon after the snow melts.
Photographed in Yellowstone Park.

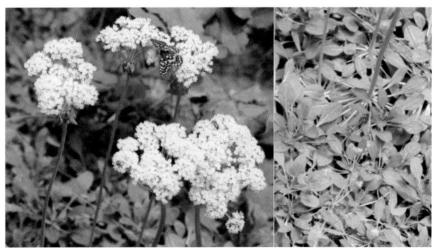

SULPHUR-FLOWER BUCKWHEAT; SUBALPINE BUCKWHEAT
Eriogonum umbellatum var. majus
Buckwheat, Knotweed or Smartweed Family (Polygonaceae)

Flower: White to almost cream, looks like the ribs of an umbrella underneath
Leaves: Basal clusters, spoon-shaped, hairy
Blooms: May-June Height: 8-18" tall
Found in sandy soil and at edges of forests. Plant also called *Erigonum subalpinum.*

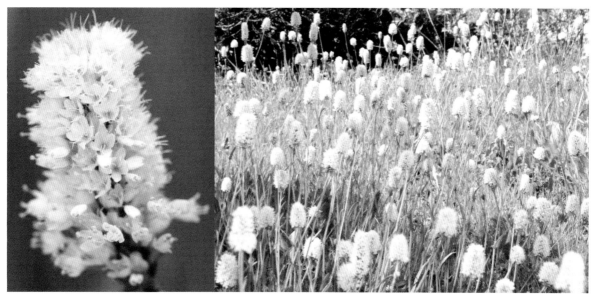

AMERICAN BISTORT; WESTERN BISTORT
Polygonum bistortoides
Buckwheat, Knotweed or Smartweed Family (Polygonaceae)

Flower: White clusters on a stalk, 5 tiny petal-like segments, funnel-shaped
Leaves: Lance-shaped, long, mostly at base of stem
Blooms: June-August Height: 6-24" tall
Found in moist mountain meadows and along stream banks.
Note: Native Americans used the root in bread and soups.

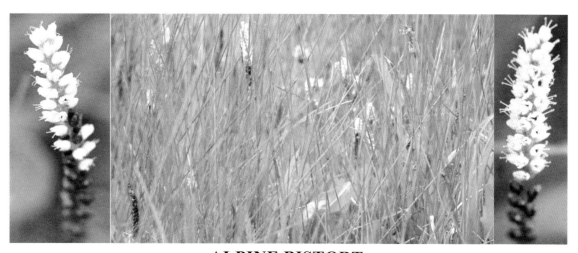

ALPINE BISTORT
Polygonum viviparum
Buckwheat, Knotweed or Smartweed Family (Polygonaceae)

Flower: White to pinkish slender clusters on a narrow spike, lower flowers have oval bulbs
Leaves: Basal
Blooms: June-August Height: 2-10" tall
Found in moist mountain meadows and along stream banks.

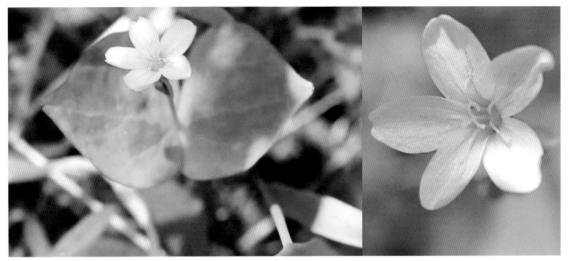

HEART LEAF SPRING BEAUTY
Claytonia cordifolia
Purslane Family (Portulacaceae)

Flower: Bowl-shaped flowers with 5 white notched petals
Leaves: Heart-shaped basal leaves
Blooms: May-June Height: 2-5" tall
Found along or in small moving streams. Photographed along edge of Deep Creek
in Lemhi County, about 8 miles from the border between Idaho and Montana.

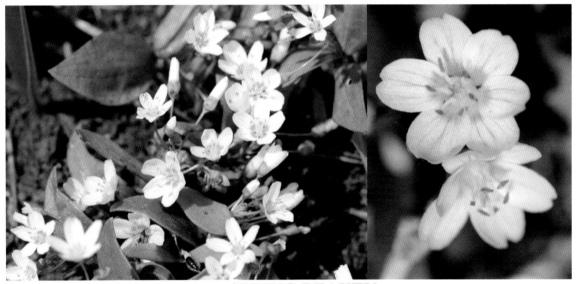

SPRING BEAUTY
Claytonia lanceolata
Purslane Family (Portulacaceae)

Flower: White bowl-shaped flowers with 5 petals streaked with pink-lavender veins,
pink anthers, yellow splotches near throat
Leaves: Basal leaves and stem leaves are lance-shaped, opposite
Blooms: May-June Height: 2-6" tall
Found in mountain meadows, foothills, and open forests as the snow melts; thousands
were seen near Bayhorse Lake in Custer County, Idaho, right after the snow melted.

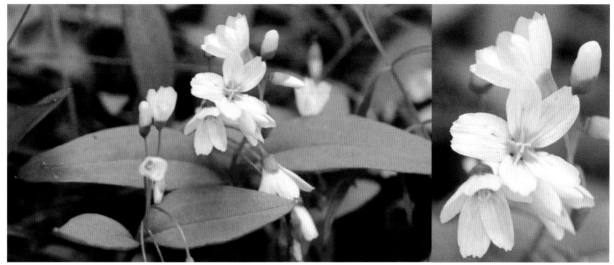

RYDBERG'S SPRING BEAUTY; LANCELEAF SPRING BEAUTY
Claytonia multicapa
Purslane Family (Portulacaceae)

Flower: White-yellow bowl-shaped flowers with 5 petals, splotches of yellow near the throat
Leaves: Basal leaves and stem leaves are lance-shaped, opposite
Blooms: May-June Height: 2-6" tall
Found in moist mountain meadows, not common. Photographed in Yellowstone Park.
Identified by Dr. Tuthill, University of Wyoming—"probably."

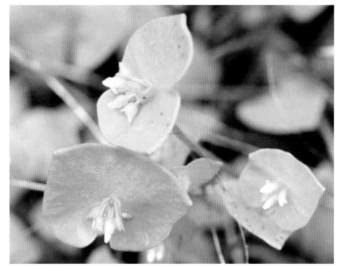

MINER'S LETTUCE; INDIAN LETTUCE
Claytonia perfoliata
Purslane Family (Portulacaceae)

Flower: White to pinkish, ¼" wide
Leaves: Basal, kidney or triangular-shaped
Blooms: May-June Height: 4-16" tall
Found in wooded areas, along springs, also called *Mantia perfoliata.*
Native Americans and pioneers used this plant as a potherb.

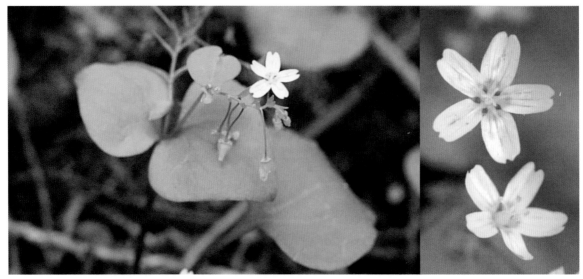

SIBERIAN SPRING BEAUTY; CANDY FLOWER
Claytonia sibirica
Purslane Family (Portulacaceae)

Flower: 5 white petals, notched, tiny pink stripes on petals
Leaves: Basal leaves, egg or heart-shaped, opposite
Blooms: June-July Height: 5-14" tall
Found along or in small moving streams or other moist places.
Photographed in July at the DeVoto Cedar Grove on the Lolo Trail.

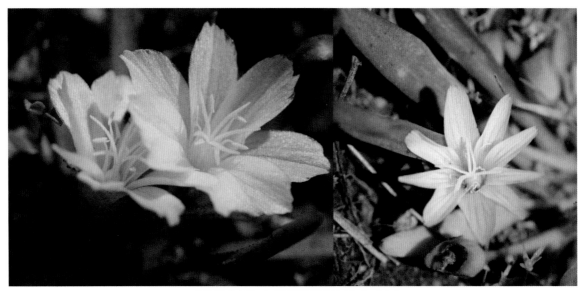

NEVADA BITTERROOT
Lewisia nevadensis
Purslane Family (Portulacaceae)

Flower: White, sometimes tinged with pink, petals veined, plant low to the ground
Leaves: Basal, thick and succulent
Blooms: April-June Height: 1-2" tall
Found in wet meadows and near gravely creeks that are drying up.

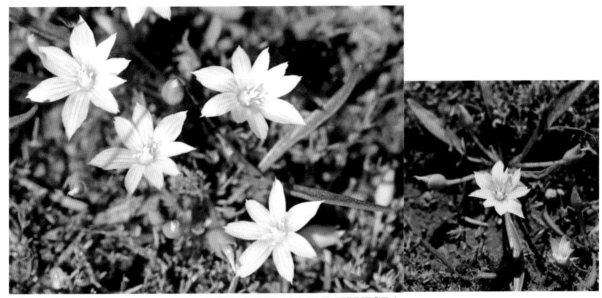

THREELEAF LEWISIA
Lewisia triphylla
Purslane Family (Portulacaceae)

Flower: White, 5-9 petals, may have pink veins
Leaves: 2-5 on upper part of stem and thread-like
Blooms: May-June Height: 3-4" tall
Found in meadows where the snows are late to melt and on gravelly slopes.
Photographed on the Lolo Trail in Idaho about ¼ mile from Packer's Meadow.

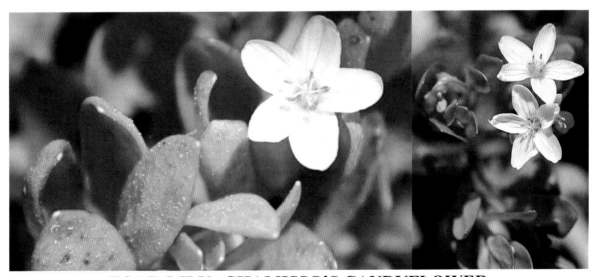

TOAD-LILY; CHAMISSO'S CANDYFLOWER
Montia chamissoi
Purslane Family (Portulacaceae)

Flower: White to pinkish, 5 petals, pink anthers
Leaves: Opposite, fleshy, oval-shaped
Blooms: April-July Height: 2-7" tall
Found in marshy areas and near slow moving creeks.

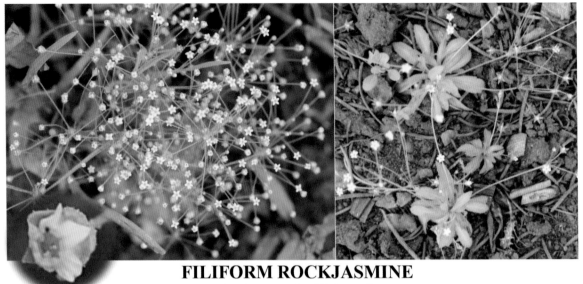

FILIFORM ROCKJASMINE
Androsace filiformis*
Primrose Family (Primulaceae*)

Flower: Umbels of tiny white petals, yellow centers, 5 petals almost triangular
Leaves: Toothed, oval, basal
Blooms: June-July Height: 2-12" tall
Found in wet meadows such as those near the Iron Bog Trailhead in Butte County.
**an DROS ah see *prim you LAY see ee*

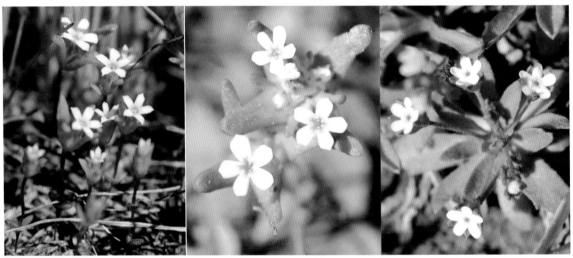

PYGMYFLOWER ROCKJASMINE
*Androsace septentrionalis**
Primrose Family (Primulaceae)

Flower: White with 5 petals that are less than 1/16" in diameter, star-shaped, yellow throat
Leaves: Basal, irregularly toothed, lance-shaped
Blooms: May-August Height: 3-10" tall
Found in open woods, meadows and along slopes.
Photographed near Bayhorse Lake in Custer County.
**sep ten tree oh NAH liss*

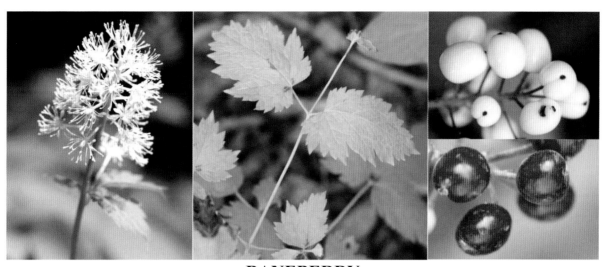

BANEBERRY
Actaea rubra
Buttercup Family (Ranunculaceae*)

Flower: White-cream clusters, berries can be red or white, both have a dark "eye" spot
Leaves: Alternate, divided into toothed compound leaflets often in groups of 3
Blooms: May-June Berries: July-August Height: 1-3' tall
Found along stream banks, moist sites in shady woods, and in swampy areas.
Toxic and can cause skin reactions.
*ra nun kew LAY see ee

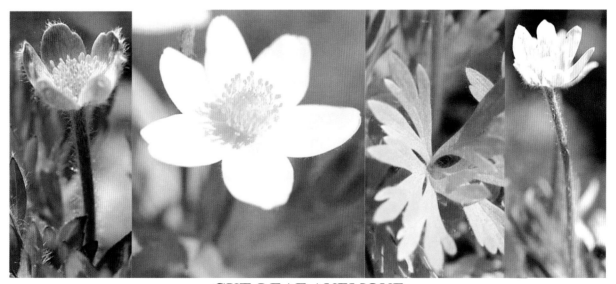

CUT-LEAF ANEMONE
Anemone multifida*
Buttercup Family (Ranunculaceae)

Flower: White to cream flowers (also pink, purple and red), 6 petals, also called the windflower
Leaves: Basal and divided into 3 wedge-shaped leaflets
Blooms: June-July Height: 6-20" tall
Found in meadows, along stream banks and in rocky areas.
*a NEM oh nee

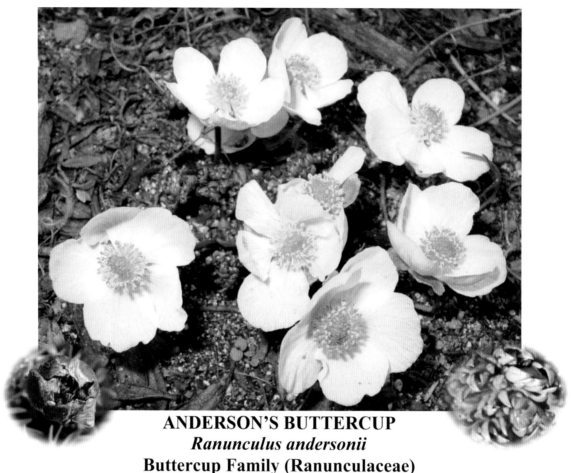

ANDERSON'S BUTTERCUP
Ranunculus andersonii
Buttercup Family (Ranunculaceae)

Flower: 5 white or pink-tinged petals, prominent green-yellow center, at ground level, as flower dies back, flower stalks lengthen, seed heads and leaves develop
Leaves: Lobed leaflets in tight balls, later light green leaflets open up
Blooms: March-April, as snow is melting Height: 2-7" tall
Found in woodlands and sagebrush flats. Flowers are often found a foot or two away from a melting snowbank. Upper picture photographed by *Wallace Keck,* City of Rocks in Cassia County. Bottom left picture shows the pink marking on the outside, right picture is a later stage after flowers have bloomed. These photographed on Tom Cat Hill in the Craters of the Moon.

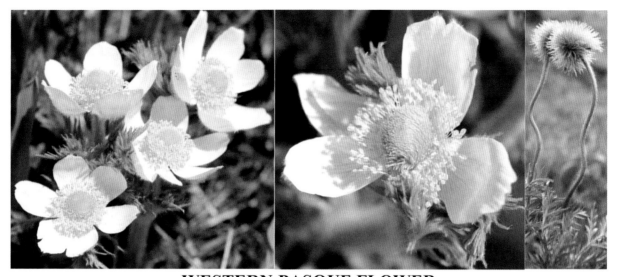

WESTERN PASQUE FLOWER
Anemone occidentalis
Buttercup Family (Ranunculaceae)

Flower: White, 5-7 petals (sepals), single stem, hairy, large green-yellow center
Leaves: Basal cluster, leaflets deeply divided
Blooms: June-August Height: 6-20" tall
Found in moist meadows and open sites and on rocky slopes soon after the snow melts.
Photographed at Glacier Park by *Eric Russell.*

PIPER'S ANEMONE
Anemone piperi
Buttercup Family (Ranunculaceae)

Flower: Single white flower, 5-7 petals, round green center, white anthers
Leaves: Compound leaves with toothed leaflets
Blooms: April-July Height: 4-20" tall
Found in shady woods and moist forest areas, photographed on the Lolo Trail.

MOUNTAIN MARSH MARIGOLD
Caltha leptosepala
Buttercup Family (Ranunculaceae)

Flower: Bright white flower with from 5-11 tongue-shaped petals-sepals, bright green and yellow center
Leaves: Large glossy broad kidney-shaped leaves that can be up to 10" long, basal, dark green
Blooms: April-May Height: 3-12" tall
Found stream banks and marshy meadows, often seen where the snow has just melted.

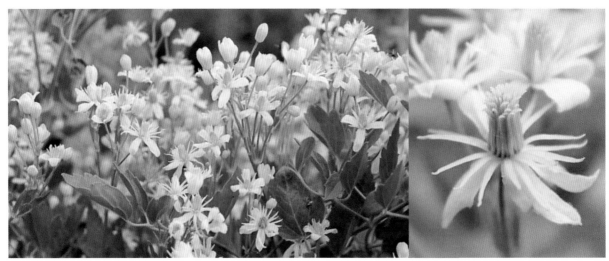

VIRGIN'S BOWER; WESTERN WHITE CLEMATIS
Clematis ligusticifolia
Buttercup Family (Ranunculaceae)

Flower: Clusters of white or cream-colored flowers, 4 petals-sepals, many white stamens
Leaves: Opposite leaves divided into 3-7 leaflets, peppery tasting leaves
Blooms: July-August Height: woody vine up to 16' long
Found along roadsides, streams, and irrigation canals. Bees love this fragrant vine that clings to trees and shrubs. Plant considered poisonous.

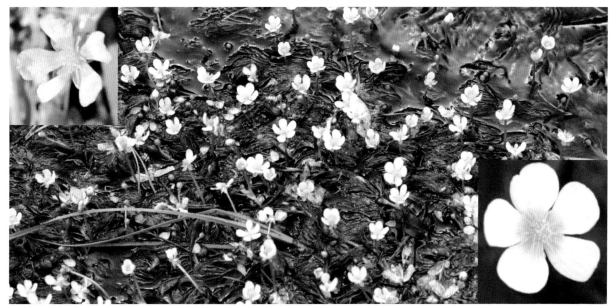

WATER BUTTERCUP; WHITE WATER CROWFOOT
Ranunculus aquatilis
Buttercup Family (Ranunculaceae)

Flower: 5 white petals with a yellow and green center
Leaves: Thread-like, aquatic and often found in mats, floats about 1" above the water
Blooms: June-August Height: about 1" above surface water
Found easily in ponds and the edges of slow-moving streams.

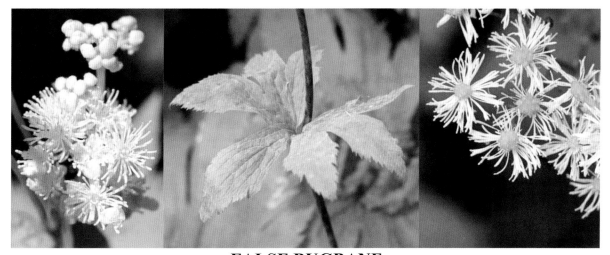

FALSE BUGBANE
Trautvetteria caroliniensis
Buttercup Family (Ranunculaceae)

Flower: Creamy white, thread-like, lacks true petals, yellowish-green center
Leaves: Deeply lobed and toothed
Blooms: July-August Height: 2-4' tall
Found in shady, wooded areas.
Photographed at the DeVoto Cedar Grove on the Lolo Trail.

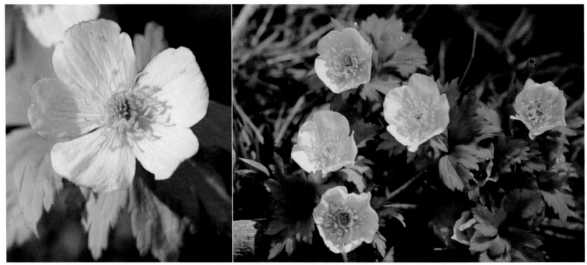

AMERICAN GLOBEFLOWER; TROLL-FLOWER
Trollius laxus
Buttercup Family (Ranunculaceae)

Flower: A single white flower about 1½" wide with a large yellow and green center,
5-8 petal-like segments
Leaves: Basal, alternate, 3-lobed and deeply notched
Blooms: May-June Height: 4-20" tall
Found in wet mountain meadows soon after the snow has melted and along stream banks.

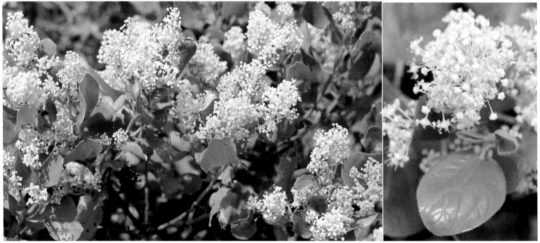

STICKY LAUREL; SNOWBRUSH CEANOTHUS; BUCKBRUSH
Ceanothus velutinus
Buckthorn Family (Rhamnaceae*)

Flower: Clusters of tiny white, star-shaped flowers on a shrub, fragrant
Leaves: Alternate, oval, shiny, hairy underneath, prominent veins
Blooms: June-July Height: 3-6' tall
Found in open forests and along mountain trails.
*ram NAYsee ee

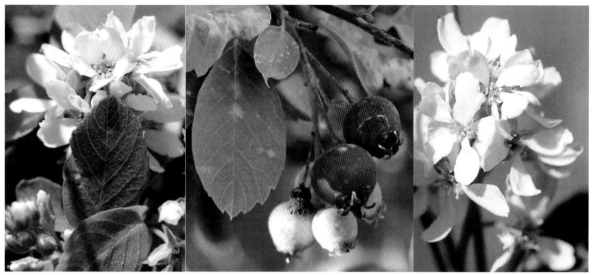

SASKATOON; SERVICEBERRY; JUNEBERRY
Amelanchier alnifolia
Rose Family (Rosaceae)

Flower: 5 long white petals in loose clusters, yellow anthers
Leaves: Oval to roundish on a large shrub or small tree, toothed
Blooms: April-June Berries: August-September Height: 4-14' tall
Found in open woods, foothills and hillsides, common.

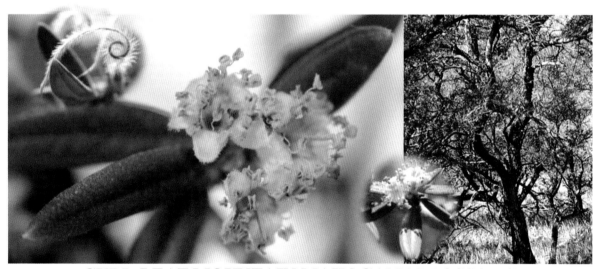

CURL-LEAF MOUNTAIN MAHOGANY BLOSSOMS
Cercocarpus ledifolius var. intercedens
Rose Family (Rosaceae)

Flower: White to cream, sometimes greenish, 5 petals, pinkish throat, sweet scent
Leaves: Narrow, alternate elliptic, dark green above, hairy underneath, slight curl
Blooms: April-June
Found on mountain slopes to desert foothills.
These blossoms photographed near Mt. Borah Trailhead on the Curl-leaf Mt. Mahogany trees.
Seed pod in top left corner by *Callie Russell* taken in late August.

DESERTSWEET;TANSYBUSH;FERNBUSH
Chamaebatiaria millefolium*
Rose Family (Rosaceae)

Flower: White to cream, 5 petals, clusters on erect stem
Leaves: Fern-like leaves finely divided, aromatic
Blooms: July-August Height: 3-6' tall
Found in rocky soils and on hillsides and meadows, easily found at Craters of the Moon.
**kam ay bay tee AY ree uh*

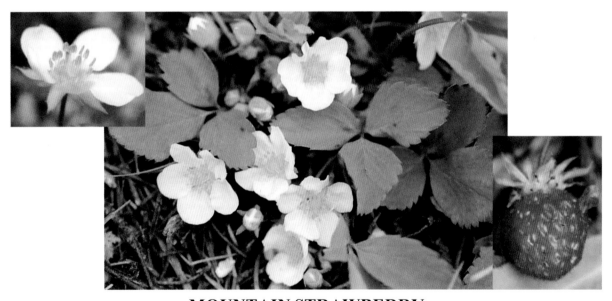

MOUNTAIN STRAWBERRY
Fragaria virginiana
Rose Family (Rosaceae)

Flower: 5 saucer-shaped white petals, yellow center, followed by a cone-shaped red berry
Leaves: Divided into 3 toothed leaflets, smooth basal leaves
Blooms: May-July Height: 1-6" tall
Found easily in meadows, near streams, and forests.

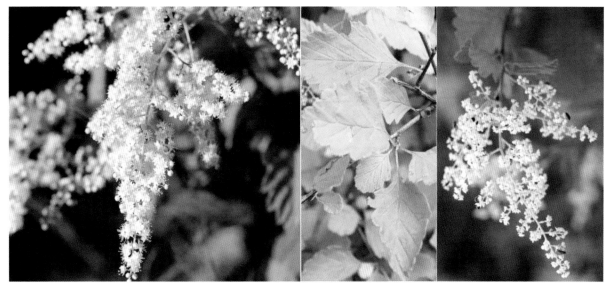

MOUNTAIN SPRAY; OCEAN SPRAY
Holodiscus discolor
Rose Family (Rosaceae)

Flower: Creamy white pyramid-like clusters made up of flowers with 5 petals
Leaves: Lobed, toothed, wooly hair underneath
Blooms: May-early July Height: 3-8' tall
Found in woodlands, slopes and rocky soils. M. Lewis collected this plant near Kamiah in 1806.

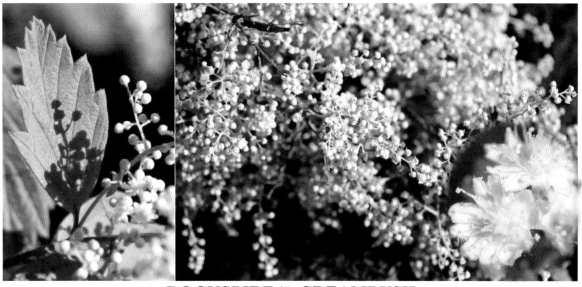

ROCKSPIREA; CREAMBUSH
Holodiscus dumosus
Rose Family (Rosaceae)

Flower: White to cream clusters, made up of flowers with 5 petals
Leaves: Long oval leaves, coarse teeth or lobed
Blooms: Late June-August Height: 3-6' tall
Found in cracks and crevices of lava flows and on foothills.
See at Craters of the Moon, going toward the caves.

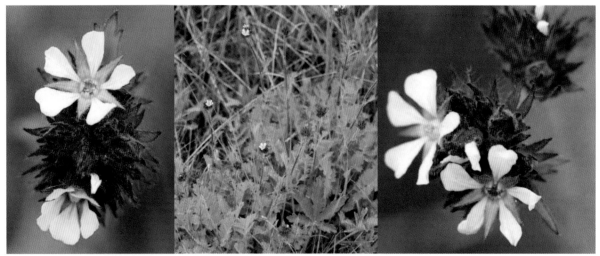

PINEWOODS HORKELIA; SMALLFLOWER HORKELIA
Horkelia fusca var. parviflora
Rose Family (Rosaceae)

Flower: White to pinkish, 5 petals, brown bracts, flat top clusters
Leaves: 2-5 leaflets toothed
Blooms: Late June-July Height: up to 30" tall
Found in meadows and open woods.

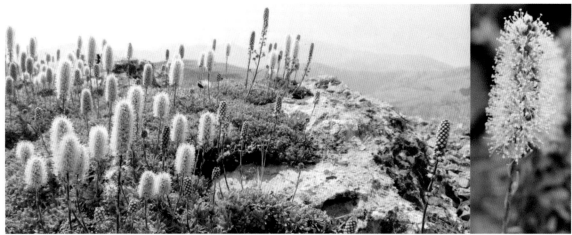

ROCKMAT; MAT ROCKSPIREA
Petrophytum caespitosum
Rose Family (Rosaceae)

Flower: Clusters, tiny white to off white and sometimes pinkish, ¾-1 ¼"
Leaves: Narrow, basal clusters
Blooms: June-August Height: 2-6" tall
Found on barren rock crevices, limestone cliffs and high plateaus.
Photographed the middle of August up Blaze Canyon on White Knob, Custer County.
Picture on the left by *Callie Russell.*

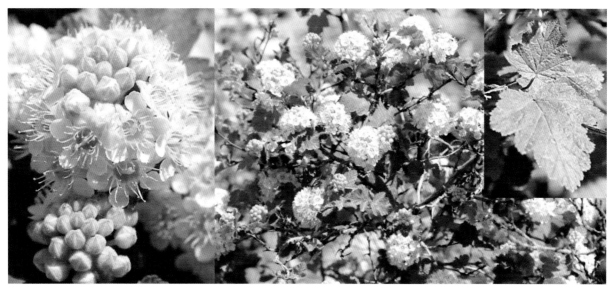

MALLOW NINEBARK
Physocarpus malvaceus
Rose Family (Rosaceae)

Flower: White clusters, made up of 5 tiny petals, gold to yellow centers
Leaves: Alternate, 3-5 lobes, toothed, deeply veined
Blooms: June-July Height: 2-7' tall
Found in canyons and along hillsides near Douglas Fir forests and Ponderosa Pine.

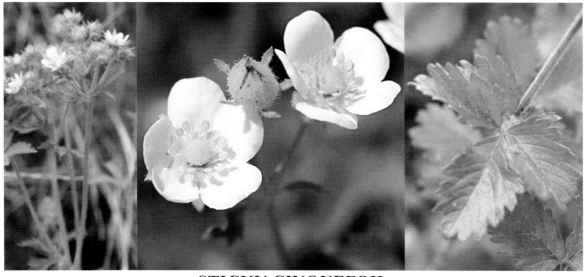

STICKY CINQUEFOIL
Potentilla glandulosa
Rose Family (Rosaceae)

Flower: 5 saucer-shaped white to cream petals, yellow centers and anthers
Leaves: Divided, 5-9 toothed leaflets, can be sticky
Blooms: May-July Height: 1-3' tall
Found open meadows, woodlands, hills, and rocky slopes, quite common.

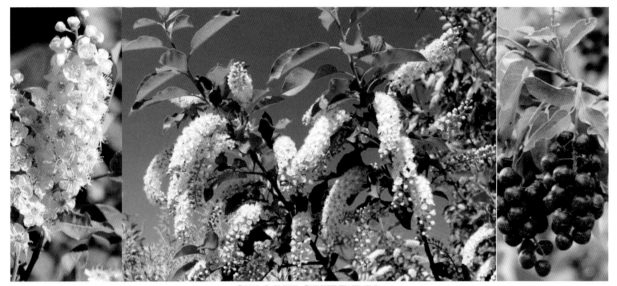

CHOKECHERRY
Prunus virginiana
Rose Family (Rosaceae)

Flower: 5 white cup-shaped petals with yellow centers, long clusters that are 3-6"
Leaves: Alternate, oval or egg-shaped, edges finely toothed
Blooms: April-May Berries: August-September Height: 2-15' tall
Found along stream banks, on slopes and shrubby thickets.
Berries often used in jellies, syrup and jams, very bitter when eaten raw.

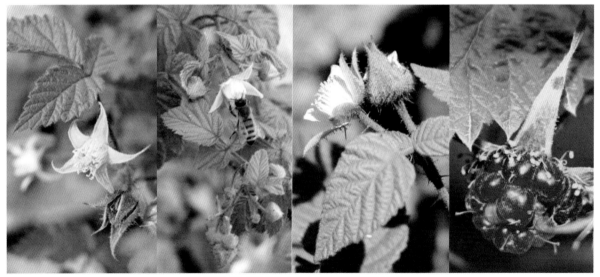

WILD RED RASPBERRY
Rubus idaeus
Rose Family (Rosaceae)

Flower: 1 to 4 white flowers, 5 petals, later red berries
Leaves: Divided into 3-7 toothed leaflets, deeply veined, prickly pinkish stems
Blooms: June-July Berries: July-September Height: 1-5' tall
Found easily in wooded areas and on foothills.
Berries may be eaten raw; they also make great jams and jellies.

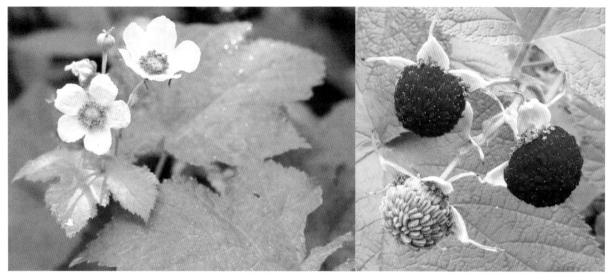

THIMBLEBERRY
Rubus parviflorus var. parvifolius
Rose Family (Rosaceae)

Flower: 5 large white rounded petals followed by a seedy, red berry
Leaves: Large and maple-like, 5 lobes, toothed, deeply veined
Blooms: June-August Height: 2-5' tall
Found along streams and in thickets.

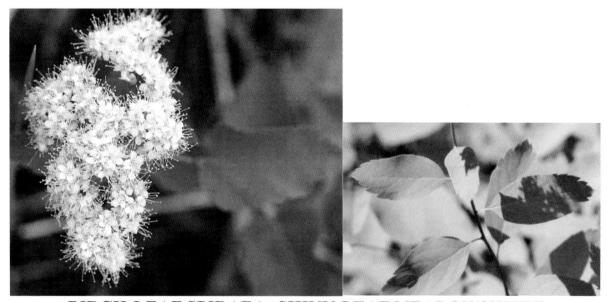

BIRCH-LEAF SPIRAEA; SHINY-LEAF MEADOWSWEET
Spirea betulifolia
Rose Family (Rosaceae)

Flower: Small, flat white clusters that can also be pinkish
Leaves: Alternate and large, birch-shaped, toothed margins
Blooms: July-August Height: 2-3' tall
Found in meadows and along streams.

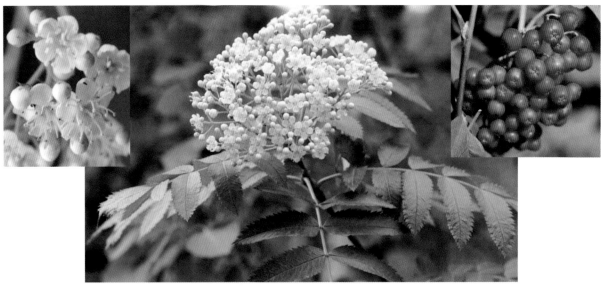

WESTERN MOUNTAIN ASH; GREENE'S MOUNTAIN ASH
Sorbus scopulina
Rose Family (Rosaceae)

Flower: Small, white and saucer-shaped in clusters (glossy reddish-orange fruit)
Leaves: Pointed leaflets, toothed
Blooms: May-June Berries: August Height: 3-12' tall
Found in moist open forests, along stream banks, in meadows and yards.

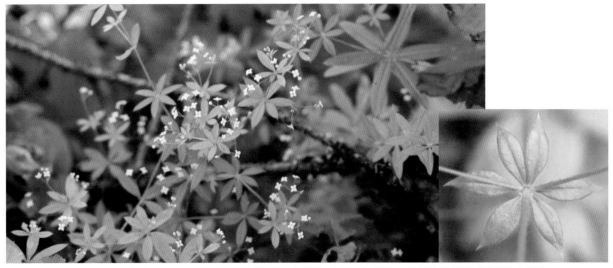

SWEET-SCENTED BEDSTRAW; FRAGRANT BEDSTRAW
Galium triflorum
Coffee or Madder Family (Rubiaceae*)

Flower: Tiny, 4 white petals about 1/8" across, in clusters of 3
Leaves: Whorls of 6 or 4, vanilla scented
Blooms: June-August Height: 6-30" tall
Found near shaded stream banks.
rew bih AY see ee

FALSE TOADFLAX; BASTARD TOADFLAX
Comandra umbellata*
Sandalwood Family (Santalaceae*)

Flower: Whitish with yellow and green centers, star-like
Leaves: Alternate, light green, lance-shaped
Blooms: May-July Height: 8-20" tall
Found in different habitats from mountainsides to Ponderosa Pine forests.
Photographed at City of Rocks in Idaho.
** koh MAN drah *san tah LAY see ee*

YERBAMANSA
Anemopsis californica
Lizard's-tail Family (Saururaceae)

Flower: White, cone-shaped, cluster of tiny flowers, surrounded by white petal-like bracts
Leaves: Fleshy, broad, spicy smell, alternate
Blooms: May-July Height: 6-30" tall
Found in wet marshy areas, especially alkaline ones. Photographed in Lincoln County, Nevada.
Root used by many Native American for medicine.

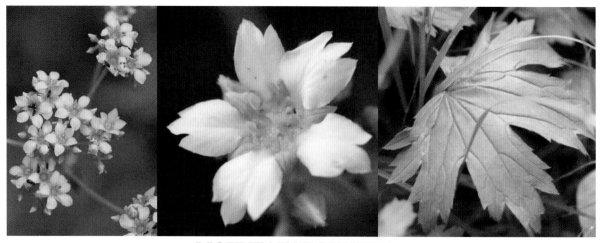

MOUNTAIN BOYKINIA
Boykinia major
Saxifrage Family (Saxifragaceae*)

Flower: Clusters of 5 white petals, notched, yellow-gold anthers
Leaves: Broad kidney-shaped with deep lobes (5-7), stem stout
Blooms: June to September Height: 12-40" tall
Found in wet meadows and along mountain streams. These pictures were taken the second week in July near the Lolo Visitor's Center along a tiny creek near the back.
*sacks ih fra GAY see ee

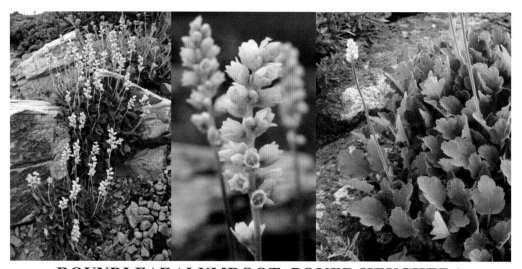

ROUNDLEAF ALUMROOT; POKER HEUCHERA
Heuchera cylindrica
Saxifrage Family (Saxifragaceae)

Flower: Spike-like heads on stiffly upright stems hold numerous, small, cream-colored, bell-shaped flowers
Leaves: Dense basal mound of round, lobed leaves, 2-3" long
Blooms: June and July Height: 7-15" tall
Found in dry rocky woodlands and on cliffs, ledges, and rocky slopes.
Photographs from the east side of Bear Lake and Mount Harrison in southern Idaho.
Description and pictures by *Stephen L. Love.*

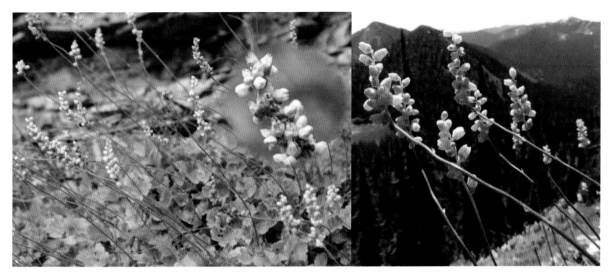

GOOSEBERRYLEAF ALUMROOT
Heuchera grossulariifolia*
Saxifrage Family (Saxifragaceae)

Flower: Small and white-cream, cup-shaped and clustered on a narrow spike
Leaves: Basal and heart-shaped, divided into 5-7 lobes
Blooms: June-August Height: 8-30" tall
Found in meadows, on rocky slopes and crevices. Photographed at Glacier Park.
Top right picture by *Callie Russell.*
**HEW ker ah*

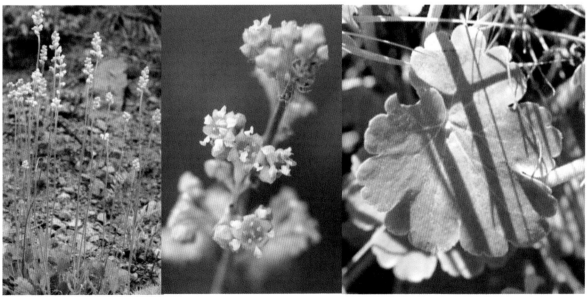

SMALLFLOWER ALUMROOT
Heuchera parvifolia*
Saxifrage Family (Saxifragaceae)

Flower: White-cream colored to yellowish-green, small separated petals, petals bent backward
Leaves: Basal, scalloped
Blooms: July-August Height: 6-24" tall
Found in meadows, on rocky slopes and crevices.

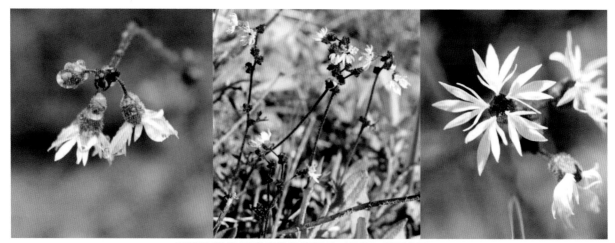

BULBOUS WOODLAND STAR
Lithophragma glabrum
Saxifrage Family (Saxifragaceae)

Flower: 5 white petals, can be tinged with pink or purple, reddish stems
Leaves: Round basal leaves that are divided into lobed segments, small bulbs in axils of leaves
Blooms: May-June Height: 2-8" tall
Found in meadows and open forests, common.

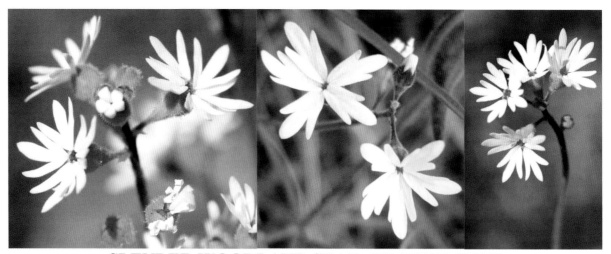

SLENDER WOODLAND STAR; PRAIRIE STAR
Lithophragma parviflorum
Saxifrage Family (Saxifragaceae)

Flower: 5 small, 3-toothed white petals
Leaves: Round basal leaves that are divided into 3-5 lobed segments, no bulbs
Blooms: May-July Height: 4-18" tall
Found in meadows and open forests.

BROOK SAXIFRAGE
Micranthes odontoloma
Saxifrage Family (Saxifragaceae)

Flower: 10 or more tiny, white flowers on a leafless stem
Leaves: Unusual round basal leaves with coarse teeth, glossy
Blooms: June-September Height: 8-24" tall
Found along stream banks, in seeps, and in slow moving creeks.

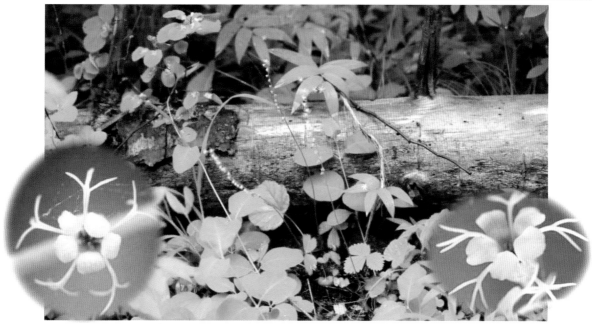

SIDE-FLOWERED MITERWORT
Mitella stauropetala
Saxifrage Family (Saxifragaceae)

Flower: 5 white, narrow petals along one side of a thin stalk
Leaves: Lobed and round, toothed, basal
Blooms: May-early July Height: 10-24" tall
Found in bogs, open and shady woodlands, along stream banks in higher elevations.
Photographed on the Lolo Trail.

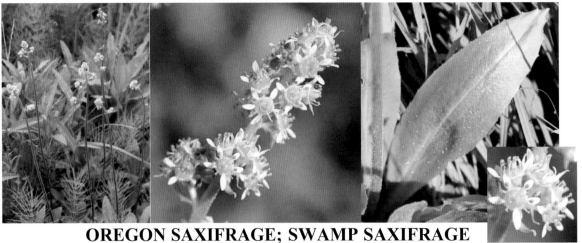

OREGON SAXIFRAGE; SWAMP SAXIFRAGE
Saxifraga oregana
Saxifrage Family (Saxifragaceae)

Flower: 5 white petals, orange anthers, large green center
Leaves: Long, oval leaves that are usually toothed, reddish, hairy stem
Blooms: April-June Height: 1-3' tall
Found in bogs, swamps, marshes, and along streams.

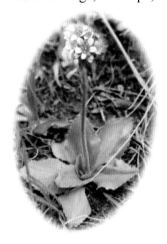

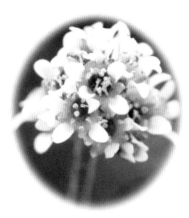

DIAMOND-LEAVED SAXIFRAGE
Saxifraga rhomboidea
Saxifrage Family (Saxifragaceae)

Flower: Small, 5 white petals in clusters
Leaves: Basal rosette of diamond-shaped or triangular leaves, usually toothed, leathery,
very small plant, stem turns red as it matures
Blooms: May-June Height: 2-6" tall
Found in moist areas after the snow melts, mountain meadows, grassy slopes. These tiny ones
were seen at Doublesprings Pass in Custer County where in June, the snow had just melted.

PEAK SAXIFRAGE; FLESHY-LEAVED SAXIFRAGE
Saxifraga nidifica
Saxifrage Family (Saxifragaceae)

Flower: Cluster with 5 white petals in a cup shape, gold anthers
Leaves: Basal rosette, oval-shaped
Blooms: April-June Height: 2-6" tall
Found in mountainous areas, in foothills shortly after the snow melts and along stream banks.
Photographed on Tom Cat Hill within the Craters of the Moon.

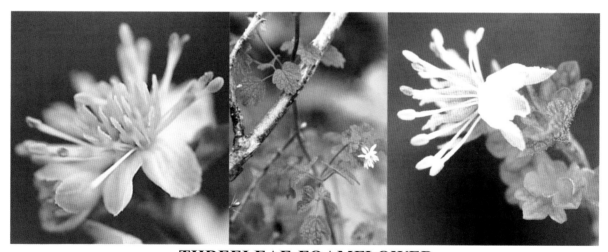

THREELEAF FOAMFLOWER
Tiarella trifoliata var. trifoliata
Saxifrage Family (Saxifragaceae)

Flower: Small and white, hangs down, lots of greenish-yellow anthers
Leaves: 3-5 lobed leaves
Blooms: July-August Height: 1-5' tall
Found in shade in the forest or along small creeks.

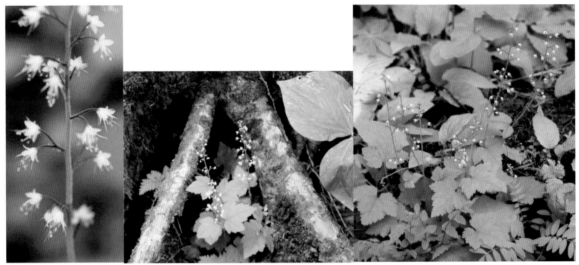

FOAMFLOWER; COOLWORT; LACEFLOWER
Tiarella trifoliata var. unifoliata
Saxifrage Family (Saxifragaceae)

Flower: 5 tiny white thread-like petals in small clusters, nodding
Leaves: Spade-shaped, similar to maple leaves, with toothed margins
Blooms: July-August Height: 6-24" tall
Found in shade in deep woods and stream banks with lots of shade.
Photographed at Glacier Park.

LYALL'S PARROT'S BEAK; SICKLETOP LOUSEWORT
Pedicularis racemosa and var. alba
Snapdragon or Figwort Family (Scrophulariaceae*)

Flower: White, can also be cream to yellow, downturned beak
Leaves: Green and narrow and lance-shaped with toothed edges
Blooms: July-August Height: 6-12" tall
Found in high mountain meadows and on slopes. Plant parasitic on other close plants.
Note how these two differ in color of leaves.
skroff yew lay ri AY see ee

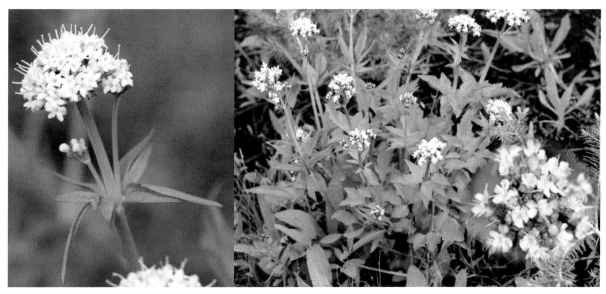

SHARP-LEAF VALERIAN
Valeriana acutiloba var. acutiloba
Valerian Family (Valerianaceae*)

Flower: White clusters (tinged with pink), 5 petals, pink-lavender buds turn white
Leaves: Opposite, pinnately divided into 3-9 lobes, usually have toothed edges
Blooms: June-August Height: 1-3' tall
Found in wet meadows, and open woods in the mid and upper elevations.
va leer I a NAY see ee

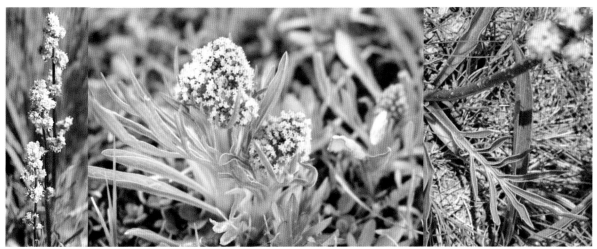

EDIBLE TOBACCO-ROOT; EDIBLE VALERIAN
Valeriana edulis
Valerian Family (Valerianaceae)

Flower: White-cream to almost lavender, irregular clusters, 5 fused petals
Leaves: Slender lance-like leaves, thick, reddish-brown stem
Blooms: May-June Height: 1-4' tall
Found in slightly dry sites to moist ones. These found near Stanley, Idaho.
Native Americans would bake the taproot for several days before eating them.

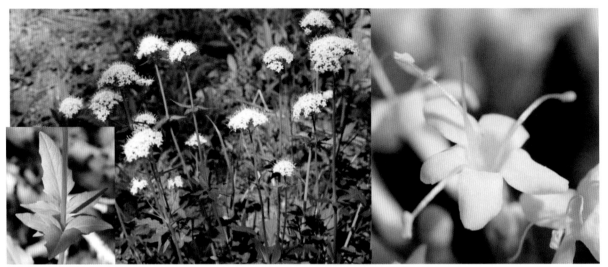

SITKA VALERIAN
Valeriana sitchensis
Valerian Family (Valerianaceae)

Flower: White clusters, 4 irregular tube-like petals, white anthers also pink
Leaves: Basal, opposite, 3 lobes
Blooms: June-July Height: 1-3' tall
Found in moist meadows and open woods in the mid and upper elevations.

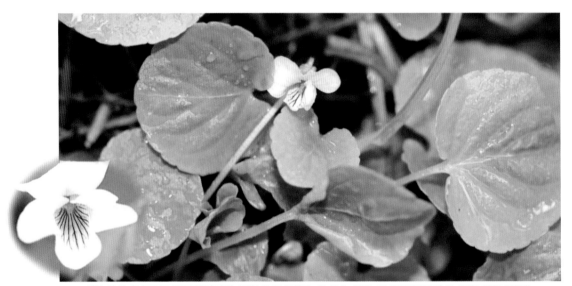

SMOOTH WHITE VIOLET; MACLOSKEY'S VIOLET
Viola macloskeyi var. pallens
Violet Family (Violaceae)

Flower: Single white at the end of stem, purple veins on the lower petal, which ends
in a short spur at the back
Leaves: Basal, kidney, round, or heart-shaped, shallow teeth along the edges
Blooms: April-May Height: 2-5" tall
Found in wet shady areas and along slow moving creeks.

PINK FLOWERS

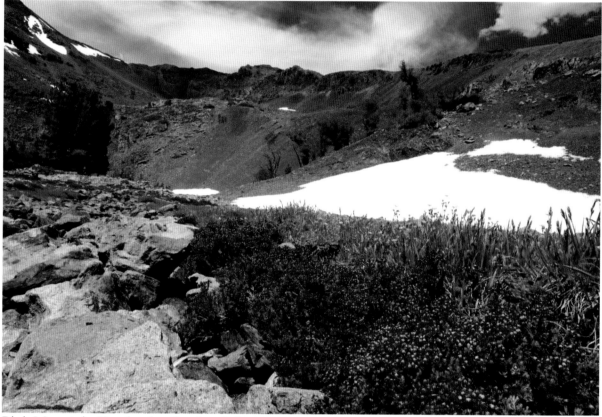

Pink Mountain Heather by *Stephen L Love.*

This section is for light pink to dark rose wildflowers and pink with white ones. A few could just have easily been placed in white.

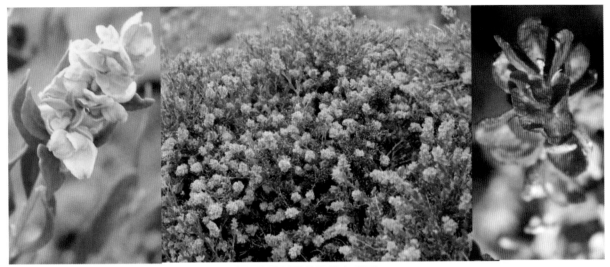

SPINY HOPSAGE
Grayia spinosa
Amaranth Family (Amaranthaceae*)

Flower: Small greenish clusters, turn to pink and rose, large shrub, purplish bracts
Leaves: Alternate, gray-green, spatula-shaped, fleshy
Blooms: May-June Height: up to 4' tall
Found in sagebrush flats.
am a ran THAY see ee

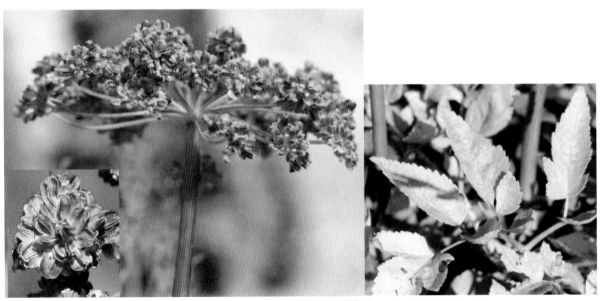

ROCK ANGELICA
Angelica roseana
Carrot or Parsley Family (Apiaceae)

Flower: Blooms white and turn pink-lavender, ball-shaped cluster of tiny flowers
Leaves: Pinnately divided into leaflets, lanceolate, toothed, on a tall, thick pink-red stem
Blooms: August-September
Found on open rocky slopes in high elevations.

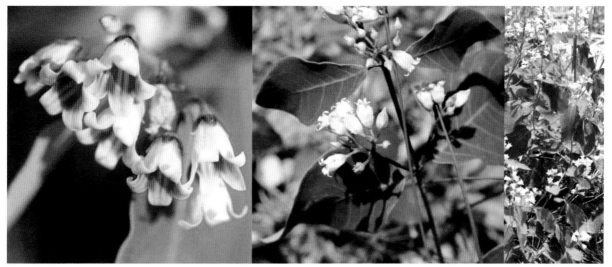

SPREADING DOGBANE
Apocynum androsaemifolium
Dogbane Family (Apocynaceae*)

Flower: Bell-shaped, 5 flaring white-pink lobes, inside thick pink stripes, nodding
Leaves: Large, opposite, oval to lance-like, dark green on top and lighter underneath, drooping
Blooms: Late June-August Height: up to 3' tall
Found in sandy and gravelly areas, in clearings, in forests, on dry hillsides and fields.
a poss i NAY see ee

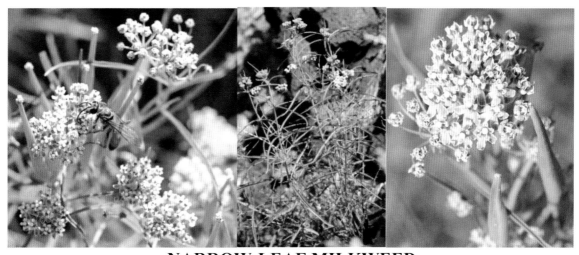

NARROW-LEAF MILKWEED
Asclepias fascicularis*
Milkweed Family (Asclepiadaceae*)

Flower: Clusters, creamy-pink, white, to greenish
Leaves: Narrow, long, lance-shaped, whorls of 3-5
Blooms: June-September Height: 20-36" tall
Found along roadsides, in dry climates, and plains.
*as KLEH pih as *as kleh pih a DAY see ee*

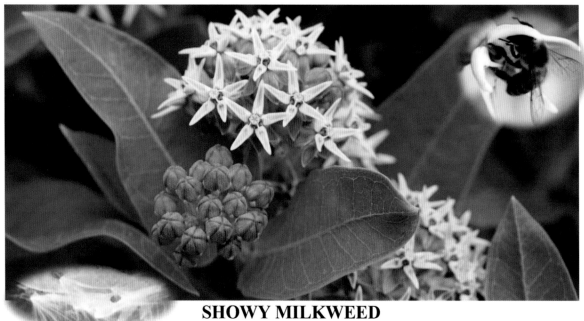

SHOWY MILKWEED
Asclepias speciosa
Milkweed Family (Asclepiadaceae)

Flower: Pink and cream-white in clusters, star-like
Leaves: Opposite, broadly lanceolate or ovate, conspicuous veins, hairy, milky sap
Blooms: June-August Height: 1-5' tall
Found on dry, gravelly slopes, sandy areas near streams and ditches and in open forests.
Plant is an important flower for Monarch butterflies.

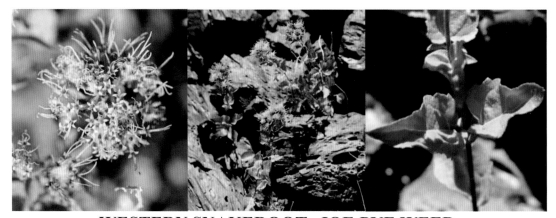

WESTERN SNAKEROOT; JOE PYE WEED
Ageratina occidentalis
Aster Family (Asteraceae)

Flower: Pink, purple or white clusters, showy flower heads, star-shaped
Leaves: Lance to triangular-shaped, pointed at the tip, toothed, deeply veined, opposite
Blooms: July-August Height: 5-24" tall
Found in opens sites from dry to moist from the plains to foothills to rocky areas.
Photographed at Craters of the Moon on the path going to the caves in July.
Name comes from old folklore that a Joe Pye used this plant to cure typhus fever.

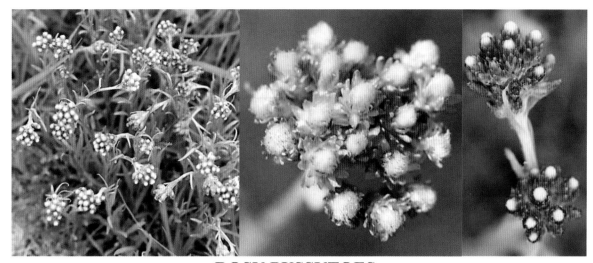

ROSY PUSSYTOES
Antennaria rosea
Aster Family (Asteraceae)

Flower: Small cluster of white and pink-rose flower heads, resemble the pads of a kitten's paw
Leaves: Basal, long, narrow
Blooms: June-July Height: 1-12" tall
Found in meadows and on rocky slopes, common in arid climates.

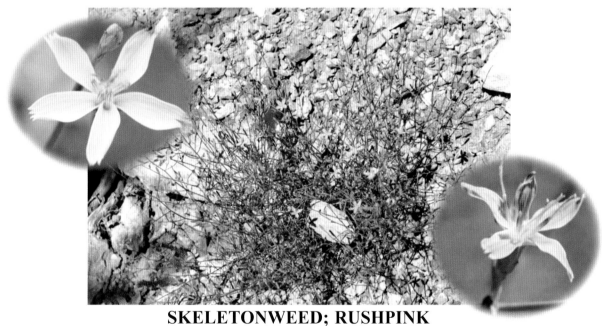

SKELETONWEED; RUSHPINK
Lygodesmia juncea
Aster Family (Asteraceae)

Flower: 5 petals, pink to lavender (rarely white), small teeth at the tip
Leaves: Stiff, linear, on spindly stems
Blooms: June-August Height: 6-14" tall
Found in dry valleys, gullies and on slopes, common.

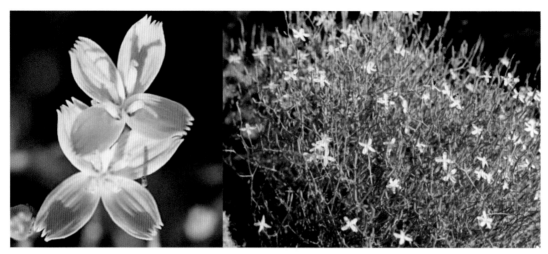

NARROW-LEAF WIRE-LETTUCE
Stephanomeria tenuifolia**
Family Aster (Asteraceae)

Flower: Pink, lavender or white with ray-like flowers, 4 toothed petals
Leaves: Narrow, thread-like
Blooms: July-August Height: up to 28" tall
Found in rocky places and on slopes.
**stef an oh MER ee a *ten yoo ih FOH lee uh*

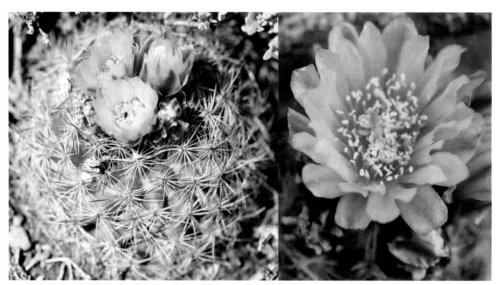

MOUNTAIN BALL CACTUS; SIMPSON'S CACTUS
Pediocactus simpsonii
Cactus Family (Cactaceae)

Flower: White to cream or very light pink with bright yellow centers, flower about 1" across, cactus up to about 6" wide
Spines: Small spines
Blooms: April-May in higher elevations Height: 3" tall
Found in dry areas near sagebrush. Because it is so small, it is easy to overlook. It is often hidden under other vegetation. During heavy winter snows, Antelope will eat the centers.

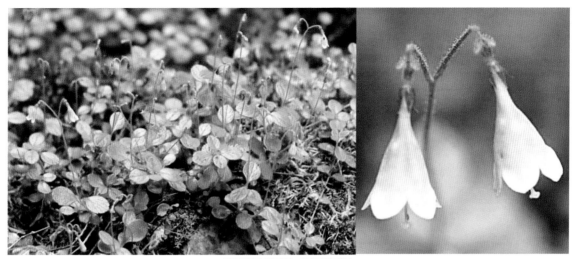

TWINFLOWER
Linnaea borealis*
Honeysuckle Family (Caprifoliaceae*)

Flower: Tiny, bell-shaped, 2 identical light pink-white flowers, nodding from a forked stem
Leaves: Opposite, basal, oval-shaped, shiny, fragrant
Blooms: June-August Height: 2-4" tall
Found in shady moist forests or along slow moving streams.
**lin NEE ah *kap rih foh lih AY see ee*

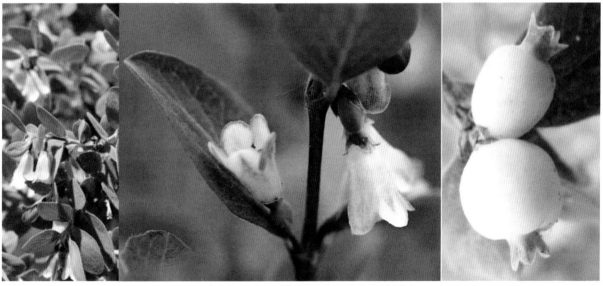

MOUNTAIN SNOWBERRY
Symphoricarpos oreophilus**
Honeysuckle Family (Caprifoliaceae)

Flower: Bowl-shaped tube of 5 pink-white petals, berries white to ivory, egg-shaped
Leaves: Opposite, oval, pale green
Blooms: May-August Height: up to 4½' tall
Found in moist to dry forests and shrub lands and pine forests, common.
**sim foh rih KAR pus *or ee oh FY lus*

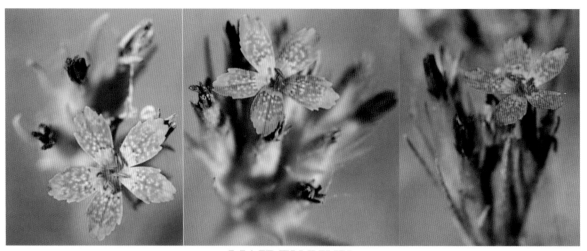

MAIDEN PINK
Dianthus deltoides
Carnation or Pink Family (Caryophyllaceae*)

Flower: 5 bright pink petals dotted with white, petal ends toothed, ring at center, fragrant
Leaves: Opposite, narrow
Blooms: June-July Height: 6-16" tall
Found along roadsides and in disturbed areas, **not native.**
carry oh fill AY see ee

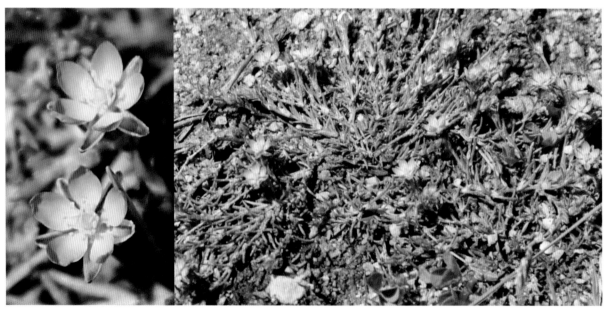

RED SANDSPURRY
Spergularia rubra*
Carnation or Pink Family (Caryophyllaceae)

Flower: 5 pink petals, light to dark, yellow anthers, hugs the ground
Leaves: Linear, fleshy, opposite
Blooms: May-August Height: 2-6" tall
Found in meadows and disturbed areas, **not native.**
sper guh LAY ree a

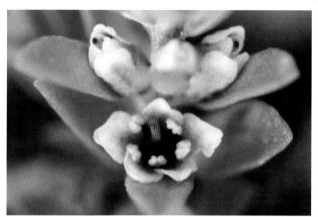

SOUTHWESTERN WATERWORT
Elatine rubella
Waterwort Family (Elatinaceae)

Flower: 5 tiny white and light to dark pink petals with yellow anthers
Leaves: Linear, oblong
Blooms: May-July Height: 3-6" tall
Found in mud or shallow water. These wildflowers seen near a tiny creek at Whiskey Springs in Custer County, Idaho. I went back two days later to retake pictures and no longer there. *Picture magnified.*

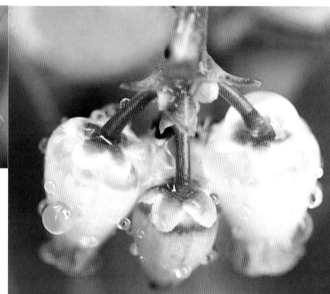

KINNIKINNICK; BEARBERRY
Arctostaphylos uva-ursi
Heath Family (Ericaceae)

Flower: Tiny, pink and white, urn-shaped, in compact clusters, nodding, flower under ¼" long
Leaves: Shiny, paddle-shaped to oblong, alternate, dark green
Blooms: May-June; red berry in July-August Height: 5-12" tall
Found in dry forests and in rocky soil in higher elevations. Fairly common but so low to the ground and such tiny flowers that the plant is often overlooked.

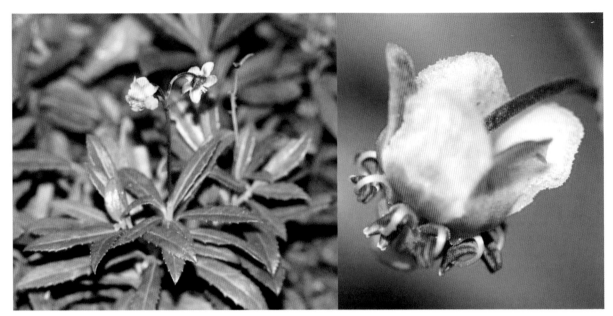

PRINCE'S PINE; PIPSISSEWA
Chimaphila umbellata*
Heath Family (Ericaceae)

Flower: Pinkish to white, nodding, 5 spreading petals, very small, bell-shaped, waxy
Leaves: Glossy, dark green, lance-shaped, toothed, mostly in whorls
Blooms: July-August Height: 2-10" tall
Found in shady woods and on alpine slopes.
**ky MAF fill ah*

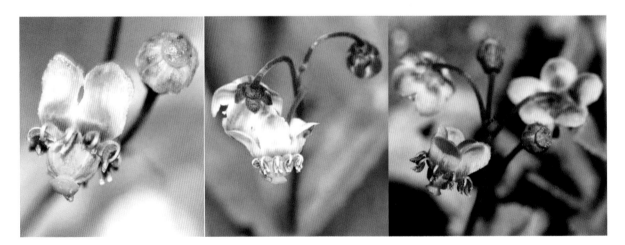

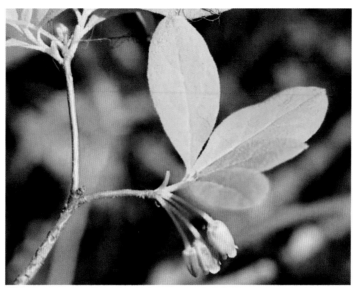

FOOLS' HUCKLEBERRY; FALZE AZELIA; RUSTY MENZIESIA
Menziesia ferruginea
Heath Family (Ericaceae)

Flower: Vase-shaped flowers ranging in color from red-rust to yellowish to pink to bronze.
Leaves: Oval, has a skunky smell
Blooms: June to August Height: 3-8' tall
Found in wooded areas.

PINEDROPS
Pterospora andromedea
Heath Family (Ericaceae)

Flower: Urn-shaped in shades of red, brown and yellow, 5 "petals" in a fused tube
Leaves: Stalk covered with sticky hairs, plant has no chlorophyll
Blooms: Late June-July Height: 1-3' tall
Found in coniferous forests and mixed ones; parasitic and survives on dead and decaying plants.
Top left picture by *Callie Russell.*

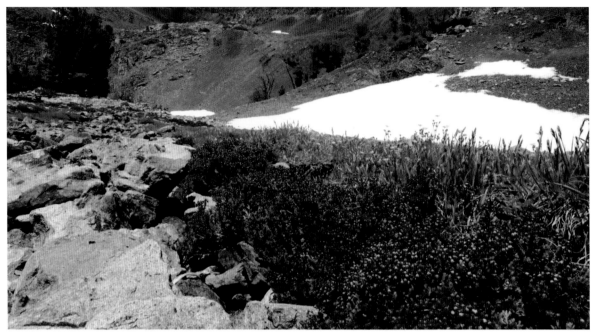

PINK MOUNTAINHEATH; PINK MOUNTAIN HEATHER
Phyllodoce empetriformis
Heath Family (Ericaceae)

Flower: Pink-rose, bell-shaped, 5 lobes roll outward, wide mats
Leaves: Needle-like, resemble fir needles, alternate, dark green
Blooms: July-August Height: 4-16" tall
Found on mountain slopes, in seeps and meadows.
Top picture by *Stephen L. Love,* bottom pictures by *Callie Russell.*

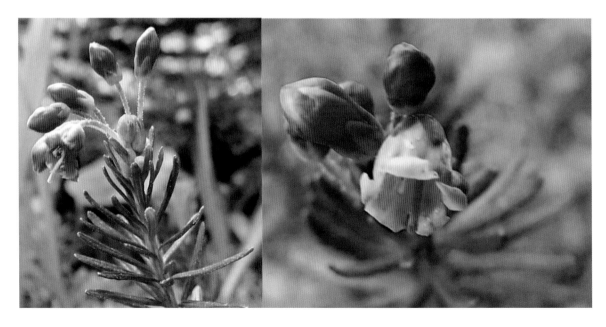

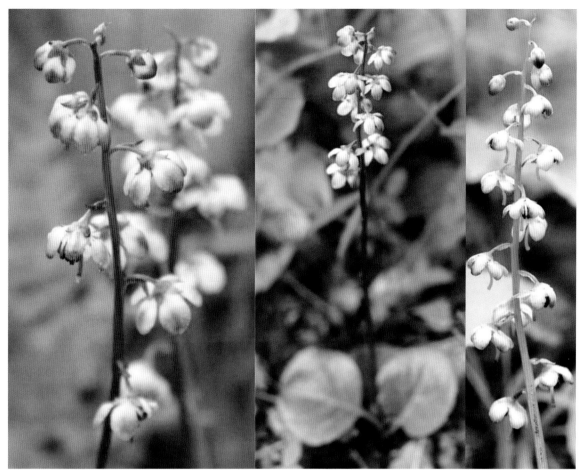

PINK WINTERGREEN; PINK SHINLEAF
Pyrola asarifolia
Heath Family (Ericaceae)

Flower: Pink and white round petals, very small, edges curled down, waxy, nodding
Leaves: Basal, round, glossy
Blooms: Late June-July Height: flower stalk to 6-14" tall
Found in bogs, woods, swamps, shaded forests.
These Wintergreen plants were in the Pyrola Family.

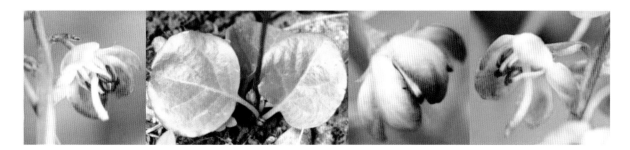

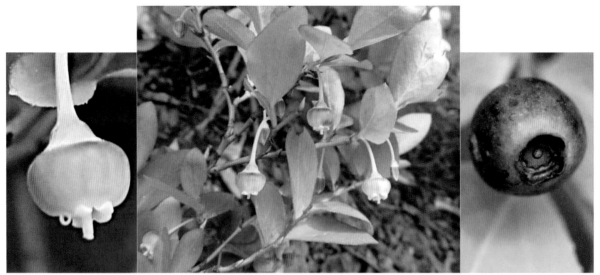

BIG HUCKLEBERRY; THINLEAF HUCKLEBERRY
Vaccinium membranaceum
Heath Family (Ericaceae)

Flower: Tiny, urn-shaped, pink to yellowish green
Leaves: Lance-shaped, edges finely toothed, alternate
Blooms: May-June Berries: July-August Height: 2-6' tall
Found in moist to dry forests; often seen where Beargrass is growing.

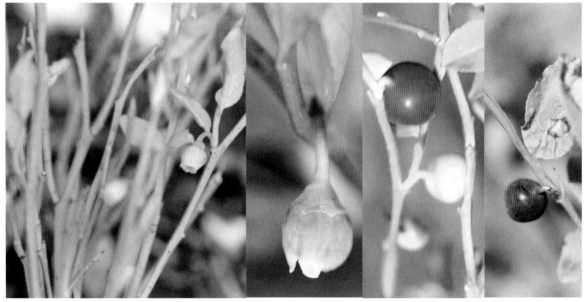

GROUSEBERRY; GROUSE HUCKLEBERRY; WHORTLEBERRY
Vaccinium scoparium
Heath Family (Ericaceae)

Flower: Tiny, pink, urn-shaped, solitary on broom-like stems
Leaves: Oval or lance-shaped, finely toothed
Blooms: May-June Berries: late July-August Height: 4-18" tall
Found in forests in the higher elevations, very tiny so easy to overlook.

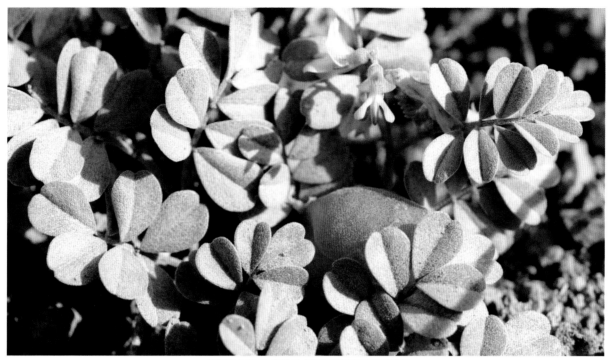

CHALLIS MILKVETCH
Astragalus amblytropis
Pea, Bean, or Legume Family (Fabaceae)

Flower: Very tiny, less than the size of a fingernail, white-cream petals with lavender-purple
or reddish markings and veins, the beak-like tip is lavender-purple, large pods are rose-pink
and then white
Leaves: Gray-green and hairy, 9-13 oval leaflets, hugs the ground
Blooms: July Height: 2-8" tall
Found near Challis, Custer County, Idaho, **rare.** This was found about 1½ miles up Bayhorse
on a dry hillside. It is often associated with volcanic ash deposits. Flowers below enlarged;
note how tiny the flower is in top picture, also notice the two colors of the flowers below
that are enlarged.

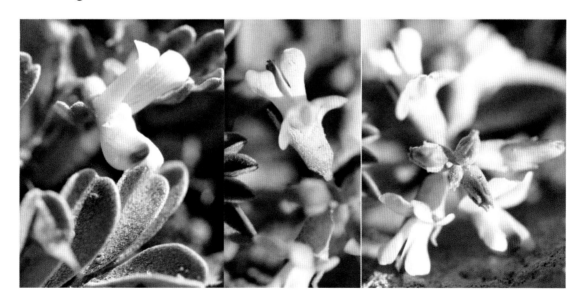

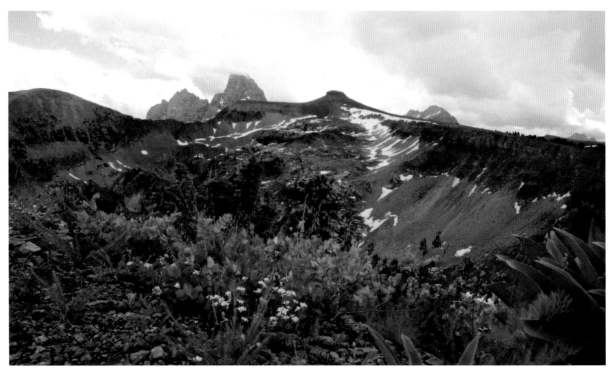

NORTHERN SWEETVETCH
Hedysarum boreale
Pea, Bean, or Legume Family (Fabaceae)

Flower: Pink, magenta, lavender pea-like clusters on tall stems, hang down,
the keel has a right-angle bend, irregular shape
Leaves: Opposite, leaflets (7-15), pinnately divided
Blooms: June-July Height: 12-24" tall
Found on sagebrush flats, dry hillsides, slopes, and open wastelands.
Top picture by *Stephen L. Love.*

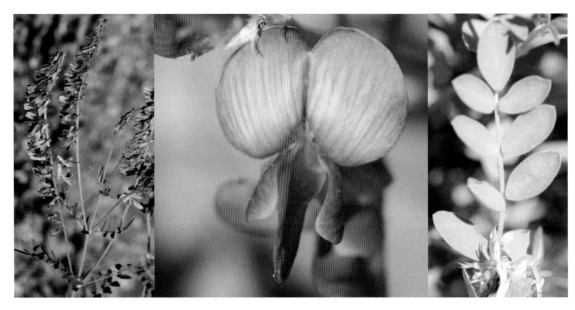

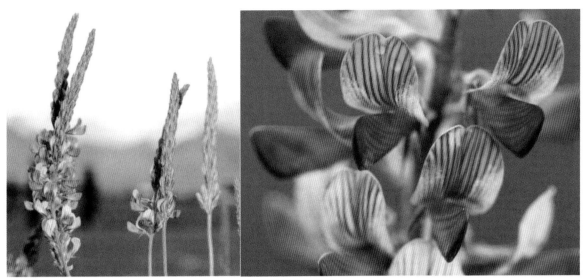

SAINFOIN
Onobryhis viciifolia
Pea, Bean, or Legume Family (Fabaceae)

Flower: Pink and showy, stripped, prominent veins, on a spike
Leaves: Feathery and small
Blooms: July-August Height: 12-30" tall
Found in fields and on hillsides under cultivation and a few scattered here and there along roadsides. This forage crop reduces the number of parasites in the guts of goats and sheep. "Blessed hay," **not native.** Pictures by *Callie Russell.*

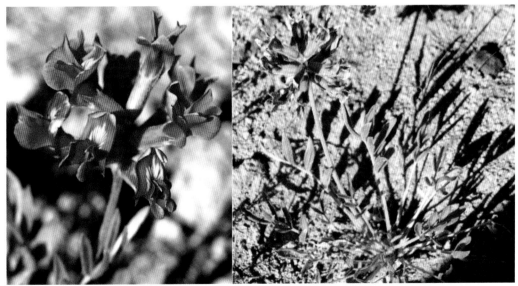

BESSEY'S LOCOWEED; CHALLIS CRAZYWEED
Oxytropis besseyi var. salmonensis
Pea, Bean, or Legume Family (Fabaceae)

Flower: Bright pink to purplish with white on the upper lip, striped near throat
Leaves: Furry, light gray-green, lanceolate, odd-pinnate, mostly basal
Blooms: May Height: 12-30" tall
Found in dry mountain valleys such as Malm Gulch near Challis, Custer County, **rare.**

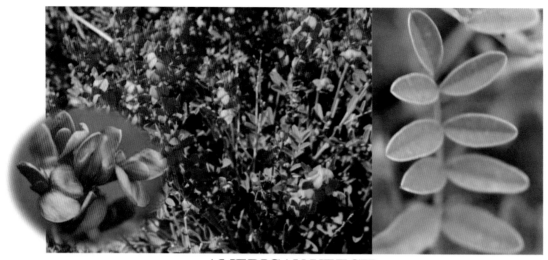

AMERICAN VETCH
Vicia americana
Pea, Bean, or Legume Family (Fabaceae)

Flower: Light to bright pink to light lavender, pea-like
Leaves: Ladder-like, 8-12 leaflets, coiling tendrils
Blooms: May-June Height: vines up to 4' tall
Found in open woods, dry gulches after the snow melts.

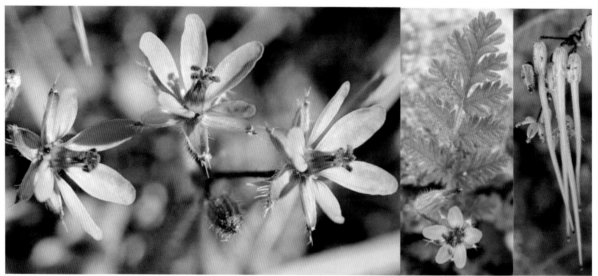

CRANE'S BILL; FILAREE; STORK'S BILL
Erodium cicutarium*
Geranium Family (Geraniaceae*)

Flowers: 5 petals, pinkish to violet, small loose clusters, darker pink veins
Leaves: Fem-like, oval, basal, weak red stem
Blooms: May-August Height: up to 12" tall
Found on desert flats, plains, sandy fields and along irrigation ditches, common, **not native.**
Top left picture by *Skylee Russell.*
**eh ROH dee uhm *ger ray nee AY see ee*

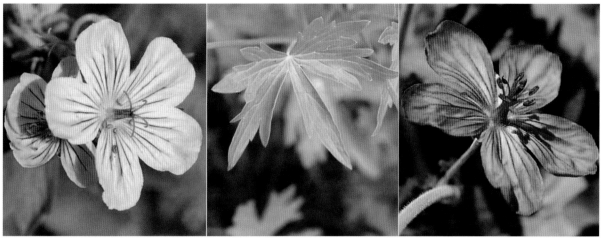

STICKY GERANIUM
Geranium viscosissimum
Geranium Family (Geraniaceae)

Flower: 5 petals that are pink to rose-purple with darker pinkish to purple veins
Leaves: Basal, 5-7 lobes that are toothed, sticky, hairy stems
Blooms: May-August Height: 1-3' tall
Found in meadows and open forests, common.

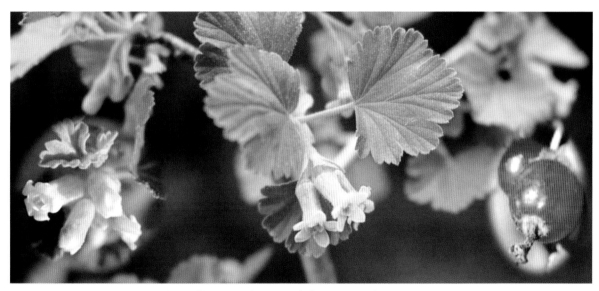

WAX CURRANT; SQUAW CURRANT
Ribes cereum*
Currant Family (Grossulariaceae)

Flower: White to pink, tubular, sticky
Leaves: 3-5 lobes, light green, hairy, deeply veined, red berry round and smooth
Blooms: May-July Berries: August Height: 1-5' tall
Found in open woods, sunny hills, and mountain meadows, very common. Berries are high in protein and Native Americans used them when making Pemmican, a mixture of fat and protein.
RYE beez

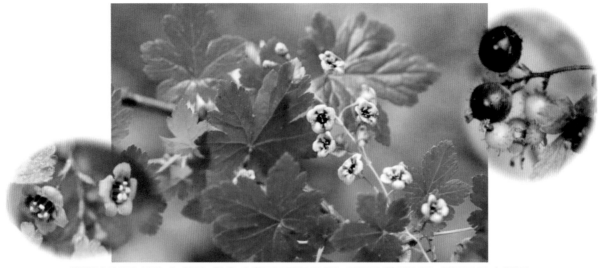

SWAMP BLACK GOOSEBERRY; PRICKLY CURRANT
Ribes lacustre
Currant Family (Grossulariaceae)

Flower: Saucer-shaped, reddish and cream, as it ages the color becomes purplish
Leaves: 3-5 lobes, bark reddish-brown, smooth and shiny, purplish hairy berries
Blooms: May-July Berries: August Height: 2-4' tall
Found in open woods, rocky bluffs, and high mountain meadows.

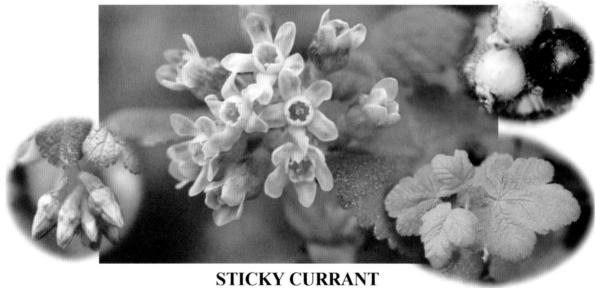

STICKY CURRANT
Ribes viscosissimum
Currant Family (Grossulariaceae)

Flower: Bell-shaped, greenish-white to cream often tinged with pink, hanging clusters
Leaves: Maple-like, dark green with soft, sticky hairs, 3-5 toothed lobes
Blooms: May-July Berries: late July-August Height: up to 6' tall
Found on hillsides and in valley, this was seen last of May on the road near the old town
of Bayhorse in Custer County, Idaho. Meriweather Lewis found this plant on June 6, 1806.

CUSICK'S GIANT HYSSOP; CUSICK'S HORSEMINT
Agastache * *cusickii*
Mint or Deadnettle Family (Lamiaceae*)

Flower: Numerous small white flowers, surrounded by light to medium dark pinkish-purple bracts form a terminal spike
Leaves: Up to 1" long, triangular blades with a long petiole, covered in fine short hairs
Blooms: June and July Height: 4-10" tall
Found primarily on open, stony talus slopes. Photographs from the Iron Bog Creek area of the Pioneer Mountains. Description and pictures by *Stephen L. Love.*
*ah gas TAH kee *lay me AY see ee

HORSEMINT; NETTLELEAF GIANT HYSSOP
Agastache urticifolia *
Mint or Deadnettle Family (Lamiaceae*)

Flower: Pink, white-lavender, clustered on a spike
Leaves: Opposite, triangular-shaped, toothed margins, deeply veined, on square stems
Blooms: June-August Height: 1-4' tall
Found in valleys, open slopes and along roadsides, common.
*ur tek ih FOH lee uh

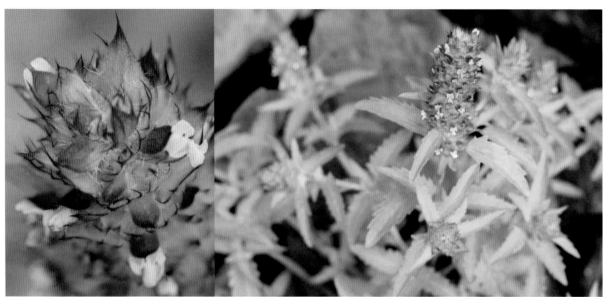

AMERICAN DRAGON HEAD
Dracocephalum parviflorum
Mint or Deadnettle Family (Lamiaceae)

Flower: Tiny, tubular, notched upper lip, light pink to rose and also purplish and light blue
Leaves: Toothed with sharp tips, opposite, stems square
Blooms: July-August Height: 8-28" tall
Found in open, often weedy areas.

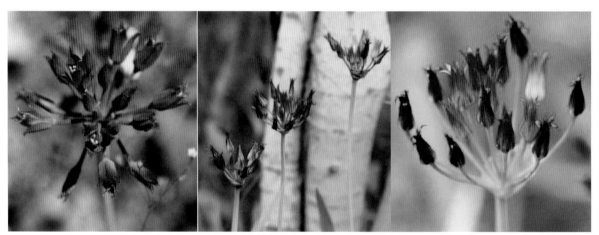

TAPERTIP ONION; HOOKER'S ONION
Allium acuminatum
Lily Family (Liliaceae)

Flower: Deep rose to pink, clusters of from 7-15 flowers
Leaves: Thin, narrow, grass-like, distinctive smell
Blooms: June-July Height: 4-14" tall
Found in moist meadows and on dry hillsides.

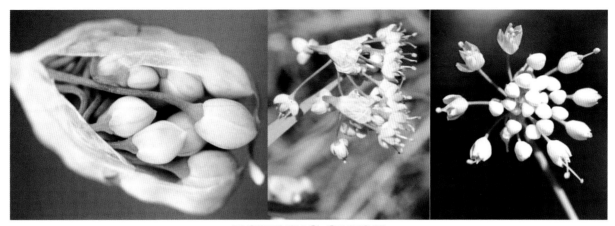

NODDING ONION
Allium cernuum
Lily Family (Liliaceae)

Flower: Pink-white on a long stalk that is bent at the top, bell-shaped, in clusters
Leaves: Basal, grass-like, shiny, onion smell
Blooms: June-August Height: 8-20" tall
Found in moist woods, valleys and on grassy slopes.
Pictures by *Eric Russell.*

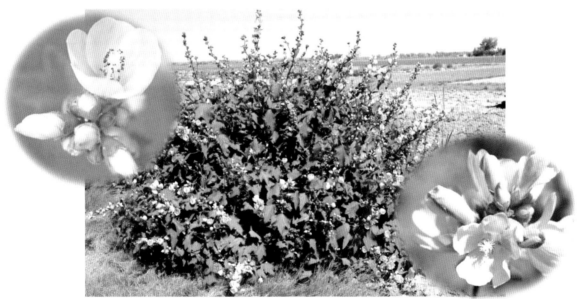

MOUNTAIN HOLLYHOCK; STREAMBANK WILD HOLLYHOCK
Iliamna rivularis
Mallow Family (Malvaceae*)

Flower: 5 large, pink to lavender petals, flowers loosely clustered on top of a tall plant
Leaves: Large with toothed edges, shaped like a maple leaf
Blooms: June-August Height: 2-6' tall
Found in moist disturbed areas, open meadows, dry hillsides, canyons, along mountain streams.
Middle picture by *Stephen L. Love.*
**mal VAY see ee*

FIREWEED
Chamerion angustifolium
Evening Primrose Family (Onagraceae)

Flower: Showy pink-lavender, rose, saucer-shaped, 4 rounded petals, clustered on a tall spike
Leaves: Long, narrow, lance-shaped, pale beneath, prominent veins, alternate
Blooms: June-September Height: 2-6' tall
Found on forest edges, in open woodlands and in disturbed areas especially in moist areas where there has been a forest fire, common. Fireweed is high in vitamins A and C.

DIAMOND CLARKIA; FOREST CLARKIA
Clarkia rhomboidea
Evening Primrose Family (Onagraceae)

Flower: 4 bright pink to lavender petals sometimes specked with darker pink shade, diamond-shaped to spoon-shaped, flower hangs down
Leaves: Alternate, lance to egg-shaped
Blooms: May-June Height: 8-22" tall
Found in open woods and shrub lands. Pictures by *Gwen Russell.*

TALL ANNUAL WILLOWHERB
Epilobium brachycarpum
Evening Primrose Family (Onagraceae)

Flower: White-pink with 4 deeply notched petals on spindly stems
Leaves: Long, narrow, opposite
Blooms: July-August Height: 1-6' tall
Found along mountain streams and in drier areas also.

FRINGED WILLOWHERB
Epilobium ciliatum var. glandulosum
Evening Primrose Family (Onagraceae)

Flower: Pink to white to lavender with 4 notched petals, darker veins on petals, bell-shaped
Leaves: Narrow, opposite, teeth along the leaf margins
Blooms: July-August Height: up to 2' tall
Found easily along creeks and streams in cool mountain areas, common.

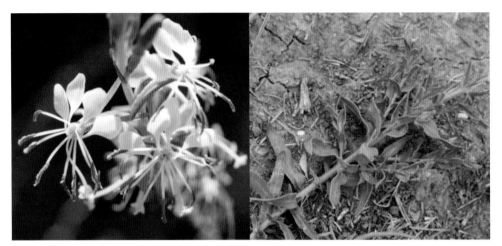

SCARLET BEEBLOSSUM; BUTTERFLY-WEED
Gaura coccinea*
Evening Primrose Family (Onagraceae)

Flower: White to reddish-pink, lighter in the evening and darker at mid-morning, irregular-shaped blossoms may have a dozen flowers or more on a nodding spike, long anthers, 4 petals
Leaves: Lance-shaped, light green, irregular spaced teeth, stiff hairs
Blooms: April-July Height: 8-24" tall
Found in fields, dry, open slopes, pine and juniper woodlands and along roadsides.
Also known as *Oenothera suffrutescens.*
GAUrah

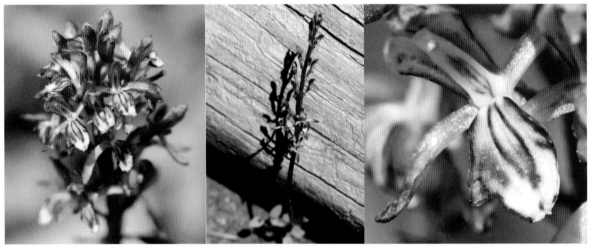

STRIPED CORALROOT
Corallorhiza striata*
Orchid Family (Orchidaceae)

Flower: Striped lower petal is mostly purple or dark pink, the upper petals being brownish
with red to purple veins
Leaves: Sheaths on the lower part of the stem, nearly leafless
Blooms: Late May-July Height: 6-20" tall
Found near stream banks, in swampy areas, and deep shady areas. Photographed in a forested
area near the river along the Lolo Trail in middle of June. There is a spotted version, *maculate.*
kor al loh RIZ ah

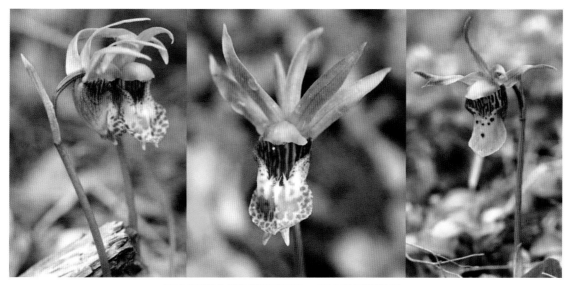

FAIRY SLIPPER; CALYPSO
Calypso bulbosa
Orchid Family (Orchidaceae*)

Flower: Unusual tiny rose-pink and white flower with reddish dots and stripes and white hairs, slipper-shaped, solitary
Leaves: Basal, egg-shaped
Blooms: May-June Height: about 2-6" tall
Found along streams, deep shaded forests and in bogs.
This rare plant should never be picked.
**or kid DAY see ee*

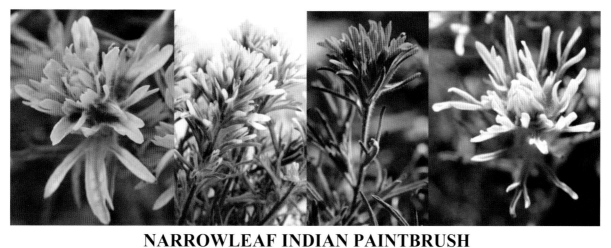

NARROWLEAF INDIAN PAINTBRUSH
Castilleja angustifolia
Broomrape Family (Orobanchaceae)

Flower: Varies in color: yellow, cream, pink, rose, peach
Leaves: Lower leaves are narrow and long, upper leaves and bracts divide into segments, stem is red-wine
Blooms: May-June Height: 4-16" tall
Found easily in the sagebrush areas, foothills, canyons, semi-desert.

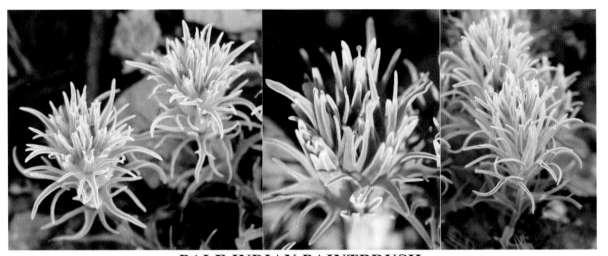

PALE INDIAN PAINTBRUSH
Castilleja pallescens var. inverta*
Broomrape Family (Orobanchaceae*)

Flower: Green to yellowish flowers, with streaks of pink, torch-like
Leaves: Linear
Blooms: May-June Height: 6-18" tall
Found in semi-arid areas.
**kas tee LEE uh *or oh ban kee AY see ee*

ALPINE INDIAN PAINTBRUSH; ROSY PAINTBRUSH
Castilleja rhexifolia
Broomrape Family (Orobanchaceae)

Flower: Red to dark or rose pink, tube-shaped and 2-lipped
Leaves: Lance-shaped, alternate, deeply veined, lower leaves can be red-tinted
Blooms: July-September Height: 5-24" tall
Found in the wooded areas and meadows in higher elevations. Plant is partially parasitic.

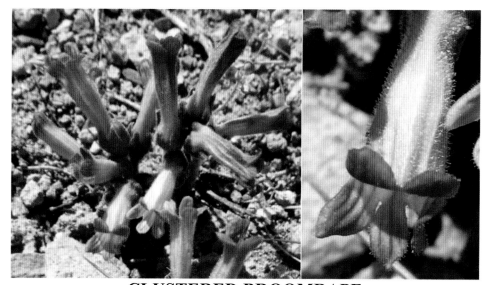

CLUSTERED BROOMRAPE
Orobanche fasciculata
Broomrape Family (Orobanchaceae)

Flower: Pink-purplish tinged flowers in the form of a funnel, sometimes yellowish
Blooms: June-July Height: 2-8" tall
Leaves: No leaves, parasitic on roots of other plants especially sagebrush and buckwheat
Found on prairies, plains, slopes and even near ditches.

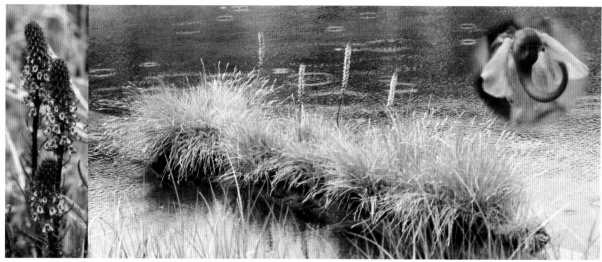

ELEPHANT'S HEAD
Pedicularis groenlandica
Broomrape Family (Orobanchaceae)

Flower: Resembles the head and trunk of tiny pink elephant, flowers on a spike
Leaves: Fern-like, feathery, alternate
Blooms: June-August Height: 6-24" tall
Found along steam banks and in moist meadows.

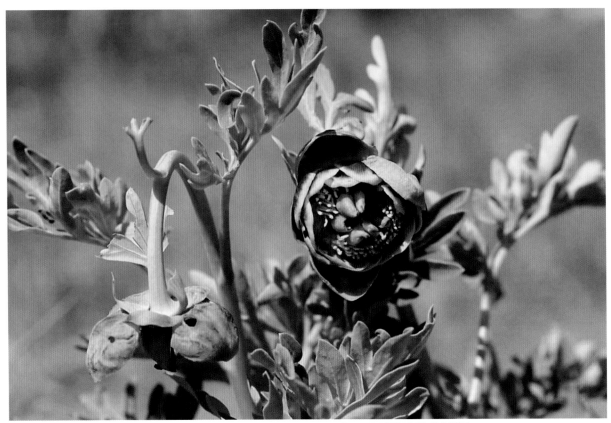

WESTERN PEONY; BROWN'S PEONY
Paeonia brownii
Peony Family (Paeoniaceae)

Flower: Single flower, thick curved stems, rust-red petals tinged with green, light yellow edges, a camouflage pattern, thus hard to notice the first time one sees the plant; picture on bottom right shows what one would see when walking on a trail. Turning it up to look inside, one sees 5 to 6 light green cup-shaped sepals—see picture on bottom left.
Leaves: Light green, alternate, 3 segments deeply toothed
Blooms: May-June Height: 8-24" tall
Found in sagebrush country and open forests.
Photographed at Adam's Gulch near Ketchum, Blaine County, Idaho, on June 3.

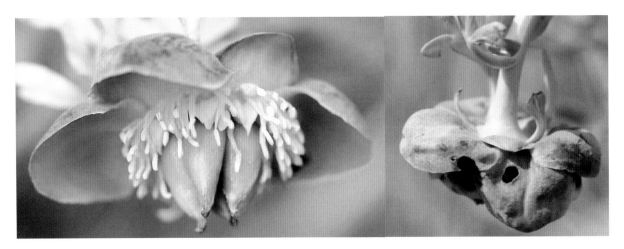

CUSICK'S MONKEYFLOWER
Mimulus cusickii (Diplacus cusickii)
Lopseed Family (Phrymaceae)

Flower: Large in comparison to the diminutive size of the plants (about ½" long), sticky-hairy on the outside, tubular with large lobes and gaping mouth, dark pink with yellow bands in the throat
Leaves: Oblong to ovate in shape with sharply tapered tips, sticky-hairy usually with soil particles adhering to the surface, 1-3" long
Blooms: May into August Height: up to 10" tall but usually much shorter
Found on somewhat bare and sterile slopes and side hills or low vernally damp areas, often growing in pebbly or gritty soils. Photographs from Succor Creek area in Oregon, near the Idaho border. Description and pictures by *Stephen L. Love.*

LEWIS' MONKEYFLOWER; GREAT PURPLE MONKEY-FLOWER
Mimulus lewisii
Lopseed Family (Phrymaceae)

Flower: Bright pink-rose and white, tubular, hairy throat with red spots and yellow lines
Leaves: Egg- or lance-shaped, usually toothed, prominent veins
Blooms: Late June-August Height: 12-48" tall
Found near streams and seeps usually in the mountains, common.
White version on right is a mutant found at Wildhorse in Custer County, Idaho.

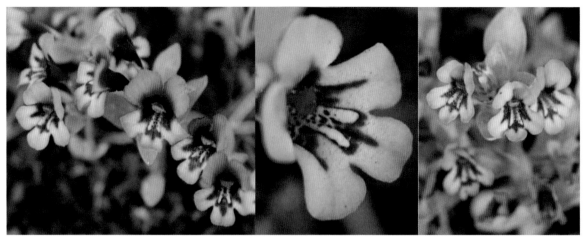

DWARF PURPLE MONKEYFLOWER
Mimulus nanus
Lopseed Family (Phrymaceae)

Flower: Tiny, tubular-shaped, pink to magenta with pink splotches and prominent spotted yellow anthers in the throat
Leaves: Long, untoothed, oval with rounded tips
Blooms: May-early June Height: ½-4" tall
Found in shrub lands, dry, sandy areas, open woods, slopes.
Easily found at the Craters of the Moon in May.

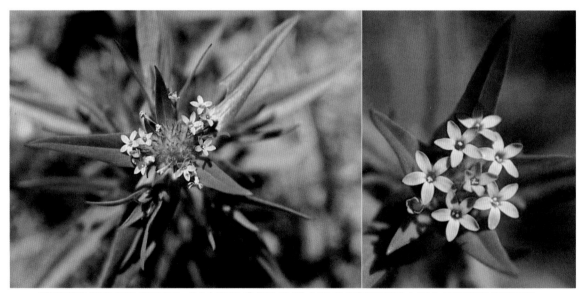

TINY TRUMPET; NARROW-LEAF MOUNTAIN-TRUMPET
Collomia linearis
Phlox Family (Polemoniaceae)

Flower: 5 small pink-lavender petals, star-shaped
Leaves: Narrow, lance-shaped, tapered
Blooms: June-July Height: up to 15" tall
Found from the lowlands of the valleys to moderate dry elevations in the mountains, common.

SLENDER PHLOX; MIDGET PHLOX; GRACEFUL PHLOX
Microsteris gracilis
Phlox Family (Polemoniaceae)

Flower: 5 tiny, notched petals that are white, pink, or lavender with a yellow throat
Leaves: Narrow, basal that turn red, red stem, opposite
Blooms: May-June Height: 2-8" tall
Found in open dry to moist areas.

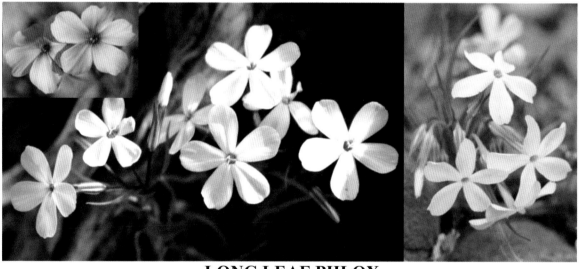

LONG LEAF PHLOX
Phlox longifolia
Phlox Family (Polemoniaceae)

Flower: 5 petals white, pink to lavender with long lobes, bud is streaked green and white
Leaves: Narrow, can be sticky, sweet scented, opposite
Blooms: April-July Height: up to 18" tall
Found in open fields, meadows and sage scrub, very common. *Longifolia* means long leaf.

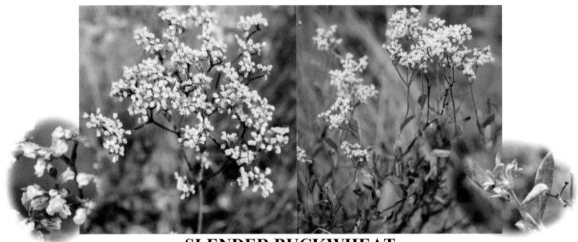

SLENDER BUCKWHEAT
Eriogonum microthecum
Buckwheat, Knotweed or Smartweed Family (Polygonaceae)

Flower: Tiny, white-pink, rose, orange-pale yellow, and sometimes cream flowers, flat topped
Leaves: Alternate, linear to elliptic, narrow, may be folded downward, hairy, stems and branches becomes woody as it matures
Blooms: July-August Height: 1-5' tall
Found in dry areas, shrub lands and sagebrush flats. Plant is variable according to where found. These were found on White Knob in Custer County, all close to or next to sagebrush.

OVAL-LEAF BUCKWHEAT - depressum variety
Eriogonum ovalifolium var. depressum
Buckwheat, Knotweed or Smartweed Family (Polygonaceae)

Note: The three variations of ovalifolium are being kept together instead of being separated by color.

Flower: Head-shaped cluster of extremely tiny flowers at the ends of decumbent, unbranched stems, flower's color ranges from cream to shades of pink to dark red
Leaves: All basal, upward angled, small, spoon-shaped, up to ½" long, fuzzy and silver-green in color
Blooms: June into July Height: less than 3" tall
Found at high elevation sites with shallow, gravelly soil including rocky slopes and ridges and cliffs. Photographs from Iron Bog Creek in the Pioneer Mountains, Seven Devils Peaks, and Sawtell Peak. Description and pictures by *Stephen L. Love.*

OVAL-LEAF BUCKWHEAT-ovalifolium variety
Eriogonum ovalifolium var. ovalifolium
Buckwheat, Knotweed or Smartweed Family (Polygonaceae)

Flower: Capitate heads of extremely tiny flowers grow at the top of stiff, unbranched stems, flowers are medium to dark yellow in color
Leaves: All basal, upward angled, small, spoon-shaped, up to 1" long, fuzzy and gray-green or silver-green in color
Blooms: June into July Height: 8-12" tall
Found on sagebrush flats, soil-less lava fields, and dry rocky slopes and ridges.
Photographs were taken at Craters of the Moon and east of Bear Lake.
Description and pictures by *Stephen L. Love.*

OVAL-LEAF BUCKWHEAT-purpureum variety
Eriogonum ovalifolium var. purpureum
Buckwheat, Knotweed or Smartweed Family (Polygonaceae)

Flower: Head-shaped cluster of extremely tiny flowers grow at the top of stiff, unbranched stems, flowers range in color from buff to light purplish red.
Leaves: All basal, upward angled, small, spoon-shaped, up to 1" long, fuzzy and silver-green or blue-green in color
Blooms: June into July Height: 8-12" tall
Found on sagebrush flats and dry rocky slopes and ridges. Photographed in the Hamer area and near Iron Bog Creek in the Pioneer Mountains. Description and pictures by *Stephen L. Love.*

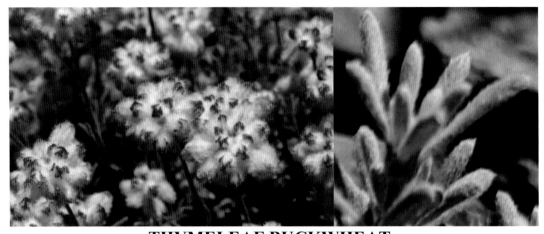

THYMELEAF BUCKWHEAT
Eriogonum thymoides
Knotweed or Smartweed Family (Polygonaceae)

Flower: Many tiny flowers grow in spherical heads, cottony, overall color is white, although the flowers are fringed in pink giving the heads a candy cane appearance
Leaves: Hairy, tiny, less than ½" long
Blooms: May-June Height: 4-6" tall
Found in very dry, rocky habitats in shallow soils. Most other plants have a difficult time growing where Thymeleaf Buckwheat thrives. Photographed near Gooding, City of Rocks in the Bennett Hills of south-central Idaho. Description and pictures by *Stephen L. Love.*

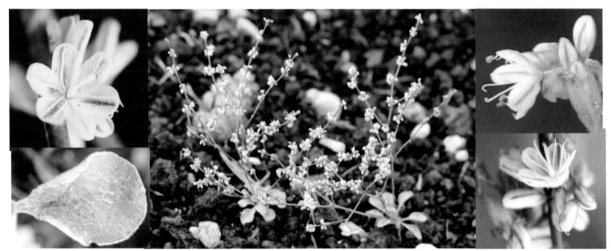

WICKERSTEM BUCKWHEAT; BROOM BUCKWHEAT
Eriogonum vimineum var. vimineum
Knotweed or Smartweed Family (Polygonaceae)

Flower: 6 tiny white to pink petals, darker pink-rose lines on the back and pink-rose veins through the center of each petal, thin branched stems
Leaves: Basal, oval to round, hairy
Blooms June-August Height: up to 12" tall
Found in rocky soils and in dry, harsh environments such as those at the Craters of the Moon where this was blooming the middle of August.

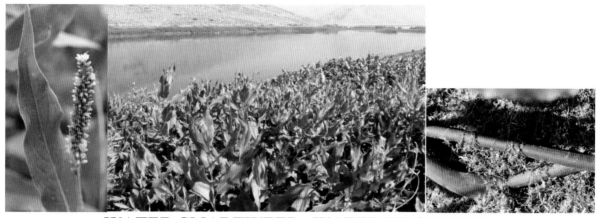

WATER SMARTWEED; WATER KNOTWEED
Persicaria amphibia
Buckwheat, Knotweed or Smartweed Family (Polygonaceae)

Flower: Clusters of light to bright pink, 5 petals-sepals on a long slender spike
Leaves: Large, lance-shaped, leathery, often floating, alternate, can be 8" long
Blooms: July-September Height: 1-3' tall
Found in bogs, near large ponds, in shallow water.
See on the right: large exposed roots after the water has dried up.

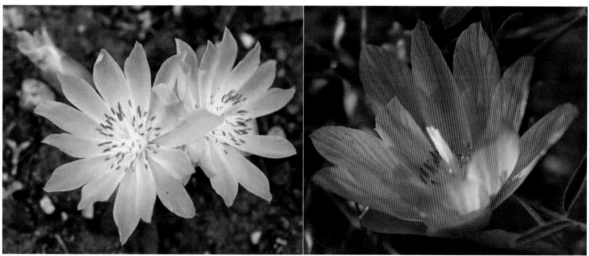

BITTERROOT
Lewisia rediviva
Purslane Family (Portulacaceae)

Flower: Showy, light pink, rose or white, 12-18 petals
Leaves: Basal, linear, growing close to the ground, succulent
Blooms: May-July Height: about 2-3" tall
Found in sagebrush plains, on dry exposed slopes and foothills of mountains.
This is the state flower of Montana. Crater of the Moon has white ones. Notice drying one
on right with seed pods.

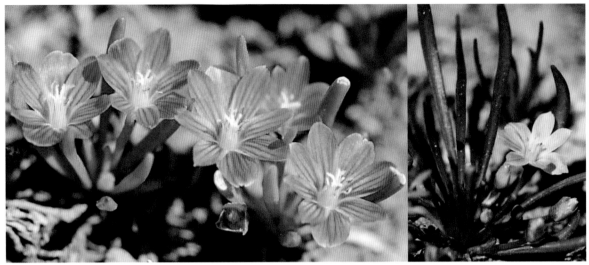

PYGMY BITTERROOT
Lewisia pygmaea
Purslane Family (Portulacaceae)

Flower: White, pink or purple, 5 to 9 petals with dark veins, saucer-shaped
Leaves: Linear, dark green, upright, basal
Blooms: May-July Height: up to 4" tall
Found in moist mountain meadows as the snow is melting or has melted. Flowers found near Little Bayhorse Lake, and Doublesprings Pass in Custer County.

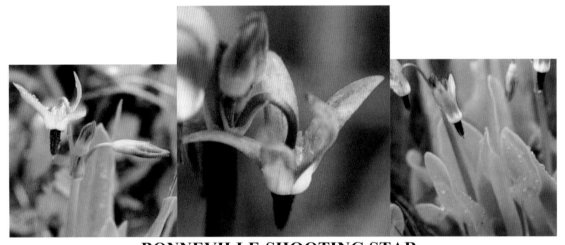

BONNEVILLE SHOOTING STAR
Dodecatheon conjugens*
Primrose Family (Primulaceae*)

Flower: 5 petals that can be magenta, lavender, pink or white, swept back with a strip of white, base yellow, and then maroon-black sharp-pointed tip
Leaves: Basal up to 6" long, egg-shaped to narrow
Blooms: May-June Height: 3-12" tall
Found as the snow is melting in wet meadows and along stream banks.
These Shooting Stars photographed along the Lolo Trail, near Packer's Meadow.
*doh dek ATH ee on *prim you LAY see ee

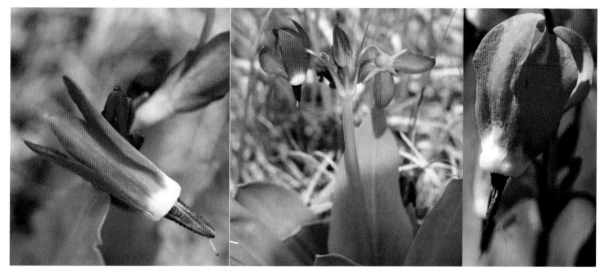

JEFFREY'S SHOOTING STAR; TALL MOUNTAIN SHOOTING STAR
Dodecatheon jeffreyi
Primrose Family (Primulaceae)

Flower: 5 bright pink or fuchsia petals swept back with a strip of white and then a yellow ring with a black sharp-pointed tip
Leaves: Smooth large basal leaves
Blooms: May-June Height: 6-24" tall
Found in wet meadows, along stream banks, common.

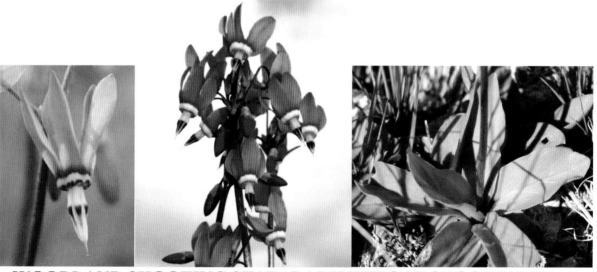

WOODLAND SHOOTING STAR; DARK THROAT SHOOTING STAR
Dodecatheon pulchellum
Primrose Family (Primulaceae)

Flower: 5 bright pink swept back petals with a strip of white and then a yellow wavy reddish-purple ring at the base and then a yellow and black sharp-pointed tip; the wavy ring distinguishes it from the *jeffreyi*
Leaves: Basal leaves, large, oval
Blooms: May-June Height: 10-24" tall
Found easily in wet meadows, along stream banks, in boggy areas.

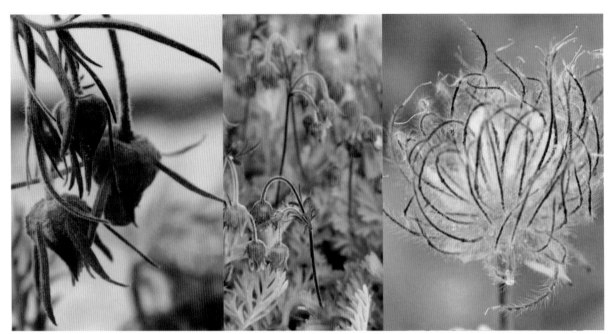

PRAIRIE SMOKE; OLD MAN'S WHISKERS
Geum triflorum
Rose Family (Rosaceae)

Flower: Nodding, bell-shaped, 5 pink to rose-maroon petals on long stalks
Leaves: Hairy, feathery and fern-like, mainly basal
Blooms: May-August Height: 4-20" tall
Found in meadows, in forests, on sagebrush plains, common.
Top left picture by *Stephen L. Love.*

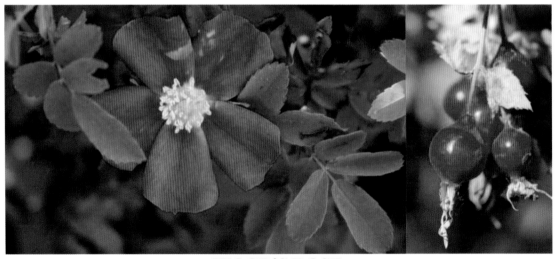

WOOD'S ROSE
Rosa woodii
Rose Family (Rosaceae)

Flower: 5 pink wavy petals, fragrant, followed by a fruit called a hip, which is red
Leaves: Oval to elliptical, opposite, toothed, 5-7 leaflets
Blooms: May-July Height: 2-5' tall
Found along streams and small clearings, common.

ROSE SPIREA; HARDHACK; STEEPLEBUSH
Spiraea douglasii
Rose Family (Rosaceae)

Flower: Rounded bright pink clusters of tiny flowers on a shrub
Leaves: Oval with serrated edges, alternate, hairy, thicket forming in marshy areas
Blooms: July-August Height: 2-6' tall
Found along stream banks and in forests. Photographed along a hiking trail near Stanley Lake.

ROSE MEADOWSWEET; MOUNTAIN SPIREA
Spiraea splendens
Rose Family (Rosaceae)

Flower: 5 tiny pink petals, in flat-topped clusters
Leaves: Hairy along the margins, toothed, egg-shaped, one main vein
Blooms: July-August Height: 1-3' tall
Found in moist forests and on shrubby slopes. Photographed along the Lolo Trail.

135

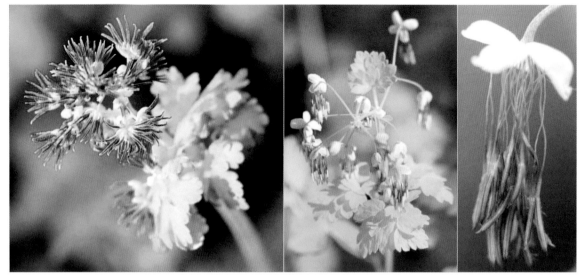

WESTERN MEADOWRUE
Thalictrum occidentale
Buttercup Family (Ranunculaceae)
(left, female right, male)

Flower: Pink to purplish, thread-like filaments and miniature tassels that are maroon and yellow-green, male and female are separate plants, female purple-pink
Leaves: 3 lobes, notched, shiny
Blooms: May-July Height: 12-40" tall
Found in moist ground often in shady woods. Top right picture by *Gwen Russell.*

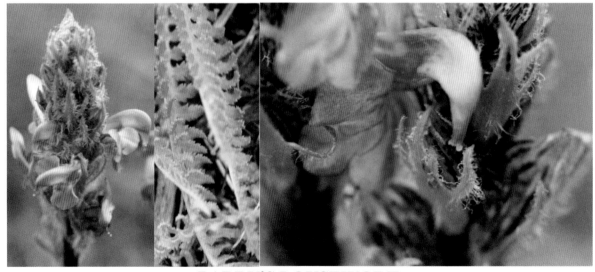

PARRY'S LOUSEWORT
Pedicularis parryi var. purpurea
Figwort or Snapdragon Family (Scrophulariaceae)

Flower: Hairy, lavender to purple, with a beak
Leaves: Basal and fern-like
Blooms: May-June Height: up to 20" tall
Found in moist meadows. Lousewort photographed in Yellowstone Park, not common.

136

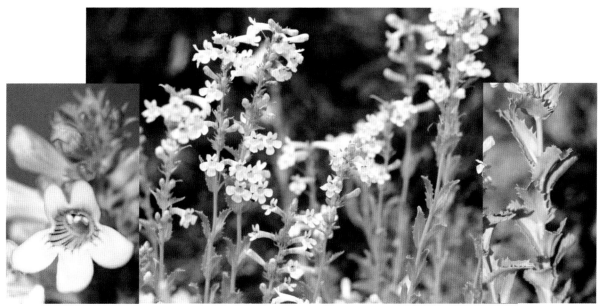

HOT-ROCK PENSTEMON; SCABLAND BEARDTONGUE
Penstemon deustus
Figwort or Snapdragon Family (Scrophulariaceae)

Flower: White or cream with pink veins, trumpet-shaped about ¾" long
Leaves: Leaves opposite and toothed
Blooms: May through June Height: 8-18" tall
Found in dry, rocky places, common.

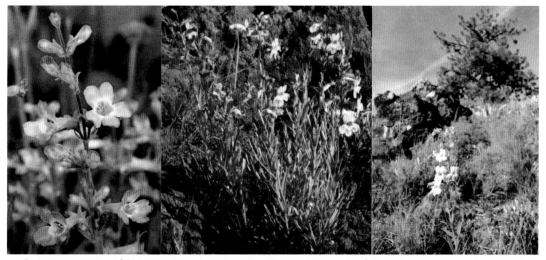

GAIRDNER'S PENSTEMON; GAIRDNER'S BEARDTONGUE
Penstemon gairdneri
Figwort or Snapdragon Family (Scrophulariaceae)

Flower: Tubular with a flat face made up of 5 sub-equal lobes, flowers are about ¾" long, medium pink to lavender in color
Leaves: Numerous and crowded along the stems, very narrow, 1-2" long, gray hairs
Blooms: May-June Height: 8-12" tall
Found on scablands and dry, rocky meadows growing in very shallow, poor soils. Photographs from the hills east of Hell's Canyon. Description and pictures by *Stephen L. Love.*

STICKYSTEM PENSTEMON; STICKYSTEM BEARDTONGUE
Penstemon glandulosus
Snapdragon or Figwort Family (Scrophulariaceae)

Flower: Tubular, blue-lavender in color, sticky-hairy on the outside surface, gaping mouth, lobes at the mouth separated into 2 upper and 3 lower
Leaves: Broad at the base where leaves clasp the stems, pointed at the tips, distinctly sharp toothed edges, smaller leaves at the base and becoming larger further up the stem, largest leaves are mid-stem, smaller below and above, stems sticky-hairy
Blooms: May into July Height: 20-40" tall
Found on slopes and ridges usually in sparse forests and on open hillsides among shrubs and grasses. Photographs from near the top of Kleinschmidt grade which traverses from Hell's Canyon to Cuprum. Description and pictures by *Stephen L. Love.*

PALMER'S PENSTEMON; BALLOON FLOWER
Penstemon palmeri
Snapdragon or Figwort Family (Scrophulariaceae)

Flower: Pale pink with dark pink stripes, tube-shaped, 3 lower and 2 upper lobes, fuzzy showy, hairy (yellow) beardtongue, fragrant, in a tall narrow cluster
Leaves: Grayish-green, clasping, upper opposite leaves joined
Blooms: May-August Height: up to 3-4½' tall
Found in sagebrush scrub, roadsides, mountain slopes, and dry washes.

YELLOW AND GOLD FLOWERS

Owl's-Claws by *Stephen L. Love.*

This section is for yellow and gold flowers and yellow ones that are mixed with other colors such as red, brown, or orange.

AMERICAN THOROW WAX
Bupleurum americanum
Parsley Family (Apiaceae*)

Flower: Yellow clusters contain 10-20 tiny yellow flowers, become reddish-brown
as they age
Leaves: Basal, simple, grey-green, hairless, linear
Blooms: July-September Height: up to 20" tall
Found in rocky areas, meadow and hillsides. Photographed above 8,000 feet
in the east fork of the Pahsimeroi in Custer County, Idaho, on August 20.
ay pee AY see ee

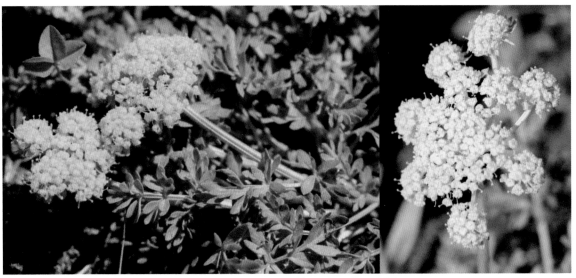

WAXY SPRING-PARSLEY
Cymopterus glaucus*
Parsley Family (Apiaceae)

Flower: Flat clusters of tiny yellow petals
Leaves: Hugs the ground, deeply lobed
Blooms: April-May Height: ½-2" tall
Found on open hillsides after the snow has melted.
*sim OP ter us *GLAW kus*

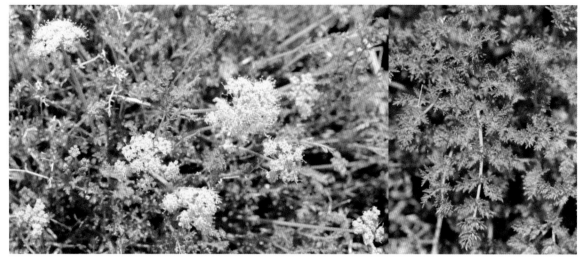

AROMATIC SPRING-PARLEY; DESERT PARSLEY
Cymopterus terebinthinus
Family Parsley (Apiaceae)

Flower: Clusters of 5 tiny yellow petals, umbrella-like clusters on long stems
Leaves: Fernlike, fragrant when crushed, anise-like smell, basal
Blooms: May-July Height: 8-24" tall
Found in sandy and rocky slopes and in the sagebrush flats, common.

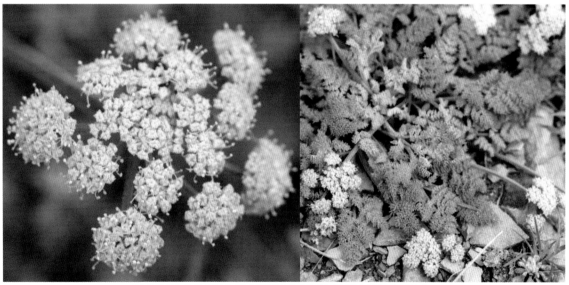

COMMON DESERT BISCUITROOT;
CARROT-LEAF DESERT PARSLEY
Lomatium foeniculaceum
Family Parsley (Apiaceae)

Flower: Clusters of tiny yellow flowers, five lobes, red stems, hugs the ground
Leaves: Gray green and divided into many small, narrow segments, basal, hairy
Blooms: April-May Height: up to 10" tall
Found in rocky areas after the snow melts.

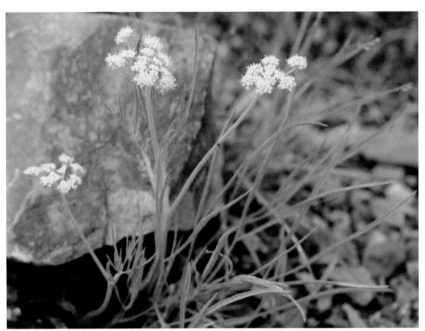

NINELEAF BISCUITROOT; NARROW-LEAF LOMATIUM
Lomatium triternatum
Family Parsley (Apiaceae)

Flower: Yellow flat clusters on top of 6-24" stems
Leaves: Linear, basal
Blooms: May-June
Found easily in the spring in sagebrush areas and in pine woodlands, common.

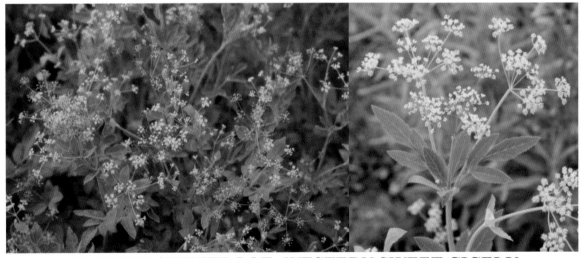

WESTERN SWEETROOT; WESTERN SWEET CICELY
Osmorhiza occidentalis
Family Parsley (Apiaceae)

Flower: Clusters of tiny light yellow flowers with 5 petals, anise scented
Leaves: Large leaves divided into irregular toothed leaflets, lance-shaped
Blooms: May-July Height: 1-4' tall
Found in grassy meadows, seeps and along streams.

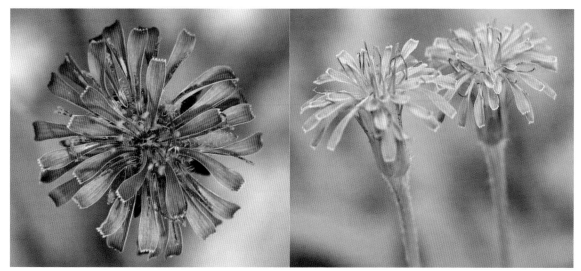

ORANGE MOUNTAIN DANDELION
Agoseris aurantiaca
Aster or Composite Family (Asteraceae)

Flower: Bright orange ray flowers, notched petals, dry to a purple
Leaves: Basal leaves a bit wider and pointed, lance-shaped
Blooms: May-September Height: 4-20" tall
Found on grassy slopes and meadows at the higher elevations.

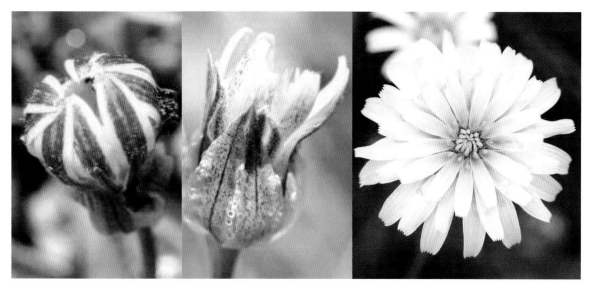

MOUNTAIN DANDELION; FALSE DANDELION
Agoseris glauca
Aster or Composite Family (Asteraceae)

Flower: Bright yellow ray flowers typical of the regular dandelion, but different outside
markings and shape, middle ray flowers are shorter, ends of petals finely toothed
Leaves: Basal, narrow toothed leaves, leaves often used in salads and teas
Blooms: May-September Height: 4-28" tall
Found easily in meadows and foothills.

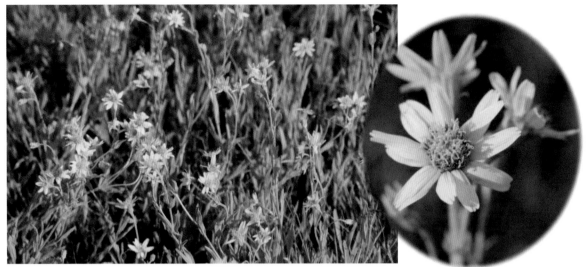

CHAMISSO ARNICA; SILVER ARNICA
Arnica chamissonis
Aster or Composite Family (Asteraceae)

Flower: Yellow rays, notched on ends, usually 13, rounded bracts, bright gold disk
Leaves: 4 or more pair of leaves, lance-shaped
Blooms: Late June-July Height: 12-36" tall
Found in moist high meadows and along stream banks.

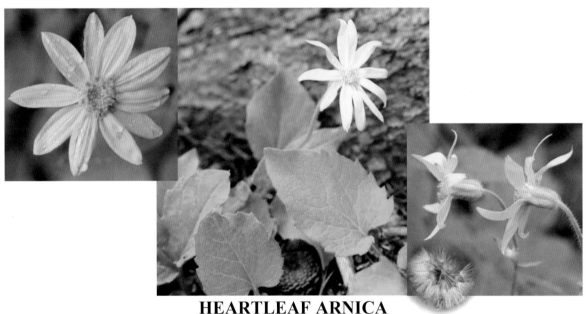

HEARTLEAF ARNICA
Arnica cordifolia
Aster or Composite Family (Asteraceae)

Flower: Bright yellow showy daisy-like petals, 10-14 ray flowers, solitary, bright yellow disk
Leaves: Heart-shaped leaves, opposite, hairy stems
Blooms: April to July Height: 6-24" tall
Found in open woods to more forested areas, common.
Left and right pictures by *Callie Russell*.

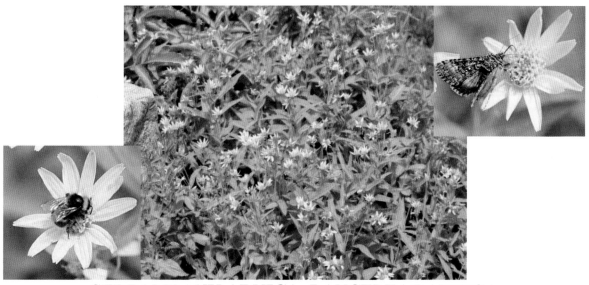

STREAMBANK ARNICA; LANCELEAF ARNICA
Arnica lanceolata
Aster or Composite Family (Asteraceae)

Flower: Yellow ray and disk flowers, petal ends usually have 3 teeth
Leaves: Opposite, lance-like, clasping
Blooms: July-September Height: 1-3' tall
Found near stream banks and in moist meadows from low to higher elevations.

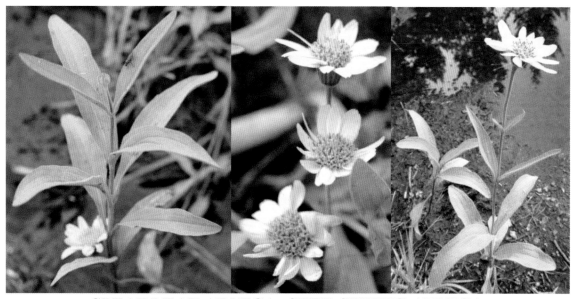

SPEARLEAF ARNICA; SEEP-SPRING ARNICA
Arnica longifolia
Aster or Composite Family (Asteraceae)

Flower: Yellow ray and yellow disk flowers, petals notched
Leaves: Opposite, lance-shaped, 5-7 pairs, sharply pointed at the base, hairy
Blooms: July-September Height: 1-3' tall
Found near streams and in moist meadows in higher elevations.

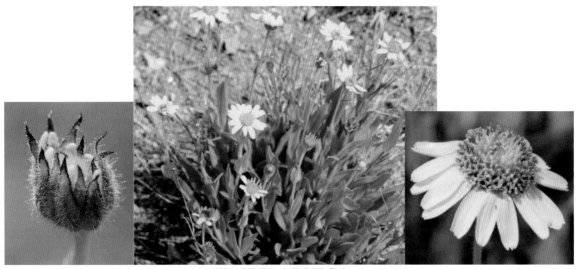

HAIRY ARNICA
Arnica mollis
Aster or Composite Family (Asteraceae)

Flower: Large yellow heads with both ray (10-15) and disk flowers, single stem, sticky-haired, triangular red-tipped bracts, petals are toothed, flower head 1-2" wide
Leaves: Broad and lance-shaped, hairy and soft, opposite, sticky stems, 3-4 stem leaves
Blooms: June-August Height: up to 2½' tall
Found along streams and springs and in drier areas.
Photographed about a mile from Galena Summit at the Titus Bird watch turn off in late July.

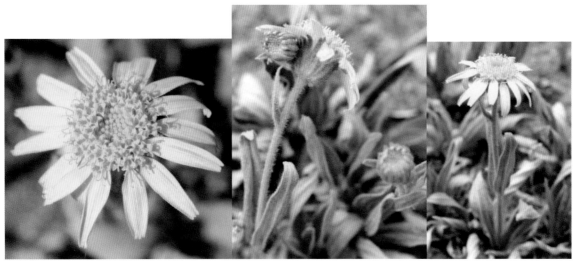

RYDBERG'S ARNICA
Arnica rydbergii
Aster or Composite Family (Asteraceae)

Flower: Large yellow heads, rays, 8-14, yellow-orange disk, petals toothed
Leaves: Spear-shaped, hairy and soft, opposite, stems sticky, prominent vein, light green-gray, low growing, 2-4 pairs of leaves, plant in small clusters, basal leaves
Blooms: June-August Height: up to 14" tall
Found on rocky alpine slopes and in meadows.
Photographed on June 10 in the Copper Basin near Corral Creek, Custer County, Idaho.

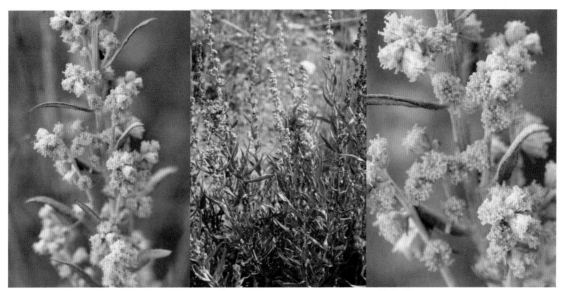

GRAY SAGEWORT; WHITE SAGE
Artemisia ludoviciana
Aster or Composite Family (Asteraceae)

Flower: Small yellow nodding flower heads about 1/8" across, no petals
Leaves: Linear or lance-shaped with white hair, silver-gray, aromatic when crushed
Bloom: August-September Height: 3-4½' tall
Found in sagebrush flats, rocky prairies and slopes.

SATINY WORMWOOD; MICHAUX'S MUGWORT
Artemisia michauxiana
Aster or Composite Family (Asteraceae)

Flower: Bundles of green-cream or yellow-cream nodding flowers, less than a ¼" long
Leaves: Narrow and thin, pinnately divided, distinctive lemon smell when crushed
Blooms: July-August Height: 8-20" tall
Found on rocky slopes, in drier forest areas and near scree.

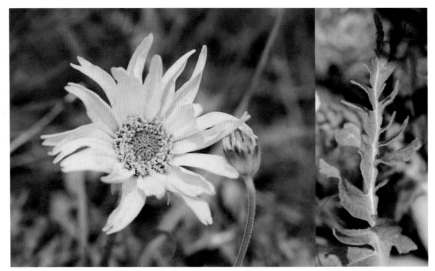

HOARY BALSAMROOT
Balsamorhiza incana
Aster or Composite Family (Asteraceae)

Flower: Bright yellow-gold heads, 1-3" wide, rays 13 or more, usually tips notched, requires more moisture than other Balsamroots
Leaves: Basal, hairy, grayish-green, lance-shaped and deeply divided, can be up to 17" long
Blooms: May-July Height: 8-36" tall
Found on rocky slopes, in sagebrush areas and on grassy meadows.

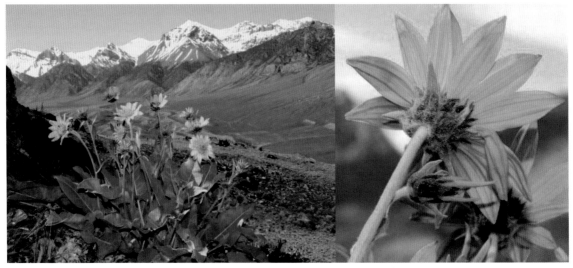

ARROWLEAF BALSAMROOT
Balsamorhiza sagittata
Aster or Composite Family (Asteraceae)

Flower: Bright yellow-gold sunflower-like heads, 2-5" wide, 8-25 rays, bracts hairy
Leaves: Arrow-shaped, basal leaves can be up to a foot long
Blooms: May-June Height: 1-3' tall
Found in clumps on open hillsides and flats, in grasslands, sagebrush and open pinewoods. Arrowleaf blooms a couple of weeks before the Mule-ears.

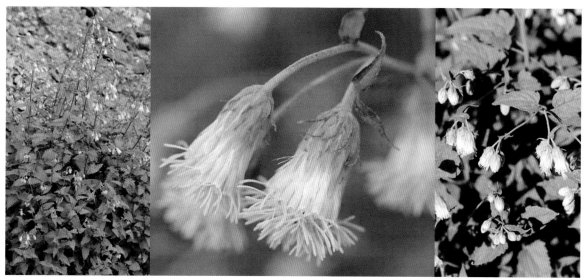

TASSELFLOWER BRICKELLBUSH; LARGE-FLOWERED BRICKELLIA
Brickellia grandiflora
Aster or Composite Family (Asteraceae)

Flower: Nodding cream to yellow colored flower heads with tiny disk flowers
Leaves: Large wide, triangular or heart-shaped and have toothed edges, deeply veined
Blooms: July-September Height: ½-3' tall
Found on rocky slopes like Trail Creek Summit, seen in the higher elevations.

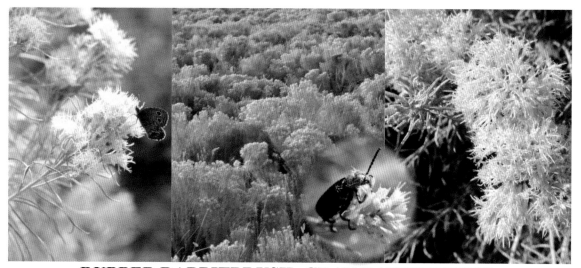

RUBBER RABBITBRUSH; GRAY RABBITBRUSH
Ericameria nauseosa
Aster or Composite Family (Asteraceae)

Flower: Tiny yellow rayless flowers in large clusters
Leaves: Thread-like and straighter, flattish leaves, matures slightly later than *viscidiflorus* and is taller than the Douglas or *viscidiflorus*
Blooms: July-September Height: 1-6' tall
Found in sagebrush flats and in dry soils, common.

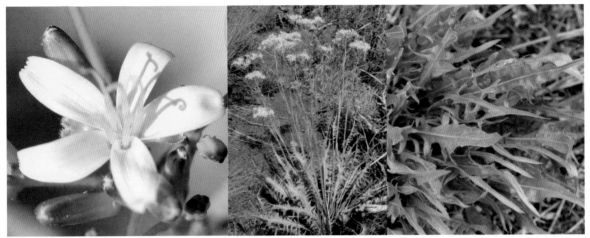

TAPERTIP HAWKSBEARD; LONGLEAF HAWKSBEARD
Crepis acuminata
Aster or Composite Family (Asteraceae)

Flower: Many bright yellow flower heads on a long stem, toothed tips
Leaves: Dandelion-like with deeply lobbed leaves, tapering tip, milky sap
Blooms: June-August Height: 8-30" tall
Found in open areas on dry slopes, sagebrush flats, and rocky areas.

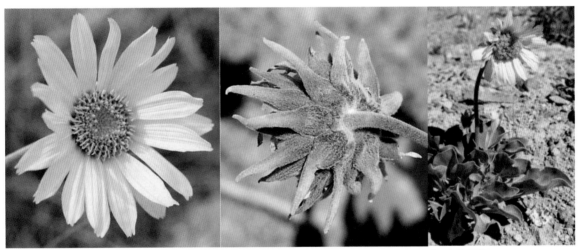

NAKEDSTEM SUNRAY; NAKED STEMMED DAISY
Enceliopsis nudicaulis
Aster or Composite Family (Asteraceae)

Flower: Golden yellow sunflower-like head, 20-35 rays
Leaves: Large basal, oval, gray-green and hairy, long and wide
Blooms: Early May to second week in June, longer in other locations Height: 12-24" tall
Found in canyons, washes, and hillsides. See along the highway from Bayhorse to milepost 235, look for them on the rocky slopes, also found in Malm Gulch and the first mile or two on the road going to Bayhorse, all in Custer County, Idaho.

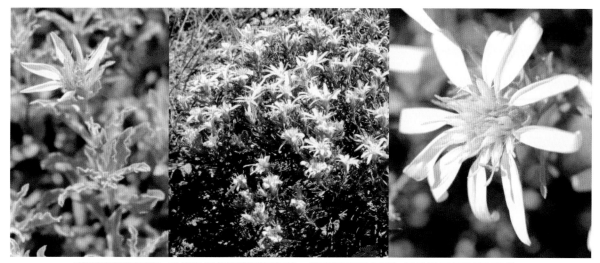

SHRUBBY GOLDENWEED, SHRUBBY GOLDENBUSH
Ericameria suffruticosa
Aster or Composite Family (Asteraceae)

Flower: Bright yellow with 5 to 9 rays around a central disk
Leaves: Wavy edges with fine hairs, alternate
Blooms: July-August Height: 1-2' tall
Found in barren areas and in dry rocky soils.

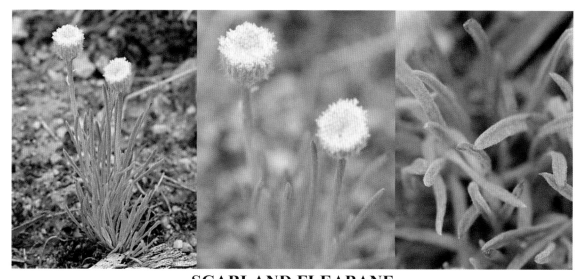

SCABLAND FLEABANE
Erigeron bloomeri
Aster or Composite Family (Asteraceae)

Flower: Bright yellow disk flowers, lack rays, solitary
Leaves: Long and thin, basal cluster
Blooms: May Height: 2-8" tall
Found in dry sagebrush flats, lava beds, on rocky slopes.

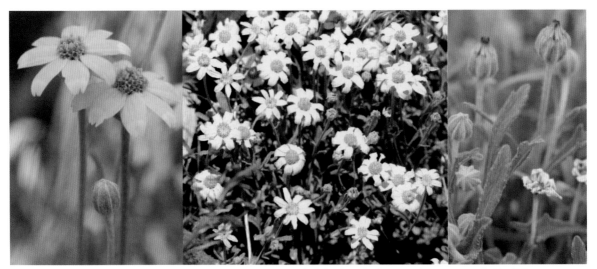

OREGON SUNSHINE; COMMON WOOLY SUNFLOWER
Eriophyllum lanatum
Aster or Composite Family (Asteraceae)

Flower: Solid yellow rays to shades of yellow-orange, 5-13, toothed at ends,
gold-orange disk
Leaves: Grayish green and linear-shaped to fern-like or deeply lobed, gray-green,
covered with fine white hair, grows in clumps
Blooms: June-August Height: 4-24" tall
Found in dry areas with sandy and rocky soils, in meadows, along roadsides, common.

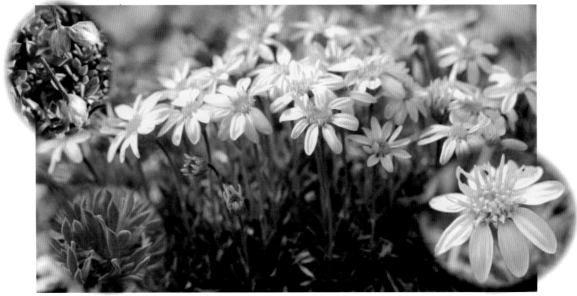

LINELEAF DAISY; DESERT YELLOW FLEABANE
Erigeron linearis
Aster or Composite Family (Asteraceae)

Flower: Bright yellow ray flower heads, yellow disk, wine-colored stem
Leaves: Narrow, oval, basal, gray-green, groups often in clumps
Blooms: May-June Height: 2-12" tall
Found in grassy plains, in sagebrush flats, on gravelly slopes.

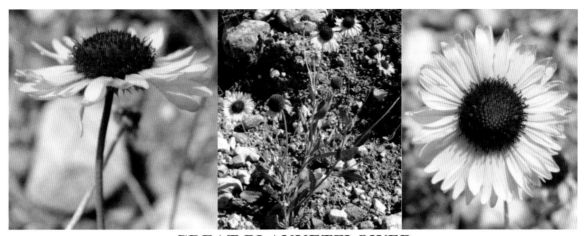

GREAT BLANKETFLOWER
Gaillardia aristata
Aster or Composite Family (Asteraceae)

Flower: Bright yellow rays with a brownish or reddish-center
Leaves: Alternate, lance-shaped
Blooms: July-August Height: 1-2' tall
Found throughout areas where there is sagebrush and in open meadows.

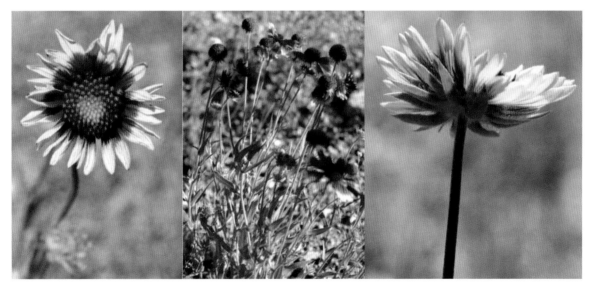

FIREWHEEL; INDIAN BLANKET
Gaillardia pulchella
Aster or Composite Family (Asteraceae)

Flower: Showy yellow and crimson ray flowers, red center and yellow edges, red-brown disk
Leaves: Alternate, linear, hairy stems
Blooms: July-August Height: 1-2' tall
Found throughout areas where there is sagebrush, in open meadows and gardens.

Photographed near Galena Summit on the way to Sun Valley.

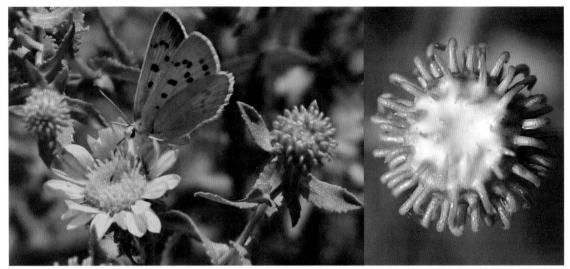

CURLYCUP GUMWEED
Grindelia squarrosa
Aster or Composite Family (Asteraceae)

Flower: Bright yellow, 20-40 yellow rays, yellow disk with a sticky white resin
Leaves: Sticky, notched, strong smelling
Blooms: July-September Height: 6-30" tall
Found easily in dry fields, and along roadsides, very common.
Native Americans made a medicinal tea from the plant.

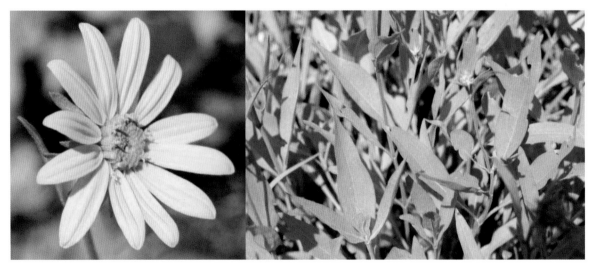

ONEFLOWER HELIANTHELLA; DOUGLAS' HELIANTHELLA
Helianthella uniflora
Aster or Composite Family (Asteraceae)

Flower: Large, solitary, bright yellow with 11-20 rays, yellow disk
Leaves: Large, oblong or lance-shaped, untoothed, opposite lower, alternate top, 3 veins
Blooms: June-August Height: 2-4' tall
Found in open woods and meadows and dry hillsides, photographed in the Tetons.

COMMON SUNFLOWER
Helianthus annuus
Aster or Composite Family (Asteraceae)

Flower: Bright yellow ray flowers, large brownish disk
Leaves: Alternate and large, stem and leaf rough and hairy
Blooms: June-September Height: 2-7' tall
Found easily found in open places, along roadsides and in open fields, common.

NUTTALL'S SUNFLOWER
Helianthus nuttallii var. nuttallii
Aster or Composite Family (Asteraceae)

Flower: Rays to 1", 10-21 rays, large brown-yellow disk, flower head to 2" across
Leaves: Long, narrow, prominent center vein, leaves to 7" long
Blooms: July-September Height: 3-12' tall
Found in moist meadows and near streams.

SHOWY GOLDENEYE
Heliomeris multiflora
Aster or Composite Family (Asteraceae)

Flower: Golden rays (12-14) and a large disk, starts out as green disk and rays
Leaves: Long narrow, opposite except upper ones, which are alternate, almost an olive green, plant often in bushy clumps
Blooms: July-September Height: 1-5' tall
Found in foothills and open meadows, and along roadsides. Top right picture by *Don Russell.*

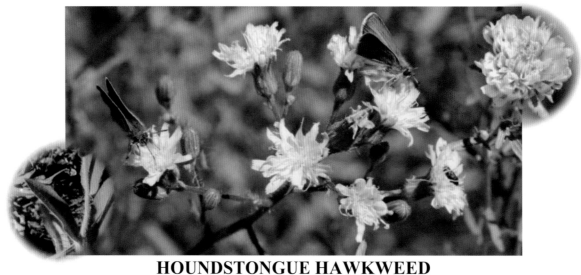

HOUNDSTONGUE HAWKWEED
Hieracium cynoglossoides*
Aster or Composite Family (Asteraceae)

Flower: Yellow rays, 10-20 dandelion-like heads, blackish cup bracts
Leaves: Alternate, large, very hairy, lance-shaped
Blooms: July-August Height: 1-4' tall
Found in open fields, mountain meadows and clearings.
**hi er uh KEE um*

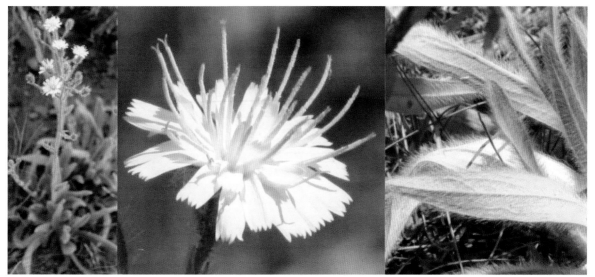

WESTERN HAWKWEED; SCOULER'S WOOLLYWEED
Hieracium scouleri
Aster or Composite Family (Asteraceae)

Flower: Yellow ray flowers with a prominent yellow center, notched petals
Leaves: Hairy, long and narrow, lance-shaped, white sap
Blooms: July-August Height: up to 2½' tall
Found in mountain valleys and slopes.

THREADLEAF SUNFLOWER; FINELEAF HYMENOPAPPUS
Hymenopappus filifolius**
Aster or Composite Family (Asteraceae)

Flower: Small, lemon yellow disk flowers clustered on tall stalks
Leaves: Thread-like, light gray-green, clustered around the base
Blooms: May-June Height: 12-36" tall
Found in foothills, arid areas and in woodlands.
Photographed at Malm Gulch and on a hillside going up Bayhorse in Custer County, Idaho.
*hy men oh PAP pus *fil ee FOH lee us

OLD-MAN-OF-THE-MOUNTAIN; ALPINE SUNFLOWER
Hymenoxys grandiflora
Aster or Composite Family (Asteraceae)

Flower: Solitary head 3-4", at least 20 rays, woolly
Leaves: Feather-like, hairy, on stout stem
Blooms: July-September Height: up to 12" tall
Found on high mountain meadows and rocky slopes. Photographed by *Stephen L. Love.*

OWL'S-CLAWS; ORANGE SNEEZEWEED
Hymenoxys hoopesii
Aster or Composite Family (Asteraceae)

Flower: Large yellow drooping head, 14-26 rays, a broad woolly gold central disk,
space between rays
Leaves: Large, lance-like to oblong, alternate, leaves 3-6" deeply veined
Blooms: July-September Height: 1-3' tall
Found on rocky slopes, woody areas and in meadows.

WEAK GROUNDSEL
Packera debilis
Aster or Composite Family (Asteraceae)

Flower: Yellow-orange disk flowers, no rays, 3-15 heads
Leaves: Thick, basal and deeply lobbed, slightly succulent
Blooms: July-August Height: 4-24" tall
Found in meadows with alkaline soil and in disturbed areas.

LANCELEAF GOLDENWEED
Pyrrocoma lanceolata
Aster or Composite Family (Asteraceae)

Flower: Bright yellow ray flowers with a large gold-brownish disk
Leaves: Lance-shaped often with saw-toothed edges
Blooms: July-August Height: 2-5' tall
Found in marshy areas and in disturbed areas with wet alkali soils.
These seen on the Fort Hall Reservation near the marker for the old Fort Hall.

ALKALI-MARSH RAGWORT; WATER RAGWORT
Senecio hydrophilus
Aster or Composite Family (Asteraceae)

Flower: Clusters of small yellow flower heads, black specks on outside bracts
Leaves: Basal leaves that are pointed and smaller as they progress up the dark reddish-purple stem, can be toothed as these were, leaves thick and succulent
Blooms: May-June Height: 2-4' tall
Found in marshy areas, bogs and moist meadows.
Photographed in a boggy area a few miles from Carey, Idaho in Blaine County.

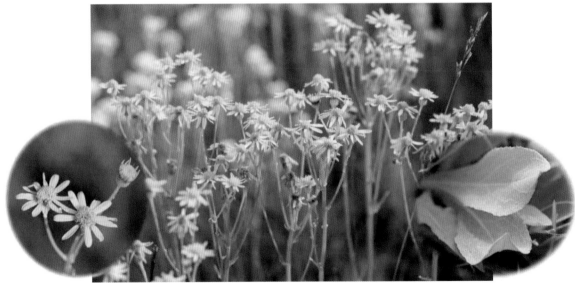

LAMBSTONGUE RAGWORT, MT. BUTTERWEED, WESTERN GROUNDSEL
Senecio integerrimus
Aster or Composite Family (Asteraceae)

Flower: Yellow ray flowers (5-13), tightly packed in clusters
Leaves: Basal and nearly vertical, sometimes leaves are serrated
Blooms: June-July Height: 6-20" tall
Found in foothills, open places and moist meadows.

TALL RAGWEED; BUTTERWEED
Senecio serra
Aster or Composite Family (Asteraceae)

Flower: Clusters of golden yellow ray flowers, gold disk
Leaves: Usually toothed, narrow, lance-shaped
Blooms: July-August Height: 2-6' tall
Found in meadows, along roadsides and in disturbed areas, common.

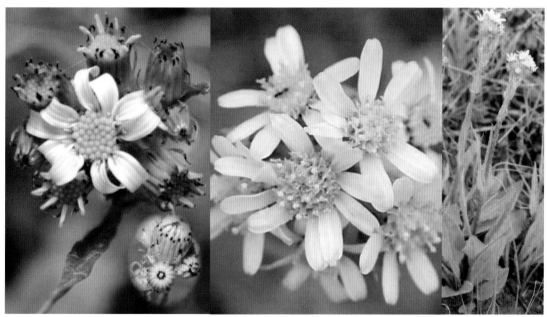

BALLHEAD RAGWORT; BALLHEAD GROUNDSEL
Senecio sphaerocephalus
Aster or Composite Family (Asteraceae)

Flower: Yellow round clusters, black-tipped bracts, disk flowers with 9-17 rays
Leaves: Basal, large oval, toothed, alternate
Blooms: May-June Height: 12-32" tall
Found in meadows, canyons, and open forests.

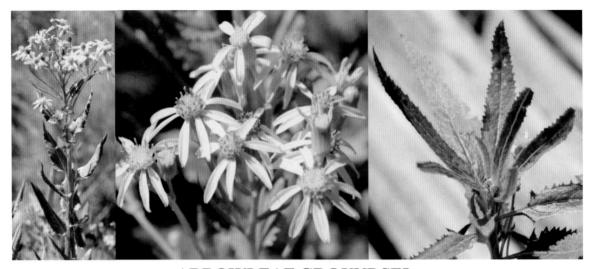

ARROWLEAF GROUNDSEL
Senecio triangularis
Aster or Composite Family (Asteraceae)

Flower: Yellow clusters, ray flowers, gold disk, 6-12 ray petals, bracts on back even
Leaves: Large, triangular-shaped, toothed margins, alternate
Blooms: June-August Height: 1-5' tall
Found along streams and in moist meadows, common.

MEADOW GOLDENROD; CANADA GOLDENROD
Solidago canadensis
Aster or Composite Family (Asteraceae)

Flower: Yellow, feathery clusters of tiny yellow flowers
Leaves: Lance-shaped, sharply toothed, 3-veined leaves, most leaves uniform in size, deep green
Blooms: July-September Height: 1-5' tall
Found easily along streams, in meadows and along ditches.

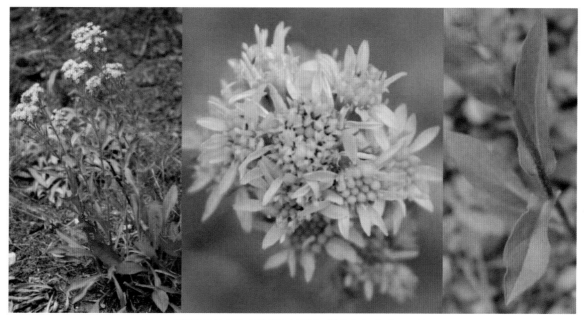

ROCKY MOUNTAIN GOLDENROD
Solidago multiradiata
Aster or Composite Family (Asteraceae)

Flower: Many small yellow ray flowers, dense clusters
Leaves: Basal and lance to spoon-shaped, hairy, tips of leaf often point up
Blooms: July-August Height: 4-24" tall
Found in meadows and open forests in higher elevations.

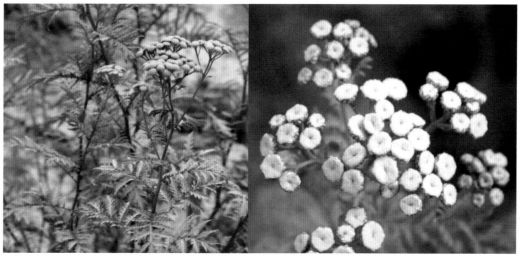

COMMON TANSY; GOLDEN BUTTONS
Tanacetum vulgare
Aster or Composite Family (Asteraceae)

Flower: Flat topped clusters of yellow button-like flowers
Leaves: Fern-like, alternate, aromatic
Blooms: August-September Height: 2-4' tall
Found along roadsides and in gardens, **not native.**

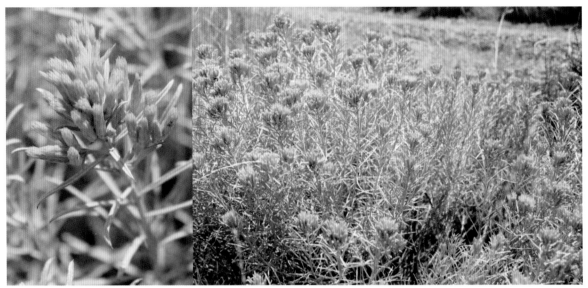

SPINELESS HORSEBRUSH; GRAY HORSEBRUSH
Tetradymia canescens
Aster or Composite Family (Asteraceae)

Flower: Yellow disk flowers on tips of short branches, clusters can be yellow or cream
Leaves: Alternate, gray-green, linear, soft white hairs
Blooms: June-August Height: ½-3' tall
Found in semi-desert, sage scrub and foothills.

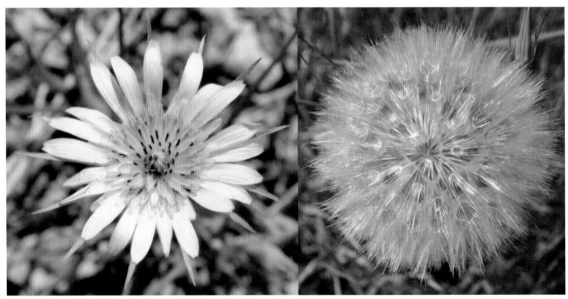

WESTERN SALSIFY; YELLOW GOATSBEARD
Tragopogon dubius
Aster or Composite Family (Asteraceae)

Flower: Single, large, lemon yellow, with pointed rays, needle-like bracts extend
beyond petals
Leaves: Grass-like, clasping, basal, alternate, showy seed heads
Blooms: May-September Height: 1-3' tall
Found in disturbed areas, along roadsides, very common, **not native**.

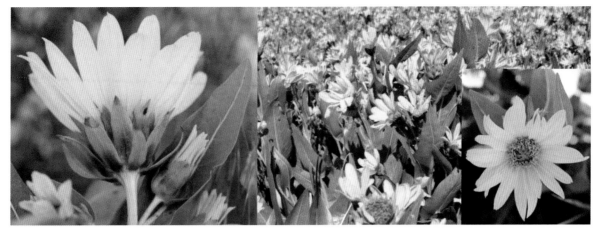

MULE-EARS
Wyethia amplexicaulis
Aster or Composite Family (Asteraceae)

Flower: Showy yellow sunflower-like blossoms, 13 to 21 rays, found in large patches
Leaves: Large up to 2' long and ½' wide, deep green and glossy
Blooms: May-June Height: 2-3' tall
Found around Aspen trees and in moist meadows, common.

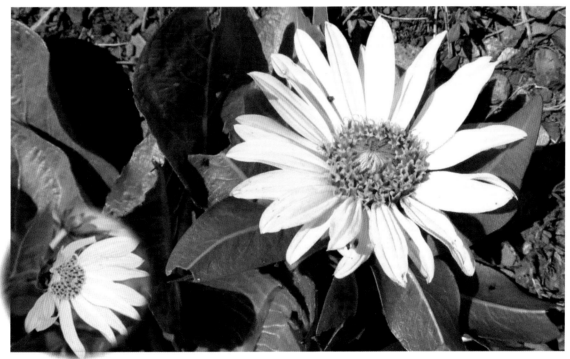

HYBRID MIX of MULE-EARS
Wyethia x cusickii
Aster or Composite Family (Asteraceae)

Flower: Showy cream to yellowish sunflower-like blossoms, a result of natural
hybridization between the white (*W. helianthoides*) and yellow (*W. amplexicaulis*) species
Leaves: Large up to 2' long and ½' wide, deep green, shiny
Blooms: May-June Height: 1-2½' tall
Found in moist meadows where there are both yellow and white Mule-ears.

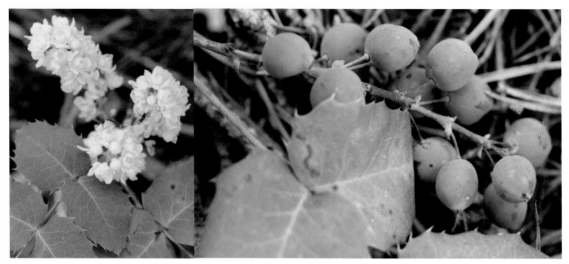

CREEPING OREGON GRAPE; CREEPING BARBERRY
Mahonia repens*
Barberry Family (Berberidaceae*)

Flower: Clusters of bright yellow flowers, 6 petals, replaced in July-August with clusters of purple berries
Leaves: Holly-like dark green leaves which turn bronze, red and orange as they age
Blooms: April-June Berries: August Height: 4-16" tall
Found in forested areas.
*ma HO nee uh *REE penz *bear ber id AY see ee

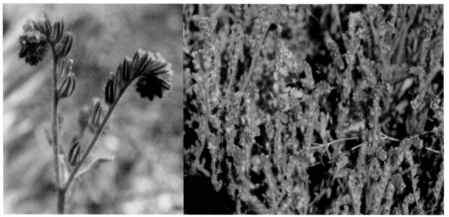

FIDDLENECK
Amsinckia menziesii*
Borage Family (Boraginaceae)

Flower: 5 tiny yellow-orange petals, trumpet-shaped, in a coiled spike, as it starts to bloom, the flower head resembles the neck of a violin, thus its name
Leaves: Hairy, narrow, bristly
Blooms: April to July Height: 1-2' tall
Found in fields, in disturbed areas, along roadsides and on overgrazed rangeland.
*am SIN ki ah

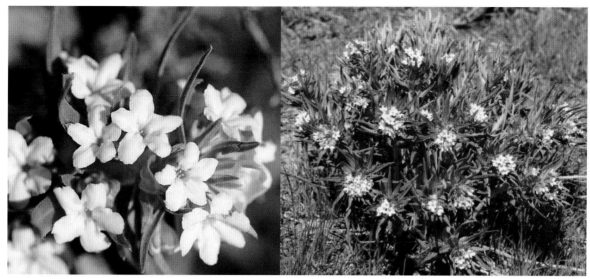

GROMWELL; STONESEED; PUCCOON
Lithospermum ruderale**
Borage Family (Boraginaceae)

Flower: Tiny pale yellow, 5 petals, almost star-shaped, yellow anthers, yellow throat
Leaves: Gray-green, ribbed, narrow, lance-shaped, hairy, alternate, lower leaves smaller, center vein
Blooms: May-June Height: 6-16" tall
Found in waste places, woodlands, foothills, roadsides, and on rocky ground, common.
*lith oh SPER mum *roo der AY lee*

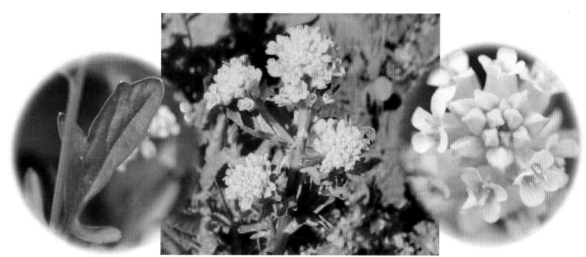

AMERICAN WINTERCRESS; YELLOW ROCKET
Barbarea orthoceras
Mustard Family (Brassicaceae*)

Flower: 4 bright yellow petals in a tight cluster
Leaves: Basal, radish looking, divided into 5-7 lobes, toothed
Blooms: June-July Height: 12-24" tall
Found in higher elevations of the mountains.
brass ih KAY see ee

MOUNTAIN TANSYMUSTARD
Descurainia incana
Mustard Family (Brassicaceae)

Flower: Compact clusters with 4 yellow petals
Leaves: Fern-like, alternate, thin stems
Blooms: April-July Height: up to 3' tall
Found in sagebrush flats, disturbed areas, along roadsides, rocky hillsides, common.

SLENDER DRABA
Draba albertina
Mustard Family (Brassicaceae)

Flower: 4 tiny bright yellow petals, yellow anthers, (petals can be white too)
Leaves: Basal, oval, hairy, unusual leaf makes it easier to identify
Blooms: May-June Height: 1-2" tall
Found on alpine slopes, in meadows at high elevations soon after the snow melts.
Since it is so tiny, it is easy to miss. These seen near Bayhorse Lake in Custer County
also have seen on Teton Pass in Wyoming, both above 8,100 feet.

PAYSON'S DRABA
Draba paysonii var. treleasii
Mustard Family (Brassicaceae)

Flower: 4 tiny yellow petals in dense, showy clusters
Leaves: Forms a cushion with tiny narrow, hairy leaves, alternate
Blooms: April-May Height: 3-6" tall
Found in dry, rocky, gravely areas. These photographed near the Mt. Borah trailhead.

WESTERN WALLFLOWER; PRAIRIE ROCKET
Erysimum asperum var. elatum
Mustard Family (Brassicaceae)

Flower: Bright yellow, 4 petals, cluster on thin stem
Leaves: Narrow, linear, leaves and pods extend out from the stem
Blooms: May-June Height: 6-36" tall
Found on rocky slopes and along dirt roads, common.

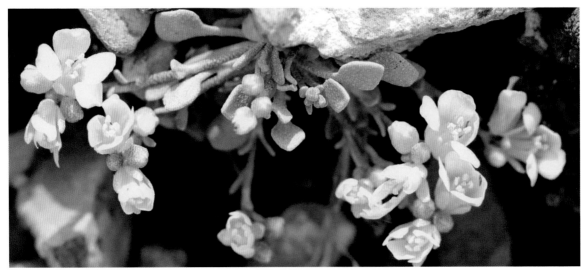

COMMON TWINPOD
Physaria didymocarpa*
Mustard Family (Brassicaceae)

Flower: 4 bright yellow petals, yellow anthers
Leaves: Spoon-shaped and grayish on a reddish stem
Blooms: April-May Height: 4-6" tall
Found in in the higher elevations in dry, gravely ground and in areas where sagebrush grows.
*fy SAR ee a *did eemo KAR pa*

WOOLLY PRINCE'S PLUME
Stanleya tomentosa
Mustard Family (Brassicaceae)

Flower: Yellow flower in plume-like clusters, individual flowers, 4 petals
Leaves: Basal, grayish green, narrow
Blooms: May-July Height: up to 6' tall
Found in dry, sandy parts of the sagebrush areas, and on rocky hillsides.
Middle picture by *Callie Russell.*

BRITTLE CACTUS; FRAGILE PRICKLY PEAR
Opuntia fragilis
Cactus Family (Cactaceae*)

Flower: Many petals, can be yellow, red, peach or orange, green center, numerous anthers
Spines: Pads have many sharp spines, segments easily broken off
Blooms: June-July Height: 2-10" tall
Found in sandy, gravely areas where there is sagebrush.
kak TAY see ee

PLAINS PRICKLY PEAR
Opuntia polyacantha
Cactus Family (Cactaceae)

Flower: Yellow, orange, or red about 3¼' wide
Spines: White to ash-gray, 3" long and sharp
Blooms: June-July Height: 8-14" tall
Found in sandy soils in desert and grasslands.

171

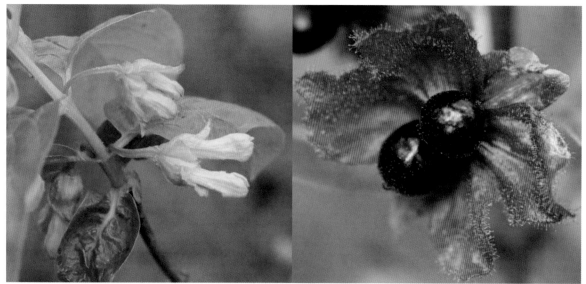

BEARBERRY HONEYSUCKLE; TWINBERRY HONEYSUCKLE
Lonicera involucrata
Honeysuckle Family (Caprifoliaceae)

Flower: Yellow to cream, tubular, hairy, in pairs, enclosed in reddish bracts, berry almost black
Leaves: Oval to elliptic-shaped, hairy on the margins, opposite
Blooms: June-July Berries: July-August Height: 2-7' tall
Found along stream banks, moist meadows and forest openings.

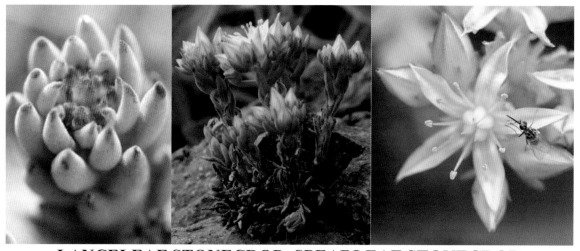

LANCELEAF STONECROP; SPEARLEAF STONECROP
Sedum lanceolatum
Stonecrop Family (Crassulaceae)

Flower: Bright yellow to greenish almost like a star, 5 petals, dense clusters
Leaves: Basal, thick and lance-like, alternate, fleshy
Blooms: June-August Height: 2-6" tall
Found easily in dry sagebrush areas, windswept ridges and rocky places.
Middle picture by *Stephen L. Love.*

WORMLEAF STONECROP
Sedum stenopetalum
Stonecrop Family (Crassulaceae)

Flower: Bright yellow in the form of a star; petals slightly longer but not as wide as the Lanceleaf Stonecrop
Leaves: Thick like worms, lance-shaped in clusters, thick and succulent
Blooms: Late June-July Height: 2-10" tall
Found in rocky woods and on cliffs.

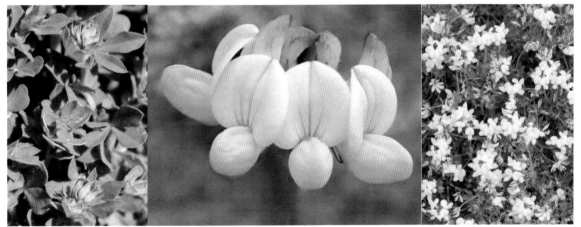

BIRD'S FOOT TREFOIL; DEERVETCH
Lotus corniculatus
Pea, Bean, or Legume Family (Fabaceae)

Flower: Bright yellow and pea-like, in a ring
Leaves: Alternate and divided into 5 leaflets, 3 at tip and 2 at stem junction, clover-like
Blooms: June to September Height: 2-14" tall
Found in meadows, lawns and in disturbed areas, **not native.**

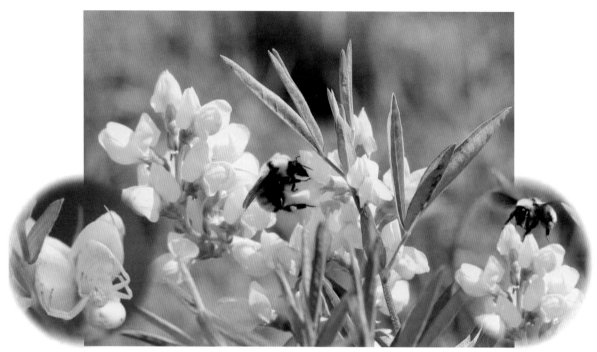

MOUNTAIN GOLDENBANNER; MOUNTAIN GOLDENPEA
Thermopsis montana
Pea, Bean, or Legume Family (Fabaceae)

Flower: Clusters of bright yellow pea-like flowers, irregular shape with banner, wings and keel
Leaves: 3 large compound leaflets, lance-shaped
Blooms: May-June Height: 2-4' tall
Found in wet meadows, photographed in Lemhi County on the road to Gibbonsville.

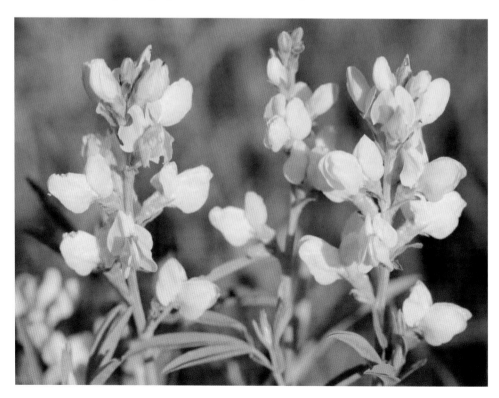

SCRAMBLED EGGS; GOLDEN SMOKE
Corydalis aurea*
Fumitory Family (Fumariaceae*)

Flower: Bright yellow, odd funnel shape, spike-like cluster
Leaves: Smoky green, fern-like, reddish-brown stem
Blooms: April-July Height: 4-24" tall
Found along dirt roadsides, washes and in disturbed areas.
*kor RID a liss *few mare I AY see ee*

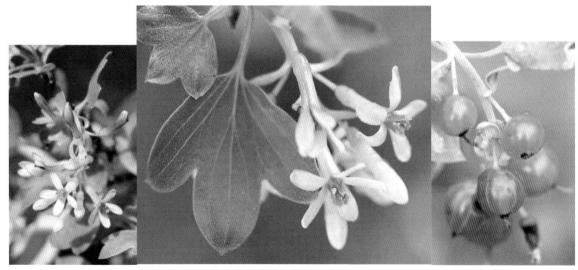

GOLDEN CURRANT
Ribes aureum
Currant Family (Grossulariaceae*)

Flower: Bright yellow tube with 5 petals, orange berry comes on in late July
Leaves: Dark green with 3 lobes
Blooms: March-April Height: 3-8' tall
Found along streams, in the bottoms of canyons, in woodland areas.

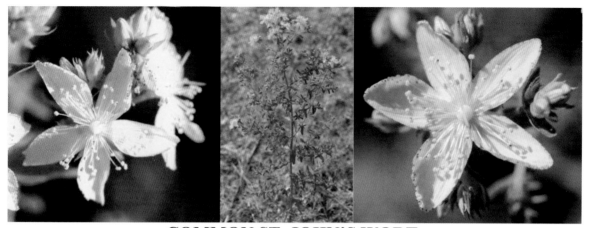

COMMON ST. JOHN'S WORT
Hypericum perforatum
St. John's Wort Family (Hypericaceae)

Flower: 5 bright yellow to yellow-orange petals, black dots on margins, many anther clusters
Leaves: Opposite, linear to oblong, paired around stem often has a red stem
Blooms: July to August Height: 1-3' tall
Found in in dry, gravely soils, rangelands, along roadsides, disturbed areas, **not native.**
Note: Often used medicinally for various ailments including depression. Plant bloomed in Europe around June 24, the feast day for St. John the Baptist, thus its name. For centuries, this plant was believed to ward off evil.

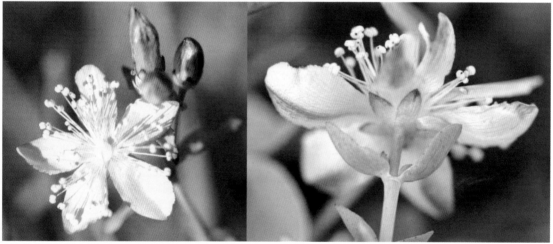

SCOULER'S ST. JOHN'S WORT; WESTERN ST. JOHN'S WORT
Hypericum scouleri
St. John's Wort Family (Hypericaceae)

Flower: 5 small bright yellow petals in clusters, buds salmon colored, many anthers, black dots on edges
Leaves: Opposite, egg-shaped, stalkless, slightly clasping
Blooms: July-August Height: 6-24" tall
Found in moist, boggy ground and near stream banks.
hy PER i kum

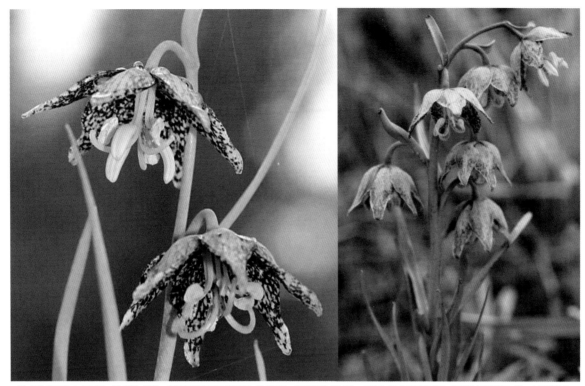

LEOPARD LILY; SPOTTED MT. BELLS; SPOTTED FRITILLARIA
Fritillaria atropurpurea
Lily Family (Liliaceae)

Flower: Mottled for camouflage, yellow and brown, almost purplish petals, large thick yellow anthers, 6 petals turned downward
Leaves: Long, thin, grass-like, and alternate
Blooms: April-July Height: 4-24" tall
Found in dry, gravely and grassy areas where sagebrush is also found. It is hard to see because of the "camouflage." It is more common than one would expect.
The bottom pictures show what one normally sees when walking in a grassy area.

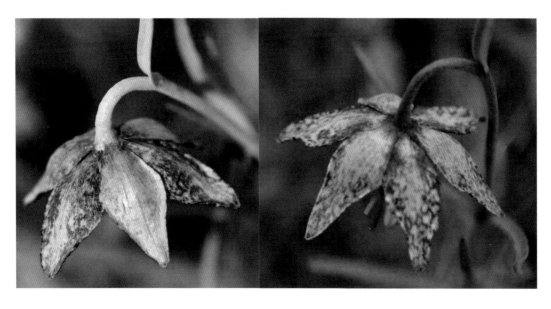

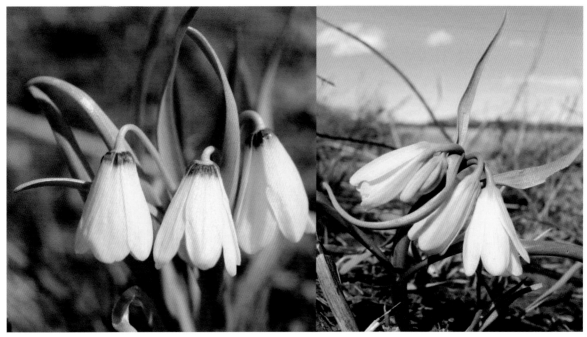

YELLOW BELL; YELLOW MISSIONBELLS
Fritillaria pudica
Lily Family (Liliaceae)

Flower: Bright yellow and bell-shaped, drooping, flowers turn orange as they age
Leaves: Narrow, long, alternate
Blooms: March-June Height: 3-12" tall
Found on open slopes, meadows and open forests in early spring as the snow is melting.
See the much smaller bottom one in the middle, which was photographed on Tom Cat Hill
in Craters of the Moon in April. One on the bottom far right is after it has bloomed.
Top right picture by *Gwen Russell*.

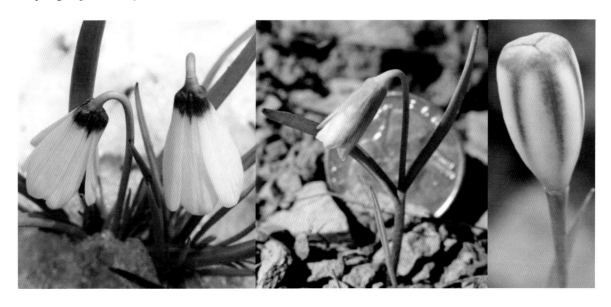

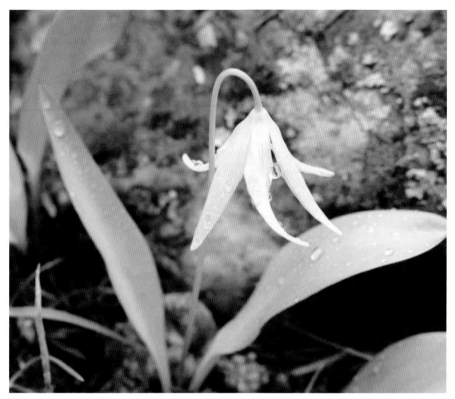

GLACIER LILY; YELLOW AVALANCHE LILY
Erythronium grandiflorum
Lily Family (Liliaceae)

Flower: Nodding, bright yellow, white throat, 6 petal-like segments, anthers can be cream, yellow or red
Leaves: Shiny green and lance-like basal leaves
Blooms: Right after or during the snowmelt in April or May Height: 4-16" tall
Found in moist mountain meadows and forest openings.

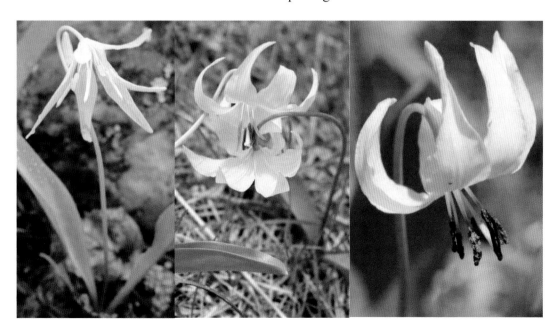

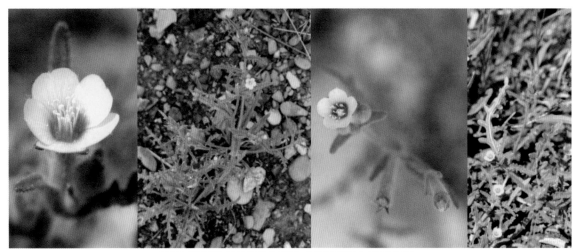

WHITESTEM BLAZING STAR
Mentzelia albicaulis
Blazing Star Family (Loasaceae)

Flower: Tiny and bright yellow, a red throat
Leaves: Leaves long, deeply lobed, slender branched stems
Blooms: June-August Height: 2-24" tall
Found in dry washes, foothills, areas adjacent to sagebrush, common but often unnoticed.

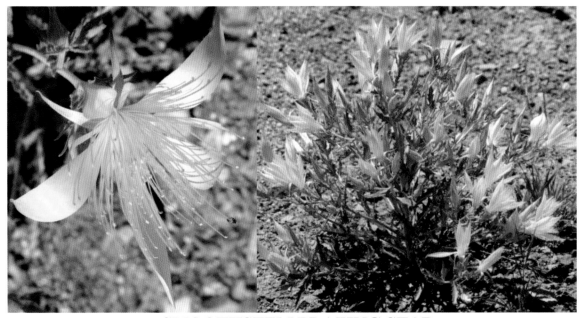

SMOOTHSTEM BLAZING STAR
Mentzelia laevicaulis
Blazing Star Family (Loasaceae)

Flower: Lemon yellow and star-shaped, yellow anthers
Leaves: Wavy leaves with large irregular notches, sticky barbed hairs
Blooms: Late June-August Height 1-3' tall
Found in clumps or solitary along rocky embankments, in washes and on slopes, in sandy or gravelly soil and on dry hills. This is a night blooming plant, closing before afternoon.

ROCKY MOUNTAIN POND LILY; SPATTERDOCK
Nuphar polysepala
Water-lily Family (Nymphaeaceae)

Flower: Yellow, globe-shaped, 2-4" across
Leaves: Egg- to heart-shaped and notched at base, from 4-18" long, leaves float on water
Blooms: May-September
Found in ponds and slow streams, photographed at Isa Lake in Yellowstone Park.

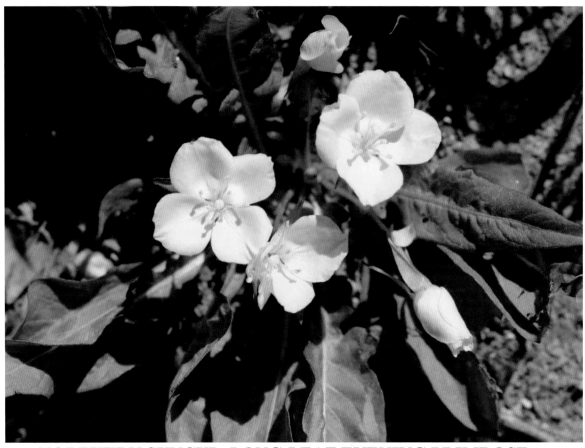

NORTHERN SUNCUP; LONG-LEAF EVENING PRIMROSE
Camissonia subacaulis
Evening Primrose Family (Onagraceae)

Flower: 4 bright yellow petals; height about 4" and flowers 1½" across
Leaves: Basal, usually lance-shaped, long, notice the difference in the leaves on this one and the Tansyleaf on the next page
Blooms: May-June Height: 3-5" tall
Found in moist meadows

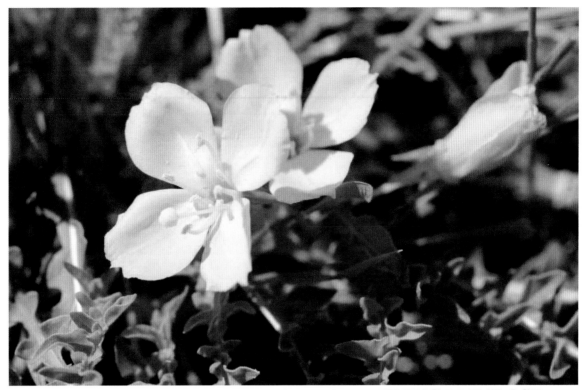

TANSYLEAF SUNCUP; TANSYLEAF EVENING PRIMROSE
Camissonia tanacetifolia
Evening Primrose Family (Onagraceae)

Flower: Bright yellow, 4 petals turns orange as it ages, yellow anthers
Leaves: Pinnately lobed
Blooms: July-August Height: 3-5" tall
Found in wet meadows and in drying up ponds.

PAIUTE SUNCUP; NAKED-STALK EVENING PRIMROSE
Chylismia scapoidea var. scapoidea
Evening Primrose Family (Onagraceae)

Flower: Very small yellow flower, 4 petals dotted with red spots
Leaves: Large, bright green, unusual oval leaves, red stems
Blooms: Early May to middle of June, have seen a few in July Height: 1-10" tall
Found on dry, rocky hillsides.

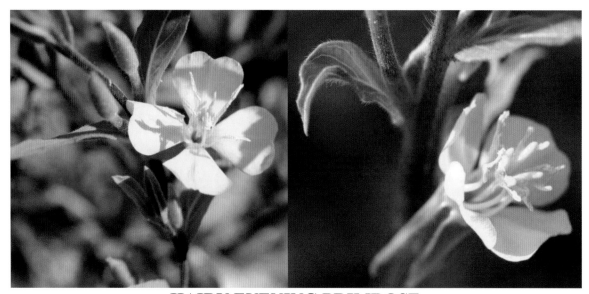

HAIRY EVENING PRIMROSE
Oenothera villosa var. strigosa
Evening Primrose Family (Onagraceae)

Flower: 4 bright yellow, showy petals, yellow anthers
Leaves: Lance-shaped, alternate, wavy edges, hairy reddish stems
Blooms: May-August Height: 2-5' tall
Found in dry shrub lands, along roadsides and in fields, common.

CHRIST'S INDIAN PAINTBRUSH
Castilleja christii
Figwort Family (Scrophulariaceae)

Flower: Grow in compact heads with individual flowers having colorful yellow, salmon, or light orange bracts.
Leaves: Lance-shaped and about 1" long
Blooms: July-August Height: 5-12" tall
Found only on south slopes near the summit of Mount Harrison, located south of Declo, Idaho. This is very **rare** plant found in alpine snow-field meadows where it grows with an assortment of grasses and wildflowers. This remarkable botanical site is easily accessed by car. Listed by the National Forest Service as a sensitive species.
Description and pictures by *Stephen L. Love.*

**CUSICK'S INDIAN
PAINTBRUSH** *Castilleja cusickii*
Figwort Family (Scrophulariaceae)

Flower: Pale yellow, sometimes violet lines on outside bracts
Leaves: Lanceolate to linear in shape, hairy, upward pointing
Blooms: May-June Height: 6-20" tall
Found in open meadows after snow has melted.

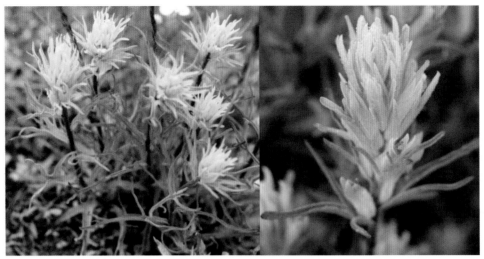

LEMON YELLOW INDIAN PAINTBRUSH
Castilleja flava
Snapdragon or Figwort Family (Scrophulariaceae)

Flower: Yellow and sometimes pale orange bracts, on wine-colored stem
Leaves: Narrow, divided and grey-green
Blooms: June-July Height: up to 14" tall
Found in dry fields on hillsides and sagebrush flats.

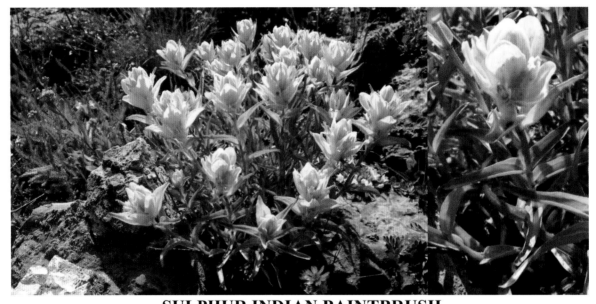

SULPHUR INDIAN PAINTBRUSH
Castilleja sulphurea
Snapdragon or Figwort Family (Scrophulariaceae)

Flower: Flowers clustered in an oblong, somewhat narrow terminal head, light yellow
ovate flower bracts, about 1" long, give color to the flower heads
Leaves: Narrowly lance-shaped, lacking lobes, with 3 prominent veins, 2-3" long
Blooms: June into September, depending on elevation Height: 10-20" tall
Found at mid- to high elevations on continuously moist slopes or meadows.
Photographs taken at the Grand Targhee Ski Resort, east of Driggs, Idaho.
Description and pictures by *Stephen L. Love.*

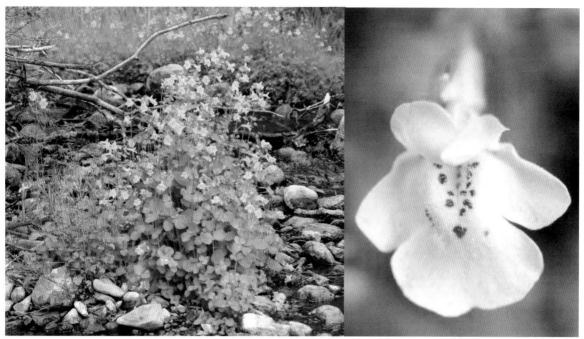

YELLOW MONKEYFLOWER; SEEP SPRING MONKEY FLOWER
Mimulus guttatus
Lopseed Family (Phrymaceae)

Flower: 5 yellow lobes, tubular, red dots or lines near the hairy throat, small hairs
Leaves: Oval, opposite, clasping leaves, hollow stems
Blooms: July-August Height: 4-30" tall
Found in moist meadows or along stream banks, common.

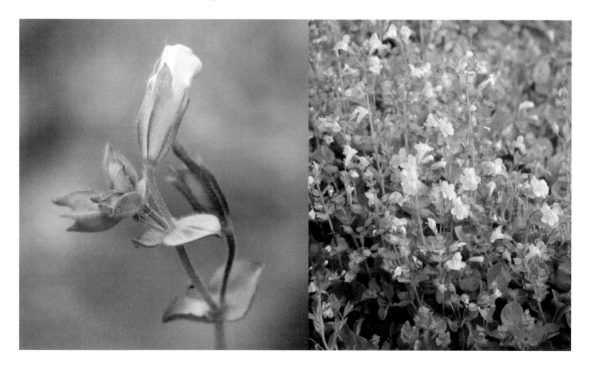

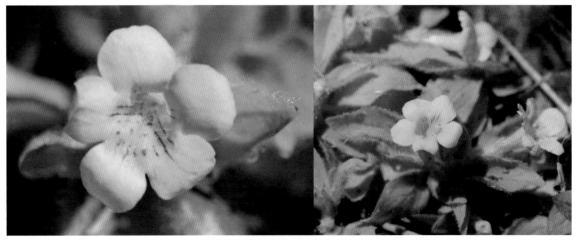

MUSKFLOWER
Mimulus moschatus
Lopseed Family (Phrymaceae)

Flower: 5 yellow lobes with red dots or lines near the throat, hairy
Leaves: Oblong, with small hairs, barely toothed
Blooms: June-August Height: 3-10" tall
Found in partial shade along streams or in slow moving streams. Have seen along
Deep Creek near the border between Idaho and Montana in Lemhi County also
near a small creek on the Lolo Trail.

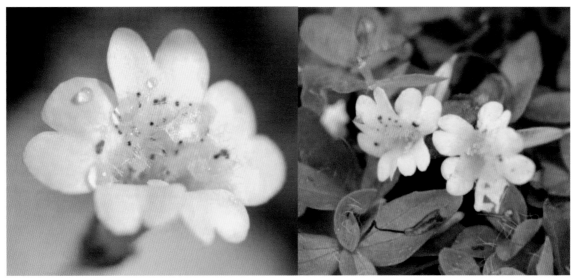

PRIMROSE MONKEYFLOWER; CREEPING LITTLE MONKEYFLOWER
Mimulus primuloides
Lopseed Family (Phrymaceae)

Flower: Tiny, mat forming, yellow with red-brown spots, notched petals, yellow anthers
Leaves: Edges have white hairs, oval
Blooms: June-July Height: 1-6" tall
Found in wet meadows. These photographed on a trail near Stanley Lake.

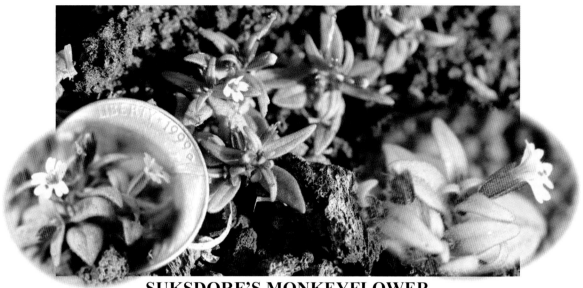

SUKSDORF'S MONKEYFLOWER
Mimulus suksdorfii
Lopseed Family (Phrymaceae)

Flower: Tiny, bright yellow, red dots in the throat, about 1/8" across
Leaves: Narrow
Blooms: May-June Height: ½-2" tall
Found in desert mountains and foothills. Photographed at Craters of the Moon.
Note: This wildflower was in the Figwort Family (Scrophulariaceae)

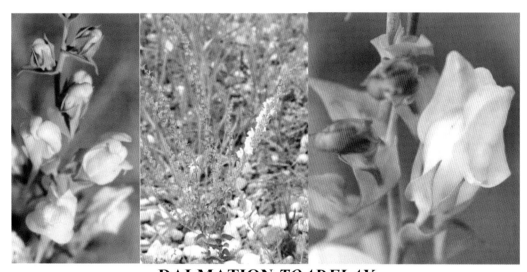

DALMATION *TOADFLAX*
Linaria dalmatica
Plantain Family (Plantaginaceae)

Flower: Yellow clusters, 5 lobes, 3 lower, with orange-yellow center, orange flower buds
Leaves: Alternate, egg-shaped, sharp tips
Blooms: June-July Height: 1-2½' tall
Found in plains, fields, and disturbed places, **considered a noxious weed, not native.**

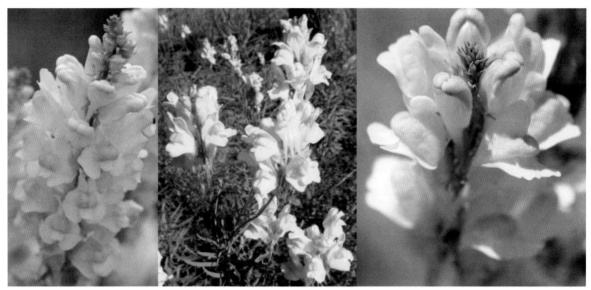

BUTTER AND EGGS
Linaria vulgaris
Plantain Family (Plantaginaceae)

Flower: Yellow clusters on a spike, orange-yellow center, 5 petals, 2 upper and 3 lower, lower bends backward
Leaves: Alternate, narrow, stiff stem
Blooms: July-August Height: 1-3' tall
Found in disturbed places, **not native and considered a noxious weed.**

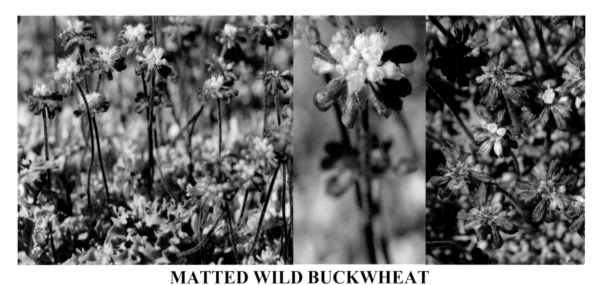

MATTED WILD BUCKWHEAT
Eriogonum caespitosum
Buckwheat, Knotweed or Smartweed Family (Polygonaceae)

Flower: Yellow, blooms from female plants turn red after pollination, while those from male plants remain yellow
Leaves: Gray-green, plants form a compact mat, hairy
Blooms: June-July Height: up to 4" tall
Found in the higher elevations in dry areas near sagebrush and in rocky and sandy areas.

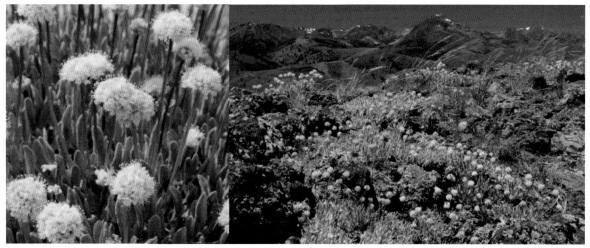

HIDDEN BUCKWHEAT
Eriogonum capistratum
Buckwheat, Knotweed or Smartweed Family (Polygonaceae)

Flower: Many extremely tiny flowers grow in dense spherical heads and grow at the top of unbranched stems, flowers hairy and dark yellow in color
Leaves: Small, less than 1" long, narrow, furry and silvery in color
Blooms: June and July Height: 3-6" tall
Found on dry, gravely and rocky slopes and ridges where there is minimal competition from larger plants. Photographed in the Antelope Valley and Iron Bog Creek areas of the Pioneer Mountains in Idaho. Description and pictures by *Stephen L. Love.*

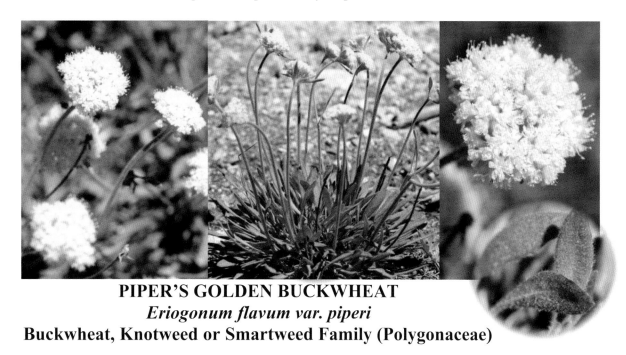

PIPER'S GOLDEN BUCKWHEAT
Eriogonum flavum var. piperi
Buckwheat, Knotweed or Smartweed Family (Polygonaceae)

Flower: Bright yellow balls, umbrella-shaped cluster
Leaves: Narrow, lanceolate, basal, smooth on top and hairy underneath
Blooms: June-July Height: 4-12" tall
Found higher elevations around rocky ground.
Photographed near Stanley Lake, Idaho, also called Alpine Golden Buckwheat.
Flowers were used by some Native Americans as an additive for tanning buffalo hides.

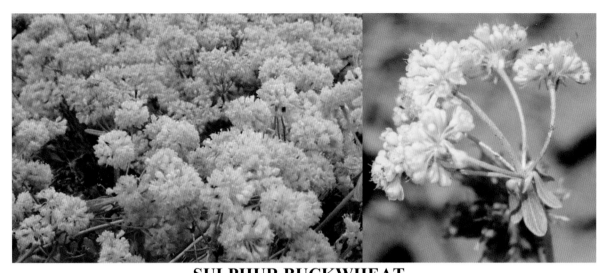

SULPHUR BUCKWHEAT
Eriogonum umbellatum var. ellipticum
Buckwheat, Knotweed or Smartweed Family (Polygonaceae)

Flower: Bright yellow, umbrella-like clusters
Leaves: Oval, spoon-shaped
Blooms: June-August Height: 2-12" tall
Found in dry and rocky areas, common.

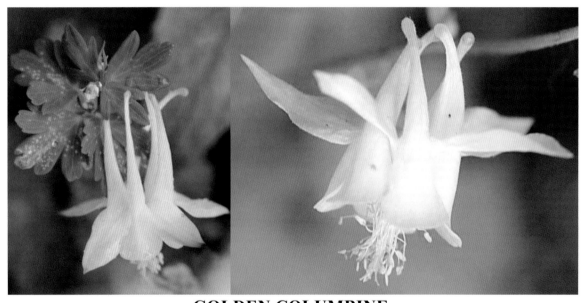

GOLDEN COLUMBINE
Aquilegia flavescens
Buttercup Family (Ranunculaceae)

Flower: Pale to dark yellow with 4 spurs ½-¾"
Leaves: Leaves divided into wedge-shaped leaflets
Blooms: Late June-July Height: 6-30" tall
Found in woods, along rocky slopes and in mountain meadows.

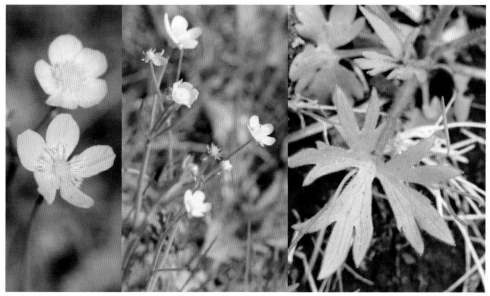

SHARPLEAF BUTTERCUP; MOUNTAIN SHARP BUTTERCUP
Ranunculus acriformis var. montanensis
Buttercup Family (Ranunculaceae)

Flower: Yellow and usually has 5 petals, green center and yellow anthers
Leaves: 3-part compound leaves, a long hairy stem
Blooms: May-July Height: 1-2' tall
Found along creeks and in moist meadows.

WATER PLANTAIN BUTTERCUP; PLANTAINLEAF BUTTERCUP
Ranunculus alismifolius
Buttercup Family (Ranunculaceae)

Flower: Bright yellow, oval petals
Leaves: Lance-shaped to oblong, basal, not hairy
Blooms: April-June Height: 1-3' tall
Found in bogs and wet meadows, photographed along the Lolo Trail.

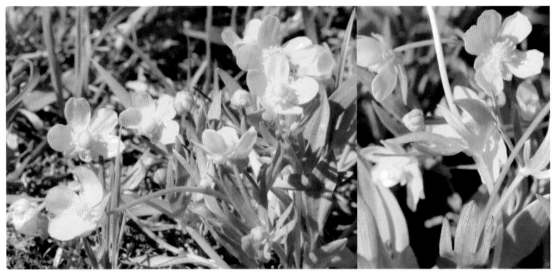

SNOWPATCH BUTTERCUP; ESCHSCHOLTZ'S BUTTERCUP
Ranunculus eschscholtzii
Buttercup Family (Ranunculaceae)

Flower: Yellow, 5-8 petals, bowl-shaped
Leaves: Deeply lobed, 3-7 lobes, basal
Blooms: May-June Height: 3-10" tall
Found in moist meadows, bogs, and woodlands.

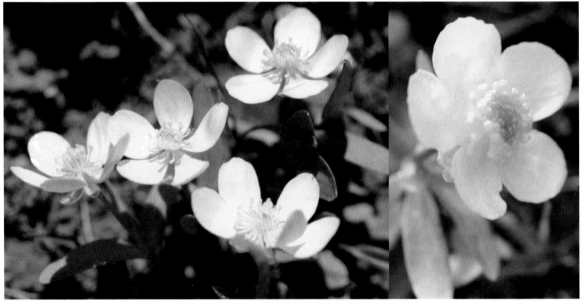

SAGEBRUSH BUTTERCUP
Ranunculus glaberrimus
Buttercup Family (Ranunculaceae)

Flower: Bright yellow, 5 petals, has a shiny gloss, round green center
Leaves: Basal, fleshy with oval leaves and smooth edges, often has 3 lobes
Blooms: March-June Height: 2-8" tall
Found easily found in areas where there is sagebrush or in open pinewoods.

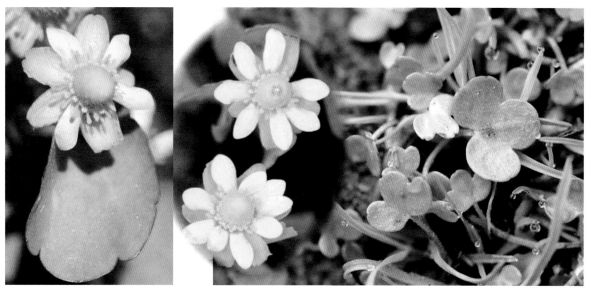

LITTLE YELLOW BUTTERCUP
Ranunculus sceleratus
Buttercup Family (Ranunculaceae)

Flower: Yellow flowers about 1/3" across with a large green center
Leaves: Fleshy, 3 lobes
Blooms: May-July Height: 2-8" tall
Found easily by small creeks, in ditches, and swampy marshes.

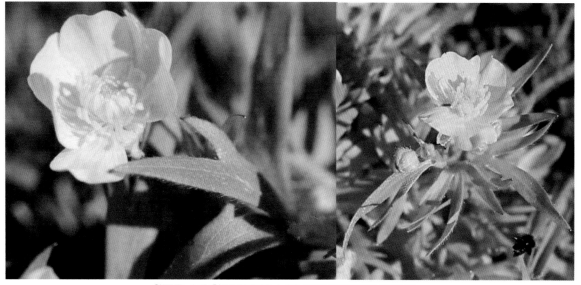

STRAIGHTBEAK BUTTERCUP
Ranunculus orthorhynchus
Buttercup Family (Ranunculaceae)

Flower: Yellow, 5 or 6 petals, green center, yellow anthers
Leaves: Usually divided into 3 or 5 coarsely toothed leaflets
Blooms: May-June Height: up to 30" tall
Found in found in meadows where the ground is still wet.

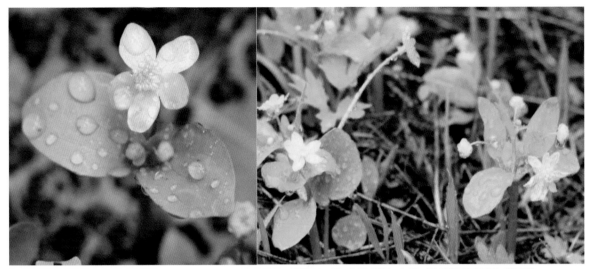

BLUE MOUNTAIN BUTTERCUP; POPULAR BUTTERCUP
Ranunculus populago
Buttercup Family (Ranunculaceae)

Flower: Shiny with 5 or 6 yellow petals
Leaves: Heart to spoon-shaped
Blooms: April-May Height: 3-12" tall
Found in wet meadows, along streams in the higher elevations.
These photographed along the Lolo Trail.

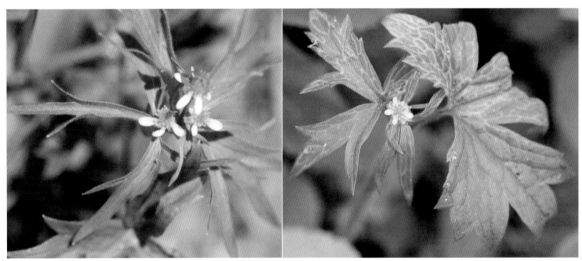

LITTLE BUTTERCUP; WOODLAND BUTTERCUP
*Ranunculus uncinatus**
Buttercup Family (Ranunculaceae)

Flower: Very small, yellow petals that are only about ¼" wide, prominent green center
Leaves: Very large basal leaf blades, 1-3" wide, divided into 3 lobed leaflets, deeply veined in a light green
Blooms: June-July Height: 10-30" tall
Found in moist areas, open forests and along stream banks.
Photographed in Yellowstone Park.
un sin NA tus

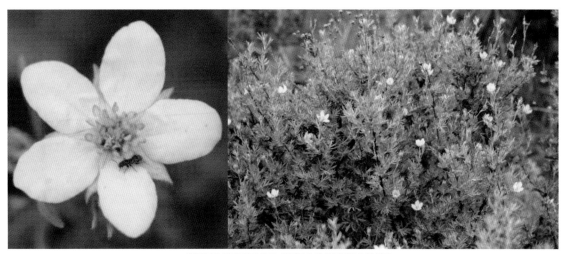

SHRUBBY CINQUEFOIL
Dasiphora fruticosa Potentilla fruticosa*
Rose Family (Rosaceae)

Flower: 5 broad bright yellow petals, yellow-gold anthers
Leaves: Woody and tall with small grayish-green leaves divided into narrow leaflets
Blooms: June-September Height: up to 3' tall
Found easily on rocky slopes, near streams and moist meadows.
**poh ten TILL luh*

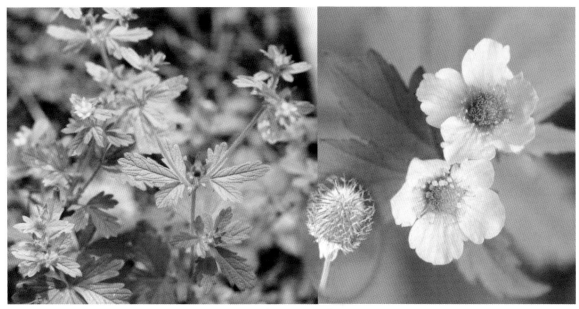

ALPINE AVENS; LARGELEAF AVENS
Geum macrophyllum
Rose Family (Rosaceae)

Flower: Bright yellow, saucer-shaped, 5 petals, ½-1" wide
Leaves: Large basal with heart to kidney-shaped on the stem, deeply lobed
Blooms: June-August Height: 1-3' tall
Found in open meadows, along stream banks and in moist forested areas.

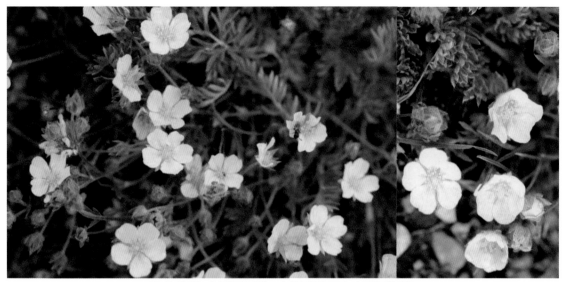

ROSS' AVENS; ALPINE AVENS
Geum rossii
Rose Family (Rosaceae)

Flower: Bright and shiny, 5 yellow petals, yellow-gold anthers
Leaves: Finely cut shiny leaves with maroon buds, plants hug the ground
Blooms: May-June Height: 3-8" tall
Found in higher elevations near tree lines, often in large colonies.

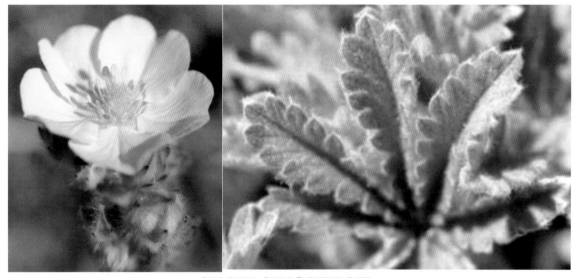

SNOW CINQUEFOIL
Potentilla nivea
Rose Family (Rosaceae)

Flower: Bright yellow petals, saucer-shaped, yellow anthers
Leaves: Basal, alternate, 3-5 leaflets, hairy, soft, velvety, reddish stem
Blooms: May Height: 2-6" tall
Found in canyons, along dirt trails, on rock faces. These photographed
in the Copper Basin near Corral Creek in Custer County, Idaho.

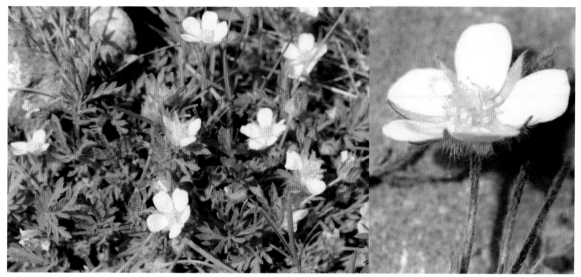

SHEEP CINQUEFOIL
Potentilla ovina
Rose Family (Rosaceae)

Flower: 5 bright yellow petals, yellow anthers
Leaves: Linear, pinnately divided into 9-21 deeply lobed leaflets, hairy, creeping plant with a wine-red stem, hugs the ground
Blooms: May-June Height: 2-8" tall
Found in open woods and meadows.

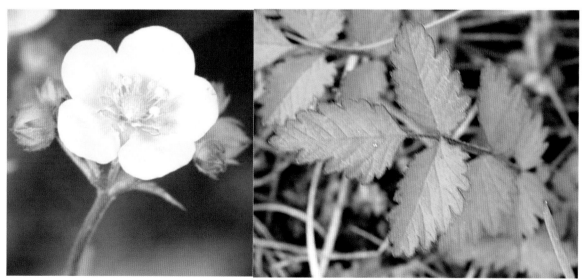

PENNSYLVANIA CINQUEFOIL
Potentilla pensylvanica
Rose Family (Rosaceae)

Flower: 5 bright yellow petals, about ¼" wide, heart-shaped or round, yellow anthers
Leaves: Leaves pinnately compound with 5-15 leaflets, hairy underneath
Blooms: June-August Height: 2-8" tall
Found in meadows, roadsides, dry gravelly areas, and grasslands.

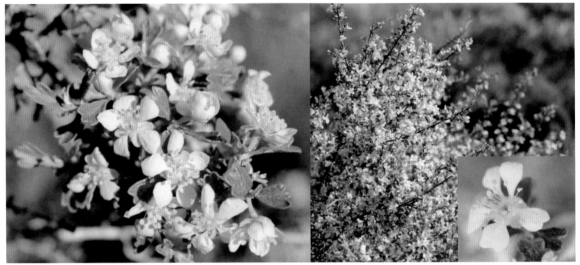

ANTELOPE BITTERBRUSH; BITTERBRUSH
Purshia tridentata
Rose Family (Rosaceae)

Flower: 5 light yellow-cream petals, very fragrant, yellow anthers
Leaves: 3 lobes on this large shrub
Blooms: April-early June Height: 2-6' tall
Found in sandy soils from desert valleys to mountain slopes,
common in areas where there is sagebrush.

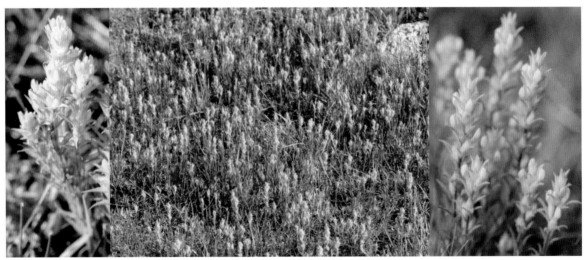

YELLOW OWL'S CLOVER
Orthocarpus luteus*
Figwort or Snapdragon Family (Scrophulariaceae)

Flower: Yellow, spike-like clusters, 2-lipped, upper forms a short beak
Leaves: Short, lance-shaped, alternate 3-5 lobed bracts
Blooms: June to August Height: up to 16" tall
Found in dry, open sites, hillsides, near sage scrub, and in moist meadows.
**or thoh KAHR puhs*

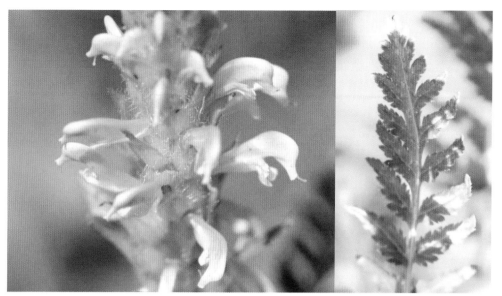

BRACTED LOUSEWORT; SMOOTHFLOWER LOUSEWORT
Pedicularis bracteosa var. siifolia
Figwort or Snapdragon Family (Scrophulariaceae)

Flower: Yellow hooded with a short lower lip, spike-like clusters
Leaves: Alternate and in segments, ladder-like
Blooms: June-July Height: 12-36" tall
Found in moist, wooded areas. Photographed on the Lolo Trail.

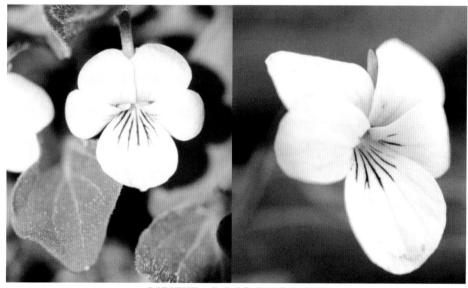

NUTTALL'S VIOLET
Viola nuttallii
Violet Family (Violaceae)

Flower: 5 bright yellow petals, lower petals have purple or brownish veins
Leaves: Lance-shaped, deeply veined
Blooms: April-May Height: 3-6" tall
Found in foothills and moist meadows.

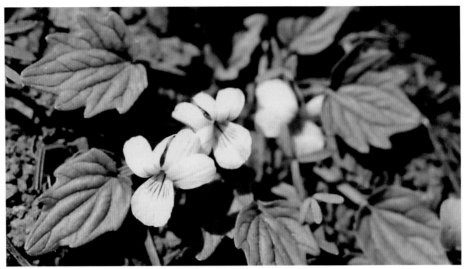

GOOSEFOOT VIOLET
Viola purpurea
Violet Family (Violaceae)

Flower: 5 bright yellow, lower petal has purple or brownish veins
Leaves: Oval, fleshy with ridges on the leaves and deep veins, leaf resembles
the foot of a goose
Blooms: April-June Height: 2-8" tall
Found in foothills and meadows.

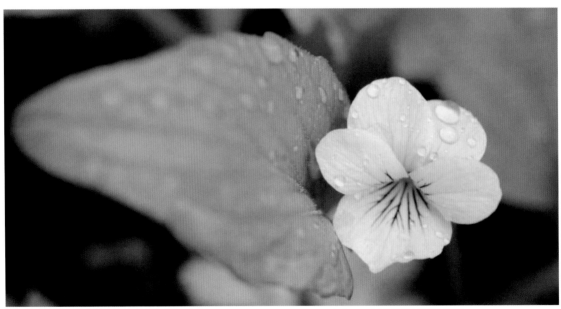

SAGEBRUSH VIOLET; VALLEY VIOLET
Viola vallicola
Violet Family (Violaceae)

Flower: 5 yellow petals, 2 upper and 3 lower with brownish-purple stripes near the throat
Leaves: Large broad lanceolate leaves, smooth-edged or shallow teeth
Blooms: May-June Height: 2-10" tall
Found along stream banks, marshes. Picture by *Callie Russell.*

RED AND ORANGE FLOWERS

Rocky Mountain Indian Paintbrush by *Stephen L. Love.*

This section is for orange and red wildflowers.

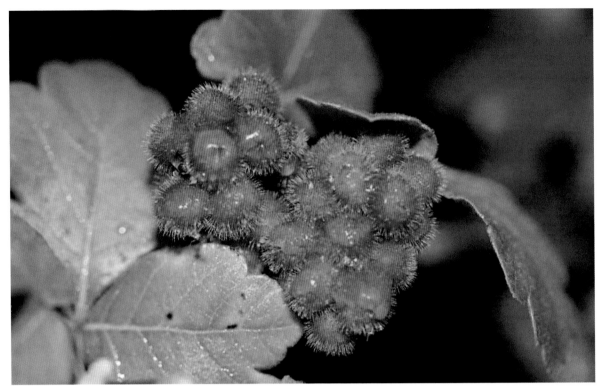

THREELEAF SUMAC; SKUNK BUSH
Rhus trilobata
Sumac Family (Anacardiaceae*)

Flower: Small dense white-yellowish clusters, followed by cluster of red hairy berries
Leaves: Alternate, 3 leaflets, coarsely toothed, shiny, smells when crushed
Blooms: May Berries: late July-August Height: 5-6' tall
Found in grasslands and mountainous shrub land.
*a nuh kar dih AY see ee

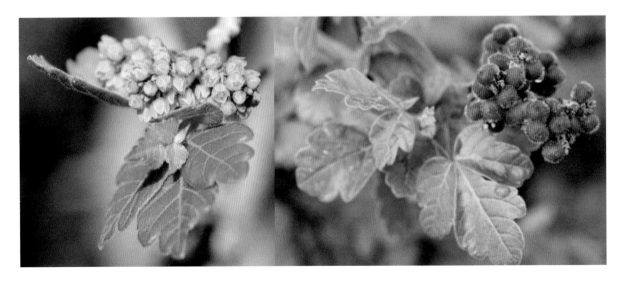

PRAIRIE CONEFLOWER; MEXICAN-HAT
Ratibida columnifera
Aster Family (Asteraceae)

Flower: Dark brown-yellowish center disk with yellow and red drooping rays, almost like a Mexican sombrero
Leaves: Lobbed or feathery
Blooms: July-September Height: 1½-3' tall
Found on prairies, along roadsides, fields, and in disturbed areas.
Top pictures by *Don Russell*.

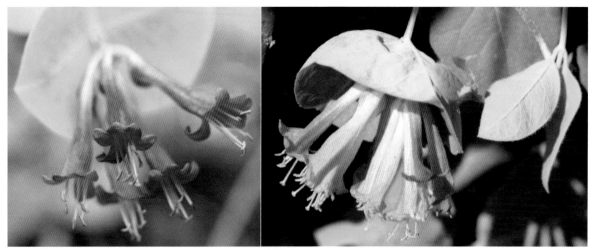

TRUMPET HONEYSUCKLE; ORANGE HONEYSUCKLE
Lonicera ciliosa
Honeysuckle Family (Caprifoliaceae)

Flower: Bright orange-red, trumpet-shaped, 1-1½" long
Leaves: Opposite, egg-shaped, a vine that climbs trees
Blooms: May to July Height: vine 6-16' long
Found on wooded slopes. Top left picture by *Eric Russell.*

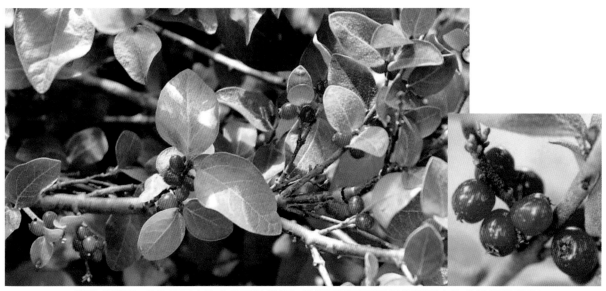

SILVER BUFFALOBERRY; RUSSETT BUFFALOBERRY
Shepherdia canadensis
Oleaster Family (Elaeagnaceae*)

Flower: Cluster, white to pale yellow, berries shiny, bright red
Leaves: Shiny, leathery, oval, opposite, has tiny white spots
Berries: July-August Height: 3-8' tall
Found in wooded areas and along streams.
eh lee ag NAY see ee

MOUNTAIN LOVER; MYRTLE BOX-LEAF
Paxistima myrsinites*
Staff Tree family (Celastraceae*)

Flower: Small, maroon or reddish-brown, tiny tubular flowers, 4 petals
Leaves: Fine teeth on the shiny, deep green oval leaves
Blooms: June-August Height: 1-3' tall
Found along lakes and in moist meadows. Photographed near Glacier National Park.
**puh KISS tih muh *see lass TRAY see ee*

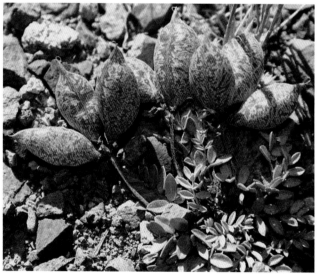

BALLOONPOD MILKVETCH; WHITNEY'S LOCOWEED PODS
Astragalus whitneyi
Pea, Bean, or Legume Family (Fabaceae)

Flower: Cream, upper petal in some varieties pink or purple, unusual for its
bright red balloon-like pods that are shown above
Leaves: Flower stems point upward with lower leaf stalks fused around stem
Blooms: June-July
Found in rocky soils at mid-to-high elevations.

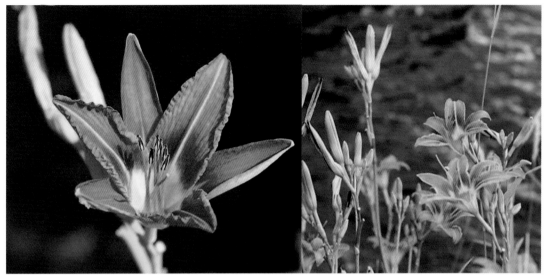

DITCH LILIES; TIGER LILY; ORANGE DAY LILY
Hemerocallis fulva
Lily Family (Liliaceae)

Flower: Light to dark orange, bell-shaped, 6 petals
Leaves: Basal, linear, sword-shaped
Blooms: July-August Height: up to 40" tall
Found near ditches, roadsides, disturbed places, in gardens, **not native.**

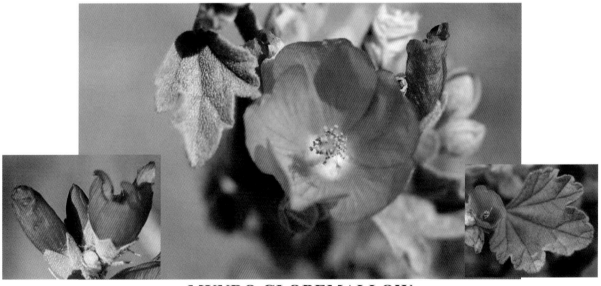

MUNRO GLOBEMALLOW
Sphaeralcea munroana*
Mallow Family (Malvaceae*)

Flower: Clusters of 5 bright reddish-orange cup-shaped petals
Leaves: Light green, scalloped to lobed, speckled, deeply veined
Blooms: June-August Height: 1-3' tall
Found in in many different soil types, very common.
**sfee RAL see ah *mal VAY see ee*

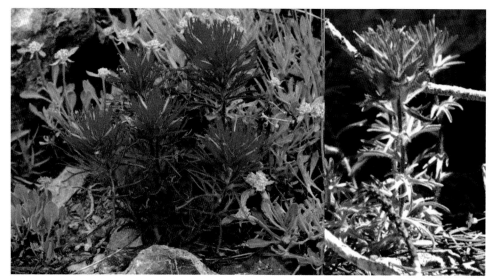

ROCKY MT. INDIAN PAINTBRUSH; COVILLE'S INDIAN PAINTBRUSH
Castilleja covilleana
Broomrape Family (Orobanchaceae)

Flower: Red, scarlet or orange-yellow bracts, clusters resemble a paintbrush
Leaves: Alternate, deeply divided, 3-7 linear lobes, long soft hairs
Blooms: Late June-early August Height: 4-8" tall
Found at high elevations on rocky ridges and forest openings.
Pictures by *Stephen L. Love.*

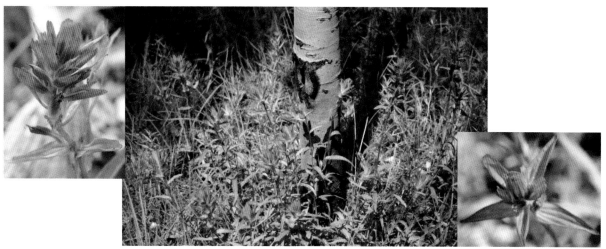

SCARLET INDIAN PAINTBRUSH; GIANT RED INDIAN PAINTBRUSH
Castilleja miniata
Broomrape Family (Orobanchaceae)

Flower: Red, scarlet, to red-orange, clusters are elongated and, like the name, a paintbrush
Leaves: Narrow and lance-shaped
Blooms: July-August Height: 12-30" tall
Found in valleys, forests, and moist mountain meadows, common.

FIRE POPPY
Papaver californicum
Poppy Family (Papaveraceae*)

Flower: Bowl-shaped, 4 fan-shaped bright orange petals, a long hairy stem, green center
Leaves: Alternate and basal
Blooms: May-June Height: 1-2½' tall
Found along roadsides, in woodlands; blooms after a fire. Photographed near Kamiah, Idaho.
**pap pa ver RAY see ee*

SCARLET GILIA; SCARLET SKY ROCKET
Ipomopsis aggregata
Phlox Family (Polemoniaceae)

Flower: 5 red-orange or scarlet petals in the form of a star with a speckling of white,
on a long tube, favorite of hummingbirds and moths
Leaves: Narrow and pinnately divided, hairy with white hairs
Blooms: April-August Height: 1-4' tall
Found in open meadows, along roadsides and in dry valleys, common.

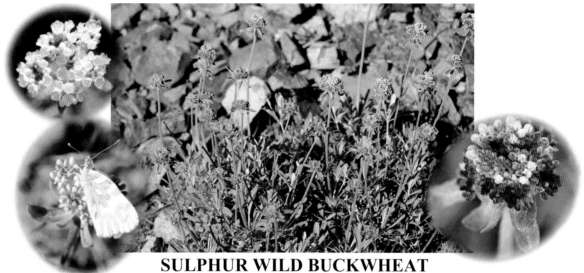

SULPHUR WILD BUCKWHEAT
Eriogonum umbellatum var. umbellatum
Buckwheat, Knotweed or Smartweed Family (Polygonaceae)

Flower: Red, yellow, cream in umbel-like cluster, 6-9 on stem, tubular, fade to orange or red
Leaves: Oval, mat of gray-green leaves, erect stem
Blooms: May-July Height: 4-14" tall
Found in dry semi desert areas, mountain slopes and ridges.
Note the umbellatum has many varieties that are highly variable and difficult to distinguish.

RED COLUMBINE; WESTERN COLUMBINE
Aquilegia formosa
Buttercup Family (Ranunculaceae)

Flower: 5 yellow and red tubular petals red, a long spur, long yellow anthers
Leaves: Lobed into 2 or 3 segments
Blooms: June-August Height: 1-4' tall
Found in open woods, mountain meadows and along streams, common.

FIVESTAMEN MITERWORT; ALPINE MITERWORT
Mitella pentandra
Saxifrage Family (Saxifragaceae)

Flower: 5 tiny green petals, saucer-shaped, fringed lobes on each side each side of the petal, reddish-brown center, very odd looking
Leaves: Basal, heart-shaped to oval
Blooms: May-August Height: 8-16" tall
Found by slow moving streams in shade, in bogs and moist woods.

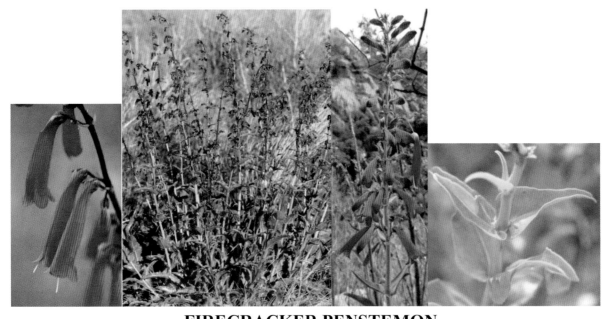

FIRECRACKER PENSTEMON
Penstemon eatonii
Snapdragon or Figwort Family (Scrophulariaceae)

Flower: Scarlet, tubular-shaped, about 1-1¼" long
Leaves: Opposite, arrow-shaped, thick, leathery, broadly lance-shaped
Blooms: June-July Height: 1-3' tall
Found easily along roadsides, on desert slopes and in open woods.

BLUE, LAVENDER, and PURPLE FLOWERS

Field of Common Camas near Stanley Creek, Idaho.

This section includes flowers ranging from dark purple to lavender and different shades of blue.

BACHELOR BUTTONS; GARDEN CORNFLOWER
Centaurea cyanus
Aster or Composite Family (Asteraceae*)

Flower: Usually blue but sometimes pink, purple or white
Leaves: Alternate, narrow, grayish and hairy
Blooms: June-July Height: 12-36" tall
Found in gardens, meadows, disturbed places, **not native.**
ass ter AY see ee

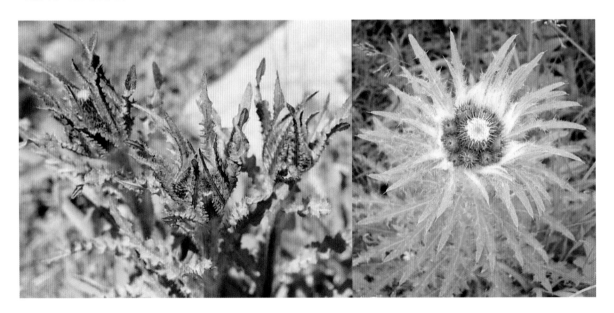

ELK THISTLE; MEADOW THISTLE
Cirsium scariosum
Aster or Composite Family (Asteraceae)

Flower: Pink, lavender, deep rose or white, clustered together at the end of large stems
Leaves: Light green, long and hairy, deeply cut into many lobes with teeth, lightly hairy, spiny
Blooms: Late June-August Height: 1-5' tall
Found on wooded slopes, it prefers moist soil. In 1870, the explorer Everts became separated from the main group and subsisted on the raw root of this plant.

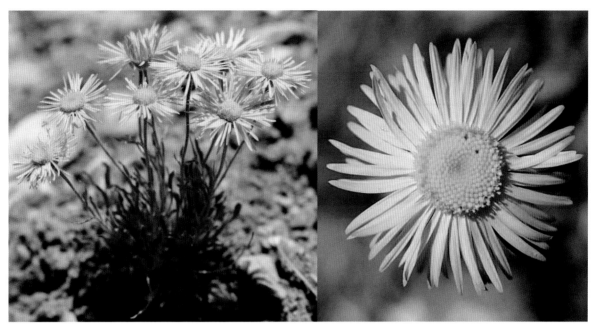

LONGLEAF FLEABANE; FOOTHILLS DAISY
Erigeron corymbosus*
Aster or Composite Family (Asteraceae)

Flower: Lavender-blue ray flowers, bright yellow disk, rays (35-65), occasionally pink
Leaves: Long and narrow, pointed tip, basal, very hairy
Blooms: May-June Height: 4-20" tall
Found among the sagebrush in open dry areas.
*er IJ er on *kor rim BOW sus

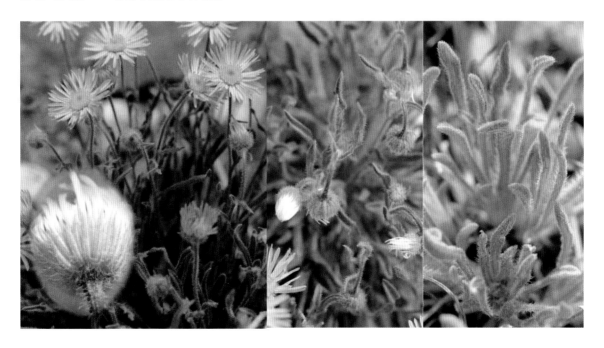

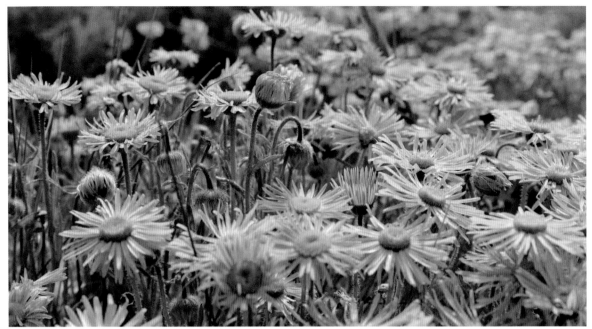

SHAGGY FLEABANE
*Erigeron pumilus**
Aster or Composite Family (Asteraceae)

Flower: Lavender-blue, white, or pink ray flowers (20-50), around a thick yellow disk
Leaves: Clusters of narrow basal leaves, hairy stems, oblanceolate or linear-oblanceolate
leaves, notice the big difference in the leaves between the *pumilus* and the *speciosus*
Blooms: May-August Height: 6-12" tall
Found in dry open places.
POO mel us

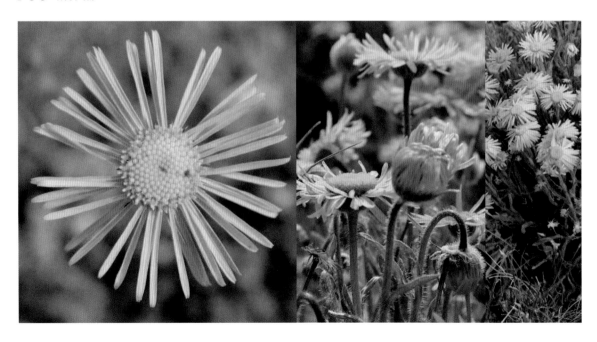

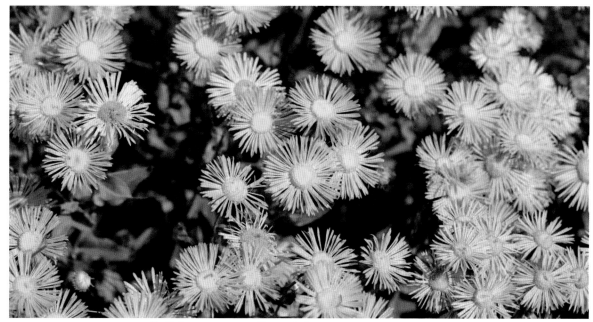

SHOWY DAISY; ASPEN FLEABANE
Erigeron speciosus
Aster or Composite Family (Asteraceae)

Flower: Blue-lavender, narrow ray flowers, a bright yellow disk
Leaves: Alternate, lance-shaped, not toothed, evenly distributed along the stem, notice how different the leaves are in the *pumilus* and the *speciosus*
Blooms: June-August Height: 6-30" tall
Found in meadows and foothills.
Left bottom picture by *Caleb Russell*.

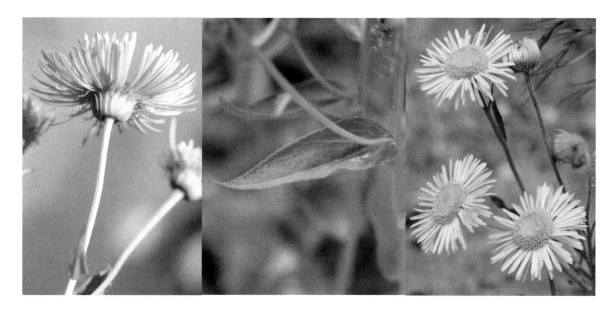

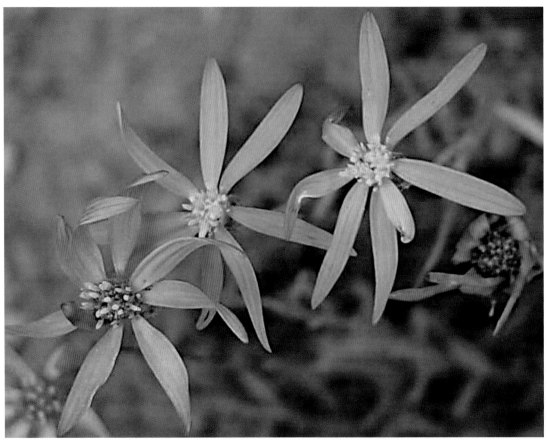

ELEGANT ASTER
Eucephalus elegans
Aster or Composite Family (Asteraceae)

Flower: Lavender or purple rays (5-8), yellow disk, shingled bracts on the back of the flower
Leaves: Long, linear or lance-shaped, alternate
Blooms: July-August Height: 1-2½' tall
Found in forests and open meadows and on rocky slopes.
These were found ½ mile up the Mt. Borah Trailhead in August.

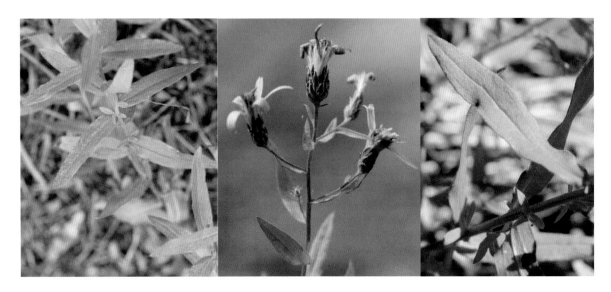

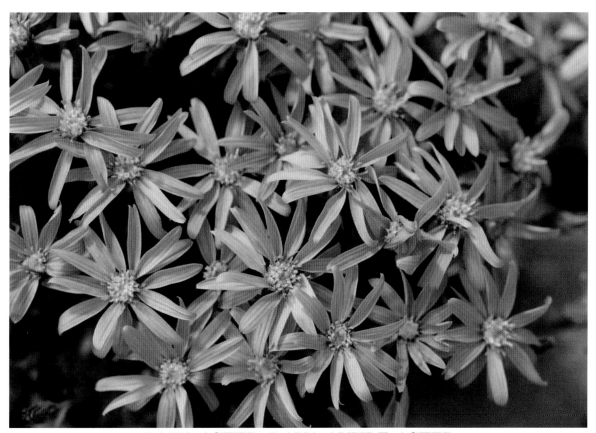

LAVA ASTER; LAVA ANKLE-ASTER
Ionactis alpina
Aster or Composite Family (Asteraceae)

Flower: Bright yellow disk, 8-16 light to dark lavender rays
Leaves: Narrow, gray-green, oval to lance-shaped, pointed, hairy
Blooms: May-June Height: 5-12" tall
Found in sagebrush flats and on rocky slopes.

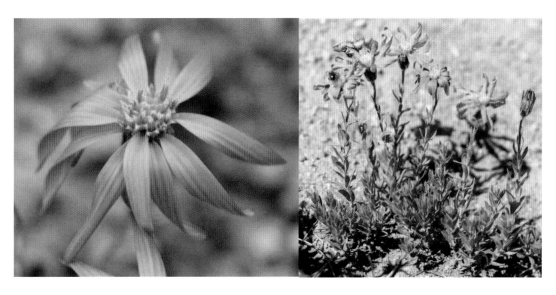

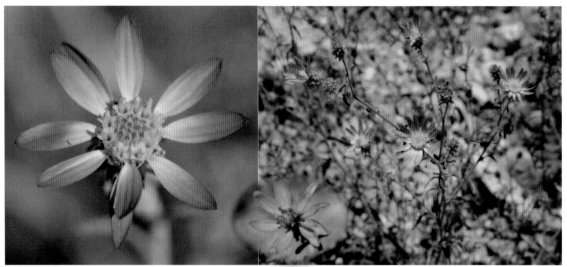

HOARY TANSYASTER
Machaeranthera canescens* var. canescens*
Aster Family (Asteraceae)

Flower: Tiny lavender ray flowers, 8-20, a bright yellow or gold disk
Leaves: Linear and often toothed
Blooms: July-August Height: 12-36" tall
Found in sandy and rocky areas and on dry sagebrush flats, places where not much else is growing, common.
*mak ee RANTH er uh *kan ESS kens*

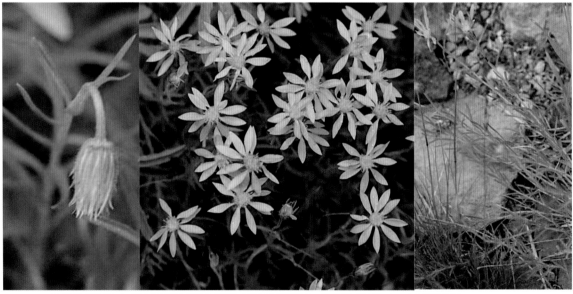

TUNDRA MOUNTAIN CROWN; TUNDRA ASTER
Oreostemma alpigenum var. haydenii
Aster Family (Asteraceae)

Flower: Ray flowers 10-40, violet or lavender, yellow or gold disk
Leaves: Long and narrow, less than 4"
Blooms: June-August Height: 2-16" tall
Found in high mountain meadows, on rocky slopes, and in boggy places.

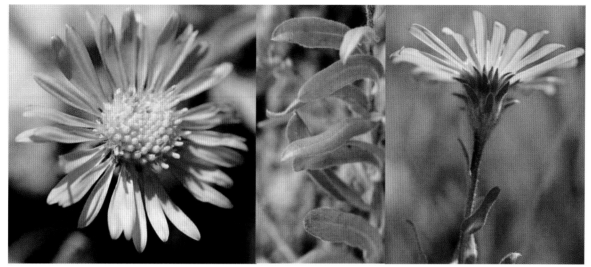

WESTERN MEADOW ASTER
Symphyotrichum campestre
Aster or Composite Family (Asteraceae)

Flower: Lavender or purple ray flowers, 15-20, on a short stem, yellow disk
Leaves: Basal leaves, lance to spoon-shaped, hairy and light green and go all the way up the stem, tiled bracts under the heads and not the same length, hairy
Blooms: August-September Height: up to 10" tall
Found on dry, rocky slopes and in meadows.
Saw August 15 near Doublesprings Pass in Custer County, Idaho, 8,318 feet.

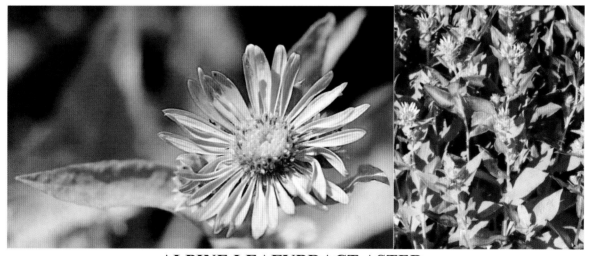

ALPINE LEAFYBRACT ASTER
Symphyotrichum foliaceum
Aster or Composite Family (Asteraceae)

Flower: Lavender to rose, purple or blue, solitary, yellow center
Leaves: Basal, egg- or lance-shaped
Blooms: July-September Height: up to 24" tall
Found on moist grassy slopes, stream banks, moist meadows, open forests.
Photographed in Glacier Park, Montana.

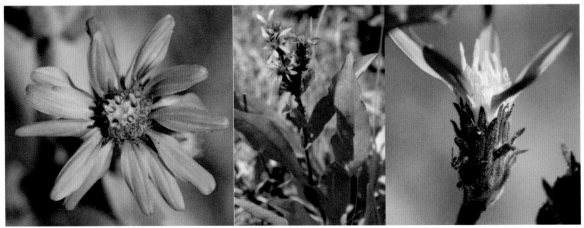

ALPINE LEAFYBRACT ASTER
Symphyotrichum foliaceum var. apricum
Aster or Composite Family (Asteraceae)

Flower: Lavender to dark purple ray flowers, a brownish or yellow disk, bracts cupping the flower head are purple-crimson (see picture on right)
Leaves: Large lance-shaped clasping leaves and basal ones
Blooms: July-August Height: 8-24" tall
Found near streams and in moist meadows.

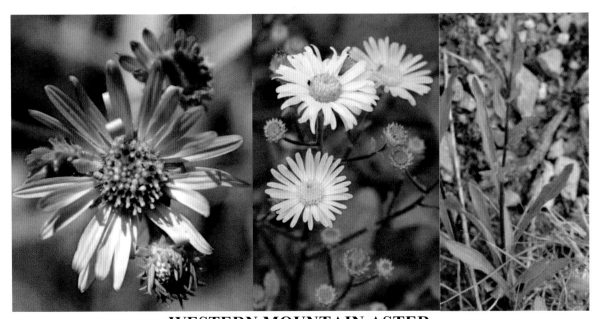

WESTERN MOUNTAIN ASTER
Symphyotrichum spathulatum
Aster or Composite Family (Asteraceae)

Flower: 15-40 lavender to blue-lavender or violet rays, yellow centers
Leaves: Lower leaves lanceolate and thin, narrower and shorter progressively up the stem
Blooms: July-September Height: 12-30" tall
Found in meadows, along stream banks and other moist areas.
Flower is extremely variable and widespread.

222

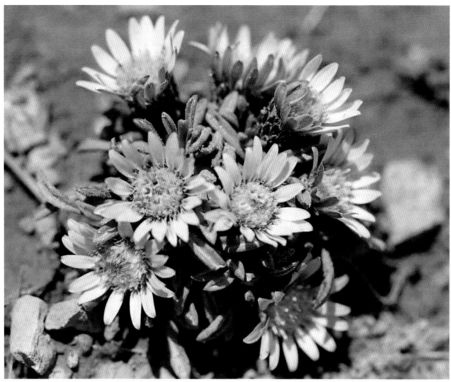

MOUNTAIN TOWNSENDIA; WYOMING TOWNSENDIA DAISY
Townsendia alpigena
Aster or Composite Family (Asteraceae)

Flower: Showy tiny lavender ray flowers (range from near white to light purple) with a large yellow disk (plant much smaller than it looks here and close to the ground)
Leaves: Narrow, thick, deep vein in center of leaf
Blooms: May-June Height: up to 6" tall
Found in higher mountains in rocky areas and windswept ridges.
Have seen this wildflower in early June at Doublesprings Pass (8,318'), Custer County, Idaho.

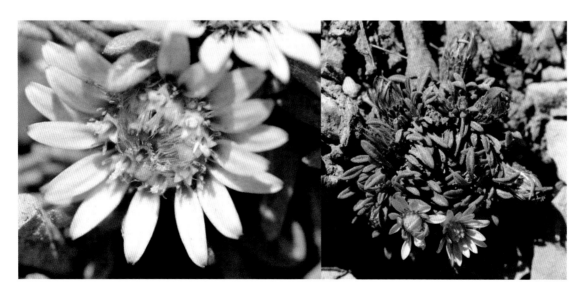

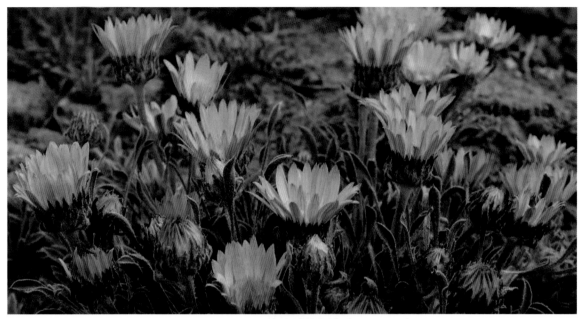

PARRY'S TOWNSENDIA DAISY
Townsendia parryi
Aster or Composite Family (Asteraceae)

Flower: Large flower head with lavender-blue or purplish ray flowers and bright yellow disk
Leaves: Basal with those going up the stem progressively smaller
Blooms: June-July Height: 2-10" tall
Found in valleys, in gravely soils, on hillsides and in fields.
Top picture by *Stephen L. Love*.

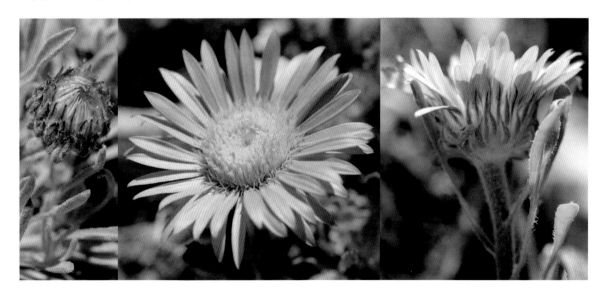

MANY-FLOWER STICKSEED; WILD FORGET-ME-NOT
Hackelia floribunda
Borage or Forget-me-not Family (Boraginaceae*)

Flower: Blue with a yellow throat, small in clusters, yellow eye with white ring around it
Leaves: Lanceolate, hairy, annoying stickers, barbed on edges of nutlets
Blooms: June-August Height: 10-36" tall
Found in dry areas, roadsides, disturbed areas and in moist thickets, common.
bore aj I NAY see ee

BLUE STICKSEED; MEADOW FORGET-ME-NOT;
JESSICA STICKTIGHT
Hackelia micrantha
Borage or Forget-me-not Family (Boraginaceae)

Flower: 5 blue petals, a yellow eye with white ring, small clusters
Leaves: Wide lance-shaped, pointed tips alternate, barbed on back of nutlet
Blooms: June-July Height: 12-40" tall
Found in moist meadows, along stream banks in higher elevations and open sites, common.

BAY FORGET-ME-NOT
Myosotis laxa
Borage or Forget-me-not Family (Boraginaceae)

Flower: Tiny, only about 1/16" across, blue with 5 petals and a yellow throat
Leaves: Narrow, alternate
Blooms: July-August Height: 2-5" tall
Found near streams and standing water. Since it is so small, it is easy to miss.

STREAMSIDE BLUEBELLS; TALL FRINGED BLUEBELLS
Mertensia ciliata
Borage or Forget-me-not Family (Boraginaceae)

Flower: Tube-like blue and pink flower heads hang loosely from stems, 5 petals
Leaves: Tall plant with long veined leaves, hairy, plant grows in clumps
Blooms: June-August Height: 1-5' tall
Found easily near streams and seeps.

SAGEBRUSH BLUEBELLS; OBLONGLEAF BLUEBELLS
Mertensia oblongifolia
Borage or Forget-me-not Family (Boraginaceae)

Flower: Tube-like blue and pink heads (white rarely)
Leaves: Lance-like and basal
Blooms: May-June Height: 4-12" tall
Found in sagebrush flats, in valleys and meadows, common.

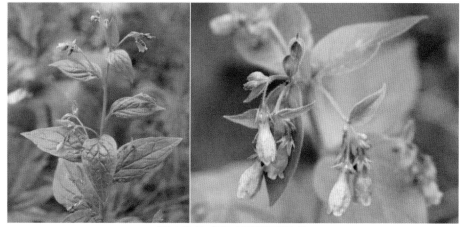

TALL BLUEBELL
Mertensia paniculata
Borage or Forget-me-not Family (Boraginaceae)

Flower: Buds pink and purple, loose clusters of blue flowers, bell-shaped, throat shorter than the bell
Leaves: Toothless, lance-shaped to egg- or heart-shaped, dark green, prominent veins, basal leaves larger, 2-7"
Blooms: May-early July Height: 1-5' tall
Found in shady to partly shady forests, damp woods and along stream banks. Photographed on the Lolo Trail.

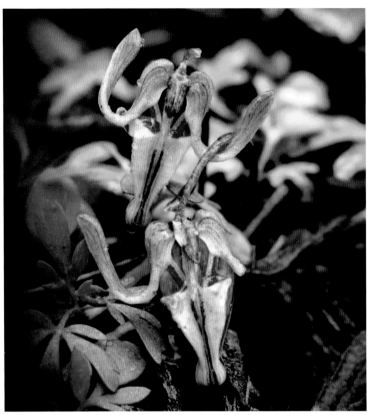

STEER'S HEAD
Dicentra uniflora
Fumitory Family (Fumariaceae*)

Flower: Tiny, in the shape of steer's head with pink, red and purplish odd markings,
1 flower to a stem
Leaves: Basal, deeply lobed
Blooms: April-May, soon after the snow melts or as it is melting Height: 1-2" tall
Found in moist soil near Mahogany trees, on rocky slopes, often follows the snowline.
Plant photographed at City of Rocks, Cassia County and on Tom Cat Hill, Butte County,
Idaho, in April.
**few mare I AY see ee*

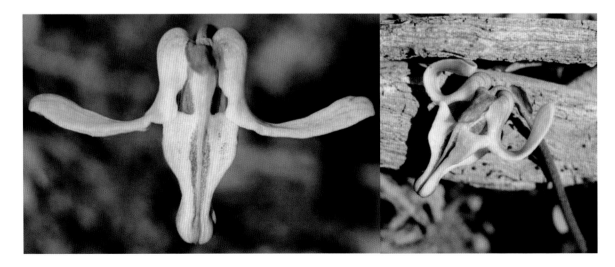

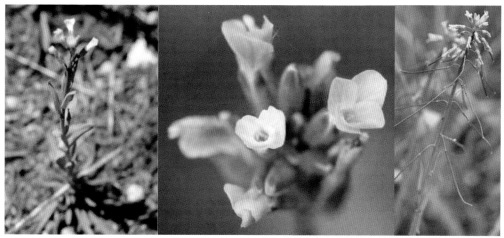

HAIRY ROCKCRESS
Arabis hirsuta
Mustard Family (Brassicaceae)

Flower: Small, 4 petals that range from white to purple, lavender to pink in clusters, on the top of a tall stem
Leaves: Linear to lance-shaped, alternate, hairy
Blooms: April-June Height: 8-24" tall
Found on rocky slopes and hillsides, sagebrush flats and volcanic rock.

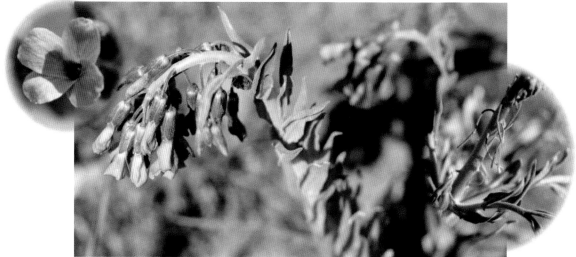

SILVER ROCKCRESS; BLUE MOUNTAIN ROCKCRESS;
HOARY ROCKCRESS
Boechera puberula
Mustard Family (Brassicaceae)

Flower: Clusters of 10-40 flowers, pink, lavender, or magenta, 4 petals, hang down, short yellow anthers inside the throat
Leaves: Basal, linear to oblong, hairy, gray-green
Blooms April-May Height: 6-24" tall
Found on loose gravely hillsides and in sagebrush communities.
These photographed on top of Tom Cat Hill within the Craters of the Moon
National Monument.

BLUE MUSTARD; CROSSFLOWER; PURPLE MUSTARD
Chorispora tenella
Mustard Family (Brassicaceae)

Flower: 4 tiny lavender-purple, spoon-shaped petals, crimped, darker lavender-purple near throat
Leaves: Alternate, and lanceolate, or elliptic-oblong
Blooms: April-early June Height: 6-18" tall
Found foothills, along roadsides, in pastures, in disturbed areas, very common in the spring with fields of purple, **not native.**

DAME'S ROCKET; SUMMER LILAC; SWEET ROCKET
Hesperis matronalis
Mustard Family (Brassicaceae)

Flower: 4 petals, usually lavender, but can be pink, or white, in showy clusters
on a tall stem
Leaves: Lance-shaped, smaller as they go up the stem, fine hairs, toothed, opposite
Blooms: May-July Height: 2-3' tall
Found in woodland edges, roadways and gardens, **not native.**

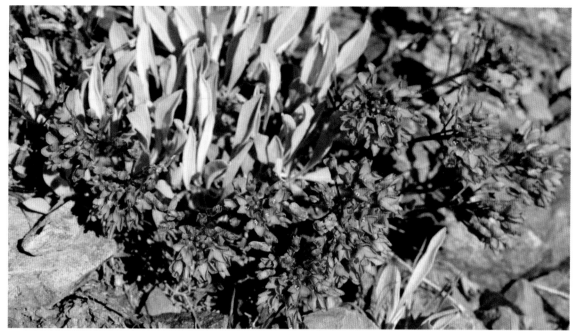

DAGGERPOD; WALLFLOWER PHOENICAULIS
Phoenicaulis cheiranthoides**
Mustard Family (Brassicaceae)

Flower: 4 petals, bright pink-rose, violet-lavender, clusters on long reddish-wine stems, yellow anthers
Leaves: Soft, gray-green, hairy, lance-shape and almost stand upright, hairy
Blooms: March-April Height: 2-10" tall
Found on rocky slopes and sagebrush flats.
*feen ih KAH lis *kv ranth OH idees*

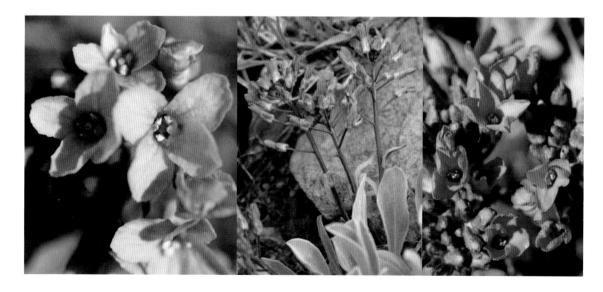

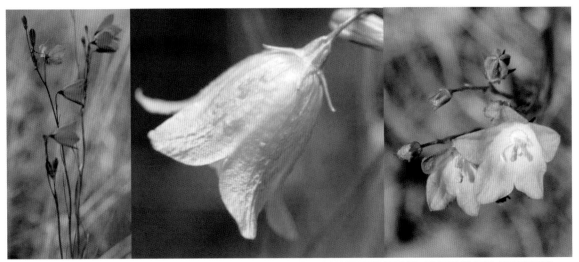

SCOTCH BLUEBELL; HAREBELL; BLUEBELL BELLFLOWER
Campanula rotundifolia
Harebell Family (Campanulaceae*)

Flower: Lavender to blue (white also) bell-shaped, 5 lobes, nodding as it ages
Leaves: Long and thin, basal, smooth stems
Blooms: July-September Height: up to 20" tall
Found in open meadows and valleys in lower and higher elevations.
kam pan yew LAY see ee

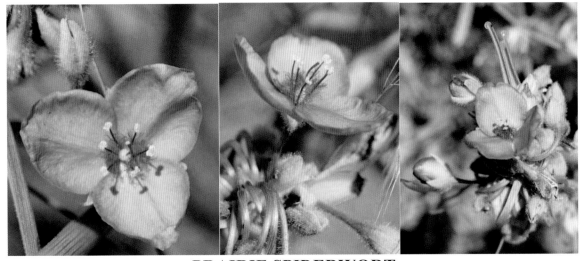

PRAIRIE SPIDERWORT
Tradescanthia occidentalis var. occidentalis
Spiderwort Family (Commelinaceae*)

Flower: Blue, purple, pink, 3 petals, open in morning, often wither in the afternoon
Leaves: Long and thin, leaf edges tend to fold up, hairless, parallel-veined
Blooms: May-August Height: up to 20" tall
Found in woods, prairies, grasslands, forest openings and fields.
KO mel ih NAY see ee

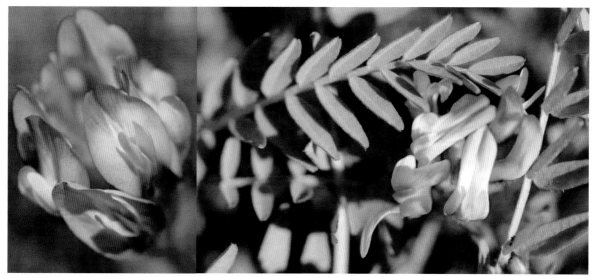

PURPLE MILKVETCH; FIELD MILKVETCH
Astragalus agrestis
Pea, Bean, or Legume Family (Fabaceae)

Flower: Lavender to purple pea-like flowers, tight clusters, about 1" wide and 1" high
Leaves: 13-21 oval leaflets, mat forming, slightly hairy
Blooms: May-July Height: 6-12" tall
Found along stream banks, in moist meadows and in open woods, common.

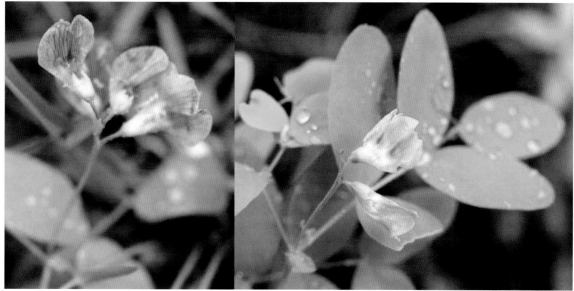

ALPINE MILKVETCH
Astragalus alpinus
Pea, Bean, or Legume Family (Fabaceae)

Flower: Bicolored, lavender-pink and white, the wing petals shorter than the keel
Leaves: Pinnately compound
Blooms: June-August Height: 4-6" tall
Found moist meadows, along stream banks. Photographed on the Lolo Trail.

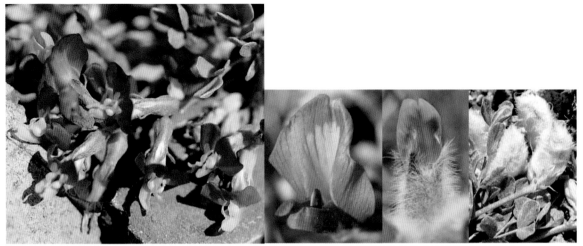

WOOLLYPOD MILKVETCH; PURSH'S MILKVETCH
Astragalus purshii
Pea, Bean, or Legume Family (Fabaceae)

Flower: Lavender to pink touched with white, have also seen all white ones
Leaves: Oval, gray-green, hairy, 3-17 leaflets
Blooms: April-May-early June Height: up to 6" tall
Found in rocky dry areas and sagebrush flats, common. Notice how it changes to woolly!

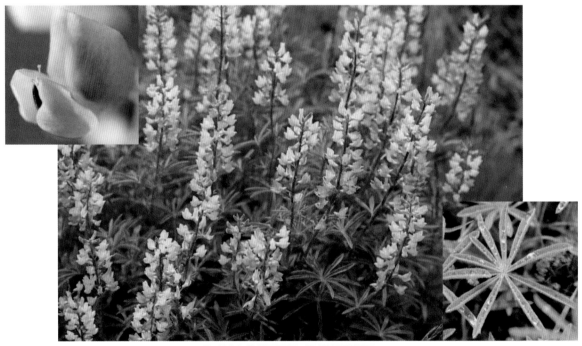

LONGSPUR LUPINE
Lupinus arbustus var. calearatus*
Pea, Bean, or Legume Family (Fabaceae)

Flower: Varicolored on the same plant, also all white, fragrant
Leaves: Large, many leaflets (7-13)
Blooms: May-June Height: 8-30" tall
Found in the mountains and on sagebrush slopes, common.
loo PIE nus

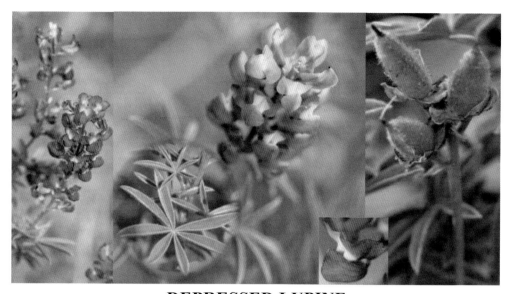

DEPRESSED LUPINE
Lupinus depressus
Pea, Bean, or Legume Family (Fabaceae)

Flower: Lavender-purple and white, pea-like
Leaves: Velvety, many small leaflets
Blooms: July-August Height: 12-24" tall
Found in meadows and on dry foothills.
Note: *depressus* means low.

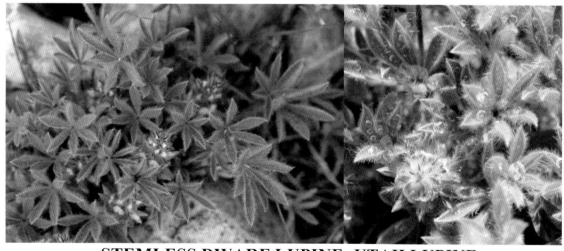

STEMLESS DWARF LUPINE; UTAH LUPINE
Lupinus lepidus var. utahensis
Pea, Bean, or Legume Family (Fabaceae)

Flower: Blue or lavender and white, much smaller than other lupines
Leaves: Soft, velvety, hairy, basal, crowded, whorled
Blooms: June-July Height: 4-10" tall
Found in meadows and fields.

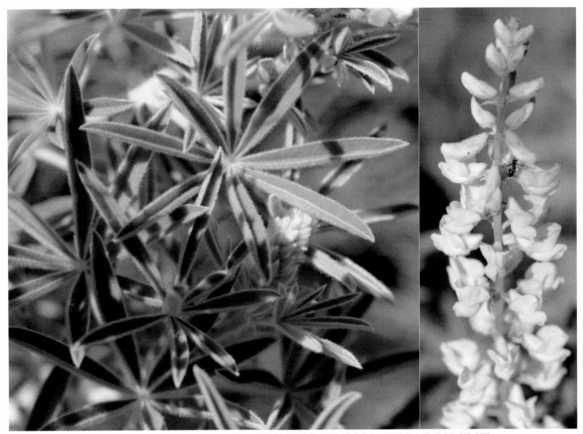

VELVET LUPINE; WOOLLY-LEAVED LUPINE
Lupinus leucophyllus var. erectus
Pea, Bean, or Legume Family (Fabaceae)

Flower: White, cream, lavender, keel turned upwards, pea-like clusters on a stalk
Leaves: Large gray-green, velvet feeling makes it easier to recognize because of the way it looks and feels, many silvery-gray woolly hairs, leaflets (7-11)
Blooms: June-July Height: 12-36" tall
Found in dry, open rangeland, sagebrush flats. Plant dangerous to grazing livestock.

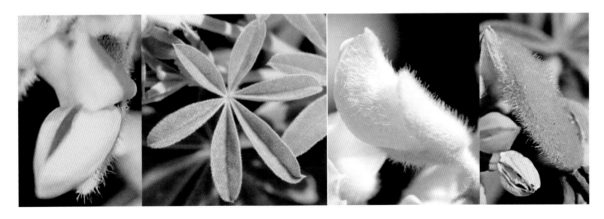

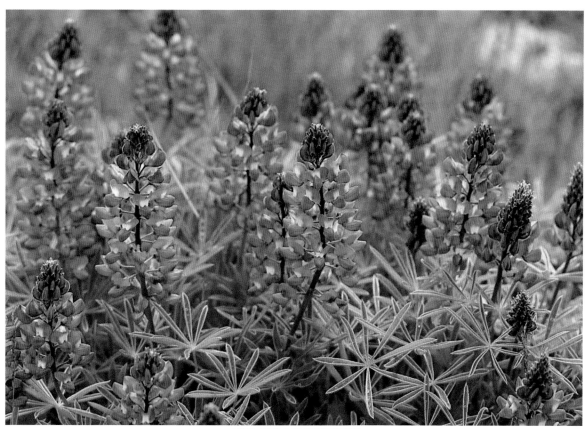

SILKY LUPINE
Lupinus sericeus
Pea, Bean, or Legume Family (Fabaceae)

Flower: Blue, lavender with a little white, the upper petal has a white center
Leaves: 7-9 rounded leaflets, fine hairs
Blooms: May-June Height: 8-30" tall
Found on dry hills and valleys, sagebrush deserts, and in meadows.

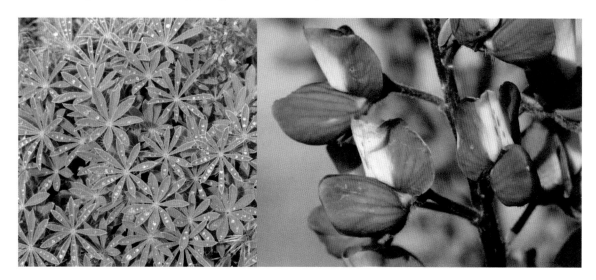

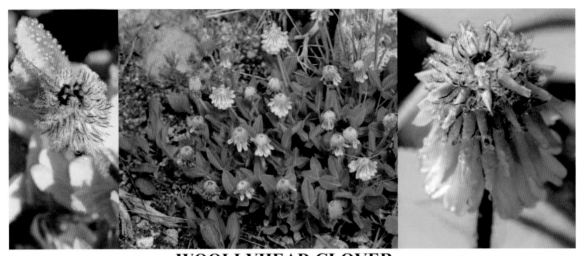

WOOLLYHEAD CLOVER
Trifolium eriocephalum
Pea, Bean, or Legume Family (Fabaceae)

Flower: Hairy, ball-shaped with white and purple or pink
Leaves: Basal with three hairy leaflets
Blooms: April-May Height: 2-12" tall
Found in moist meadows and bogs.

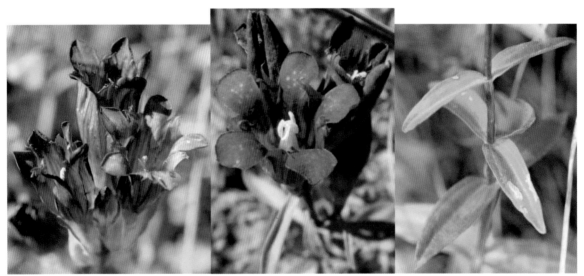

PLEATED GENTIAN; TRAPPER'S GENTIAN
Gentiana affinis
Gentian Family (Gentianaceae)

Flower: Dark blue to lavender or purplish, sometimes spotted, vase-shaped, often in clusters
Leaves: Opposite, lance-shaped, occurring all along stem
Blooms: July-August Height: up to 16" tall
Found in moist meadows and along streams.
Note: It comes on a little earlier than the calycosa, a bit taller and found at lower elevations.

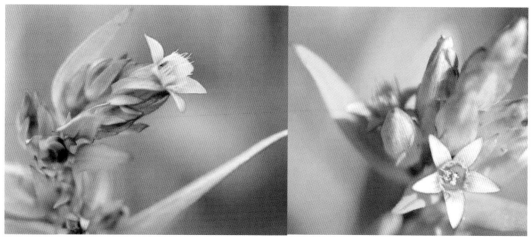

AUTUMN DWARF GENTIAN; NORTHERN GENTIAN
Gentiana amarella*
Gentian Family (Gentianaceae*)

Flower: Tiny from light blue to lavender or even pinkish and yellowish
Leaves: Oblong, opposite, lance-shaped
Blooms: July-August Height: 2-12" tall
Found in moist meadows late in the season, very small and easy to miss.
**jen she AY nay *jen shun AY see ee*

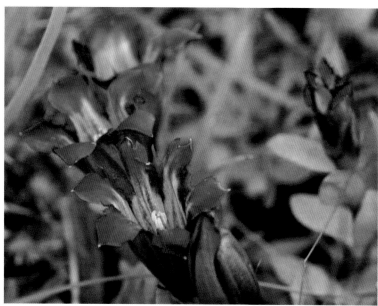

EXPLORER'S GENTIAN; RAINIER PLEATED GENTIAN
Gentiana calycosa
Gentian Family (Gentianaceae)

Flower: Funnel-shaped, dark blue, inside from blue to yellowish green, 5 petals
Leaves: Long, oval, shiny and opposite
Blooms: July-October Height: 3-12" tall
Found on high mountain meadows and along stream banks.
Picture by *Stephen L. Love* was photographed in the Pioneer Mountains up
the right fork of Iron Bog Creek near Brockie Lake, in Idaho.

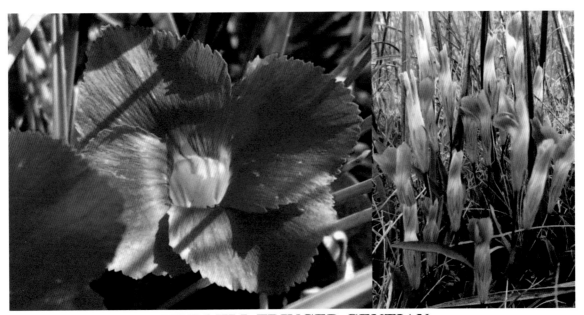

WINDMILL FRINGED GENTIAN
Gentianopsis detonsa
Gentian Family (Gentianaceae)

Flower: Deep blue, blue-violet, bell-shaped, 4 fringed petals, fold over each other, white throat
Leaves: Long, narrow, opposite
Blooms: July-August Height: 8-18" tall
Found in bogs, meadows and in moist areas. Top pictures by *Callie Russell*.

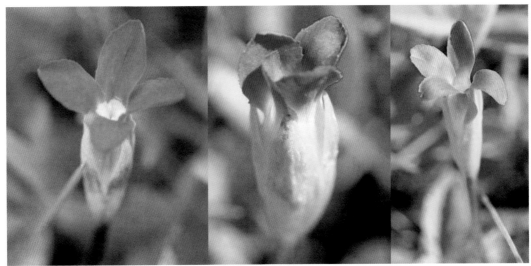

ONE-FLOWERED GENTIAN; HIKER'S GENTIAN
Gentianopsis simplex
Gentian Family (Gentianaceae)

Flower: Solitary lavender, dark purple to dark blue, funnel tube, white throat
Leaves: Stem leaves in pairs, lance-shaped
Blooms: August-September Height: 4-8" tall
Found in wet mountain meadows and along hiking trails in the mountains.

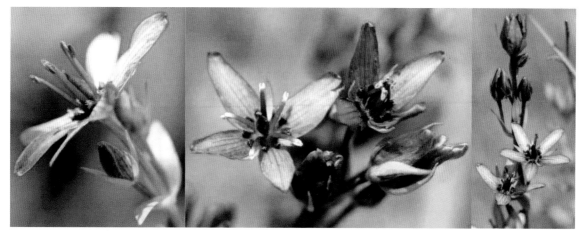

STAR GENTIAN; BOG SWERTIA; FELWORT
Swertia perennis
Gentian Family (Gentianaceae)

Flower: 5 star-shaped petals, pale bluish-purple to lavender, fringed glands, stripes on petals
Leaves: Mostly at the bottom, lance-shaped, opposite on upper stem
Blooms: July-September Height: up to 2' tall
Found in bogs or wet meadows in higher elevations.

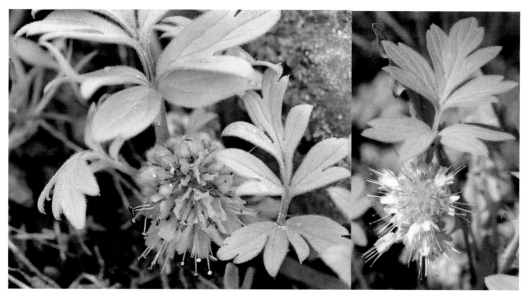

BALLHEAD WATERLEAF
Hydrophyllum capitatum
Waterleaf Family (Hydrophyllaceae)

Flower: Lavender-blue or white, ball-like heads, long anthers, flower head may be hidden by leaves
Leaves: Alternate, deeply lobed with 5-7 leaflets, low growing
Blooms: April-June Height: 4-18" tall
Found on moist open slopes, foothills, often found just after the snow melts.

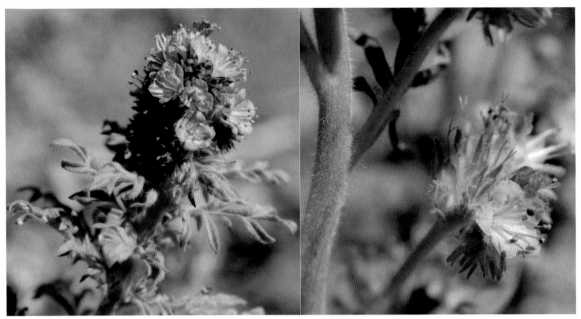

FRANKLIN'S PHACELIA*
Phacelia franklinii
Waterleaf Family (Hydrophyllaceae*)

Flower: 5 lavender to dark purple petals, (also white), bell-shaped, clustered
on a thick stem
Leaves: Deeply lobed, alternate, hairy
Blooms: June-July Height: up to 2½' tall
Found in dry valleys and meadows.
Photographed in the Copper Basin, Custer County, Idaho.
*fa SEE li ah *hy droh fill LAY see ee*

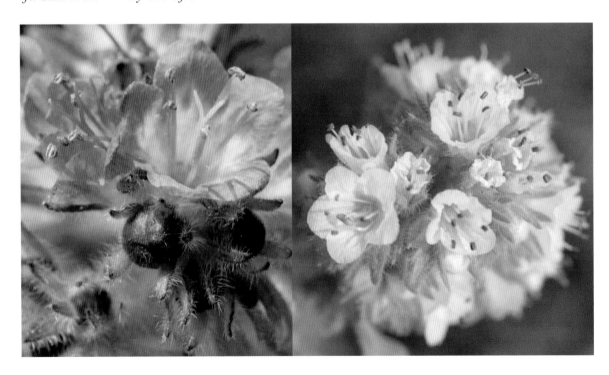

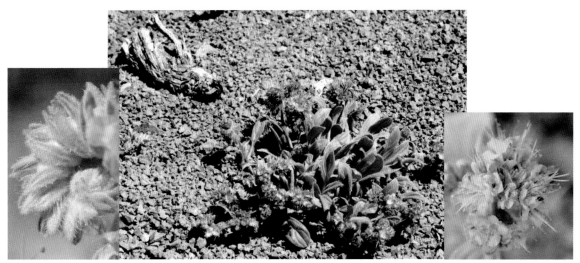

SILVERLEAF PHACELIA; SCORPION WEED
Phacelia hastata
Waterleaf Family (Hydrophyllaceae)

Flower: Pale lavender to white in spiraled clusters, 5 fused petals, notice the coiled scorpion left top picture shows how it looks before it blooms
Leaves: Alternate, elliptical and narrow and covered with silky-white hairs
Blooms: May-July Height: 6-36" tall
Found on dry slopes and in gravely or sandy soils, very common.
Middle picture by *Stephen L. Love*.

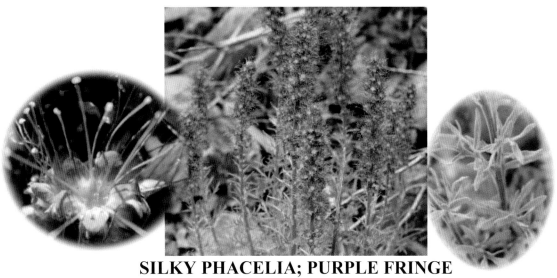

SILKY PHACELIA; PURPLE FRINGE
Phacelia sericea
Waterleaf Family (Hydrophyllaceae)

Flower: 5 lavender to dark blue-violet petals, funnel-shaped, a white center, pincushion-like feathery clusters
Leaves: Alternate, divided into many smaller lobes, silky hairs
Blooms: Late June-August Height: 5-20" tall
Found at higher elevations on ridges, rocky hillsides, and near lakes.

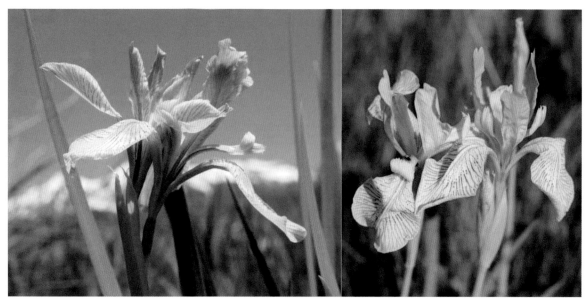

ROCKY MOUNTAIN IRIS; WILD IRIS; FLAGS
Iris missouriensis
Iris Family (Iridaceae*)

Flower: Lavender to pale blue, streaked with dark purple and yellow markings
Leaves: Long and thin, sword-shaped
Blooms: May-June Height: 1-3' tall
Found in moist meadows, along stream banks.
Have often seen the Idaho Blue-eyed Grass near the Wild Iris.
eye rih DAY see ee

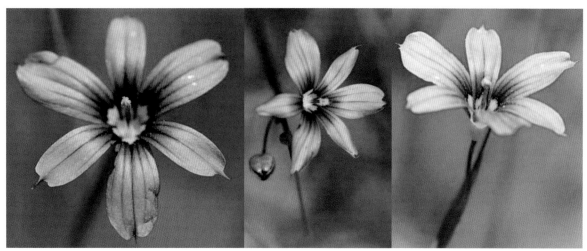

IDAHO BLUE-EYED GRASS; BLUE STAR
Sisyrinchium idahoense*
Iris Family (Iridaceae)

Flower: Blue to purple, 6 star-like petals, a bright yellow center, a pointed tip on each petal
Leaves: Long, thin, and narrow
Blooms: May-August Height: 4-20" tall
Found in meadows and along stream banks, common.
sis I RINK I uhm

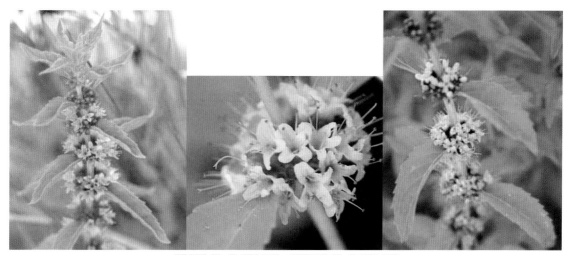

WILD MINT; FIELD MINT
Mentha arvensis
Mint or Deadnettle Family (Lamiaceae)

Flower: Clusters of tiny pale pink or lavender flowers (smells minty)
Leaves: Lance-shaped with toothed edges, opposite, stem square
Blooms: July-September Height: 4-24" tall
Found along streams and in moist meadows, common.

WILD BERGAMOT
Monarda fistulosa
Mint or Deadnettle Family (Lamiaceae)

Flower: Large, pink or lavender, irregularly shaped in a cluster
Leaves: Opposite and lanceolate to ovate with toothed edges, square stem
Blooms: July-August Height: 2-5' tall
Found in open fields, woodlands, dry hillsides, abandoned pastures.
Pictures by *Callie Russell*.
*mo NAR dah

SELFHEAL; HEAL ALL
Prunella vulgaris
Mint or Deadnettle Family (Lamiaceae)

Flower: Clusters of blue-violet or lavender, splashed with white, on a short spike, 2-lipped, upper a hood, lower drooping (occasionally white or pink), slightly fringed petals, mint aroma
Leaves: Oval, veined, and usually untoothed, taper to a point, longer than wide
Blooms: May-July Height: 3-8" tall
Found in moist meadows, along streams, in disturbed areas and along roadsides.

PURPLE SAGE
Salvia dorrii
Mint or Deadnettle Family (Lamiaceae)

Flower: Arranged in terminal clusters, about ½" long, two-lipped, pale blue to blue-purple in color, surrounded by dark reddish-purple (in some cases less colorful) bracts
Leaves: Fairly small, smooth margins, ½-1½" long, light green with a hint of blue color, all above-ground parts strongly aromatic, woody evergreen shrub
Blooms: May-July Height: 20-30" tall
Found in very dry habitats growing in sandy or rocky limestone soils, usually with other drought tolerant shrubs. Photographs include a plant at the Aberdeen Research Center and ones from south of Mountain Home, Idaho. Description and pictures by *Stephen L. Love*.

NARROWLEAF SKULLCAP
Scutellaria angustifolia
Mint or Deadnettle Family (Lamiaceae)

Flower: Lavender-blue or purple, hooded upper lip, 2 patches of white on a flaring lower lip
Leaves: Narrow, thick and opposite, rounded tips, small hairs, red-wine stem
Blooms: May-June Height: 4-12" tall
Found in rocky areas after the snow melts.

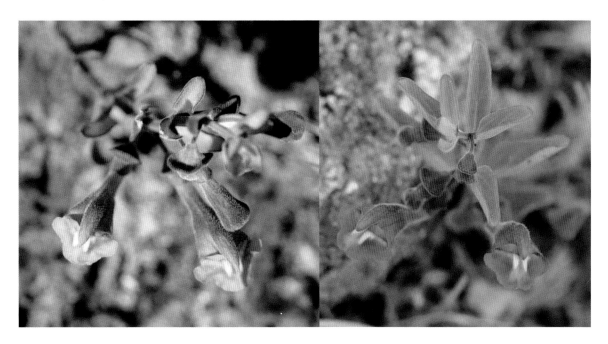

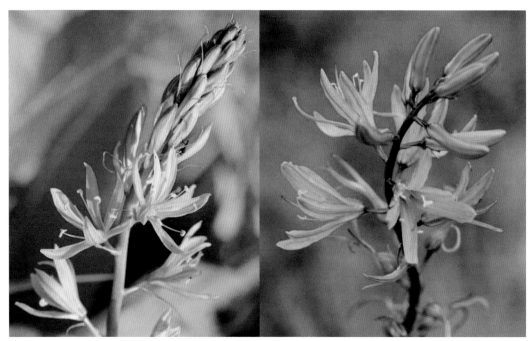

COMMON CAMAS
Camassia quamash
Lily Family (Liliaceae)

Flower: Violet, pale to deep blue, occasionally white, star-like flowers clustered on the stem
Leaves: Basal, grass-like, bulbs are egg-shaped
Blooms: May-June Height: 1-2½' tall
Found in moist meadows and grasslands.
Note: Many Indian tribes fought over the rights to collect the Camas in certain meadows, as it was an important root crop, which they either cooked or dried for later use. The Bannock War of 1878 was fought over digging grounds for the Camas.

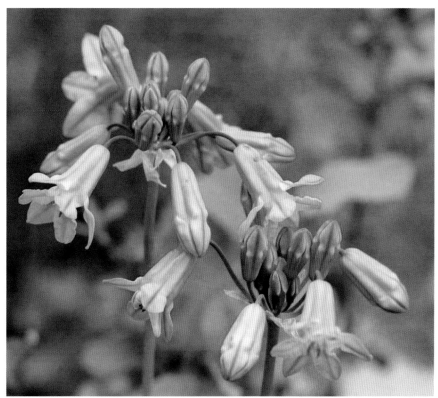

WILD HYACINTH; TRIPLET LILY
Triteleia grandiflora
Lily Family (Liliaceae)

Flower: Blue to lavender, funnel-shaped, dark lines through the middle of the petals
Leaves: Basal, long and thin
Blooms: May-July Height: up to 28" tall
Found open forests, meadows and valleys.

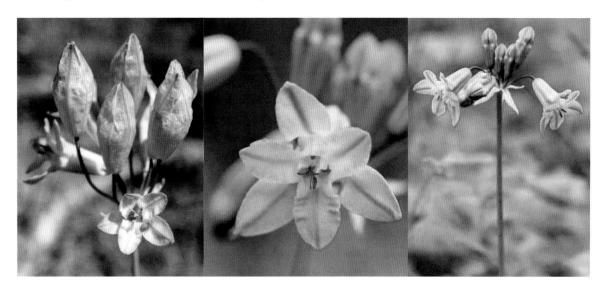

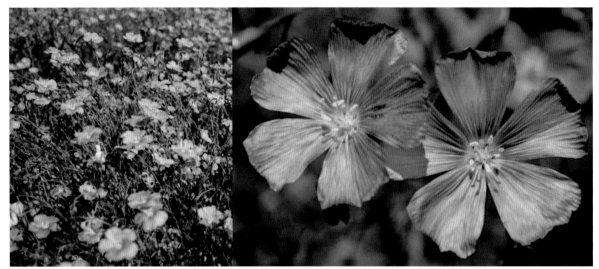

BLUE FLAX; LEWIS FLAX
Linum lewisii
Flax Family (Linaceae)*

Flower: 5 bright, blue petals, yellow throat, white anthers, a slender stem
Leaves: Alternate, narrow, sharp-pointed
Blooms: May-August Height: 12-36" tall
Found in open valleys, along roadsides and in forests.
ly NAY see ee

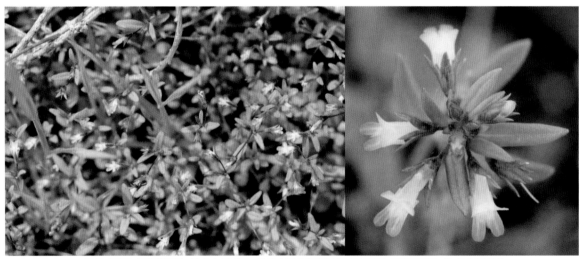

BLUE EYED MARY; MAIDEN BLUE EYED MARY
Collinsia parviflora
Plantain Family (Plantaginaceae)

Flower: Tiny, blue-violet and white, 2-lipped, less than ¼" long
Leaves: Opposite, oblong or lance-shaped
Blooms: April-June Height: 2-12" tall
Found in meadows and open forests especially after a rain, common.

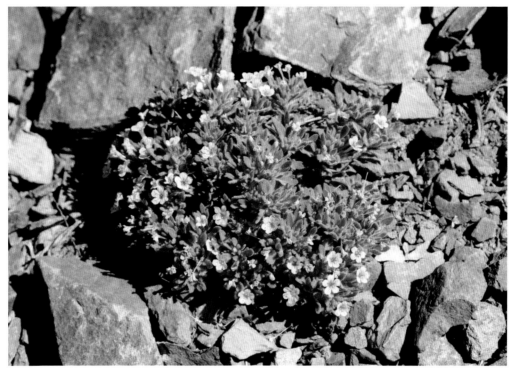

ALPINE MOUTAIN-TRUMPET; ALPINE COLLOMIA
Collomia debilis
Phlox Family (Polemoniaceae)

Flower: 5 petals, lavender veins near the throat, trumpet-shaped, flowers can be blue, pink, white, or cream and lavender
Leaves: Loose green sprawling mat, alternate, often hairy, spoon-shaped to oval with tips
Blooms: June-August Height: 2-8" tall
Found on high dry rocky ridges. Photographed on a very rocky slope about 7,000 feet up Bayhorse in Custer County, Idaho, on June 22; plant is **rare.**

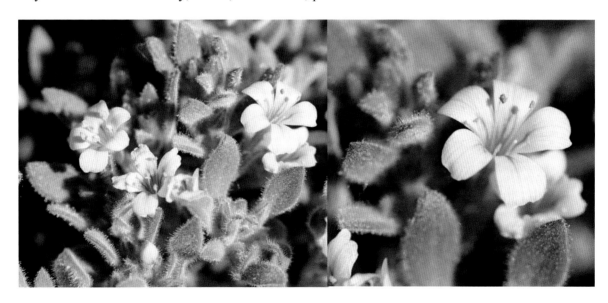

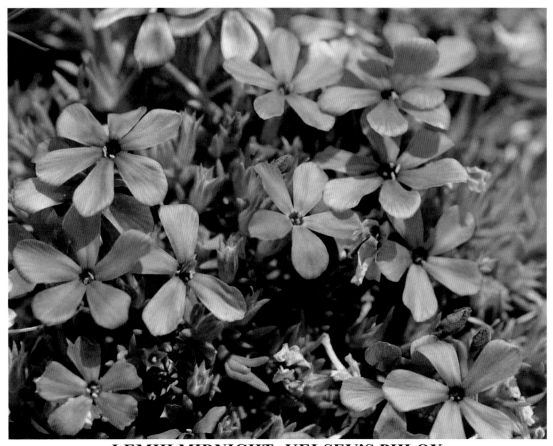

LEMHI MIDNIGHT; KELSEY'S PHLOX
Phlox kelseyi
Phlox Family (Polemoniaceae)

Flower: 5 lavender-purple petals but can also be white, pink, or blue, tubular throat
Leaves: Opposite with sharp-pointed leaves, plant hugs the ground
Blooms: May-June Height: up to 8" tall
Found in Lemhi and Custer County, Idaho. Pictures taken at Whiskey Springs, just off
Highway 93, about 16 miles from Mackay in Custer County, Idaho. Bottom right
picture taken at Birch Creek in Lemhi County, Idaho, by *Stephen L. Love*.

LOW JACOB'S LADDER; MOVING POLEMONIUM
Polemonium californicum*
Phlox Family (Polemoniaceae)

Flower: Bell-shaped, lavender-blue or blue, a yellow throat, lavender veins near yellow throat, plant smaller than the *pulcherrimum*
Leaves: Oval- to lance-shaped, divided into 11-19 leaflets
Blooms: May-July Height: 8-12" tall
Found in shaded to open forests such as Lodgepole Pine.
These photographed along the Lolo Trail.
**poh lee MOH ni uhm*

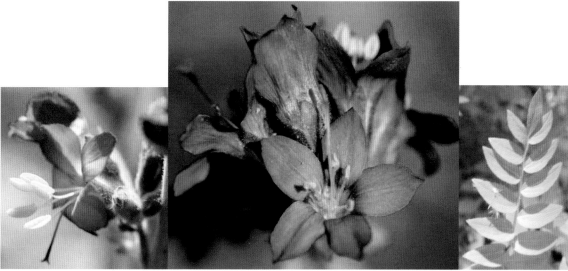

JACOB'S LADDER; WESTERN POLEMONIUM
Polemonium occidentale
Phlox Family (Polemoniaceae)

Flower: Bright blue, 5 petals and prominent gold anthers, in clusters, stems sticky
Leaves: Pinnately divided leaflets (9-17), ladder-like, lance-shaped
Blooms: June-July Height: 8-38" tall
Found along stream banks and in wet meadows, common.

253

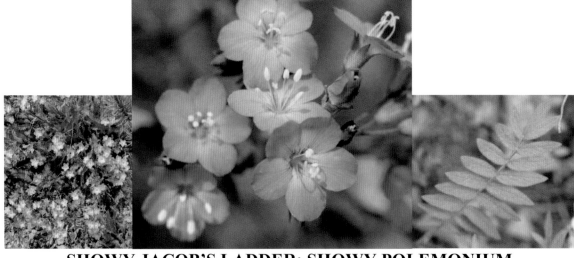

SHOWY JACOB'S LADDER; SHOWY POLEMONIUM
Polemonium pulcherrimum
Phlox Family (Polemoniaceae)

Flower: Light lavender-blue with 5 petals, yellow-gold throat, white anthers, clusters
Leaves: Pinnately divided leaflets, looks like a ladder
Blooms: May-August Height: 2-24" tall
Found in forests and meadows, near stream banks. Photographed in Yellowstone Park.

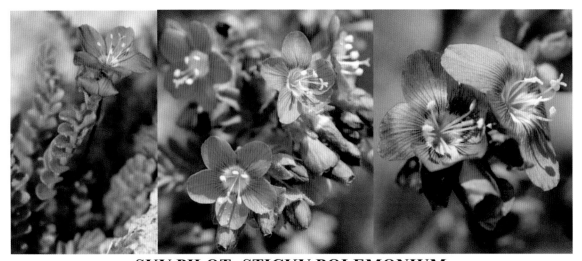

SKY PILOT; STICKY POLEMONIUM
Polemonium viscosum
Phlox Family (Polemoniaceae)

Flower: Lavender to blue-violet, bowl-shaped with white anthers and a yellow eye, 5 petals
Leaves: Smaller than other 2 Polemoniums, dark green, tight leaflets from 9-25, looks like
a corkscrew, sticky, skunk-like scent
Blooms: May-July Height: 4-16" tall
Found on rocky slopes and in open meadows in higher elevations.

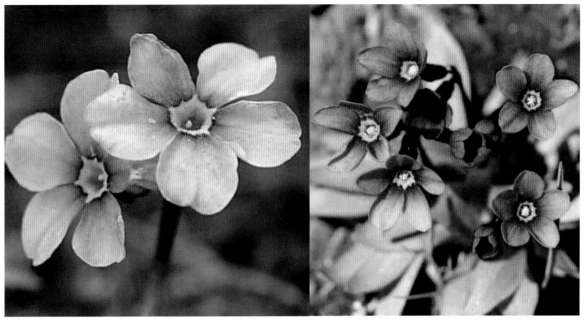

CUSICK'S PRIMROSE
Primula cusickiana
Primrose Family (Primulaceae)

Flower: 5 petals, a bright yellow throat and eye, color ranges from light to dark purple or rose.
Leaves: Basal and ½-2" long, lance- to spoon-shape
Blooms: Late in April as the snow melts or soon after-to late May Height: 2-14" tall
Found May 11 on the Stanley Creek Road about a mile in, high on a moist embankment, picture on the left. Although it is found in Central Idaho, it is **rare** to find one. Also found on Tom Cat Hill near Craters of the Moon April 20 on the southwest side where they were very small, 2". Top right and bottom pictures, found about 4 feet from the melting snow.

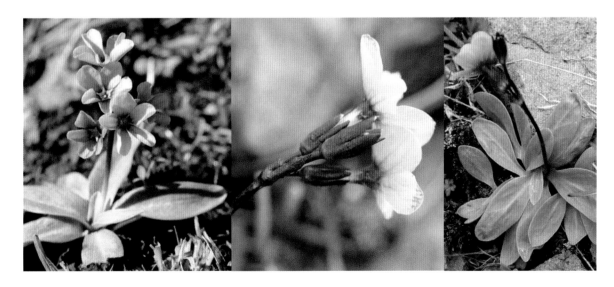

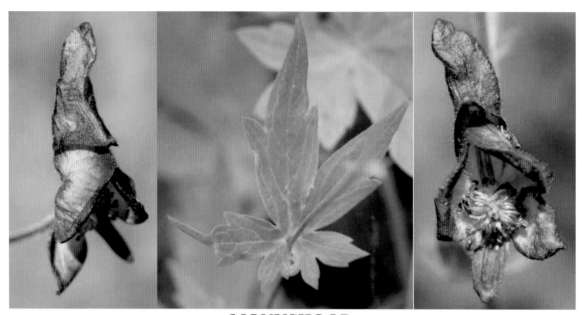

MONKSHOOD
Aconitum columbianum
Buttercup Family (Ranunculaceae)

Flower: Dark blue, lavender or purple (occasionally white), about ¾" long, helmet-shaped like a hood worn by medieval monks
Leaves: Deeply notched, alternate, clasp the stem, 3-5 irregular lobes
Blooms: July-August Height: 2-5' tall
Found in wet meadows, bogs, and along stream banks. Plant is poisonous.

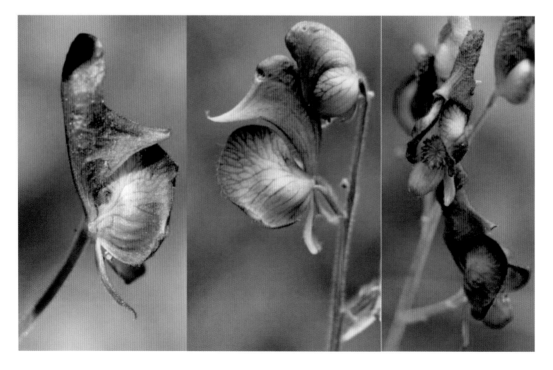

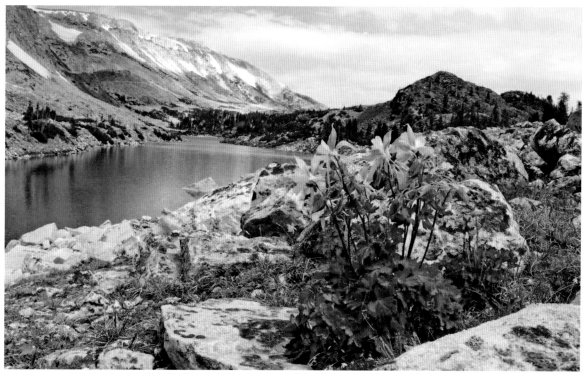

BLUE COLUMBINE; COLORADO BLUE COLUMBINE
Aquilegia coerulea
Buttercup Family (Ranunculaceae)

Flower: Deep pale blue to purple with white, long lavender-blue spurs (1-2¾")
Leaves: Divided into leaflets
Blooms: July-August Height: 6-30" tall
Found in wet mountain meadows, rocky slopes and along stream banks.
This is the state flower of Colorado.
Top picture by *Stephen L. Love*, bottom left picture by *Callie Russell*.

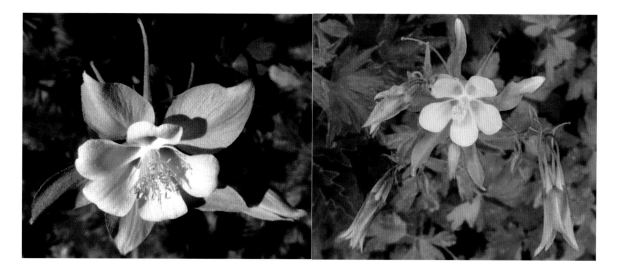

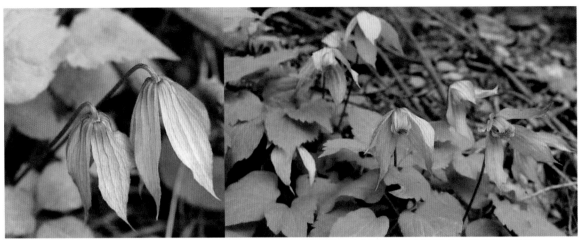

ROCKY MT. CLEMATIS; COLUMBIAN VIRGIN'S BOWER
Clematis columbiana
Buttercup Family (Ranunculaceae)

Flower: Bell-shaped, pale lavender to purple or bluish-violet (rarely white) on a creeping vine
Leaves: 2-3 lobed toothed leaflets
Blooms: May-June Height: vines 5-10' long
Found on dry ridges among low shrubs or in rocky groves of small trees and shrubs as it drapes over the top of surrounding plants.
Top right picture by *Gwen Russell*.

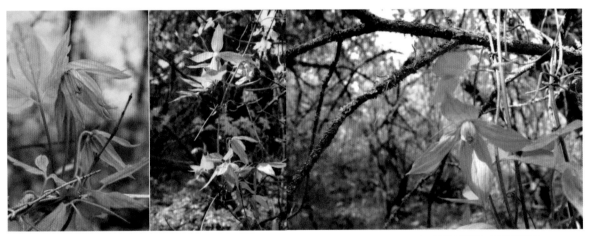

WESTERN CLEMATIS; WESTERN BLUE VIRGINSBOWER
Clematis occidentalis
Buttercup Family (Ranunculaceae)

Flower: Sparsely arranged along the extensive vines, large, 4 widely separated petals that tend to droop and are blue to blue-purple in color, almost twice as large as the *columbiana*
Leaves: Few but fairly large, divided into 3 leaflets, much longer than *columbiana*
Blooms: May and June Height: vines up to 20' long
Found in heavily forested riparian areas, where it thrives in the shade and climbs into the branches of surrounding trees. Description and pictures by *Stephen L. Love*

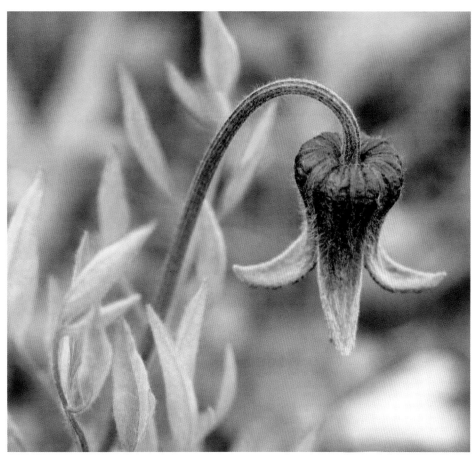

SUGARBOWLS; HAIRY CLEMATIS; VASE FLOWER
Clematis hirsutissima
Buttercup Family (Ranunculaceae)

Flower: Purple and bell-shaped to dull reddish and lavender, 4 petal-like segments fused
Leaves: Long, opposite, finely divided
Blooms: April-June Height: 8-24" tall
Found in open pine forests, in sagebrush and meadows.

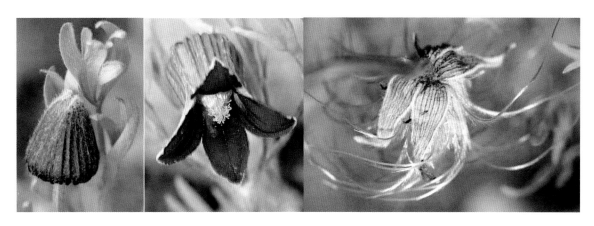

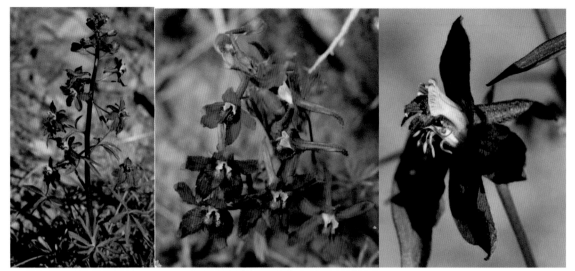

ANDERSON'S LARKSPUR
Delphinium andersonii
Buttercup Family (Ranunculaceae)

Flower: Taller than the Low Larkspur but flowers look about the same: dark blue to purple with upper petal being light blue with purple markings, also white-lavender, slender spur
Leaves: Basal and divided into narrow segments, "finger-like lobes"
Blooms: April-June Height: 4-25" tall
Found on dry mountain foothills, toxic to livestock. Photographed at Craters of the Moon.

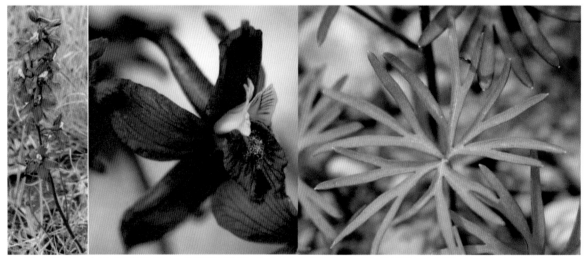

LOW LARKSPUR; LITTLE LARKSPUR; LOWLAND LARKSPUR
Delphinium bicolor
Buttercup Family (Ranunculaceae)

Flower: Dark blue and purple, upper petal has light blue with purple markings, the flower spike may have up to 15 blossoms
Leaves: Basal, alternate and divided into many narrow segments (stems can be reddish)
Blooms: May-July Height: 4-24" tall
Found in sagebrush flats, disturbed areas and wooded areas, common, toxic to livestock.

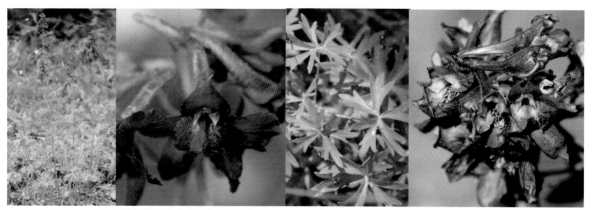

SIERRA LARKSPUR; TOWER LARKSPUR
Delphinium glaucum
Buttercup Family (Ranunculaceae)

Flower: Blue-violet with white on upper petal and violet on the lower ones
Leaves: Deeply lobed, grayish waxy covering
Blooms: July-August Height: 3-6' tall
Found in partially wooded areas.

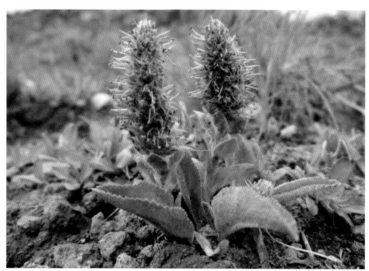

WYOMING KITTENTAIL; WYOMING BESSEYA
Besseya wyomingensis
Snapdragon or Figwort Family (Scrophulariaceae)

Flower: Numerous tiny pinkish-purple flowers grow in dense, terminal heads that are 1-4" long. Flowers are interspersed with long hairs. Stamens extend far beyond the mouth of the flowers, giving the heads a fuzzy appearance.
Leaves: Downy basal leaves are 1-3" long and lance-shaped, smaller leaves grow on the flower stems
Blooms: May-July Height: 2-12" tall
Found at a wide range of elevations in grasslands, open forests, and fell-fields. These photographs were taken along the road to Sawtell Peak near Island Park, Idaho.
Description and pictures by *Stephen L. Love*.

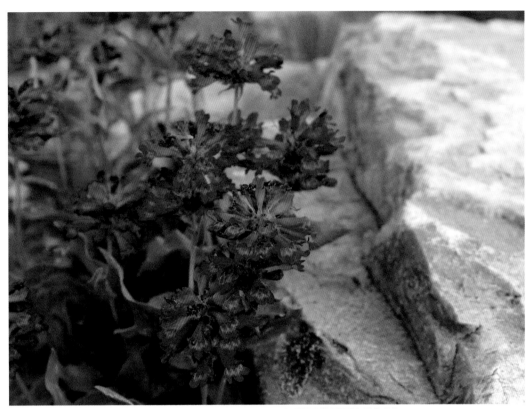

TAPER-LEAVED PENSTEMON
Penstemon attenuatus
Snapdragon or Figwort Family (Scrophulariaceae)

Flower: Crowded clusters on a stem, color varies from blue-purple to yellow, pink, or white
Leaves: Opposite, lance-shaped, tips pointed, glandular hairs on bottom of throat
Blooms: June-August Height: 1-2' tall
Found in meadows, on sagebrush flats, open slopes, and in woods.
Some of these were taken near the Iron Bog Trailhead in Idaho.
Top picture and bottom right by *Stephen L. Love*.

BIG BLUE PENSTEMON
Penstemon cyaneus
Snapdragon or Figwort Family (Scrophulariaceae)

Flower: Bright blue-violet, tubular with 5 petals, wide at the mouth, 2 upper and 3 lower lips, flowers tend to be on one side of the stem more than both
Leaves: Long basal leaves cluster at the bottom, leaves on the upper stem diminish in size, opposite
Blooms: June-July Height: up to 3' tall
Found in the mountain regions on sagebrush slopes and in grassy meadows.
Middle top picture by *Stephen L. Love*.

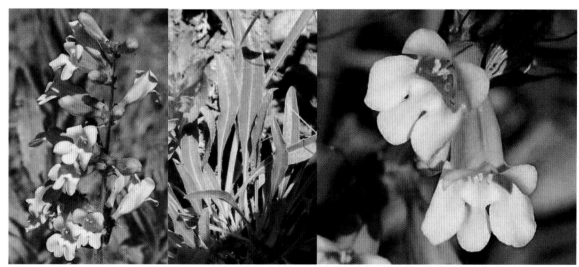

Unusual pink version of cyaneus

263

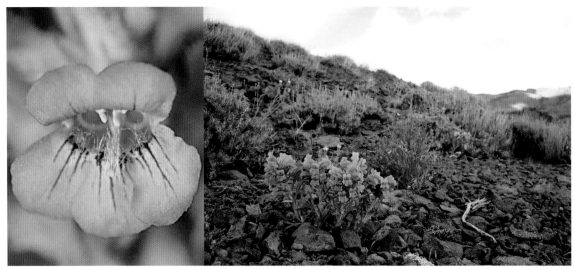

FUZZYTONGUE PENSTEMON; LONGSAC PENSTEMON
Penstemon eriantherus var. redactus
Snapdragon or Figwort Family (Scrophulariaceae)

Flower: Lavender-light purple, purple veins in the throat, a prominent hairy yellow beardtongue
Leaves: Thin and narrow, opposite
Blooms: May-June Height: 6-18" tall
Found on rocky hillsides and in open meadows.
Top right picture by *Stephen L. Love*.

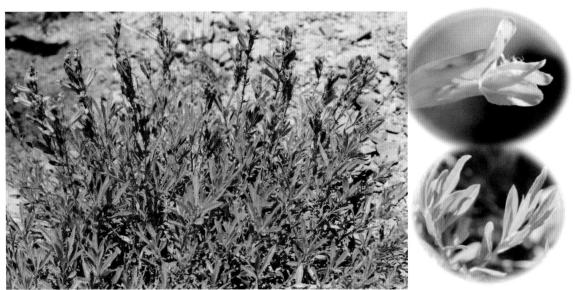

SHRUBBY BEARDTONGUE; SHRUBBY PENSTEMON
Penstemon fruticosus
Snapdragon or Figwort Family (Scrophulariaceae)

Flower: Light lavender and tube-shaped, 2 prominent white lines on the lower lips, clusters
Leaves: Shiny, lance-shaped, plant broader than tall
Blooms: May-August Height: 6-16" tall
Found on rocky hillsides and in drier forests.

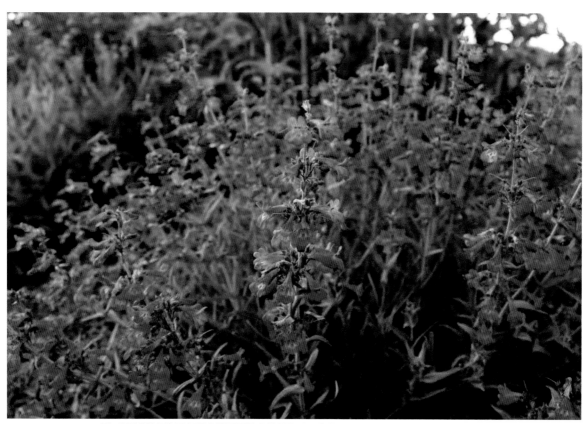

LOWLY PENSTEMON; LOW BEARDTONGUE
Penstemon humilis
Snapdragon or Figwort Family (Scrophulariaceae)

Flower: Small narrow tube, bright blue to lavender, dark purple lines and
yellow hairs in inner tube
Leaves: Basal leaves spoon-shaped; higher on erect stem, the leaves are lance-shaped
and opposite
Blooms: May-June Height: 3-10" tall
Found in areas where there is sagebrush, in dry rocky plains, and on rocky ridges, common.
Top picture by *Stephen L. Love.*

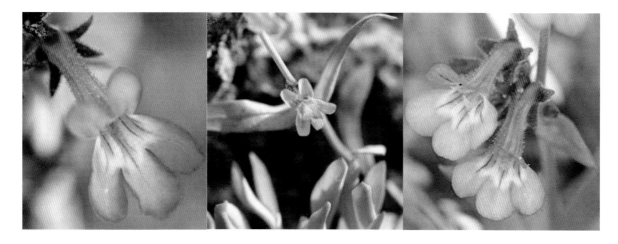

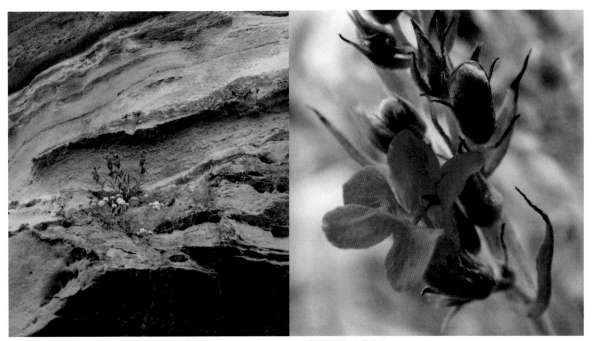

IDAHO PENSTEMON
Penstemon idahoensis
Snapdragon or Figwort Family (Scrophulariaceae)

Flower: Dark blue to bluish-purple, medium-large tubular flowers, outside flower surface sticky and often covered with soil particle

Leaves: Mostly basal leaves narrowly oblong, 2-3" long, leaf edges rolled upward

Blooms: June Height: 3-9" tall

Found on embankments and patches of somewhat sterile, white soil within a small area south of Oakley, Idaho. Photographs taken along Goose Creek Road south of Goose Creek Reservoir, Cassia County. *Penstemon idahoensis* is **rare** and has been considered for listing as an endangered species. Description and pictures by *Stephen L. Love*.

MOUNTAIN PENSTEMON; CORDROOT BEARDTONGUE
Penstemon montanus var. montanus
Snapdragon or Figwort Family (Scrophulariaceae)

Flower: Lavender, funnel-shaped, 3 lower lobes and 2 upper, hairy
Leaves: Grey-green, notched edges and hairy, unusual leaf makes it easy to identify
Blooms: July-August Height: 4-14" tall
Found on rocky slopes.
Top picture by *Stephen L. Love* taken in the Pioneer Mountains near Brokie Lake, Idaho.

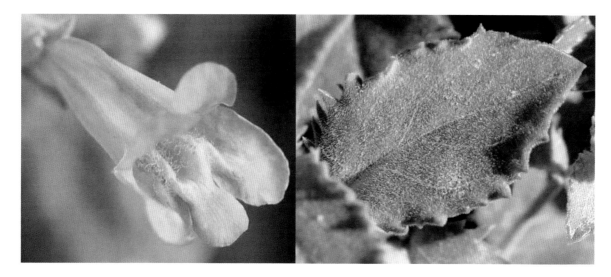

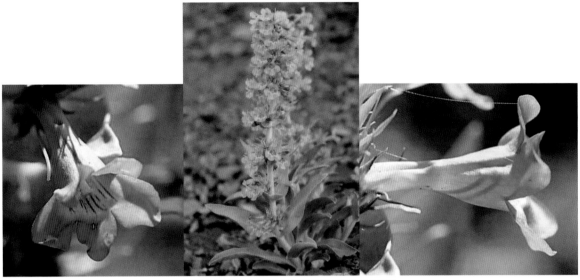

WAXLEAF PENSTEMON
Penstemon nitidus
Snapdragon or Figwort Family (Scrophulariaceae)

Flower: Azure blue, lavender veins inside, long and funnel-shaped
Leaves: Long, thick and lance-shaped, opposite, blue-grey
Blooms: April-May Height: 8-30" tall
Found in well-drained soil, prefers sunny, dry conditions, the earliest Penstemon to bloom.
Photographed on the road to the old town of Bayhorse in Custer County, Idaho, in May.

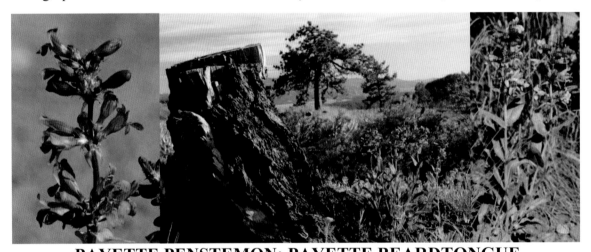

PAYETTE PENSTEMON; PAYETTE BEARDTONGUE
Penstemon payettensis
Snapdragon or Figwort Family (Scrophulariaceae)

Flower: Tubular with a flaring throat, completely hairless outer surface, 2 upper lobes
shorter than the 3 lower, color blue to blue-purple with an occasional pink variant
Leaves: Both basal and stems leaves present, basal leaves 6-7" long and ovate with a petiole,
upper leaves still broad but stemless and more pointed, foliage hairless
Blooms: June-July Height: 10-24" tall
Found in an assortment of habitats: open slopes and ridgetops to sparse forests and brushy
areas. Photographs from hills east of Hell's Canyon.
Description and pictures by *Stephen L. Love*.

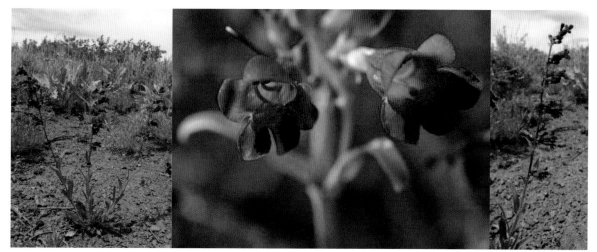

MINIDOKA PENSTEMON; MINIDOKA BEARDTONGUE
Penstemon perpulcher
Snapdragon or Figwort Family (Scrophulariaceae)

Flower: Tubular blue or blue-violet flowers, 2 upper lobes and 3 lower, held in a long, narrow inflorescence, flowers completely hairless and have a bulging belly
Leaves: Both basal and stem leaves present, narrow, 2-5" long, widest near the end, smooth and shiny, somewhat curved, size reduced in the upward parts of the stems
Blooms: May and June Height: 12-24" tall
Found in plains and foothills in southern Idaho, often growing with sagebrush.
Description and pictures by *Stephen L. Love*.

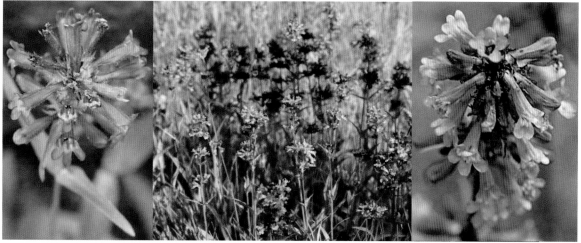

SLENDER BLUE PENSTEMON; LITTLEFLOWER PENSTEMON
Penstemon procerus
Snapdragon or Figwort Family (Scrophulariaceae)

Flower: Whorls of small, lavender-blue to bluish-purple, funnel-shaped, dense clusters, flowers, 1/4-3/8", are smaller than Rydberg's
Leaves: Opposite, basal, oval to lance-shaped, deep green
Blooms: June-July Height: 8-24" tall
Found in meadows and fields, common. Procerus means tall and slender.

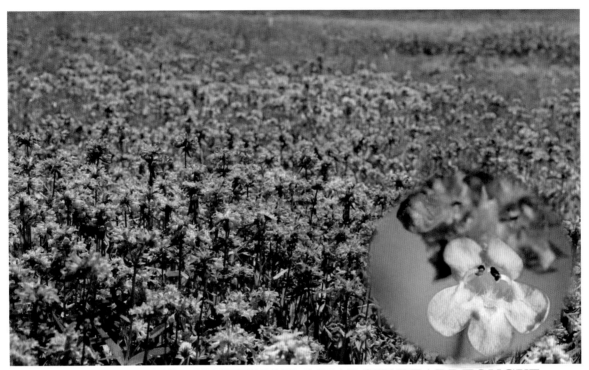

RYDBERG'S PENSTEMON; MEADOW BEARDTONGUE
Penstemon rydbergii
Snapdragon or Figwort Family (Scrophulariaceae)

Flower: Small, lavender-blue and funnel-shaped, flowers 7/16-3/4" long, lower lip has hairy, yellow or whitish patch, flowers are slightly larger than the *procerus*
Leaves: Opposite, linear
Blooms: June-August Height: 8-30" tall
Found in meadows, slopes, and fields. Photographed near Bayhorse Lake in Custer County, Idaho.

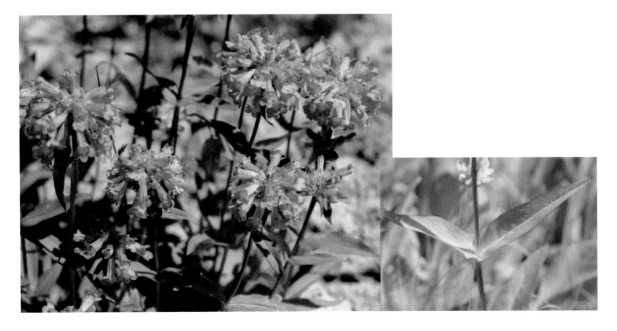

ROYAL PENSTEMON; SHOWY BEARDTONGUE
Penstemon speciosus
Snapdragon or Figwort Family (Scrophulariaceae)

Flower: Tubular, up to 1½" long, medium to dark blue with a lavender to violet tube, the flat face has 5 corolla lobes—2 on the top and 3 on the bottom. Inside the flower, the staminode (the sterile anther) lacks hairs. This is a variable species and plant size varies from 6" to 3', depending on origin.

Leaves: Narrowly spoon-shaped, mostly basal, creased upward along mid-vein, dark green, somewhat waxy on the surface.

Blooms: April to June, depending on elevation Height: varies, average about 15" tall
Found in a variety of habitats, from steep cliffs to rocky slopes, to sagebrush flats.
Description and photos by *Stephen L. Love*.

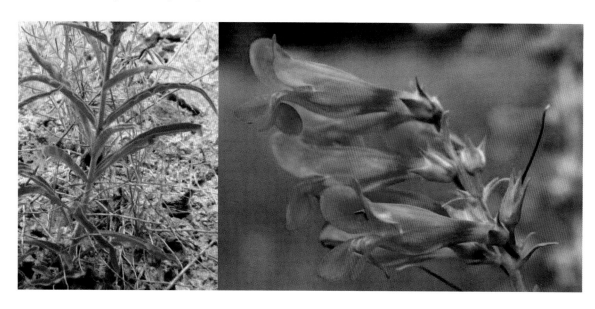

271

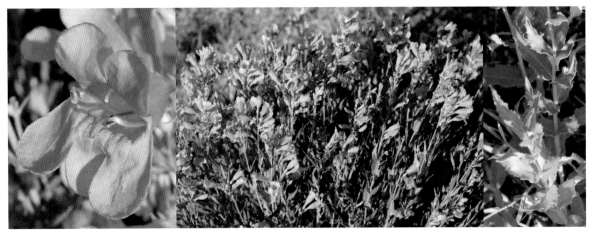

ELEGANT PENSTEMON; VENUS PENSTEMON
Penstemon venustus
Snapdragon or Figwort Family (Scrophulariaceae)

Flower: Bright blue to lavender-blue, white hairs sometimes on floor of tube
Leaves: Lance-shaped, stiff, sharply saw-toothed
Blooms: July-August Height: 12-36" tall
Found in dry, rocky slopes at high elevations. Photographed near Galena Summit in Idaho.

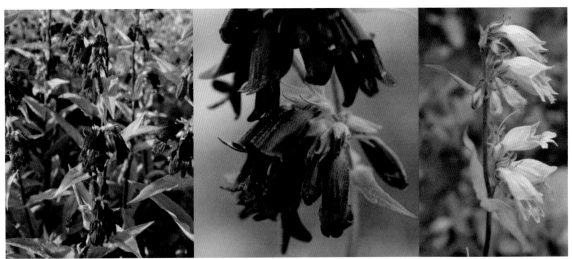

WHIPPLE'S PENSTEMON; WHIPPLE'S BEARDTONGUE
Penstemon whippleanus
Snapdragon or Figwort Family (Scrophulariaceae)

Flower: Tubular, about 1" long, flowers tend to curve downward, 2-lobed upper lip much shorter than the 3-lobed lower lip, color in this species extremely variable depending on location—from pure white to dull yellow to lavender, wine, blue, to so dark purple as to look black
Leaves: Extensive basal mat to dark green shiny leaves with size up to 3" long, basal leaves are spoon-shaped; smaller but prominent leaves grow along the flowering stems
Blooms: May into July Height: up to 24" tall
Found where conditions are moderately moist—subalpine woodlands, open slopes, and occasionally alpine tundra. Most photographs of plants are from the author's garden; white one from Teton Range in Wyoming. Description and pictures by *Stephen L. Love*.

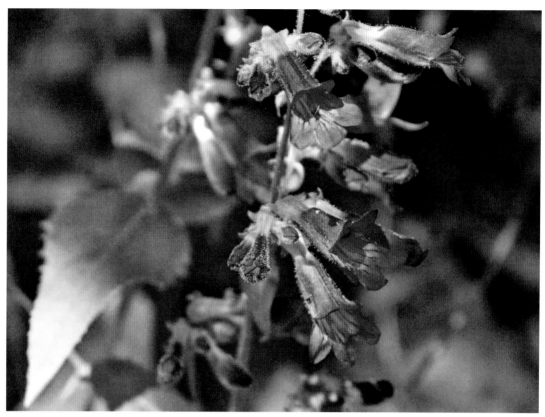

WILCOX'S PENSTEMON
Penstemon wilcoxii
Snapdragon or Figwort Family (Scrophulariaceae)

Flower: Lavender-pink, and blue-violet, funnel-shaped, a stripped throat, yellow beard
Leaves: Opposite, lance- to heart-shaped, toothed edges
Blooms: May-July Height: 16-40" tall
Found in open meadows, on forested slopes, and in rocky areas.
Top picture by *Stephen L. Love*.

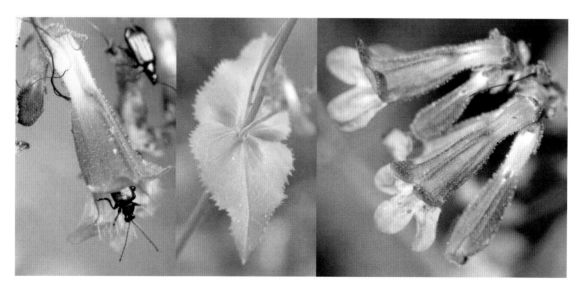

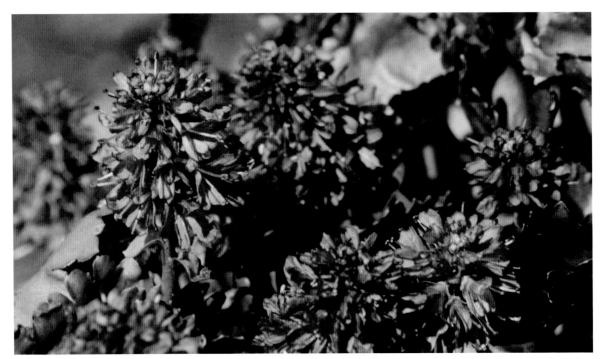

WESTERN MOUNTAIN KITTENTAILS; TAILED KITTENTAILS
Synthyris missurica
Snapdragon or Figwort Family (Scrophulariaceae)

Flower: Terminal, elongated heads of numerous small, dark blue flowers, elongated stamens stick out of the flowers, imparting a fuzzy appearance to the heads
Leaves: Leaf blades are smooth, large, and round with toothed margins; sometimes having edges that curve upward
Blooms: Early May to June Height: 2-7" tall
Found at mid to high elevations in vernally moist forest openings or meadows.
Photographs taken near the Horse Mountain Fire Lookout north of Cuprum, near Hell's Canyon. Description and pictures by *Stephen L. Love*.

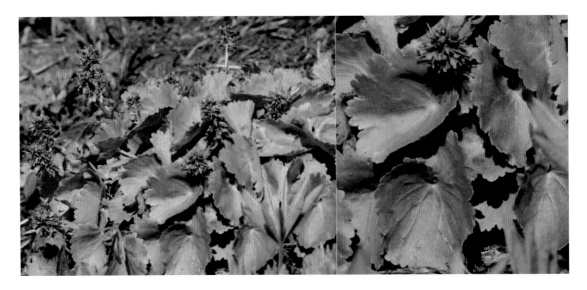

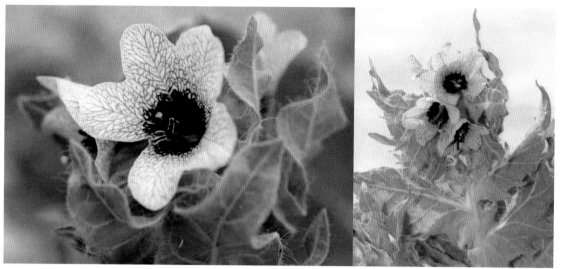

BLACK HENBANE
Hyoscyamus niger
Potato family (Solanaceae)

Flower: Oddly colored, purple, almost black and white to cream, prominent cobwebby purple veins
Leaves: Large, oblong and egg-shaped, pointed, toothed, greyish-green, hairy
Blooms: May-June Height: up to 3' tall
Found in disturbed areas, can cause hallucinations and death, **not native, invasive.**

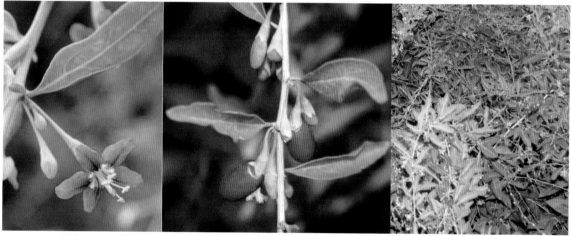

MATRIMONY VINE; WOLFBERRY; CRIMSON STAR
Lycium barbarum*
Potato family (Solanaceae)

Flower: White or lavender tube-like flowers, dark purple veins, orange-red berries
Leaves: Alternate, lanceolate, rounded tips, woody
Blooms: July-August Height: vine 3-9' long
Found in dry, desert areas, **not native.**
Note: Fruit eaten in China for thousands of years and used medicinally for 2,000 years.
**LISS i uhm*

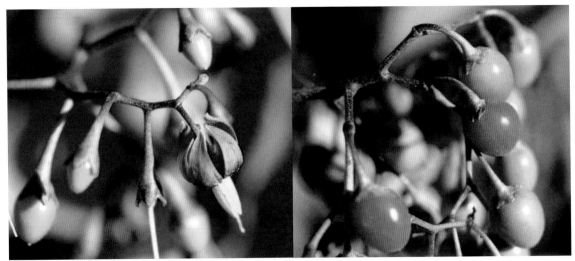

CLIMBING NIGHTSHADE; BITTERSWEET NIGHTSHADE
Solanum dulcamara
Potato family (Solanaceae)

Flower: Purple, petals swept back, prominent yellow cone, small clusters, berries turn red
Leaves: Dark green, divided into 3 leaflets, stems climb on shrubs and fences
Blooms: June-August Height: 1-9' tall
Found in disturbed areas, edges of pastures, along roadsides, considered a toxic weed, berries somewhat poisonous, **not native.**

POTATO BLOSSOMS
Solanum ssp
Potato family (Solanaceae)

<u>No</u>, these are not wildflowers! Columbus brought the plant to Europe.
Louis XVI wore the potato flower for a boutonnière.
Besides, Idaho is famous for its potatoes.

BROOKLIME; AMERICAN SPEEDWELL
Veronica americana
Figwort or Snapdragon Family (Scrophulariaceae)

Flower: Tiny, blue streaked with lavender, saucer-shaped with tiny pink-lavender veins
Leaves: Opposite, lance-shaped to oval, and large compared to the flower
Blooms: May-August Height: 1-3" tall
Found along slow moving streams, seeps, and ponds, common.

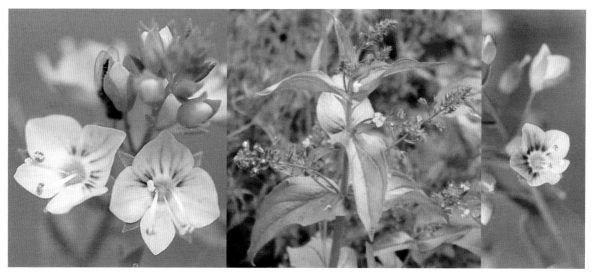

WATER SPEEDWELL
Veronica anagallis-aquatica
Figwort or Snapdragon Family (Scrophulariaceae)

Flower: Small, pale blue, almost white with darker purplish-blue veins on the 4 petals,
a green center, fused into a cup, each flower about ¼"
Leaves: Large oval, opposite, clasping, up to 4" long, plant forms large mats
Blooms: July August Height: 1-3' tall
Found in seeps, near outer edges of streams in low, slow to nonmoving water, **not native.**

ALPINE VERONICA; AMERICAN ALPINE SPEEDWELL
Veronica wormskjoldii
Plantain Family (Plantaginaceae)

Flower: Small plant with 4 lavender-violet petals and lavender veins on the petals,
1 petal is slightly smaller than the other 3, tight clusters
Leaves: Opposite, sometimes slightly toothed and lance-shaped, hairy stem
Blooms: July-September Height: 2-10" tall
Found near ponds and slow moving stream, in moist alpine meadows in higher elevations.
Pictures taken in July near Little Bayhorse Lake, Custer County, Idaho.

BIGBRACT VERBENA
Verbena bracteata
Verbena family (Verbenaceae)

Flower: 5 united petals, small tubular, from pinkish to pale blue or white
on the end of the spikes
Leaves: Lobed, oval with a pointed tip, hairy, prostrate in mats on the ground, square stem
Blooms: August-September Height: 4-20" tall
Found on roadsides, disturbed sites and along ponds.

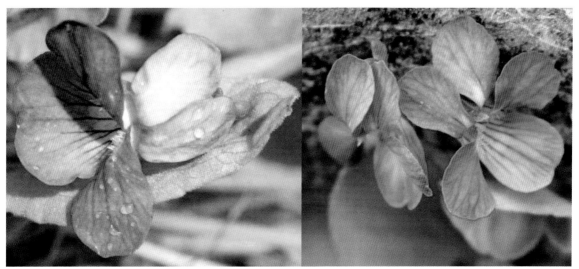

EARLY BLUE VIOLET; HOOKEDSPUR VIOLET
Viola adunca var. adunca
Violet family (Violaceae*)

Flower: Lavender to lavender-blue touched with white, lavender-purple veins,
white hairs, 5 petals, spurred lower petal, irregular shape
Leaves: Egg-shaped to heart-shaped, basal, tiny teeth on the edges.
Blooms: April-July Height: up to 4" tall
Found in valleys, near timberlines, grassy meadows and along streams, common.
**vy oh LAY see ee*

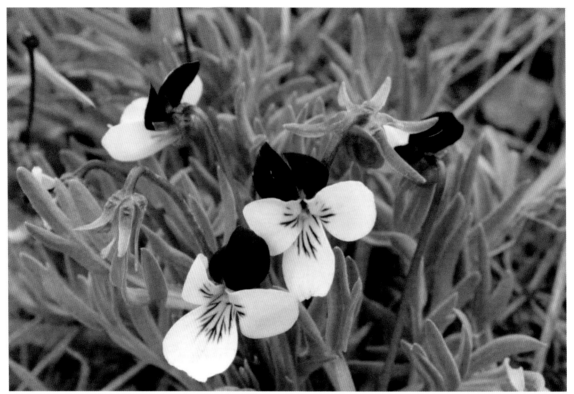

SAGEBRUSH PANSY; GREAT BASIN VIOLET
Viola beckwithii
Violet family (Violaceae)

Flower: Multicolored, upper lips maroon and the lower 3 are white or blue-purple
or maroon, yellow throat with maroon veins, irregular shape
Leaves: Fan-shaped and deeply divided, gray-green
Blooms: March-May Height: 2-18" tall
Found in the sagebrush flats and dry rocky areas.
Photographed on Tom Cat Hill within the Craters of the Moon, Butte County, Idaho.
Top picture by *Gwen Russell*.

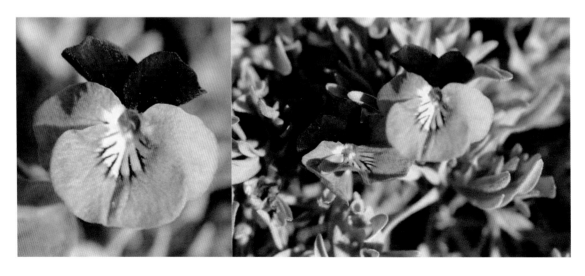

BLACK, BROWN, and GREEN FLOWERS

Western Coneflower at Teton Pass.

This section is for black, brown, chocolate, or pale to dark green plants or ones that did not quite fit in the other sections.

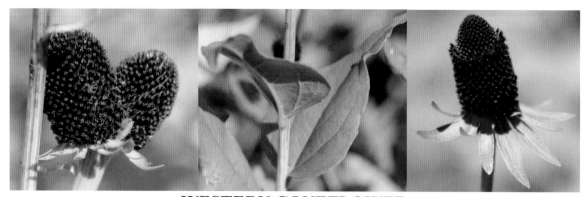

WESTERN CONEFLOWER
Rudbeckia occidentalis*
Aster Family (Asteraceae)

Flower: Cone almost black or purplish-red, no petals only the sepals enclose the bud
Leaves: Large, oval and pointed, prominent central vein
Blooms: June-August Height: 3-6' tall
Found in moist meadows and hillsides. When it first blooms, it has a yellow ring of
pollen around it. Photographed near Jackson Hole, Wyoming.
*rood BECK i ah

COMMON JUNIPER
Juniperus communis alpina
Cedar or Cypress Family (Cupressaceae*)

Flower: Ground hugging shrub, berries blue-green
Leaves: Needle-like, green but can appear almost silver, woody stems
Blooms: Bluish berry-like seed cones appear the last of July-August Height: 2-3' tall
Found on rocky hillsides and in open forests.
*kew press AY see ee

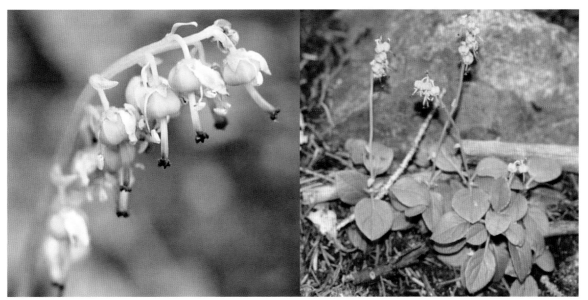

SIDEBELLS; ONE-SIDED WINTERGREEN
Orthilia secunda
Heath Family (Ericaceae)

Flower: Greenish to white, nodding on one side of bent stem
Leaves: Basal, shiny, oval to elliptical
Blooms: July-August Height: 2-8" tall
Found in moist forests and woody areas.

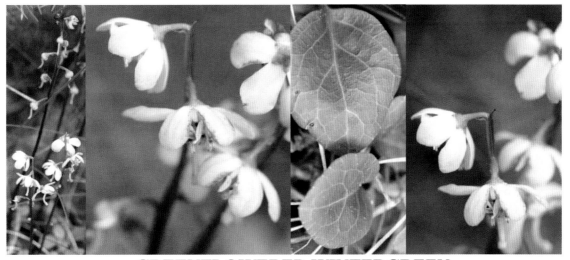

GREENFLOWERED WINTERGREEN
Pyrola chlorantha
Heath Family (Ericaceae)

Flower: 5 fused green-white petals in the form of a cup, faces downward
Leaves: Basal, round, toothless, prominent veins
Blooms: Late June and July Height: 4-12" tall
Found in partial to full shade in woods. Photographed on the Lolo Trail.

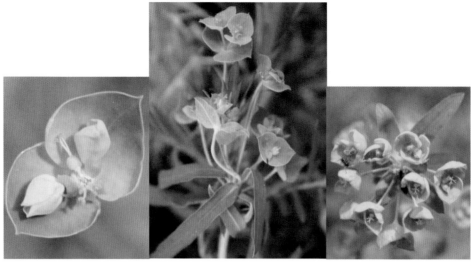

LEAFY SPURGE
Euphorbia esula
Spurge Family (Euphorbiaceae*)

Flower: Bright yellow-green, cup-like cluster
Leaves: Small, lance-shaped with a slight wavy margin, milky sap
Blooms: June-July Height: 1-3' tall
Found in disturbed areas, along roadsides, **not native, noxious, invasive species.**
Note: The milky sap is toxic to humans and livestock.
**you for bi AY see ee*

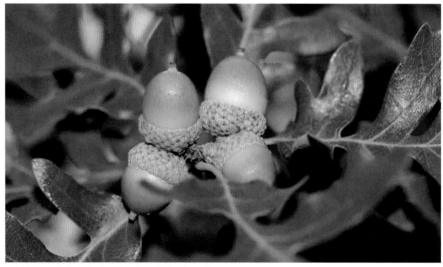

GAMBEL OAK ACORNS; MOUNTAIN WHITE OAK ACORNS
Quercus gambelii*
Beech or Oak Family (Fagaceae*)

Tree: Can grow to 30', oval acorns, hairy scales
Leaves: Deeply lobed, dark green, older tree bark is grayish-brown and rough
Blooms: Acorns form late July-August
Found on slopes, in valleys, on mountains and foothills.
**KWUR kuss *fay GAY see ee*

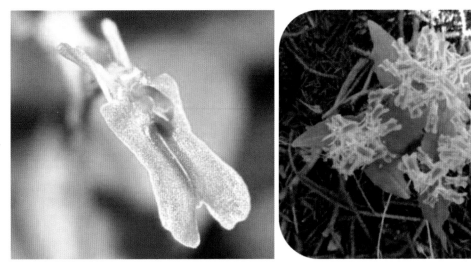

NORTHERN TWAYBLADE
Listera borealis
Orchid Family (Orchidaceae*)

Flower: Pale green with two darker green stripes on the lip petal
Leaves: Large, opposite, oval-shaped
Blooms: June-July Height: up to 12" tall
Found in forested areas near streams.
Photographed in a forest above Challis on the Custer Motorway in late June, Custer County.
*or kid DAY see ee

GREAT BASIN WILDRYE
Elymus cinereus
Grass Family (Poaceae)

Flower: Tall grass that forms clumps
Blooms: June-July Height: 2-8' tall
Found in a wide range of conditions from grasslands to forests, very common.

INDIAN RICEGRASS
Achnatherum hymenoides
Grass Family (Poaceae)

Flower: Grass, white to straw colored
Blooms: June-July Height: up to 2' tall
Found at Craters of the Moon and other dry desert areas.

SMOOTH BROME
Bromus inermis
Grass Family (Poaceae)

Grass: Introduced grass, spikelets
Blooms: May-August Height: 2-3½' tall
Found in disturbed areas, along roadside, in meadows and grasslands, **not native.**

TIMOTHY GRASS
Phleum pratense
Grass Family (Poaceae)

Flower: Grass used for fodder
Blooms: June-September Height: up to 24" tall
Found in pastures and rangelands where cattle are grazed. Useful in revegetation projects.
Not native.

CURLY DOCK; MOUNTAIN SHEEP SORREL
Rumex crispus*
Buckwheat Family (Polygonaceae*)

Flower: Mostly green or yellowish-green, non-showy clusters, tiny red-brown flowers in whorls as it matures
Leaves: Alternate, narrow, long, curled, or wavy edges, mostly basal, hairless
Blooms: June-September Height: 1-4' tall
Found along streams, on roadsides, open meadows, fields, along forest edges, and disturbed places, common, **not native.**
**ROO mecks *pol lig oh NAY see ee*

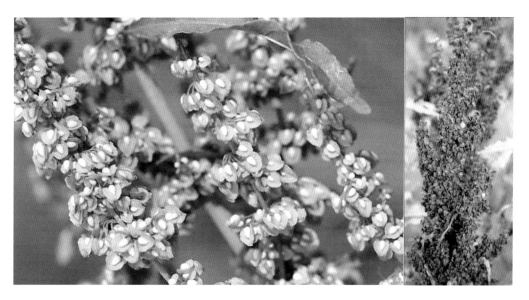

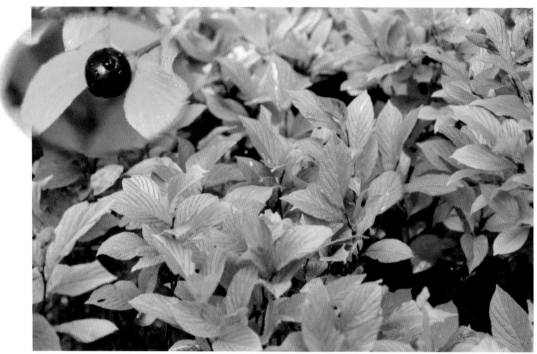

CASCARA BUCKTHORN; CHITTAM BARK; CASCARA SAGRADA
Rhamnus purshiana
Buckthorn Family (Rhamnaceae*)

Flower: Tiny bell-shaped yellow-greenish clusters, berry red to purplish-black
Leaves: Alternate, wavy-edge, toothed, broad, oval- or egg-shaped, deeply veined
Blooms: Flower in June Berries: late July
Found in forested areas, near bogs, can be shrub or tree-like.
Notes: After the bark was aged for a year, some Native American tribes used it as a healing plant and as a laxative. During the 1940s, the bark brought such high prices that it became an endangered species. Now the plant thrives almost unnoticed.
ram NAY see ee

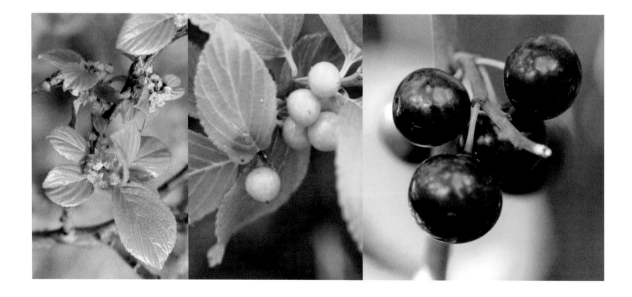

BROADLEAF CATTAIL
Typha latifolia
Cattail Family (Typhaceae*)

Flower: Brown, long cylinder on spike
Leaves: Alternate, ribbon-like, erect, dark green
Blooms: July-August Height: 4-8' tall
Found in still or slow moving water, marshes, edges of lakes, ponds. Leaves can be used to weave mats and even hats. Early pioneers used the fluff from cattails for bedding.
ty FAY see ee

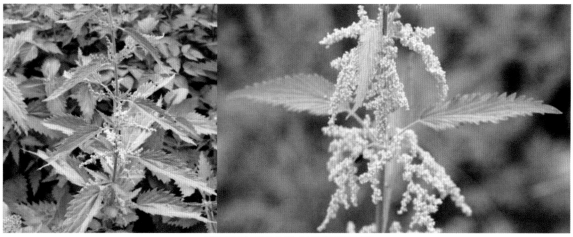

STINGING NETTLE
Urtica dioica
Nettle Family (Urticaceae*)

Flower: White-cream or greenish, small clusters
Leaves: Opposite, toothed, has hollow stinging hairs on the leaves and stems
Blooms: June-July Height: 2-4' tall
Found in disturbed areas, near streams and thickets. Mild sting (formic acid) when touched.
Note: For centuries, Nettles have been used for food, medicine and dyes. They are a great substitute for spinach as they are rich in Vitamins C and A.
ur ti KAY see ee

Book would not be complete without these two very common native plants.

BIG SAGEBRUSH
Artemisia tridentata
Sunflower Family (Asteraceae)

Flower: Plant silvery-blue, yellow round flower heads
Leaves: Undivided, 3 lobes, wedge-shaped, dense gray hairs on plant, older plants have trunks with brown bark
Blooms: August-September Height: average 3' but can be as tall as 10'
Found in sagebrush flats. Plant is an important source of food for wildlife, common.

GREASEWOOD
Sarcobatus vermiculatus
Goosefoot Family (Chenopodiaceae)

Plant: Male flowers form small cone-like shapes, white bark turns gray, Meriwether Lewis found the flesh-tearing spines troublesome when he first collected it in 1806 and called it "the fleshy leafed thorn"
Leaves: Bright green, small linear, succulent, spines
Blooms: June-August Height: 3-8' tall
Found in salt flats in the sagebrush areas, and semi-desert areas, common.

Selected References

Anderson, Richard, and Jaydee Gunnell, and Jerry Goodspeed, *Wildflowers of the Mountain West*, Boulder, CO, University Press of Colorado, 2012.

BLM, *Common Wildflowers of Southern Idaho*, Idaho State Office, 1387 S. Vinnell Way, Boise, ID 83709.

Brandenburg, David, *Field Guide to Wildflowers of North America*, New York, NY, Sterling Publishing, 2010.

Clackwell, Laird R., *Great Basin Wildflowers*, Helena MT, Falcon Publishing Company, 2006, 2012

Earle, A. Scott and Jane Lundin, *Idaho Mountain Wildflowers*, Boise, ID, Larkspur Books, 2012, third edition.

Harris, James G. and Melinda Woolf Harris, *Plant Identification Terminology, an Illustrated Glossary*, Spring Lake, UT, Spring Lake Publishing, 2017.

Kershaw, Linda, *Edible and Medicinal Plants of the Rockies*, Edmonton, AB, Lone Pine Publishing, 2000.

Kershaw, Linda, Andy MacKinnon, and Jim Pojar, *Plants of the Rocky Mountains*, Vancouver, BC, Lone Pine Publishing, 1998.

Kimball, Shannon, and Peter Lesica, *Wildflowers of Glacier National Park and Surrounding Areas*, Kalispell, MT, Trillium Press, 2010.

National Audubon Society, *North American Wildflowers, Western Region*, New York, NY, Chanticleer Press, Inc., 2001

Newcomb, Lawrence, *Newcomb's Wildflower Guide,* Boston, MA, Little, Brown and Company, 1976.

Phillips, H. Wayne, *Central Rocky Mountain Wildflowers*, Helena, MT, Falcon Publishing Company, 2012, second edition.

Phillips, H. Wayne, *Northern Rocky Mountain Wildflowers*, Helena, MT, Globe Pequot Press, 2001.

Pojar, Jim and Andy MacKinnon, *Alpine Plants of the Northwest Wyoming to Alaska,* Vancouver, BC, Lone Pine Publishing, 2013.

Schiemann, Donald, *Wildflowers of Montana*, Missoula, MT, Mountain Press Publishing Company, 2005.

Schreier, Carl, *A Field Guide to Wildflowers of the Rocky Mountains*, Box 193, Moose, WY 83012, Homestead Publishing, 1996.

Shaw, Richard J. and Marion A. Shaw*, Plants of Yellowstone and Grand Teton National Parks,* Wheelwright Publishing, Helena, MT, Revised Edition 2008.

Strickler, Dee and Zoe Strickler*, Wayside Wildflowers of the Pacific Northwest,* Helena, MT, Riverbend Publishing, 1993.

Taylor, Ronald J., *Sagebrush Country, A Wildflower Sanctuary,* Missoula, MT 59801, Mountain Press Publishing, 1994.

Taylor, Ronald J., *Northwest Weeds,* Missoula, MT 59801, Mountain Press Publishing, 1990.

Underhill, J. E., *Northwestern Wild Berries*, Blaine, WA, Hancock Publishers, Ltd., 1980.

Whitson, Tom D., and Burrill, Larry C., *Weeds of the West*, Jackson, WY, University of Wyoming, 2009.

Useful Websites:
BONAP.org and Go Botany https://gobotany.newenglandwild.org/full/

https://idahonativeplants.org/native-plant-resources/

Colorado Wildflowers http://www.swcoloradowildflowers.com—very helpful website

Dave's Garden http://davesgarden.com/guides/botanary/

Lady Bird Johnson Wildflower Center http://www.wildflower.org/plants/

Turner Photographics http://www.pnwflowers.com/flower/
Pacific Northwest Wildflowers contains 16,235 wildflower photographs by Mark Turner. (Most helpful with many pictures and easy to understand descriptions—my favorite place.)

https://tetonplants.org/category/plant-id

USDA Plants Database http://plants.usda.gov/

US Wildflowers http://uswildflowers.com/

https://web.ewu.edu/ewflora/

http://www.wildflowersearch.com/
If you have a smart phone or, better yet, a tablet, consider getting a free guide to the plants of any state from Free WildflowerSearch Apps

Index

Dr. Stephen L. Love

Dr. Stephen L. Love is an amateur botanist and extension horticulturist for the University of Idaho. He earned his bachelor's degree at Brigham Young University and Ph.D. at Clemson University. Dr. Love develops native plant products for use in water-conserving landscapes and has collected over 1,200 species of Intermountain native wildflowers and shrubs.

Sharon Larter Akers

Sharron Akers earned her Master's in World Missions, a Doctorate in Ministry and is an author. Her love of wildflowers was influenced by her father who every spring, as a child, would take her up on their cattle range under Mt. Borah and show her the breathtakingly beautiful purple, yellow, red or white flower-blooming foothills as one will see illustrated in this book.

Sharon Phillips Huff

Sharon Huff earned her master's degree from Arizona State University and taught English to high school students. She and her husband live in Phoenix but spend summers in Mackay, Idaho, her old hometown. As a hobby, she photographs wildflowers in Montana and Idaho, especially those in Blaine, Butte and Custer County.